ADVANCED CINEMATOGRAPHY

ADVANCED PHOTOGRAPHY

A Grammer of Techniques

Michael J. Langford, F.I.I.P., Hon. F.R.P.S.

Senior Tutor in Photography
Royal College of Art, London

Fourth Edition

Focal Press · London

Focal/Hastings House · New York

© 1980 FOCAL PRESS LIMITED

British Library Cataloguing in Publication Data

Langford, Michael John
 Advanced photography.—4th ed.
 1. Photography
 I. Title
 770 TR145

ISBN (excl. USA) 0 240 51029 1 (casebound)
 0 240 51028 3 (paperback)
ISBN (USA only) 0 8038 0450 4 (casebound)
 0 8038 0396 6 (paperback)

First published 1969
Second edition 1972
Third edition 1974
Fourth impression 1975
Fifth impression 1977
Sixth impression 1977
Fourth edition 1980

Italian Edition
TRATTATO COMPLETO DI FOTOGRAFIA
Fotografare, Rome

Spanish Edition:
TRATADO DE FOTOGRAFIA
Ediciones Omega, S.A., Barcelona

Filmset by Computer Photoset Ltd., Birmingham.
Printed in Great Britain by Thomson Litho Ltd., East Kilbride
and bound by Hunter & Foulis, Edinburgh.

CONTENTS

vi

viii

INTRODUCTION

This is the second of three textbooks written specifically for student professional photographers. Like its predecessor *Basic Photography*, it is intended to complement practical work undertaken in studios and in full-time, part-time day release and evening classes at schools of photography. Students will find this book gives a useful technical background to colour photography, flash work and the more advanced aspects of monochrome photography.

As the titles imply, *Advanced Photography* develops but does not repeat the principles covered in *Basic Photography*. It is not necessary to have a scientific background to follow this book, but it is assumed that the reader is familiar with the basic equipment, materials and processes of black and white photography discussed in the primer.

The book approaches its subjects from the point of view of a professional photographer. The main value of theory lies in the greater control and underlying self-confidence it can bring to practical work. As before, the aim in writing has been readability without loss of accuracy–and a coupling of principles with practical applications at every opportunity. It is hoped that the student will find this descriptive approach encouraging, leading him on to a more profound coverage elsewhere if he intends to be primarily a technical or scientific photographer.

Advanced Photography is intended for students preparing for final year College examinations in professional photography and the written papers on photographic principles for degree and vocational courses. Current syllabuses should be compared with the contents list of this and the previous volume.

It would be presumptious to claim that any one book, let alone any one author can cover the breadth of ground of such a large subject, to any great depth. Perhaps this book will serve the function of a main trunk, containing information and practical experience but with departure points for additional reading. This is why the titles of books covering narrower fields more deeply are located at the end of each chapter. The serious student should make use of them.

As for the layout of this book: the first six chapters look at lenses, imaging and lighting (principally flash). The next section takes a more advanced look at our monochrome materials and processes, their limitations and the ways in which they may be manipulated. Section three deals with colour photography from first principles, as *Basic Photography* did not include colour. The final section 'Photographs into Print' looks at graphic reproduction–something with which we are *all* likely to come into contact as professional photographers, being the bridge between our work and a mass audience: its influence is important.

There are questions located at the end of each chapter, many of them taken from College internal second and third year examination papers, and appropriate national examinations.

Although references to practical job handling appear frequently, *Advanced Photography* contains no section devoted specifically to studio practice. I feel strongly that at this stage photographers are unlikely to be helped by what would inevitably be an over-brief reference in a book devoted primarily to the background of practical

work. A superficial coverage risks establishing factual 'rules' of lighting, viewpoint, etc., stifling individual reaction to the subject and encouraging sterotyped work. This is hardly a substitute for a programme of work under a sympathetic teacher, augmented by regular contact with the most stimulating published photography.

In this latest edition due regard has been paid to recent improvements in technology, general changes in the contents of courses, and new internationally agreed terms. Previous chapters on early lens designs and the theory of latent image formation have been deleted–to allow more space for important developments in colour photography. Note also that the outline history of photography no longer appears here. Greatly expanded and illustrated it now forms a separate textbook, *The Story of Photography*. Overall I hope that this revised *Advanced Photography* will continue to give a useful background to the tools and methods of present day photography.

MICHAEL J. LANGFORD

This book again owes muct to the encouragement and suggestions from fellow teacher photographers, and students. In particular, thanks are due to Geoff Cooper, and John Still, for reading over the text, Frank Hawkins, for helpful suggestions, and Terry Butler, Charlotte Marx and Frank Owen, in organising specialised illustrations. Many of the credited pictures are the work of students in schools of photography. I also thank James Walter Burden for his advice in up-dating Chapter 15.

Section I

CAMERA AND LIGHTING

1. PROBLEMS OF LENS DESIGN

We know that lenses form images due to their refractive index and surface contours. Light rays are reduced in speed on entering the lens, and unless they are exactly at right angles to the lens surface a change in direction occurs. The more oblique the angle between ray and lens surface the greater this bending or 'refraction' becomes until a critical angle, when the incident light is reflected. A 'thick', strongly curved lens, made in a material with a high refractive index, has a short focal length.

Image quality produced by a simple single lens is usually quite unsatisfactory for professional photographic purposes, and instead a compound lens system is used. Today compound lenses take many forms. They can be classified into groups – telephoto; 'zoom'; process; inverted telephoto; soft focus, etc. Designed for particular functions, each lens type offers specific optical advantages to the photographer.

Every professional quality lens embodies many years of developments in optical glass technology, design mathematics and precision engineering. Before discussing modern lens types it is useful to know something of the basic problems faced by the lens designer. This may also explain why a good lens may easily cost more than a camera body.

Optical glass

A good lens relies on good raw material – optical glass. Unlike the maker of simple sheet glass or glass containers, the manufacturer of optical glass must supply the lens designer with a very sophisticated product. It is essential that each batch of glass is uniform throughout its mass. This uniformity must be both *chemical* (achieved by meticulous mixing and stirring of the molten material), and *physical* (controlled by 'annealing' to prevent stresses forming whilst cooling after the glass is cast). Obviously there must be no risk of, say, refractive index varying from one part of a block of glass to another. The specified refractive index must not only be accurate, but repeatable batch-to-batch; similarly the dispersive qualities of the glass.

This dispersion of white light into component spectrum colours upon refraction is expressed as an Abbe Number*. Generally speaking, the higher the refractive index the greater the dispersive property of the glass. However, the two can be independently altered by varying the chemical composition of the glass, thus giving many possible permutations of refractive index and dispersive power. This is of great importance to the designer of lenses in the control of aberrations, as described later.

Optical glass must be free of bubbles – these must not be induced during the stirring necessary at the molten stage to achieve homogeneity. It must also have a high degree of transmission. The soda glass used for windows is superficially colourless, but has a distinct greenish colour when the edge of the glass is viewed along its length. A block of optical glass should not show such characteristics – otherwise lenses made from it

*Abbe Number = Mean refractive index – (Refractive index for blue light – Refractive index for red light). Mean refractive index is measured using a wavelength in the middle of the visual spectrum. The *lower* the Abbe number the greater dispersion of colours produced by the glass. By tradition, optical glasses having an Abbe number of 55 and above are crown glasses: those with a lower Abbe number are flint glasses, e.g., Hard Crown, 60; Dense Flint, 25. Named after German physicist Ernst Abbe.

will produce a slight colour cast. Some absorption of light by glass is inevitable, but this should be kept to a minimum, and be even throughout the spectrum.

The glass, and thereby the final lens, must be hard wearing in the sense of resistance to water vapour, fumes and other aerial conditions met in commercial and industrial photography. At the same time the material will need mechanical characteristics which allow grinding and polishing to design curvatures.

The raw materials, plant and accumulated experience needed to produce a useful range of optical glasses is so exacting that world-wide sources only amount to a few firms, which are located in highly developed countries such as Germany, America, Great Britain, Russia and Japan, supplying lens manufacturers in these and certain other countries.

Designer's basic problem

Given the requirements of a new photographic lens, (normally for a specific type of work) the lens designer's job is to decide the number of components, the required glass characteristics and radius of curvature for each component, its spacing and assembly. His aim is to minimise 'aberrations' or image errors inherent in all lenses. His standards are determined by the purpose of the lens and requirements such as maximum aperture, focal length, field, and of course price.

The seven basic aberrations are Spherical aberration; Chromatic aberration; Lateral Chromatic aberration; Coma; Astigmatism; Field curvature and Curvilinear distortion. These faults are present collectively. Examine the image projected by a simple magnifying glass–misty, distorted and colour fringed. For convenience here we will try to distinguish aberrations one at a time in isolateion. An outline knowledge of these image errors will be helpful later in discussing lens types.

Axial faults (these errors even affect the image point formed on the lens axis)

Spherical aberration. Most lens surfaces are spherical–this being a convenient shape to grind mechanically. Unfortunately however if a bundle of parallel rays is refracted by a single lens with a spherical surface a number of slightly differing points of focus are created. This inherent fault can be proved by geometrically plotting the paths of rays through each zone of the lens. Rays refracted by the outer zones of the lens, i.e. farthest from its axis, come to focus nearer the lens than rays refracted through central zones. In fact the overlapping rays caused by this aberration form a 'caustic', a characteristic spread of light. (In a similar way the curved inner surface of a cup of tea reflects light to form a caustic on the surface of the liquid.) We can therefore say that *Spherical aberration is the inability of a lens to bring marginal and axial rays to the same point of focus.* (See Fig. 1.1.)

A photographic lens suffering from spherical aberration would yield a diffused, low contrast image over the whole image field. It is obvious that one way to reduce the effects of this fault is to 'stop down' the lens, thus using only the central zones. In fact stopping down creates a focus 'shift' away from the lens. This characteristic means that any lens suffering from spherical aberration must always be rechecked for focus when stopped down. Unfortunately for the designer, demand for wide aperture lenses means that he must use correction methods other than stopping down.

4

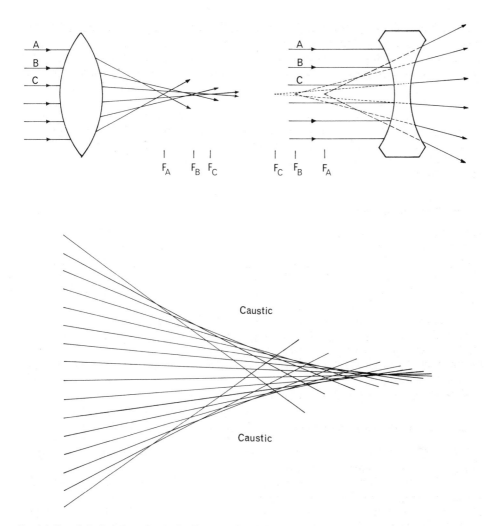

Fig. 1.1. Top: Spherical aberration in simple converging and diverging lens elements. Bottom: Light rays which have passed through a lens suffering from spherical aberration cross each other in many places, forming 'caustic curves' of increased intensity. Note: For clarity all diagrams of aberrations show the faults in a greatly exaggerated form.

The solution lies with mathematically related radii of curvature; with glass of higher refractive index, thus reducing the surface curvature needed; by combination of a positive element with a weaker negative component of equal but opposite spherical aberration, or grinding to an *aspheric* shape (i.e. with surface curvature not forming part of a sphere, Fig. 2.10). The aberration is actually utilized in some forms of 'soft focus' lenses. (See page 28.)

Chromatic aberration. As the name suggests, this is a fault concerning colour. We know that white light undergoing refraction is dispersed into its spectral colours,

blue wavelengths being refracted slightly more than red wavelengths. Consequently when a parallel beam of white light is passed through a simple lens the different wavelengths are brought to differing points of focus, blue being focused closer to the lens than red. For example, the image formed by a simple lens may be focused on the

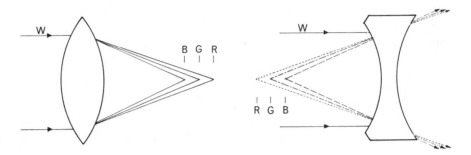

Fig. 1.2. Chromatic aberration. Dispersion of white light in simple converging and diverging lens elements. The fault is largely self cancelling if the two elements are combined, but the converging element must be made of glass of higher refractive index if the combination is to function as a positive lens.

camera screen in terms of its green light content, visually the brightest region of the spectrum. If however blue sensitive material such as line film is being used the emulsion will react to wavelengths which are not in focus.

Chromatic aberration is the inability of a lens to bring light of different colours to the same point of focus.

Keeping the maximum aperture small will reduce the effects of chromatic aberration by increasing depth of focus. Better still, the designer will combine the positive lens with a negative element made in another type of glass. This negative element has equal but opposite dispersive power, but a lower refractive index than the positive element. The combination therefore remains convergent but virtually 'corrected' for chromatic aberration.

A lens corrected by the use of two types of glass brings two colours (usually blue and green) to a common point of focus and is known as an *achromat*. Lenses further corrected so that blue, green and red wavelengths coincide require at least three types of glass and are sometimes needed for specialist technical photography and process work (page 29). Such lenses are called *apochromatic*–they are usually highly corrected for most other aberrations, and are expensive.

Full chromatic correction at a reasonable price is a most difficult problem, particularly as spherical aberration is affected by wavelength, and corrections for this latter fault may be thrown out of balance. Fortunately a good achromatic lens has so little residual chromatic aberration, even at full aperture, that except for critical colour work such as separation negative making, the commercial photographer need not anticipate trouble. He must however realise that when shooting on infra-red sensitive material his normally excellent lens will not bring these long wavelengths to the same plane of focus as the visible image. Slightly extra bellows extension is required (about 0·3%), unless the lens is well stopped down. Some small format camera lens focusing scales have an additional datum mark for infra-red.

6

'Off-axis' aberrations

The remaining lens aberrations affect only off-axis image points–those parts of the image field which are well away from the lens axis. The defects here are more numerous and complex.

Lateral chromatic aberration (or lateral colour). A simple converging lens will form images which vary in their *size* according to colour. For example, a white square imaged to one side of the format will show a colour fringe–the blue content of the white square may be imaged slightly smaller than the green content, which is in turn smaller than the red content image. In effect the focal length of the lens varies with different wavelengths. The more oblique the image forming rays, the greater the spread of colour.

Lateral chromatic aberration is the inability of a lens to maintain the same size image for different colours. The image is not improved by stopping down, for this influences depth of focus, not magnification. Reduction of chromatic aberration by mutually neutralizing components may not necessarily reduce lateral aberrations (see Fig. 1.3).

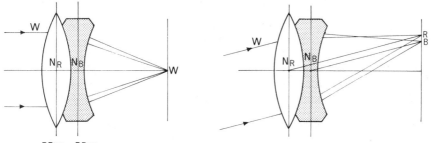

Fig. 1.3. Left: By combining elements of two appropriate types of glass equal, but opposite, dispersion occurs and chromatic aberration is 'corrected'. The combination can be considered as having separate principal planes and rear nodal points for red(R) and blue(B) light. Right: When imaging oblique light from an off-axis subject point the separated rear nodal points show that the image positions for the red and blue components of the light are laterally displaced. The more oblique the light the greater this displacement. Lateral colour is unaffected by stopping down.

Lateral colour is visually far more apparent than the displaced planes of focus of chromatic aberration (examine the image projected by a magnifying glass). It is also a very serious error in lenses intended for critical colour work. The designer therefore has to work to far narrower tolerances in reducing this fault to an acceptable level.

Coma. Another important fault restricted to off-axis images is discovered when we examine the image of a subject point formed obliquely by a simple lens. The image is spread out into a patch of light usually but not always resembling the tail of a comet–hence the name *coma*. Superficially the fault can be considered as oblique spherical aberration. Each zone of the lens causes the rays to reach the focal plane at a different position. Many points of focus are thus formed for the one subject point. Each lens zone is circular and forms a ring of light. The outer lens zones being of larger diameter than the central zones form larger rings of light. Light from our point object is therefore imaged as many overlapping rings of differing sizes. Where these

7

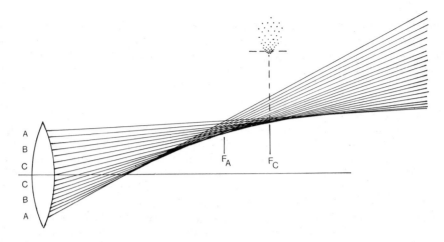

Fig. 1.4. Coma. Each circular zone of the lens causes oblique rays from an off-axis point to come to focus at a different position relative to the lens and lens axis. Insert: The patch of light formed (a cross section taken at the point of focus for zone C) shows a characteristic comet shape. Compare with Fig. 1.1, and see Plates 1 and 2.

rings overlap the light level is intensified—rather like the caustic curves of spherical aberration—creating the comet tail patch of light (Fig. 1.4).

Coma is the inability of a lens to form an oblique, point image, and to give instead an unsymmetrical light patch spreading outwards from a nucleus.

Coma is reduced by stopping down, as this limits the lens zones used to form the image. A system of mutually correcting elements is needed to control this fault. The aberration is particularly difficult to correct in lenses designed to have both wide aperture and wide field of view.

Astigmatism. When light from a point on the object is imaged obliquely by a lens suffering from astigmatism the image can only be focused as one or other of two

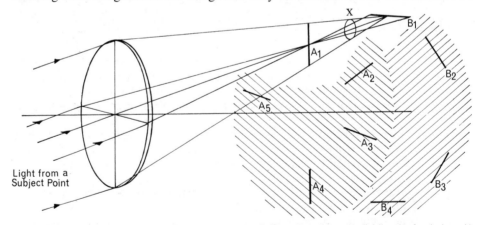

Fig. 1.5. Astigmatism. Light from an off-axis subject point is imaged as either a radial line (at focal plane A) or a tangential line (plane B). The best compromise image is the disc of light X at an intermediary plane. Other off-axis subject points are imaged as A_2 or B_2, etc. A lens free of astigmatism is an anastigmat.

8

straight lines at different positions in space and at right angles to each other. As can be seen from Fig. 1.5 the refracted rays appear to converge, in a horizontal plane only, to one position. Rays converging in a vertical sense meet on a plane at a different distance from the lens. The required point image is therefore unattainable and the best compromise is the circular patch of light produced midway between the two planes.

On the other hand, if the object is a short straight line instead of a point an acceptable image may be formed at one of the image planes, as line sharpness in width is very much more apparent than in length. In fact if a lens suffering from astigmatism is used with a test card comprising a number of ruled lines, it is found that object lines radiating out in directions away from the lens axis can be brought to reasonably sharp focus at one of the two image planes. Lines at right angles to these radial lines (i.e. 'tangential' lines) can be resolved at the other image plane.

Astigmatism is the inability of a lens to form an oblique point image at one position in space—giving instead short lines in different focal planes. The designer's problem is therefore to bring tangential and radial object lines to a common plane of focus over the whole usable field of the lens. When, by means of suitably computed elements, astigmat errors are virtually zero at a point well out in the field it can be said that astigmatism is 'corrected'. At many other parts of the field some slight residual astigmatism will almost certainly remain. This remaining error increases rapidly towards the limits of lens coverage. It is one very good reason why a lens must not be used for a larger format negative than it was designed to cover.

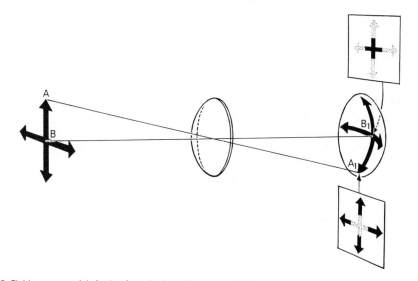

Fig. 1.6. Field curvature. A is further from the lens than centre B. Therefore image A₁ is formed closer to the lens than B₁—in fact the focal plane is saucer shaped. The image centre and edges cannot both be focused on one (flat) focal plane.

Field curvature (or curved field).　Perhaps strangely, it is not a 'normal' phenomena for a lens to image a flat object over a flat focal plane. The off-axis parts of a flat object facing the lens are always slightly further from its optical centre than the

part of the same object which lies on the lens axis. Consequently a simple lens sharply images these off-axis objects slightly closer to the lens. The result is a saucer shaped plane of focus (Fig. 1.6.). Such a lens can be focused for the centre of the negative format or the edges, but not both at the same time.

Field curvature is the inability of a lens to form an image of a flat object over a flat focal plane.

Stopping down reduces the *visual effect* of field curvature by increasing depth of focus. The emulsion could also be curved slightly if on a flexible base. Normally however it is the lens designer's task to determine surface curvatures and glasses which will provide a flat field. Residual curved field is noticeable with some wide angle lenses.

Curvilinear distortion (or distortion). When a simple lens is used with a metal stop either in front of or behind the components, off-axis rays may be prevented from passing through the centre of the lens. In the theory of image formation with simple lenses it was always assumed that the central ray in any oblique beam of image forming light passed through the centre of the lens. Here it met two parallel glass surfaces and travelled on without change in overall direction. If a stop is placed some way in front of, or behind, a simple lens, all rays in the oblique light from objects well off-axis will pass through areas other than the lens centre. The image

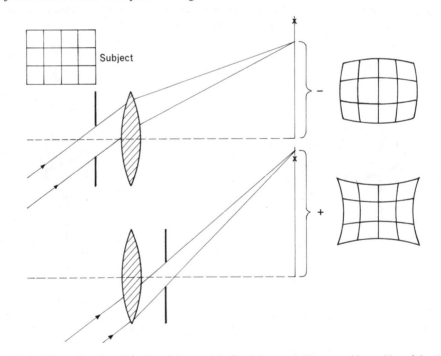

Fig. 1.7. Curvilinear distortion. Distortion of the true (x) off-axis image position caused by position of the stop. Magnification varies with distance of the image from the lens axis, giving (top) barrel and (bottom) pincushion distortion. By superimposing the two diagrams about the stop it can be seen how in a symmetrical lens construction the distortion of the front component is counteracted by the rear component.

10

position for these rays will therefore be distorted, being located too close to or too far from the lens axis. In other words the image will vary in its magnification across the field.

Curvilinear distortion is the inability of a lens to maintain the same magnification across the image plane.

A grid consisting of vertical and horizontal lines when imaged by a lens suffering curvilinear distortion will appear barrel shaped (if the stop is in front of the lens) or pin-cushion shaped (stop behind the lens). See Fig. 1.7. This aberration is unusual in that only shape, not sharpness, is affected. Stopping down therefore offers no improvement. In the earlier days of lens design the only answer lay in placing the stop in the exact centre of a symmetrical compound lens (i.e. one having two identical or closely similar sets of components). Today, when for other reasons many lenses are unsymmetrical in construction, the most favourable stop position can be calculated.

Recapping the seven principal lens aberrations:

(1) *Spherical aberration.* Different zones of the lens, concentric about the lens axis, each producing the image of an object point at a different distance along the lens axis. Rays passed through outer zones are focused closest to the lens. An axial aberration which is greatly reduced by stopping down.

(2) *Chromatic aberration.* The bringing of different colours (or the colour components of white light) to focus at different distances from the lens. Blue wavelengths are focused closest to the lens. An axial aberration; its effect is · reduced by stopping down to increase depth of focus.

(3) *Lateral chromatic aberration.* Variation of image size according to colour. Colour fringes are created around images of white objects near the limits of lens field. An off-axis fault unaffected by stopping down.

(4) *Coma.* Off-axis spherical aberration by which an oblique subject point is imagined as a patch of light, often comet shaped. Each lens zone causes rays to come to focus at a slightly different distance and position in the image field. An off-axis fault reduced by stopping down.

(5) *Astigmatism.* An oblique subject point imaged as a patch of light which changes to a short horizontal or vertical line at different positions of the focal plane. At one image position radial object lines appear sharp, tangential lines unsharp. The opposite occurs at the other image position. An off-axis fault reduced by stopping down.

(6) *Field curvature.* The formation of a sharp image of a flat object over a curved saucer shaped surface instead of a flat focal plane. An off-axis fault; its effect is slightly reduced by stopping down, thus increasing depth of focus.

(7) *Curvilinear distortion.* Variation in magnification across the image plane. Straight lines are reproduced curved away (barrel), or towards (pincushion) the lens axis. An off-axis fault unaffected by stopping down, but influenced by stop *position.*

Significance of lens aberrations

No one is able to separate out individual aberrations from the image formed by a lens, without extensive tests. Do not expect to recognise each characteristic feature

on the focusing screen. In the extreme case of a single element lens the multitude of errors will produce a fuzzy, generally distorted image which is impossible to focus over the whole format. By comparison, a good modern multi-element lens will show so few errors that very close examination of image quality is necessary to find any. This examination is worthwhile when comparing lenses. A simple general check can be carried out by imaging distant individual point sources of light, preferably well away from the lens axis. The combined effects of residual aberrations such as coma and astigmatism may then show as spread and distorted patches of light (see Plates 1 and 2). Here the differences between lenses of different types and prices become more apparent.

From the designer's point of view there is no great problem in correcting any one aberration. Correcting several simultaneously however creates great difficulties, as reduction of one error often increases another. The use of small aperture to reduce effects of say, spherical aberration and astigmatism goes against current demands for faster lenses. Again there are conflicts between designs which give good picture quality in the central area of the image, and those giving greatest improvement well out in the field. The designer has to decide the best compromise he can achieve here and must obviously know the maximum angle of view his lens will be reasonably expected to cover. Similarly corrections are influenced by subject and image con-jugates–compromises are required if a lenses must shoot both distant and very close-up subjects. It is for this reason that a lens designed for distant subjects but used for macrophotography often gives better images if reversed on its mount. Meanwhile the photographer demands the contradictory requirements of highly corrected, wide aperture, versatile, even illumination, wide angular field* lenses–and expects the designer to produce a design compromise which is effective, simple and inexpensive.

In order to calculate a new lens the designer must first have a firm specification of the outer limit of the proposed performance–focal length, aperture, angular field, working distances, minimum standards of sharpness and residual aberrations. Having decided on a tentative basic design many individual rays of light from various parts of the object field must be traced to each part of the anticipated image field.

Today electronic computers are used to calculate the path of refracted light through each element. Calculations which once took several days are now carried out in minutes. The thousand or so rays plotted can be read out as 'spot diagrams' (Fig. 1.8). Thus the designer can make many trial designs, in each case obtaining a clear idea of what lens performance will be like before proceeding further. See Fig. 2.10.

Eventually the type of glasses, number of elements, their thickness, curvatures and spacing within the lens barrel are determined–together with the position of the stop. Later the manufacturer must follow through by accurately grinding each element (often within 0·00025 mm in curvature) and accurately locating it in the lens barrel.

'Flare' and lens coating

If the number of elements in a compound lens is increased the designer is given

*Maximum angular field refers to the angle, made at the rear nodal point, between rays travelling to the two extremes of acceptable field when the lens is focused for an infinity subject. Angle of view relates focal length and the diagonal of the format covered by an acceptable image. Angle of view cannot exceed maximum angular field. See also 'Field Covered', Appendix I.

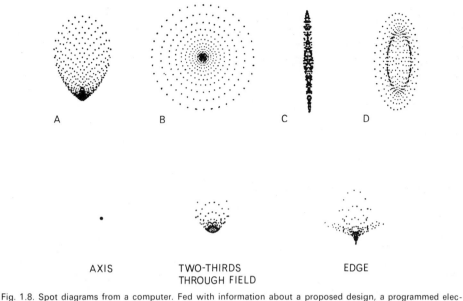

<div align="center">

A B C D

AXIS TWO-THIRDS EDGE
THROUGH FIELD

</div>

Fig. 1.8. Spot diagrams from a computer. Fed with information about a proposed design, a programmed elec-tronic computer can calculate the paths of a representative selection of rays through the lens. Taking light from a single subject point the computer quickly reads out the position of each resulting ray on the focal plane as a black spot—their distribution giving an idea of the shape and intensity of the image patch. A: Pattern formed in the presence of Coma. B: Spherical aberration. C: Astigmatism, and D: A mixture of aberrations. Bottom: Typical spot diagrams for three positions in the image field given at one focus setting by a 300 mm 5·6 lens. Approximate magnification: A & B × 400; C & D × 1250. Bottom × 250.

more ways of correcting image aberrations. But unfortunately, as more and more elements are used image contrast and illumination are found to diminish. This is because refraction of light is always accompanied by a loss by reflection (typically 5%) at each air/glass surface. Naturally the total proportion of reflected light grows alarmingly with a modern lens of say six or more elements. The high refractive index glasses increasingly required for wide field designs tend to reflect an even higher proportion of light.

The result is a scattering of light within a compound lens. Some light is reflected out of the lens again, but much is multi-reflected to finally find its way to the focal plane. This 'non-image forming' light has been derived from the optical image and is now added to it indiscriminately as 'flare'–either as a patch or ghost image in one area near a bright light source, or a more or less even haze. Proportionally the light has greatest effect on the shadow areas, diluting them and reducing the overall brightness range of the image (see Fig. 1.10). Flare has an important effect on tone reproduction.

The amount of overall flare in an image can be quoted as a figure or 'flare factor'.

$$\text{Flare factor} = \frac{\text{Brightness range of subject}}{\text{Brightness range of resulting image}}$$

If flare was totally absent the two brightness ranges would be equal and the factor 1. In practice an untreated multi-element lens may produce a flare factor of 6 or more in unfavourable environmental conditions.

13

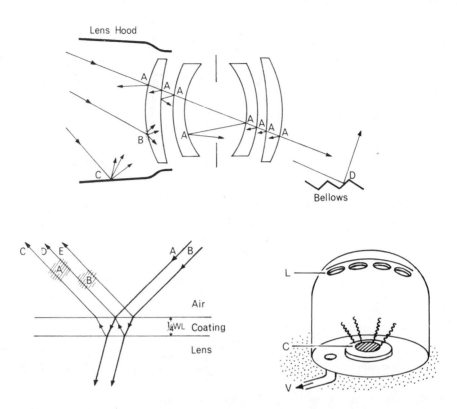

Fig. 1.9. Top: Light scatter caused by (A) Inter-reflection at air/glass surfaces; (B) Dust or grease on lens surface; (C) Reflective areas of lens hood or (D) camera bellows. Bottom left: The effect of coating—light ray A forms two reflected rays C & D which are out of phase and therefore interfere. Similarly reflected light rays D & E from ray B cancel out. Bottom right: Coating by evaporation in a vacuum. Lens elements are located in frames equidistant from coating material (C) which is heated either by electric filament or by an electron beam.

Manufacturers now reduce reflection losses by coating, or 'blooming', a thin film of transparent material on each air/glass surface. The anti-reflection coating must have a refractive index equal to the square root of the refractive index of the glass. This produces two reflections of equal intensity (see Fig. 1.9). It should also be coated to a thickness equal to one quarter of the wavelength of the incident light. In this way light reflected from the underside of the coating travels half a wavelength further than light reflected from the top. The result is two rays of reflected light which are 'out of phase'–i.e. the troughs of the waveform of one ray correspond to the crests of the other ray. Due to the phenomena of light 'interference' rays combining in this way cancel each other out. Light energy previously reflected follows the path of refraction. The result is an image of improved brightness range and intensity.

In practice the materials used to coat lenses do not reach the theoretical ideals of appropriate refractive index, total lack of colour and hard wearing properties (particularly important on the outer surfaces of a compound lens). Furthermore, visible light consists of wavelengths ranging from approximately 400–700 nm so that the thickness of coating must be a compromise. For example, most high quality

lenses made between 1950 and 1970 were coated with magnesium fluoride to a thickness of one quarter of a wavelength in the central (green) section of the spectrum. This suppressed green light reflectance but still reflected a little blue and red–such lenses have a slight purple bloom when viewed by reflected light.

Clearly, any one coating can only be really efficient for one wavelength. The problem has been largely overcome in today's lenses by making repeated coatings of different materials to different thicknesses, until a 'stack' is built up on each air-to-glass surface. Whereas a single coated lens typically reduces light reflectance at each surface from 5% to 2%, multicoating can bring this down to 0·2%. The more even effect now achieved throughout the spectrum can be seen in the way multicoated lenses often have a more neutral, almost 'black' appearance when the camera is viewed from the front.

Modern coating techniques are of great importance to the lens designer. They make practical the use of a dozen or more components–something which would previously have given intolerable levels of flare. Multicoating has therefore unlocked many new kinds of fisheye and zoom lens types, as discussed in Chapter 2.

The most common materials used for anti-reflection coatings are fluorides, particularly magnesium fluoride. The basic method for each coating is outlined in Fig. 1.9. Lens elements are supported on a frame near the top of a vacuum chamber. The coating substance at the bottom of the chamber is heated until it evaporates and condenses evenly on the exposed lens surfaces. Thickness may be gauged by simply watching reflection of light from the lens surfaces. As film thickness builds up blue light is first suppressed and the surface appears straw coloured. This will change to purple, then blue, then cyan, as thickness equals one quarter of the wavelength of

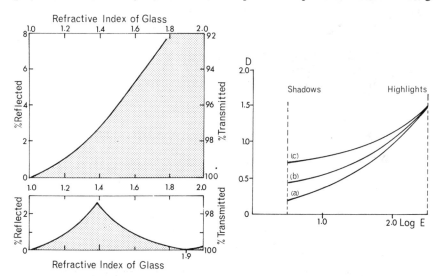

Fig. 1.10. Top left: Percentage of incident light reflected and transmitted at normal incidence by uncoated glass (ignoring losses by absorption). Glasses commonly used for photographic lenses have refractive indices ranging from 1·5–1·8. Bottom: Reflection and transmission by glass coated one quarter wavelength thick with a material having a R.I. of 1·38 (=$\sqrt{1·9}$). Right: The photographic effect of flare. Curve (a) shows the result of contact printing a grey scale. In (b) the grey scale was photographed against a grey background and (c) against a large white background. (See also Fig. 8·5, page 145).

15

green, then yellow and then red light. Evaporation is therefore halted at an appropriate stage. Coatings for at least the external surfaces of a compound lens are finally baked on to form a 'hard' coating.

In practical terms a coated lens gives improved image contrast, particularly in the shadows (see graph curves, Fig. 1.10). This also helps to improve visual sharpness. Remember however that despite coating, flare is greatly increased by:

(*a*) Having lights or unnecessarily large light coloured backgrounds behind the subject, without using a lens hood. (This is often the cause of slight colour casts or desaturated colour in colour transparencies.)

(*b*) Reflective surfaces close to the front of the lens – white paper reflectors, chipped lens hoods etc.

(*c*) Grease or dust on the surfaces of lens or filters.

(*d*) Reflections within the camera body.

The effect of flare on tone reproduction is discussed further in Chapter 8.

'T' numbers. The ratio of focal length to diameter of effective aperture gives the *f* numbers of a lens. However, as an indication of light passing power this ignores the light energy absorbed and reflected by the actual glass. The more glass in a lens design the more light is lost by absorption. Even the type of optical glass and its surface coating influences the amount of light transmitted, and two lenses of equal relative aperture but of different optical design may give different transmissions – the simple concept of *f*-numbers may therefore have to be replaced for critical exposure calculations by a Transmission or 'T' number.

The manufacturer establishes the 'T' number of a lens by photo-cell measurements of actual light transmitted. The *f*-number at which a theoretically perfect transmitting lens would give the same image intensity then becomes the 'T' number of the lens. For example a 'TTH KINETAL 9 mm T2 *f*1·9' lens has a focal length 1·9 times its effective aperture, but for exposure purposes produces the illumination which might be expected from a perfect lens of *f*2. 'T' numbers therefore represent the 'working *f*-number' of a lens for all exposure purposes.

TABLE 1.1

THE MAXIMUM APERTURES OF SIX MOVIE LENSES,
EXPRESSED IN *f*-NUMBERS AND T NUMBERS

f-no.		*T no.*	*f-no.*		*T no.*
1·9	—	2·0	2·8	—	3·2
2·0	—	2·3	3·8	—	4·0
2·6	—	2·8	4·0	—	4·5

T numbers are today rarely encountered, except on professional motion picture and TV camera equipment. Here any slight change of exposure level due to change of one lens to the next can cause problems shot-to-shot, particularly in colour. For most still photography the slight difference between *f* and T numbers (usually less than one-third of a stop) is not sufficient to justify the cost of T calibration.

16

Related reading

The Focal Encyclopaedia of Photography (Lens History), Focal Press 1965.
RAY, S. *The Lens and All Its Jobs*. Focal Press 1977.
The Manual of Photography (chapter 7), Focal Press 1978.

Chapter summary—lens design

(1) The designer's basic requirements of optical glass are refractive index and dispersion to specification; physical and chemical uniformity; freedom from bubbles or selective absorption; high transmission; resistance to atmospheric conditions; and good machining properties.

(2) The designer faces the problem of controlling seven basic lens aberrations–Spherical; Chromatic; Lateral chromatic; Coma; Astigmatism; Field curvature; and Curvilinear distortion.

(3) When reducing aberrations, priorities have to be chosen relative to the type of work the lens will do. The designer works towards a lens with a specified maximum aperture, angular field, ratio of conjugates and price. He uses permutations of types of glass, and the number, shape and spacing of elements.

(4) 'Flare'–non-image forming light–is greatly increased by internal reflections at air/glass surfaces in a compound lens. Clear fluoride materials with RI equal to \sqrt{RI} of the glass are vacuum coated on the lens air/glass surfaces to reduce reflections by interference.

(5) Coating improves image contrast (reduces flare factor) and slightly increases transmission.

(6) Transmission numbers indicate the 'working f-number' of a lens. 'T' numbers take into account light losses due to absorption and reflection in an individual lens design; f-numbers are only a geometrical relationship.

Questions

(1) What is meant by the term 'flare' applied to photographic lenses? List the main causes of image flare, in each case indicating what you would do to prevent or minimise its occurrence.

(2) List the seven basic aberrations of simple lenses.
State which aberrations are particularly serious for the designer of a wide angle lens. Which aberrations are reduced by restricting the maximum lens aperture?

(3) Explain the following terms:
(*a*) Symmetrical and triplet lens constructions.
(*b*) Anastigmatic lenses.
(*c*) Apochromatic lenses.

(4) Discuss the general problems faced by the designer in formulating a new, high quality photographic lens.

2. MODERN LENS TYPES

Recent years have brought many new and improved lens designs. The reasons for this are fivefold:

(1) Application of modern computers to problems of optical design. Given data on the optical properties of glasses and the design requirements of a new lens, the computer can speedily run through many thousands of complicated optical proofs and arrive at the best compromise solutions.

(2) The increasing range of optical materials including glasses containing rare elements, giving unusual combinations of refraction and dispersion (Fig. 2.10).

(3) New manufacturing techniques which allow lens elements of unusual shapes to be produced economically. These shapes allow corrections with fewer elements and wider maximum apertures.

(4) Improvements in multi-layer coating techniques.

(5) Ever widening applications of photography and image forming. Often commercial demands result in cross-fertilization – research applied to lenses for say, military or television use leads to improvements in lenses for commercial photography.

Irrespective of maker or detailed number of elements, most special construction lenses we handle in making photographs today can be categorised as follows: Telephoto; Inverted Telephoto; Zoom; Wide-angle; 'Fish-Eye'; Mirror; Soft Focus; Process; Macro; or Enlarging Lenses. Looking at them in this order will make it easier to understand the principles by which they work.

Telephoto lenses

Examples: Vivitar 800 mm $f/8$; Nikon Nikkor H 300 mm $f/4.5$; Olympus Zuiko 135 mm $f/3.5$ (all 24×36 mm format).

Long focus lenses produce larger images of distant subjects than shorter focus 'normal' angle lenses. At the same time they require spacing farther from the film plane. This presents no particular problems with stand cameras, but in the case of the smaller format camera (particularly 35 mm) results in a very long lens barrel. To avoid this problem most long focus lenses today are of telephoto design, which requires little more extension than a normal angle lens.

You will remember that in discussing the focal length of a compound lens it was stated (*Basic Photography*, page 52) that by tracing parallel light rays forward and emergent rays backwards we establish an image principal plane of refraction. The place at which the imaginary plane crosses the lens axis is the rear nodal point. The distance between the rear nodal point and the focal plane for light from infinity is the focal length (strictly 'equivalent' focal length) of the compound lens.

Now a telephoto construction consists of two main groups of components – the front group converging or positive, and the rear group weak diverging or negative lens components. Applying the same methods to establish the image principal plane it is found that the light behaves as if refracted at a plane well out in front of the lens

18

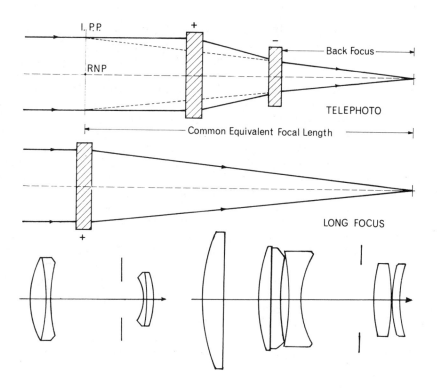

Fig. 2.1. Top: Basic telephoto lens construction. A predominantly positive group of elements followed by a rear negative group results in the formation of the rear nodal point in front of the lens. The image produced is equivalent to that from a long focus lens placed in this position, but requires a shorter lens mount. Bottom: telephoto lens designs (left) the Schneider Tele-xenar, and (right) the Zeiss 180 mm Sonnar for the Contax.

(Fig. 2.1). The focal length is therefore much longer than the space needed between the rear surface of the lens and the focal plane (known as the 'back focus').

The ratio between focal length and back focus is known as the 'power' of the telephoto. For example a 2x telephoto has a focal length twice its back focus, and requires positioning only half the distance from the film that one would expect for the size of image produced. Most modern telephotos have powers of between 2x and 3x.

It is important to realize that, viewed on the focusing screen, there is virtually no difference between the image of a distant subject by a long focus lens and the image given by a telephoto lens of the same focal length and *f*-number. Only the physical length of the lens is different.

Early telephotos were made only as 'attachments' (additional rear negative components) for normal lenses. In view of the fact that aberration corrections were often upset, telephotos are now usually self contained lens systems. Their smallness and light weight relative to conventional type long-focus lenses give a better physical balance when camera and lens are hand-held. (Both features are taken further still with mirror designs, page 26). In fact so many small format camera long focus lenses are designed as telephotos the terms are now practically synonymous.

A great deal of research and development in the late 1970s was directed to improving telephoto lens performance, and most lenses of this type (up to about 150 mm in focal length) now have maximum apertures similar to those of normal angle lenses of a few years ago. Beyond this the sheer diameter of the glass needed imposes limits. It is also difficult with long focus lenses to provide aberration corrections all the way down from infinity to close subject conjugates. For this reason, plus the considerable physical focusing movement needed, the closest permitted subject distance on the distance scale is quite restrictive. With a 200 mm lens closest distance might be 2·5 m (8 ft), becoming 20 m (66 ft) with an 800 mm lens. Gradually this too is being overcome by designing lenses with groups of 'floating' elements which shift their internal positions as the lens is focused out for close work, see page 30. Remember that like all long focus lenses, telephotos give extremely shallow depth of field.

Telephoto attachments, in an up-dated form, are still made. They are known as tele-convertors or tele-extenders and consist of an extension tube containing several coated lens elements designed to be attached between a lens of normal construction and the camera body. They reduce the lens f-number as well as increasing its focal length – the aperture becomes two stops less for a $\times 2$ convertor, three stops for a $\times 3$. The focusing distance range remains the same. Telephoto convertors are cheaper than telephoto lenses, but image standards vary – often the quality is less good.

The stand camera user will seldom use a lens of telephoto construction. He usually has sufficient bellows extension for a conventionally constructed long focus lens, which may also be of wider aperture. The few telephotos designed for large formats are intended for press-type or baseboard cameras with limited bellows extension.

Inverted telephotos ('Retrofocus' lenses)

Examples: Nikon Nikkor 24 mm $f2$; Zeiss Distagon 40 mm $f4$ (88° on 6 × 6 cm).

Just as telephoto design helps to reduce the lens-film space needed when using long-focus lenses, so an inverted telephoto (or *retrofocus*) construction increases this space with wide-angle lenses. It allows a short-focus wide-angle lens to be used in a single lens reflex, without interrupting the mirror movement.

As shown in Fig. 2.2, basically an inverted telephoto uses a group of negative lens elements placed before a group of positive elements. The resulting rear nodal point is formed behind the lens, and focal length is much shorter than the back focus. Compare the diagram with Fig. 2.1.

The first lens of this type was designed in the early 1930s as a normal angle lens for the technicolor motion picture camera. This camera required extra room behind the lens for a semi-silvered mirror system. With the growth of single lens reflex cameras, the inverted telephoto offered a solution to the problems of fitting wide angle lenses; similarly cine cameras or any equipment requiring space between lens and film for mirrors, shutters, photo-cell, etc. It also allows a wide-angle lens to be fitted to any camera body having a front-to-back depth too great to allow a conventional short-focus lens to focus distant subjects, unless on a deeply recessed mount.

Today all wide angle lenses for SLR cameras tend to be of this construction. The result is that a set of three interchangeable lenses—wide-angle, normal and moderately long-focus telephoto—can often all be seated about the same distance from the

film. Inverted telephotos also reduce the old problem of wide angle distortion and uneven image illumination common to conventional wide angle designs. By being further from the film plane there is less difference in distance between the lens and the centre of the format relative to the edges.

Note that the unusual positioning of both telephoto and retrofocus lenses upsets the normal relationship for exposure increase factors when working close-up. Calculations based on conjugate distance formulae for a lens of normal construction (*Basic Photography*, page 61) are no longer quite accurate–exposure factors are less with a retrofocus and more with a telephoto. However this is taken into account when using a through-the-lens meter which measures actual image brightness. Any lens can be checked to discover whether it is normal, telephoto, or retrofocus design by holding it at arm's length. Compare the size of the aperture when seen through the front with its appearance through the back. A normally constructed lens shows circles equal in size. If the aperture appears larger seen through the back of the lens it is of retrofocus design; if smaller it is a telephoto.

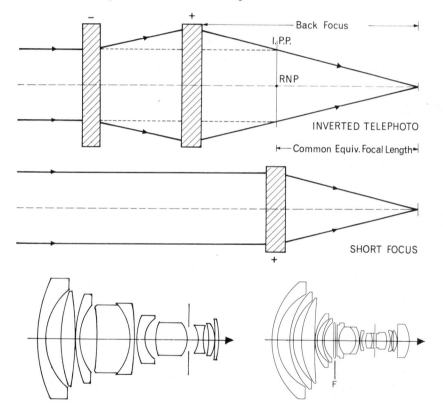

Fig. 2.2. Top: Basic inverted telephoto lens construction. A predominantly negative group of elements followed by a positive group produces a rear nodal point behind the lens. The image formed is equivalent to that from a short focus lens placed in this position. Bottom: Inverted telephoto wide angle designs (left) 40 mm *f*4, Zeiss Distagon giving 88° on 6 × 6 cm SLR & (right) 15 mm *f*5·6, Nikon Nikkor giving 110° on 35 mm SLR. The latter has a back focus 2.45 times the focal length. Both lenses are wide angles, not fish-eyes, for they are fully corrected to eliminate the linear distortion given by fish-eye optics, see page 25.

21

For the designer inverted telephoto lens constructions present special difficulties. It is easy for example to introduce barrel distortion (page 10), for most of the converging elements are positioned at one end, towards the rear of the lens. The situation has been greatly improved by use of modern optical glasses, aspheric shaped surfaces (page 32) and multilayer coating which makes it practical to use a dozen or more separate lens elements if needed. Note that wide-angle lenses for stand cameras still remain mostly of conventional design. Using bag bellows there is much less of a space problem, and the smaller market hardly justifies the cost of production.

'Afocal' attachments

A telephoto or inverted telephoto lens can also be formed by adding appropriate optical attachments to the *front* of a conventional camera lens. This arrangement will change its focal length without changing its distance from the film plane. It is therefore useful where a camera has a non-interchangeable lens. The great drawback is the upset to aberration corrections. The combinations have to be restricted to small aperture and even then may result in inferior image quality.

However, a few special attachments have been made, highly corrected for combined use *with a specific lens*. As shown in Fig. 2.3, the attachments alone do not form images—parallel incident light emerges still parallel, hence they have no focal length and are termed 'afocal'. They do however alter the width of the light beam, so that when afocal attachment plus camera lens are considered as a single unit the result is a telephoto or inverted telephoto, depending on the design of the attachment.

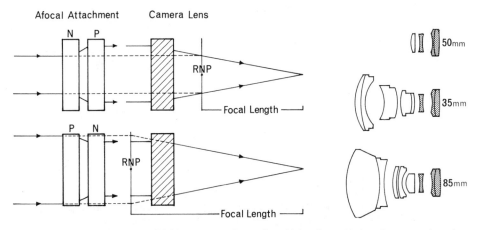

Fig. 2.3. Left: Afocal attachments. Multi component lens units which, when added to the camera lens, form (top) a short focus, or (bottom) a long focus combination. The change in effective aperture must be considered in relation to changed focal length. *f* number may not appreciably alter. Right: A convertible lens system in which rear elements remain permanently in the camera and front sections are changed to alter focal length.

As an alternative to afocal attachments for *complete* lenses, some camera lenses are designed to have interchangeable front components. As shown in Fig. 2.3, part of the lens—usually components positioned behind the diaphragm—are permanent fixtures within the camera. Various front halves of the lens are available, changing it

22

to shorter (inverted telephoto) or longer focal length. The whole system must be specially designed to offer acceptable corrections whatever permutation of static and interchangeable components are used. On the other hand the use of common components, diaphragm and shutter usually means that the cost will be less than interchangeable complete lenses.

Zoom (variable focal length) lenses

Examples: Nikon Zoom-Nikkor 50-300mm $f4.5$, Zeiss Vario-Sonnar 40-120mm, Vivitar 24-48mm $f3.8$ (all 24 × 36mm format); Schneider Variogon 8-48mm $f1.8$ (8mm movies); Angenieux 12-240mm $f2.2$ (16mm movies).

A zoom lens is so constructed that its focal length can be varied continuously within a set range. This has distinct practical advantages. From any given camera position image size can be enlarged or reduced to exactly fill the frame. One lens can take the place of many, saving the inconvenience and time lost when changing lenses. It is also possible to alter focal length during the actual exposure, giving radiating blur effects, (see Plate 4). To make full use of a zoom lens the camera must offer some form of reflex viewfinding–zooms are impractical for direct viewfinder cameras unless the finder zooms too.

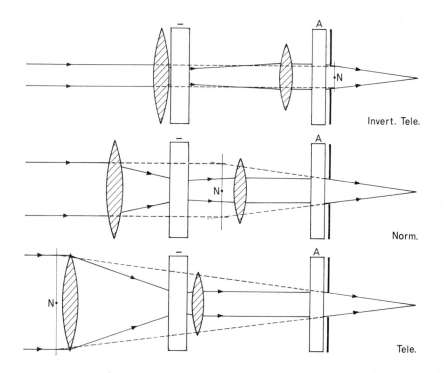

Fig. 2.4. A basic form of zoom lens in which two sets of components are moveable. Top: Movement backwards to give the inverted telephoto setting, Bottom: Movement forwards for the telephoto setting. Rear nodal point (N) becomes progressively further from the focal plane. Converging components A remain static.

23

Basically the design uses elements or groups of elements which move within the lens barrel, often altering their position relative to a static convergent group at the back of the lens (see Fig. 2.4). Comparison with Fig. 2.3 shows that in effect the front part of this zoom design is an afocal unit which alters its 'throw' and therefore its influence on focal length. The zoom is variable between telephoto and inverted telephoto states. Ratio of maximum to minimum focal length is known as its 'zoom range'. Often a group of elements right at the front of the lens shifts separately to focus objects closer than infinity.

The design requirements for a high quality zoom are formidable. It must maintain the plane of sharp focus and f-number throughout its zoom range. Aberrations must remain acceptably corrected throughout both zoom and focusing ranges. Control of aberrations is particularly difficult and calls for extremely complicated optical calculations. The lens barrel too must be engineered to shift accurately and give the photographer a zoom control ring which is easy to operate. The most convenient arrangement here is a wide double action sleeve which slides, trombone style, to change focal length and also rotates to alter focus.

Zoom lenses date from the 1930s, when a few bulky types were made for movie and TV use. In both areas zooming offers a valuable optical alternative to tracking the camera forward or backward during a shot. The first popular zoom lens designed for a 35 mm still camera was the Voigtlander 36-82 mm $f2\cdot8$ Zoomar, introduced in 1959. Development since then can be directly related to the availability of modern digital computers and improved lens coating.

Zoom range is still limited by the need to maintain standards of image quality, and keep physical size and price within acceptable limits. Typical zooms for 24×36 mm format cameras run from long to extremely long focal length (80–250 mm) or operate either side of normal focal length (35–70 mm). However each newly introduced design extends this range, moving increasingly into wide-angle focal lengths. Already lenses for 8 mm movie and small TV cameras can encompass a zoom range of more than 20:1 and have virtually replaced fixed-focus interchangeable types. Zoom lenses are beginning to appear for 6×6 cm SLR cameras, and they are also used extensively for slide and movie projectors. For macro zoom lenses see page 30.

Wide-angle lenses (non-retrofocus)

Examples: Schneider 75 mm $f5\cdot6$ Super Angulon; Rodenstock 75 mm $f4\cdot5$ Grandagon (both for 4×5 in).

The great majority of conventional wide angle camera lenses today are intended for use with large format stand cameras. Here they must offer a generously wide field, free of off-axial aberrations, to allow full use of camera movements. Illumination level must also be kept as even as possible across the field. Due to the cosine[4] law (see page 323) alone, a 90° lens produces 'fall off' in illumination across the image to the extent that the corners are only 25% of the brightness at the centre. (Some manufacturers supply special compensating neutral density lens filters, darkest at the centre and graduated outwards.)

To minimise vignetting by the lens barrel wide angle lenses tend to be of symmetrical construction, with closely packed elements of much wider diameter than the stop. The

two outer elements are often large negative 'collector' lenses, made in high refractive index, low dispersion rare earth glass. They give the whole unit an hour glass shape (Fig. 2·5).

Cost increases with field, even more than with aperture. For example the 90mm *f*8 Super Angulon is almost double the price of the 90mm *f*6·8 Angulon. Compared in the same format cameras however the former lens's greater angular field allows a more extensive use of movements and better coverage at the same aperture.

Fig. 2.5. Symmetrical type non-retrofocus wide-angle lenses. Left: *f*6·8 Angulon. Centre: *f*8 Super Angulon (both for large formats). Right: 15mm *f*8 Hologon for Lecia M. Compare this with Nikkor of same focal length, p. 21.

Most 80°-90° lenses for large format cameras have maximum apertures between *f*4·5 and *f*8. Wide angle lenses for rollfilm and 35mm cameras are now mostly retrofocus designs, to give space for mirror/meter systems (see page 20).

Fisheye wide-angle lenses

Examples: Nikon Fisheye-Nikkor 6·3 mm *f*2·8 (220° on 35mm); Pentax Fisheye 17mm *f*4 (180°); Zeiss F-Distagon 16mm *f*2·8 (180°). All for 24 × 36mm format cameras.

Rectilinear projection—the image structure seen when using long-focus, normal and wide-angle lenses—cannot reasonably be maintained over more than about 100°. In a fisheye lens, correction of linear (barrel) distortion is sacrificed in favour of an angle of view well beyond this figure. As Plate 3 shows, a fisheye makes all straight lines (except those radiating from centre field) appear curved, and there is considerable foreshortening. Depth of field extends from infinity to within a few centimetres from the lens.

Fisheyes are most often used to give spectacularly distorted images for advertising, architectural, fashion photography etc. Their extreme geometry however often dominates the subject and can soon become repetitive. A few special fisheye types (giving orthographic instead of the more usual geometry) are used for technical purposes such as aerial surveys and all-sky photographs. Here an orthographic projection grid laid over the image allows direct measurements to be made.

Introduced in the 1960s, the earliest fisheyes intruded so far into the camera body they could only be used with the SLR mirror locked up. Today this problem has been overcome by using an extreme form of retrofocus construction, see overleaf. Almost all fisheyes are designed for 35mm cameras, although a few are made for 6 × 6cm and movie cameras. As shown in Fig. 2.5a, types encompassing more than about 180° give a circular image in the centre of the normal picture format.

25

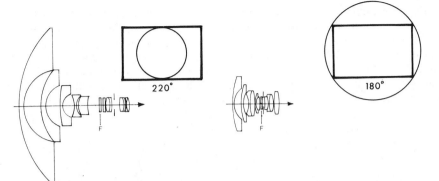

Fig. 2.5a. Fisheye optics. Left: 6·3 mm *f*2·8 Fisheye-Nikkor, showing its circular 220° image field within the 24 × 36 mm format. Right: 17 mm *f*4 Pentax Fisheye. This lens fills the entire format, giving 180° across the diagonal. Both allow use of SLR mirror. Construction is basically simpler than linearly corrected extreme wide-angle, fig. 2.2.

The bulbous, dome-shaped front surface of a fisheye lens makes it easy to damage accidentally in camera handling. This also means that external filter holders cannot be fitted, so most of these lenses have a series of internal dial-in colour filters. Some fisheye lenses cause through-the-lens meters to give faulty exposure readings unless they are of the spot-reading kind. A separate hand meter may be needed.

As a lower cost alternative to a complete fisheye it is possible to use a 'fisheye convertor'. This is a deeply curved afocal lens group, which attaches over the front of a normal camera lens. Used at small aperture, a good convertor can give excellent results.

Mirror lenses

Examples: Zeiss 500 mm *f*4·5 Mirotar; Nikon 2000 mm *f*11 Reflex Nikkor. (All for 24 × 36 mm format).

A *reflecting* ('catoptric') system can be used instead of the usual refracting ('dioptric') system to form photographic images. An image-forming system of mirrors offers the following special advantages.

(1) Complete freedom from chromatic aberration, due to the fact that light is not refracted.
(2) Compact physical form – the optical system is virtually 'folded up'.
(3) Light-weight, due to the considerable reduction in glass.

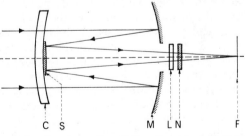

Fig. 2.6. The basic structure of a long focus mirror lens. C: Corrector plate. F: Focal plane. M: Primary mirror. S: Secondary mirror. L: Weak secondary correctors. N: Neutral density filters.

26

All mirror lenses contain weak refracting 'plates' to correct spherical aberration, and strictly speaking this combination of reflection and some refraction should be described as a 'Catadioptric' system. The designer must of course be careful not to introduce chromatic aberration by creating too much refraction with these plates. If chromatic errors are unavoidable, they must be nullified by other correctors in the system.

Light entering a modern mirror lens passes in through a large corrector plate and is converged by a mirror at the rear, to a second mirror coated on the inside of the corrector plate. This reflects the still converging light through a hole in the rear mirror, and then through further aberration corrector plates to the focal plane. Mirror lenses are easily recognized by their characteristic 'drum' shape and the opaque central area of the front element (the rear of the second mirror).

The compact mirror design is a great advantage in long focus lenses for small format SLR cameras. Relative apertures of around *f*4·5 are possible, providing that the focal length is in the region of 500mm or more and not therefore making great demands on angular field. There are however some serious disadvantages:

(1) A diaphragm cannot be included in mirror systems. Neutral density filters are usually provided for control of image brightness, but you cannot control depth of field.

(2) Out-of-focus highlights are each rendered as 'doughnut' rings instead of discs of light, see Plate 6.

(3) Cost. Difficulty in manufacture and assembly, coupled with limited demand, make these lenses expensive–although not as costly as conventional designs of similar aperture and focal length.

(4) Off axis aberrations are severe, so that at present the design is limited to extreme long focus lenses.

Fig. 2.7. Modern lens types. (A) 500mm long focus lens of conventional construction. (B) 500mm mirror lens (C) 90mm Angulon (D) 90mm Super Angulon wide angle lenses (E) 160° Fisheye lens.

27

'Soft focus' lenses

Examples: Kodak 'Portrait' lens 30 cm $f4\cdot5$; Rodenstock 'Imagon' 120 mm $f4\cdot5$ (for 4×5 in).

A soft focus lens images a point subject as a circular patch of light with a 'core' of greater intensity. It therefore differs from an out-of-focus image. The effect is a luminous 'halo' or softness of outline, which is popular for some types of portraiture. As it is *light* which is spread the highlights are spread if the lens is used on the camera – the shadows are spread if the lens is used on the enlarger.

Soft focus lenses are mostly made for large format cameras. They are usually of high quality but deliberately under-corrected for spherical aberration. Stopping down therefore reduces the degree of soft focus. Some older lenses are of triplet construction and allow movement of one component to vary the amount of spherical aberration.

Other soft focus lenses such as the Rodenstock have a special front-mounted aperture disc in addition to the normal iris, Fig. 2.8. The metal disc has a large central hole surrounded by a series of smaller holes. (A set of discs is usually provided, each disc having a differing number and size of perimeter holes.) Each hole creates its own circle of confusion, so that every image point consists of a hard core (central aperture) surrounded by overlapping smaller patches of light. Changing the disc changes the quality of the soft halo.

Soft focus effects can be produced more cheaply by using a diffusion attachment for a normal lens, e.g. a glass disc with engraved concentric rings and a clear central area. A piece of clear glass with a smear of grease around the perimeter will give a similar effect, and has the advantage of allowing diffusion of very localised areas of the image. See Plate 10.

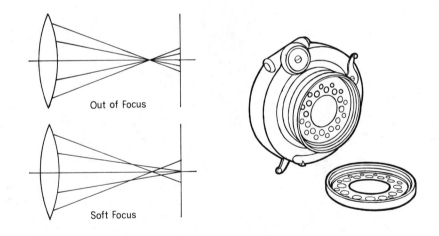

Out of Focus

Soft Focus

Fig. 2.8. Soft focus lenses image each point on the subject as a nebulous halo of light with a hard 'core'. They utilise deliberate spherical aberration or (right) have interchangeable perforated discs fitted over the lens to give light spread (See also Plate 10).

Process lenses

Examples: Schneider Repro-Claron *f*8; Zeiss Apo-Tessar *f*9.

Process lenses are specially designed for large format copying work in photo-mechanical processes (e.g. blockmaking). It is essential for such lenses to have an undistorted flat field, even illumination and a high degree of chromatic correction, as they will be used for making separation negatives of colour originals.

The normal camera lens achromatic correction for two colours is no longer enough. Process lenses are usually corrected for three colours and thus termed 'Apochromatic' (this explains the frequent prefix 'Apo'). They are also more thoroughly corrected for astigmatism, spherical aberration, distortion and curved field than normal camera lenses.

The standards of correction required can only be maintained over a limited range of object/image conjugates. Process lenses are therefore designed for one of a set range of copying reductions or magnifications. The designer normally uses a perfectly symmetrical type of construction for 1:1 copy ratios (see Fig. 2.9). This automatically corrects distortion, coma and lateral colour. Process lenses for more unequal conjugates may be less symmetrical and even a form of triplet design.

Process lenses are not required to cover a wide field and need not be of wide aperture – both factors which help the designer in attaining a high degree of correction. Maximum apertures are frequently *f*8 or *f*11. Some process lenses have waterhouse stops with unfamiliar shaped apertures – square, or square with elongated corners etc. These influence the shape of the halftone dot when making screened negatives for blockmaking purposes (Chapter 15). Apochromatic process lenses are often very expensive.

Fig. 2.9. Left: *f*8 Repro-Claron process lens Centre: *f*2.8 Makro-Kilar macro lens Right: *f*4 Componon enlarging lens.

Macro lenses

Example: Kilfit Makro-Kilar *f*4·5; Zeiss Vario-M-Sonnar.

'Macro' is a general term applied to lenses for extreme close-up photography conditions under which the image is often as large or larger than the subject. They are generally of short or normal focal length, but corrected for close subject distances. Maximum field is usually of a diameter matching focal length. When using these lenses care has to be taken to establish the effective – as opposed to engraved – *f*-number, as this will vary with subject distance. (On the other hand, an internal through-the-lens meter will take such changes into account.)

29

The use of macro lenses at their smallest aperture (i.e. to increase the shallow depth of field under close up conditions) should be avoided. The very high effective f-number which can result leads to image deterioration due to diffraction. Macro lenses are made for both large and small format cameras. Long bellows or extension tubes are required, or the lens barrel allows extended focusing movement.

A number of longer-focus macro lenses (e.g. 100 mm for 24×36 mm format) were introduced during the late 1970s. These require still more lens-film extension for a given image magnification, but have the advantage of allowing macrophotography from a greater subject distance – which allows more room for lights etc. Some zoom lenses too have a macro capability. Having set the zoom at a particular focal length the focusing ring is pushed beyond its normal stop into 'macro range'. This alters the configuration of some internal lens elements and allows the sharp imaging of subjects down to a distance of a few centimetres. Macro zoom lenses require no increase in exposure calculation when used in this way.

Enlarging lenses

Examples: Schneider Componon $f4$; TTH Ental $f4\cdot5$.

In common with process lenses an enlarging lens must offer a distortion-free perfectly flat image of a flat object – this time the negative. Achromatic correction is important, as most enlarging lenses are used for colour printing. A moderately wide aperture – say $f4\cdot5$ – is needed to give sufficient illumination and a shallow depth of focus when focusing. However there must be no risk of shift of focus as the lens is stopped down. Corrections are made on the assumption that the image conjugate will be greater than the object conjugate, and the lens will image a negative diagonal equal or slightly shorter than its focal length.

The designer will often use a symmetrical construction for lenses required to give enlargements of less than 10 times. Alternatively and for greater enlargements modified triplet constructions are common.

Enlaring lenses are fitted with 'click' stops which can be felt in the dark, and sometimes marked in exposure ratios 1, 2x, 3x, etc. instead of f-numbers. Coating of air/glass surfaces is just as important in an enlarging lens as a camera lens. Finally the designer must remain particularly conscious of price. Illogically, the average photographer is more disposed to buy an expensive lens for his camera, than for his enlarger, although poor quality from the latter will nullify the former.

Choice of lens

As photographers, an outline knowledge of design problems should now enable us to draw some conclusions. The most important fact that emerges is that no one lens will produce good images under *all* conditions. As with choosing a camera, we must thoroughly assess what type of work we want the lens to do, and how it complements our other lenses and camera equipment. If a special type of lens is only required occasionally then consideration has to be given to the cost of hiring against the cost of straight purchase.

As every lens design is a compromise, the designer may be aiming particularly

at aperture, or field, or focal length. (Sometimes he is aided by the camera designer who may give him a square format; no camera movements; a curved film plane; or restricted focusing movement.) As in running a car, try to restrict a lens to the conditions of use its designer originally envisaged. A lens with aberrations corrected to allow a wide angular field, will probably not give as good image quality at or near the axis as a lens designed for a narrower field.

Remember conjugate distance considerations too. A macro or process lens may give a disappointing image of a distant landscape; a telephoto lens on an extension tube will probably be unsatisfactory for 1:1 copying. If general purpose lenses must be used for macrophotography they usually give better images when reversed on the lens panel. Some small format cameras allow lenses to be mounted backwards (e.g. the Rollei SL66). This also helps to increase the lens-film distance.

Read the manufacturer's technical specification before choosing a lens, and then have one on trial to use under your own conditions. It is easy to assume for example that only the appearance of 'cut off' (corner darkening due to vignetting) on the focusing screen denotes the limit of useful coverage. In fact off-axial aberrations such as coma and lateral colour can destroy image quality well inside the field of good illumination. This could easily nullify the wide range of movements offered by a large format monorail camera. The manufacturer's literature will state the maximum angular field or format covered.

Lenses are also individual by the very nature of their many-shaped elements—which can be ground and assembled in minutely differing ways. Thus lenses of one design which appear absolutely identical can vary as they come off the production line. The manufacturer's quality control should detect lenses below specification—some may be above this standard.

Similarly, a lens which is dropped may show no physical sign of damage, yet may have suffered slight mis-alignment of one or more components. The result can be a surprising decrease in image quality. It is therefore wise to test all second-hand lenses thoroughly. Paying for a test on a new lens is also a sound investment. (Some simple testing methods are suggested in Chapter 3.)

Future trends in design

New lens designs usually follow on new optical materials, new production techniques and above all commercial demand.

Many new types of optical glass have become available since the 1950s (Fig. 2.10). Most tend to combine high refractive index with medium dispersive properties. They are therefore easily combined with lens elements with equal but opposite dispersion and low refractive index—important in the design of highly corrected short focus lenses. New rare earth optical glasses contain elements such as lanthanum or thoria, with little of the silicon traditionally used in glass. Calcium fluorite, long used for making apochromatic microscope objectives, is another promising material, provided that problems in making sufficiently large 'blanks' from the crystals are overcome.

Lenses moulded in optical plastic offer attractive cost-saving possibilities. Most current plastics are not stable enough for precision lens making—they tend to change their refraction of light with changes of atmospheric humidity and temperature.

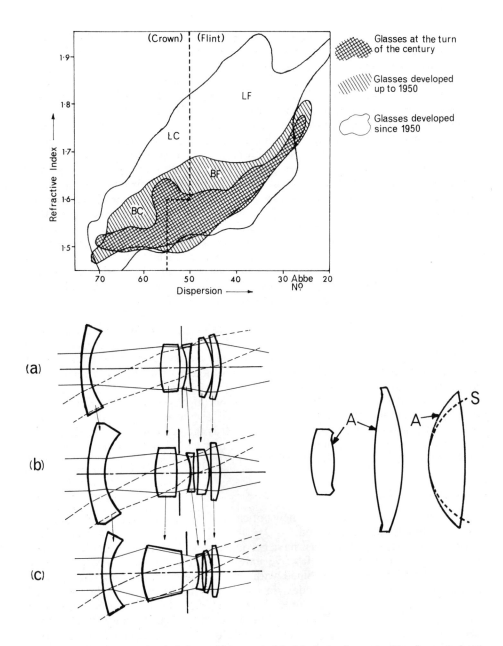

Fig. 2.10. Top: Development of optical glasses. Glasses to the left of the broken line are traditionally crown glasses, those to the right are flint glasses. Local areas BC: Barium crowns. BF: Barium flints. LC: Lanthanum crowns. LF: Lanthanum flints.

Bottom left: The use of a programmed computer to meet a target lens performance. (a) The starting design; (b) a design from the middle of the optimisation run; and (c) the final solution (35 mm f2.8, Distagon). Courtesy Carl Zeiss. Right: Various lens elements, each having one aspheric surface (A). (S) denotes the contour if spherically shaped.

32

They also scratch easily. For the present, plastic lenses are mostly limited to cheap simple cameras and viewfinders, but research may greatly extend their applications.

In shaping glass lenses, new manufacturing methods now make *aspheric* surfaces a practical proposition. (Traditional lens elements always have spherical surfaces – their surface contours form part of a sphere.) Aspheric elements bulge more-or-less in their centre than a spherical element, see Fig. 2.10. Detailed surface contours tailored to the requirements of aberration control are of great value to the designer of advanced wide-aperture lenses.

The problem of maintaining a high standard of aberration corrections in wide-aperture lenses throughout a focusing range from infinity to very close-up, is being overcome by use of 'floating' groups of elements. This is a spin-off from zoom lens research. Movable rear lens elements are programmed to adjust position as the focusing ring is turned. In this way spherical aberration in particular is kept down to an acceptable level.

The general trend is towards even smaller camera equipment. Lens manufacturers endeavour to follow this by designing lenses which are more compact, without sacrificing aperture or performance. At the same time efforts to make wider-ranging zoom types lead to larger rather than smaller lens units. The enormous popularity of 110 and 35 mm size cameras means that most lens innovations are designed for these formats first. Much further 'down the line' medium and large format lens equipment eventually benefits, but at very much higher prices because of the smaller numbers of these cameras sold.

Related reading

COX, A. *Photographic Optics*. Focal Press 1974.
RAY, S. *The Lens in Action*. Focal Press 1977.

Chapter summary – modern lens types

(1) Telephoto lenses have a group of positive elements followed by a negative group. The image principal plane is formed in front of the lens, and the focal length is longer than the back focus. (Ratio = Telephoto power.) The design gives a narrow angle long focus lens which does not require excessive lens-to-film space; it is therefore particularly useful for small format cameras. Like all long focal length lenses, depth of field is shallow.

(2) Inverted telephoto lenses are of short focal length but contain a negative element group before a positive group, and give an image principal plane behind the lens. Focal length is therefore shorter than back focus – allowing room for camera mechanisms. Most wide-angle lenses for small format cameras are now of this construction.

(3) Within moderate limits 'afocal' attachments to normal lenses can produce either telephoto or inverted telephoto conditions. The attachment delivers parallel light to the lens; it should be specially computed for the lens if image quality or aperture is not to be reduced.

(4) Zoom lenses allow a continuously variable focal length within fixed limits (zoom range). *f*-number and plane of sharp focus must remain constant. Zoom lenses are used for 'apparent' tracking (but do not give perspective change) on movie and TV cameras; also for slides and movie projection, filling the screen from various distances; and as substitute for a range of lenses on small and medium format still cameras.

(5) Wide angle lenses for large-format cameras are usually of symmetrical construction with special attention paid to correction of field aberrations, and therefore have relatively small apertures.

(6) Extreme wide-angle ('Fisheye') lenses have residual curvilinear distortion and may give a circular image within the picture format. They produce considerable depth of field. Similar images are possible using a fisheye convertor – an afocal front attachment for a normal camera lens.

(7) Mirror designs suffer no chromatic aberrations, and provide compact wide aperture long focus lenses. Usually angular field is very limited; iris diaphragms are impractical; focus is limited to distant subjects; and out-of-focus highlights form 'doughnut' shapes.

(8) 'Soft focus' lenses deliver definable image points overlaid with a local 'spread' of light. The lens spreads highlights when used on the camera; shadows when on the enlarger. Designs are either based on under-correction for spherical aberration, or may use perforated discs to control image characteristics. Soft focus effects are possible using diffusion discs on normal type lenses.

(9) Highly corrected apochromatic process lenses are of small aperture and designed for a limited range of conjugates. They may contain 'stops' of unusual shape.

(10) Macro lenses are specially designed for close subject conditions using long camera bellows. Several zoom lenses are designed to be used for macrophotography.

(11) Enlarging lenses are usually anastigmats, corrected for images of close, flat subjects. Aperture must be usefully large; lens elements coated and colour corrected; and the iris be adjustable by 'feel'.

(12) Even the most expensive lens will not give the best possible images under all imaging conditions. Try to limit the lens to the job it was originally designed to do, and use specialist lenses for specialised jobs. Fully examine the manufacturer's specification in choosing a lens, and if possible test it under working conditions. A knocked lens may have mis-aligned elements and must be checked. Photography is a visual medium – cheap lenses are usually false economy.

(13) Designers' future ambitions include improvements in field corrections plus wider apertures; shorter minimum subject focusing distances; and zoom lenses having extended focal-length range, without loss of quality. Designer and manufacturer are aided by new optical glasses, greater use of computers for design mathematics, economic methods of manufacturing aspheric surfaces; multicoating techniques for surface coating, and experience in the application of 'floating' lens elements.

Questions

(1) Outline (with the aid of diagrams) the principles of two of the following:
Inverted telephoto lenses.
Telephoto lenses.
Soft focus lenses.
In each case suggest a likely application of such a lens.

(2) Illustrate diagrammatically:
(a) The formation of a virtual image by (i) a positive lens, and (ii) a negative lens.
(b) How a telephoto lens differs from a normal lens of the same equivalent focus.

(3) Explain the difference in meaning between the pairs of terms in each of the following:
(a) Achromatic and apochromatic.
(b) Relative aperture and effective aperture.
(c) Soft focus and out of focus.
(d) Aspheric and afocal lenses.
(e) Refraction and dispersion.

(4) What considerations influence the choice of the focal length of a lens to be used for portraiture?

(5) List, giving brief qualifying comments, the necessary qualities and probably design type of
(a) A lens for wide-angle large format shots of architectural exteriors and interiors.

34

(*b*) A lens for process work.

(*c*) A lens for enlarging 4 in × 5 in negatives.

(*d*) A lens for a 35 mm single lens reflex for natural history close-up photography.

(6) Explain the following terms used in connection with photographic lenses.

'T' number.

Zoom range.

Telephoto power.

Flare factor.

(7) What are the likely disadvantages of

(*a*) Using a 75 mm wide angle lens (for 4 in × 5 in formats) as a normal angle lens on a 6 × 6 cm single lens reflex.

(*b*) Reversing a telephoto lens on its mount to use it as a wide angle lens on the same camera.

(*c*) Using a zoom lens on an extension tube for macrophotography.

(8) Explain the optical principles and typical applications of each of the following:

(*a*) A fisheye lens.

(*b*) A mirror lens.

In each case list their special advantages and disadvantages in practical photography.

3. IMAGE QUALITY AND CALCULATIONS

All of the highly developed lenses considered earlier that are available to the professional photographer should yield good image quality under their intended conditions of use. But what is 'good' image quality? Can you give a lens a figure or factor which usefully indicates its practical performance? How can you make practical tests on lenses? This chapter also looks at a few additional calculations relating to supplementary lenses, and the production of stereoscopic images.

Problems of expressing 'sharpness'

When discussing the sharpness of photographs we have to remember that the final image on paper is effected by factors other than the camera (and enlarger) lens quality. The most important additional factor is the ability of the photographic emulsion itself to carry a 'sharp' image. Other influences could be called mechanical—camera shake, subject movement, etc. Even the type of subject is significant.

To avoid confusion consider first the quality of the image *projected by the lens onto the focal plane*. The other factors can be added later—so that we finally come to some idea of overall photographic sharpness.

It is surprisingly difficult to come to a figure or set of figures which accurately indicate practical lens image quality. To add to the confusion terms like 'resolution' and 'definition' are used interchangeably, although they really mean very different things. The problem begins with resolving power.

Lens resolving power. For depth of field and focus calculations it is convenient to say that a point on the subject is sharply imaged if the cone of light from the lens yields a patch of light not exceeding the maximum permissible circle of confusion. The diameter of this circle will be determined by eventual requirements of the image— degree of enlargement, viewing distance, etc.

In checking lenses we must have a more accurate idea of the size of this circle, and

Fig. 3.1. A resolution test chart. A basic pattern of black lines (left) is repeated over a large wall chart (right).

compare it in various positions within the image field. The most convenient way to do this is to use a test subject consisting of a basic pattern of two or three thick parallel lines – the width of the lines being equal to the space between them. A basic pattern of vertical lines is placed next to a pattern of horizontal lines and this combination is repeated in a range of sizes across a large wall chart. Commercially made test charts are available. These often have the pattern (black lines on white) repeated to form a union jack type design. It is obviously useful to have the patterns right out to the corners of the chart, in order to test the extremities of the image field (Fig. 3.1).

The lens is set up at a distance from the chart appropriate to its intended usage. For general purpose camera lenses this is at least 20 focal lengths. Working from conjugate distances and focal length, the size of the image can be calculated in terms of numbers of pattern lines per mm. Obviously the smallest patterns on the chart will be very small images indeed.

The lens is focused – usually for the centre of the field – and the image microscopically examined (either using the aerial image across a flat plane or the image projected onto a flat white surface). The smallest pattern which can be recognized as lines – horizontally or vertically – represents the maximum *resolving power* of the lens. It is expressed by the number of lines per mm of that particular pattern image.

From the discussion of lens design different zones of the image must be expected to show differences in resolving power. Example figures might be 150 lines per mm on the lens axis and 35 lines per mm near the edge of the field of a 60° lens. These figures are by no means typical – a wide-angle lens may well give lower resolution on the axis, as aberrations have been corrected to give a compromise which allows reasonable resolution out in the extremes of field. Resolving power is seen to be a quantititative measurement – perhaps this provides us with the needed figures for expressing image quality?

Objections to resolution figures. In the past resolution figures were much publicised in sales literature. Some dealers in second-hand lenses published figures along with other technical details. Unfortunately lines per mm figures do not reliably indicate visual sharpness. As can be seen from plates 8 and 9, our assessment of sharpness is greatly influenced by *contrast*. A high resolution lens may well form separate images of closely spaced lines, but unless the blacks and whites are also clearly definable by their contrast the impression of 'definition' will be poor. (Despite past attempts to derive a quantitative figure for definition, this term is generally accepted as a *qualitative* expression.)

In correcting aberrations the designer may produce a lens which resolves fine detail, but residual aberrations will create a slight overlaying spread of light at borders. This lowers the contrast over fine detail; at borders between large areas of dark and light it creates a slight 'fuzz' of grey. The alternative open to the designer is to balance aberrations in another way, resulting in a lens which images without light spread at borders but cannot resolve fine detail. At present the designer cannot achieve the best features of both types of image with the same lens. (See Fig. 3.2).

A lens might therefore offer high resolving power but poorer definition, whilst another lens gives good definition but low resolution. In some cases the same lens may offer each of these characteristics at different focal planes.

Fig. 3.2. Image information. Top row: Cross-section of images of a white line on a black background, plotted in terms of illumination and distance across image. Bottom row: Reproduction of part of a test chart. Left: The performance of an 'ideal' lens. Centre: The image from lens A gives high contrast but poorer resolution. The image from lens B gives better resolution but lower contrast—resulting in poorer definition. (See also Plate 9.)

The answer to this one depends upon the type of work we are doing and in particular the characteristics of the light sensitive material with which the image is to be recorded. To take extreme examples, a lens for a television camera will have its image transmitted by a system which (because of 625 scan lines) cannot resolve more than about 20 lines per mm. An appropriate lens would be one designed with correction giving maximum definition at the expense of resolving power, down to this figure.

A lens for micro-copying of line documents onto high resolution film will be projecting its image on an emulsion capable of resolving 300 lines per mm. High resolution is essential—the resulting low contrast (therefore poor definition) is largely eliminated by the high contrast of this type of emulsion and the requirement to record only black and white.

Fig. 3.3. Modulation Transfer function plots (axial image) for two lenses. Lens A is balanced for aberrations in such a way that priority is given to good contrast (modulation) images, at the expense of some resolution. It therefore gives best definition of broad detail. Lens B is corrected so that it gives higher resolution, but at the cost of image contrast. X denotes the 'cut off' frequency of (625) television systems. Considering only the area to the left of this line lens A would be the better choice for a TV camera. Z is the approximate limit of resolving power of the eye viewing a photograph from a distance of 25 cm (10 inches). In the case of Z lens B would be a better compromise. For pictures made with these lenses see Plates 8 & 9.

SINGLE ELEMENT LENS

Plates 1 & 2 Images formed with a simple magnifying glass instead of a camera lens. Subject highlights are distorted into interesting shapes, due to the combined effects of aberrations. In both cases the subject was a string of pearls against a silver braided dark material. Using a 4×5in camera the front and rear elements of the camera lens were first removed, leaving the diaphragm and shutter. The 'magnifying glass' was a single plano convex condenser lens from a small format enlarger—positioned obliquely to use the edge of its field. These pictures differ only in the plane of focus and aperture chosen. Many of the light patches also contained an intense miniature spectrum of colour, owing to the chromatic errors.

FISHEYE LENS

Plate 3 The circular picture given by an 8 mm fisheye lens. The photographer held the 35 mm camera facing himself in one corner of a closed telephone kiosk. Note the great depth of field. 1/30 second at *f*8.

ZOOM LENS

Plates 4 and 5 were both taken with a 70-150mm zoom lens on a 35mm camera, zooming during exposures of $\frac{1}{4}$ or $\frac{1}{2}$ sec. at f16.

Plate 4 (Top) Studio background consisted of spotlit crumpled kitchen foil. The image was centred on the nose of the right-hand figure. Highlights in the eyes show the extent of image movement. Fast zoom to stationary at the long long focus extreme.

Plate 5 (Centre) Image centred on a postbox on the corner of a street, behind which a car was travelling. Background consisted of trees. Zoom movement extended over the whole exposure period.

MIRROR LENS

Plate 6 (Bottom) A bundle of small Christmas tree lights, about 6 metres behind the girl, spread into characteristic rings or 'dough-nuts' when imaged out of focus by a mirror lens. Bright unsharp highlights always take on the frontal appearance of the lens or diaphragm. In this case the mirror component behind the front element (page 27) forms a black blob. Taken with a 500mm f8 Nikon mirror lens.

RESOLUTION AND IMAGE CONTRAST

Plates 8 & 9 (Top) At first sight (and certainly from the other side of the room) the left-hand image formed by lens A with its greater local contrast appears sharpest. Yet the right-hand image by lens B has far higher resolution. Visual sharpness is not necessarily indicated by resolution figures. For graphs relating to these lenses see figure 3.3. (Courtesy Carl Zeiss.)

SOFT FOCUS

Plate 10 (Left) Spread of highlights caused by a sheet of glass with clear grease smears around its perimeter, placed about two inches in front of the camera lens. Effect is similar to a soft focus camera lens.

FLASH

Plate 11 A single flash source on a pole about 3 m above the ground, well to the left of the foundrymen. One large M class flashbulb. Effective flash factor 60 and exposure of 1/60th sec. at f11.

Plate 12 (Left) One flash high from the left, and one of double light output bounced from wall on the right. MF flashbulbs. Exposure based on factor of key light (i.e. left). 1/60th sec. at f11.

Plate 13 (Below) The soft, yet directional quality of a large single diffuse flash source. Lit by one 5 ft. × 4 ft. 'window light' 2,000 joule flash in a light toned studio. Background about 3 m behind the figures. (Group of professors by John Hedgecoe for *The Times*).

Plate 14 (Opposite top) Open flash technique allowed this house and garden to be 'floodlit' using only one small portable electronic flash. The tripod mounted camera was set at f8 and shutter opened. The photographer then walked around the scene, firing a total of 23 flashes from various parts of the garden, but always keeping out of the field of view. Flash factor 36. Average flash distance 4 m. Shutter open time 10 min.

Plate 15 (Opposite, bottom) Two clusters of three large 'M' bulbs were bounced off the ceiling and walls behind the camera, lowering the subject luminance range to about 30:1. (John A. Rose for the London Steak House, Esher).

Plates 16-20 Electronic flash used to 'fill-in' daylight. (Top left) No flash, 1/60th sec. at *f*8. (Top right) Quarter power flash, bounced. Factor 6, total flash distance 2 m. 1/60th sec. at *f*8, daylight/flash ratio is about 8:1. (Centre left) Exposure as 18, but bounced flash now full power (factor 12). Ratio 2:1. (Centre right) Flash as 19, but exposure now 1/250th sec. at *f*8. Ratio 1:2 (Bottom) Full power flash used direct. Factor 24. Flash distance 1.5 m. 1/500th sec. at *f*16.

SOLARIZATION

(Previous page)

Plates 21-22 (Top) A straight print from the original camera negative. A solarized interpositive was then made from the negative, and from this a less dense 'straight' negative prepared. A print from this negative shows (bottom) reversal of some tones and characteristic borderline effects, e.g. around the figures and staircases. For details see page 164.

POSTERIZATION

Plate 23 (This page, top) In this example the original graduated tone image was broken down into two high contrast separations, resulting in a final print with flat tones of white, one grey and black only. Details of posterization procedure appear on page 166. (F. Owen.)

MASKING

Plates 24-25 (Bottom) Negative (Left) contains dense, low contrast detail through windows. Interior detail prints on normal grade paper. By making an underexposed, low contrast same size print on film (right) a contrast reducing mask is formed. Mask and negative combined will now print on hard paper, enhancing highlight detail. See fig. 8.9.

PHOTOMECHANICAL REPRODUCTION

Plates 26-28 Macro images of half-tone areas taken from (Top) an international news magazine printed by offset photolithography; (Centre) a photographic journal printed letterpress on semi-art paper, and (Bottom) a mass circulation woman's weekly printed by rotary gravure. Magnification is ×12 throughout.

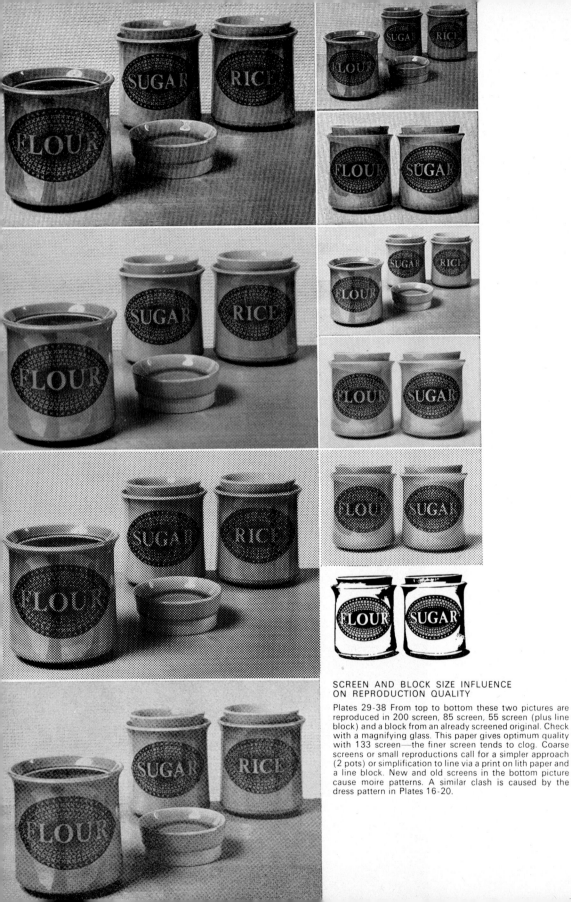

SCREEN AND BLOCK SIZE INFLUENCE ON REPRODUCTION QUALITY

Plates 29-38 From top to bottom these two pictures are reproduced in 200 screen, 85 screen, 55 screen (plus line block) and a block from an already screened original. Check with a magnifying glass. This paper gives optimum quality with 133 screen—the finer screen tends to clog. Coarse screens or small reproductions call for a simpler approach (2 pots) or simplification to line via a print on lith paper and a line block. New and old screens in the bottom picture cause moire patterns. A similar clash is caused by the dress pattern in Plates 16-20.

It is possible to plot a graph showing image contrast (modulation) against image size (frequency). (See Fig. 3.3.) The Modulation axis is plotted as Modulation Factor, being the ratio between the image contrast of an ideal lens and that of the lens under test–at a set frequency. The Modulation Factor cannot be greater than 1·0. The curve thus produced indicates the lens's relative qualities of image contrast and resolving power. Bearing in mind the frequency limit of the light sensitive material to be used with the lens, eventual degree of enlargement etc., it is possible to see which lens has the best characteristics for the particular recording system.

Such lens performance graphs are called *Modulation Transfer Function* curves and for most practical purposes this term is also interchangeable with 'Optical Transfer Function' of a lens. It is difficult to express the information on such a graph in terms of a single figure which accurately relates to practical lens perform-ance–still more difficult if information is to be added together from various positions in the image field, and for different apertures.

Frequency response measurements are used by most manufacturers to check the standard of their lens. Computerized equipment handles the complexities of measure-ment automatically–and then checks against a minimum standard. The system has virtually replaced lens resolving power figures, which are now used only in special cases.

Fig. 3.4. The effect of stopping down on image resolution. In the case of this particular lens, *f*11 offers the best com-promise between inherent aberrations and diffraction.

Photographic sharpness

In practice the sharpness of a photographic image exposed in the camera can be said to depend upon four groups of variables–lens quality; mechanical precision; emulsion quality; and the actual subject.

(1) Lens quality. The balance of aberration corrections relative to resolution and definition. Influences include lens flare, aperture (Fig. 3.4), demands on image field, conjugate distances, and physical lens condition.

(2) Mechanical precision. Image quality can be upset by inaccurate focusing, or inaccurate registration of focusing screen and emulsion; camera or subject movement; or 'bowed' film plane.

(3) The recording quality of the emulsion. This too was once simply expressed

39

Fig. 3.5. Emulsion Acutance. A knife edge is contact printed onto the emulsion under controlled conditions of exposure. When plotted with a microdensitometer the shape of the resulting density/distance curve is dependant upon emulsion thickness, silver halide concentration, and development effects.

as emulsion resolving power, by measuring the smallest resolvable (contact printed) detail in lines per mm. In order to include contrast as well, a knife edge can be contact printed by a point source light onto the emulsion. The resulting density difference across the image of the knife edge will in cross-section be 'S' shaped instead of sheer. A formula (Fig. 3.5) including the minimum and maximum densities and slope of the curves results in one figure which is known as the *Acutance* of the emulsion.

Acutance of the photographic material is similar to lens image definition in that it is not necessarily linked to resolving power. Acutance is however a physical quantitative measurement.

More recently emulsion qualities have been expressed by Modulation Transfer Function curves. These show the emulsion's modulation plotted against (contact printed) subject grids of various frequency. The advantage of M.T.F. is that it allows a direct line up of lens and emulsion qualities (Fig. 3.6).

Whatever way it is expressed, the recording quality of the emulsion will be affected by emulsion thickness and grain size, level of exposure, type and

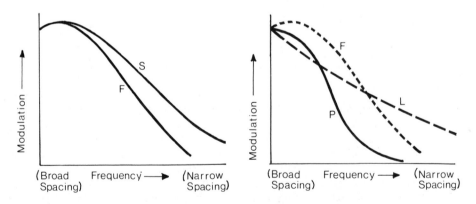

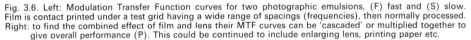

Fig. 3.6. Left: Modulation Transfer Function curves for two photographic emulsions, (F) fast and (S) slow. Film is contact printed under a test grid having a wide range of spacings (frequencies), then normally processed. Right: to find the combined effect of film and lens their MTF curves can be 'cascaded' or multiplied together to give overall performance (P). This could be continued to include enlarging lens, printing paper etc.

40

degree of development; also the subsequent enlargement (with the enlarging lens M.T.F. performance).

(4) The subject of the photograph. Lighting contrast, type of background (i.e. detailed texture or smooth matt), impression of subject movement, use of pastel or strong colour schemes all subjectively influence our standards. The *type* of subject has an influence. It can be argued that we inherently demand higher standards for 'clinical' technical records than for atmospheric or 'mood' advertising pictures. Where a subject demands fine detail information yet the lens/recording material has unsuitable M.T.F. characteristics the only solution is to move into close-up and record the subject section by section. This is a common technique on television and 8 mm films.

Finally we must remember that the eye is an imperfect instrument. Standards of eyesight, conditions and distances of viewing affect our assessment of acceptable 'sharpness'. In fact Frequency Response Function curves can be prepared for the eyesight and viewing conditions of an observer – to be combined with M.T.F. data for lens/recording material.

A definitive method of expressing photographic sharpness, in a form which truly predicts the reaction of the viewer, is still the subject of research. We can at least appreciate the variety of physical, chemical, biological and psychological influences involved.

Fig. 3.7. Modulation transfer function curves published for a zoom lens at (left) 70 mm and (right) 210 mm settings. Notice how at the longer focal length the image quality differs markedly between centre and corners of the picture.

Simple testing of lenses

In view of the difficulty in establishing numerical standards for image quality, is there any point in the photographer testing his lenses? Obviously the practising photographer has none of the specialist equipment needed for frequency response measurement. Detailed assessment of a lens demanding optical bench facilities is best carried out by experts in optical or camera repair firms offering this service. Simple practical tests are nonetheless valid and useful for:

41

(1) Comparing two lenses. For example, comparing a new lens with a frequently used lens of known performance.

(2) Checking a lens for possible damage–following a knock, or when a second-hand lens shows signs of amateur repair work.

(3) Becoming acquainted with limitations to image field offered by a lens. This is really worthwhile when the lens is to be used in a camera allowing extensive movements.

For testing camera lenses two types of subject are useful–a 'point' source of light, and a large surface covered in some form of fine detail. A tungsten light source screened by an opaque card with a small hole can form the 'point' subject. The detailed surface might be a resolution test chart or even a textured brickwall.

As discussed in Chapter 1, the lens-to-subject conjugate distance should be similar to conditions expected in typical practical photography. If the tests are to go as far as the actual taking of photographs, the type of negative emulsion, level of exposure, type and degree of development and final size of enlargement should all follow normal daily technique.

Tests using the large surface. Arrange the detailed surface at right angles to the lens axis, and examine the focused image on the camera ground glass screen with a watchmaker's eye glass or 'linen prover'. If the focusing screen is larger than the format to be used (i.e. $8\text{in} \times 10\text{in}$ if the lens will be used on $4\text{in} \times 5\text{in}$) this will be helpful in establishing the limits of image field. $4\text{in} \times 5\text{in}$ horizontal and vertical formats can be pencilled on the screen. The acceptable image area which exceeds these outlines indicates how much the lens may be used off-centre–by rising, cross or swing front, for example.

Focus the lens (widest aperture) for the centre of the format and examine the image out in zones away from the lens axis. As distance from the axis increases the image may grow noticeably unsharp. This is due to residual off-axis aberrations and curved field. The latter can be proved by refocusing–see if the zone becomes sharper at the expense of the central area, which grows less sharp. Slight curved field is often found with wide aperture lenses. The designer tries to keep this fault within the depth of focus under anticipated 'normal' conditions of enlargement.

The position of sharp focus for the centre of the image field should be quite definite Any uncertainty about this position, or any change as the lens is stopped down indicates residual spherical aberration. Lines running parallel to the format edges well out in the image field should be checked for curvilinear distortion (use a ruler on the focusing screen).

Tests using the point source. Other aberrations are more easily checked using the illuminated pinhole. The pinhole should be sharply imaged in the centre of the field and then slid sideways until imaged well out in the filed. Watch for a change in the *shape* of the spot of light, and any colour fringing away from the lens axis. These are likely to be the combined effects of astigmatism, coma and lateral colour. Check the effect of stopping down on aberrations you would expect to be influenced by aperture.

Try altering the focusing. If the spot shows reduced aberration fringes on two parts of the circumference (in line with the lens axis) at one focusing position, and on

parts at right angles to these at another focusing position, astigmatism is indicated.

A damaged lens may have one or more elements de-centred. The axis of the lens elements need only be a few ten-thousandths of an inch out of alignment to give noticeable reduction in image quality. To check this, image the illuminated pin-hole on the lens axis in the centre of the format. When the focusing screen is moved forward or back through the position of accurate focus, the spot of light should widen to a circular patch. A change to an *uneven shape* indicates centring error. Strictly speaking the above tests would require more critical analysis than is possible on a camera focusing screen. In order to simulate practical working conditions enlargements from fine grain negatives are required.

The susceptibility of a lens to flare is worth checking. This is particularly valid for older second-hand lenses. If they are to be used for architectural interiors, multi-headed flash work, night scenes, and any back-lit work (particularly in colour) it is useful to know how much flare is likely to influence results. Look through the lens at a dark surface, and hold a bright light source between lens and surface just outside the field of view. The amount of light scattered within and between the elements appears as a series of highlights or as overall luminosity. Comparative photographs can be taken of a dark subject (e.g. a room interior) using a photoflood lamp just out of the picture area. In the first shot shield the lamp from the lens, and for the second picture remove the shield.

Most of the foregoing tests can be adapted for enlarging lenses. The 'subject' in this case should be a photographic plate, fogged and developed, and with clear lines scratched through the emulsion. Like a test chart, the scratches should extend to every corner of the format. They should be made with the aid of a ruler so that linear distortions in the projected image can be easily checked against a rule on the enlarger baseboard. Whether the tests involve a camera or an enlarger it is obviously essential that subject, lens and image planes should be parallel and all 'movements' set at neutral.

Even these simple lens testing techniques can show up wide variations between lenses. These differences are often reflected in price, but in some cases show remarkable variations in so-called identical lenses from the same manufacturer. Variations are more common in lower priced lenses–the manufacturer is less able to afford stringent standards of inspection, with consequent higher reject rate.

Most of the more useful optical formulae are grouped together in the Glossary on page 321. The majority of them were explained in *Basic Photography*. Calculations required when using supplementary lenses or producing stereo image pairs may more easily be remembered if a little time is spent now in discussing the practical problems involved.

Supplementary lenses

Single element positive or negative lenses–commonly meniscus-shaped–are sold for attachment to camera lenses in order to change their focal length. (The intention is that these simple supplementaries are usable with *any* camera lens. Do not confuse them with compound afocal attachments or interchangeable front sections specially computed for combinations with a *particular* camera lens.) In special cases it may even be necessary to use a lens from some other optical equipment in conjunction with

the camera lens. As can be imagined, these supplementary devices inevitably create some upset to carefully balanced aberrations. It is therefore always better to use a properly corrected compound lens of required focal length. If this is not possible then the supplementary lens chosen should be the weakest (i.e. longest focal length) possible to fulfil the requirement.

The focal length of supplementary lens elements is sometimes quoted in Diopters or d power, a term commonly used by opticians. This is simply the focal length expressed as a reciprocal of a metre (100 centimetres). For example, a lens quoted as having a power of one diopter has 100 cm focal length; if of four diopter its focal length is 25 cm, and so on. To find the focal length in inches it is usually sufficiently accurate to divide the diopter power into 40. Note that the higher the diopter power, the *shorter* the focal length. Also, the diopter system is speedy for calculating the combined focal length of a group of lens elements – their individual powers in diopters are simply added together.

Positive (converging) supplementary lenses. The effect of using a positive supplementary lens with a positive compound lens is an effective *shortening* of focal length. Some uses of positive supplementaries are:

(1) In macrophotography, to allow a closer approach to the subject (Fig. 3.8), without requiring extra lens-to-film extension. In effect the supplementary allows a larger image to be formed than would otherwise be possible. Remember that the closer approach also records steeper perspective.

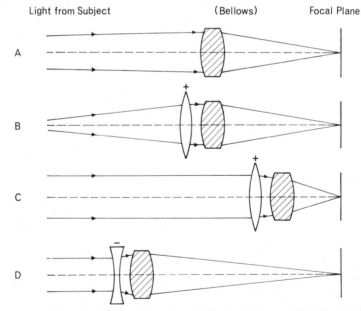

Fig. 3.8. Supplementary lenses. A: Camera lens, positioned to focus the closest subject allowed by the bellows, or focusing ring. B: Positive supplementary lens allows imaging of a closer subject. C: Positive supplementary used to allow a small image of a distant subject. (Giving a wider angle of view if aberrations and vignetting allow). D: Negative supplementary used to allow a larger image of a distant subject. Extra bellows or extension tubes are necessary.

(2) To give a wider angle of view when photographing distant subjects, by creating a smaller image. The camera will have to allow the lens to be placed closer to the focal plane. There is also a strong risk of poor image quality towards the corners of the format.

(3) To create intentional upset of aberrations for visual effect–distorted lines, colour fringes, curved field, etc. In this case a short focus supplementary such as a reading glass may be combined with a long focus camera lens.

The combined focal length of camera lens plus positive supplementary can easily be calculated (formula Appendix I, page 321). We have to remember that the f-number scale also changes with change of focal length. The *effective* f-number is the v distance (lens to image) divided by effective aperture, or

$$\text{Effective } f\text{-no.} = \text{Engraved } f\text{-no.} \times \frac{\text{Combined focal length} \times \text{v distance}}{\text{Focal length of compound lens}^2}$$

It can be seen that a positive supplementary lens by reducing focal length actually increases the 'speed' of a lens, particularly when subjects are distant and light loss due to bellows extension does not nullify the gain. This method of increasing image brightness is not of course recommended, owing to aberrations.

Occasionally it may be necessary to use a positive supplementary lens on a camera equipped with scale focusing (e.g. direct vision cameras). For distances other than infinity the marked scale can be converted thus:

$$\text{Actual distance focused upon} = \frac{\text{Scale setting} \times \text{S}}{\text{Scale setting} + \text{S}}$$

where S = focal length of supplementary lens (in same units as the scale).

For example, using a 1 metre (1 diopter) positive supplementary on a camera lens set to a focusing position marked '3 m', the actual distance focused upon will be

$$\frac{3 \times 1\,\text{m}}{3 + 1} = \tfrac{3}{4}\,\text{m} = 0 \cdot 75\,\text{m or } 75\,\text{cm}$$

Negative (diverging) supplementary lenses. Combined with a normal compound lens a weak diverging lens will create an *increase* in focal length. Uses of negative supplementaries include:

(1) The production of larger images of distant subjects–assuming that the camera allows the combination to be mounted further from the focal plane.

(2) The production of images equal in size to those formed by the camera lens alone, but with the camera further from the subject–thus recording flatter perspective.

Once again, the shorter the focal length of the supplementary lens the greater the deterioration in image quality due to unbalance of aberrations. The formula to calculate the combined focal length of camera lens plus negative supplementary lens will be found in Appendix I.

When the focal length of the diverging supplementary equals that of the camera lens, the combination is effectively non image forming. If the supplementary lens focal length is shorter than the camera lens, calculations prove that the combination becomes diverging.

45

Effective f-number must again be established, using the formula quoted above. This time the 'speed' of the lens is found to be reduced.

Whenever it is necessary to use a simple supplementary lens the camera lens should be well stopped down to minimise resulting aberrations. This does not apply to the more expensive multi-element afocal devices described earlier.

Stereoscopic images

Our ability to use two eyes in viewing a scene (binocular vision) gives us the sense of three-dimensional relief. The parallax difference between the two viewpoints gives differences in sighting foreground objects, relative to distant objects. To some extent we 'see around' close objects. This can easily be checked by looking carefully at a scene containing near and distant items, first with one eye and then with the other.

The normal two-dimensional photograph relies on lighting, perspective, and differential focus to *imply* depth. To actually record three-dimensional stereoscopic vision two pictures of the subject must be taken, equivalent to the view of each eye. Finally the stereo pair of photographs (or *stereograms*) must be viewed in a device which permits each eye to see just one of the pictures–the left eye seeing the left hand photograph and so on. In this way the brain receives the two pictures as if in normal binocular vision, fusing them to form a single stereoscopic image. (See Fig. 3.9.)

The uses of this optical principle for making stereoscopic photographs have varied according to fashion. In the late Victorian era for example most middle class homes had a stereoscopic viewer in the parlour. Stereo prints of places and famous personalities were sold in tens of thousands. Today only a few firms market stereo pictures–usually travel scenes in the form of half-frame or 16 mm cine format colour transparencies for use in special hand viewers. The 1950s saw a brief revival in '3D' productions for the entertainment cinema. The objections from an entertainment point of view have always been the inconvenience of peering into viewers or through glasses.

Nevertheless, stereophotography has very live applications today. The most important of these is aerial survey, where stereophotographs taken from the air are put through special analysis equipment and allow measurement of the height of objects on the ground, and the accurate plotting of contours. Also technical report illustration or teaching visual aids covering medical or industrial subjects such as metal erosion, require a detailed three-dimensional concept which is impossible via a single picture. (There have been advances too in systems not requiring viewing glasses, which give stereophotography much wider applications, particularly for advertising images. See page 52.)

Usually the two photographs are taken with a lateral displacement equal to the average separation between human eyes–65 mm ($2\frac{1}{2}$ in). This average is known as the *interocular distance*. Sometimes–in the case of aerial survey for example–the whole of the subject is too distant to give useful differences in a stereo pair shot with normal 65 mm separation. The sense of three dimensional relief can be heightened in these circumstances by giving abnormal separation (e.g. allowing time for the aircraft to travel an appropriate distance between the two exposures). This technique is known as *hyperstereoscopy*. The separation given will vary with the degree of

46

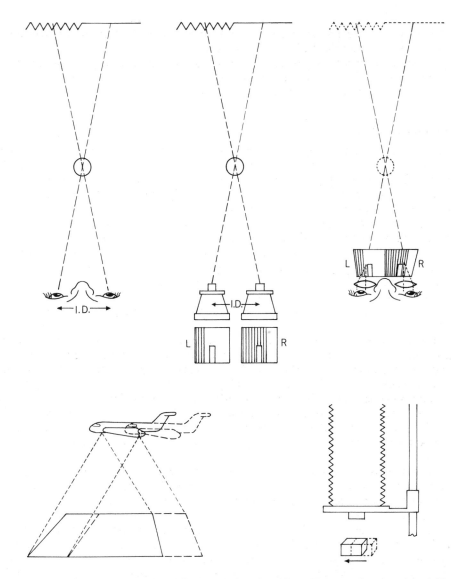

Fig. 3.9. Stereoscopy photography. Top left: Normal binocular vision with interocular separation of 65 mm. Centre: Two photographs taken with separation equal to standard interocular distance. Right: Viewing the appropriate left and right hand prints in a stereo viewer recreates the apparent position of the subject relative to background. Bottom: Examples of (left) Hyperstereoscopy, and (right) Hypostereoscopy.

depth exaggeration required but is often chosen to be one-fiftieth of the distance to the nearest subject plane. The three dimensional appearance of the stereo pair will then approximate that of a subject 3 metres (10½ ft) distant seen with normal binocular vision.

On the other hand close-up or macro subjects will show extreme displacement

47

differences between the pictures if interocular separation is used. The viewer will not find it possible to 'fuse' the two photographs. The three dimensional relief must be reduced to manageable proportions by appropriately reducing the separation in shooting – the technique of *hypostereoscopy*.

The separation chosen will vary with the distance of subject and its degree of texture. For subjects closer than 25 cm it is usual to choose a displacement equal to one quarter of the lens-to-subject distance. The result approximates the three dimensional appearance of the subject viewed from 25 cm (normal reading distance) with normal binocular vision. Alternatively the scaled down lateral displacement for hypostereoscopy can be calculated from image magnification. The simple formula when image height exceeds subject height is:

$$\text{Required separation} = \frac{\text{Interocular distance}}{\text{Magnification}}$$

For example, images of a coroded wire are required, imaged x3. Lateral separation would therefore be 65 mm ÷ 3, or in practice 2 cm.

Camera technique. To shoot stereoscopic photographs four camera systems are commonly used:

(1) A normal camera (conveniently rollfilm) which is shifted sideways between the two pictures. This is obviously limited to static subject matter, but is flexible in allowing hyper and hypostereoscopy without much difficulty. *Stereo attachments* are available for tripod tops. These conveniently allow the camera to slide sideways between the two positions for exposures. As a variation when shooting a simple subject against a plain background the camera may remain stationary and the *subject* moved sideways (about 1 mm for every 5 cm u distance). In this case the lighting should move on a platform with the subject.

(2) A normal camera fitted with a 'beam splitter' attachment on the front of the lens. This is a system of surface-silvered mirrors or prisms which splits the field of view vertically. It produces two images (as seen with interocular separation), side-by-side on the same picture format. (See Fig. 3.10.) Beam splitter devices are conveniently used with 35-mm cameras, as the horizontally positioned frame more usefully divides into two vertical halves than, say, 6×6 cm. If the camera is not a single lens reflex type the viewfinder of course requires modifying.

(3) A twin-lens stereo camera. This is really two cameras, mounted side-by-side, having identical lenses and sharing the same film – normally 35-mm. Mechanically the lenses focus together on a common lens panel. Their shutters are linked to set and fire together. The film winding is ingeniously arranged to allow interlinked pairs of pictures to be exposed along the whole length of the film without either wasting emulsion by excessive spacing, or superimposition. The viewfinder on a stereo camera is usually a direct vision type positioned between the two lenses.

(4) A camera specially designed for parallax stereograms (page 52). One such system, the Steriflex or Wonderview, uses a diaphragm which tracks sideways

5 cm within the lens during exposure, while a moulded lenticular screen moves minutely just in front of the film. This gives a single, blurred-looking image which must be faced with a similar plastic screen to appear in 3D.

Viewing stereo pairs. In systems (1), (2), and (3) above, the exposed and processed pairs of pictures are usually printed onto paper or glass ready for viewing. In printing care must be taken to match each of a pair in contrast and density. Cropping should be avoided – if it must occur the same image width should be removed from each of the pair. Stereo pairs taken on reversal colour transparency material are ready for immediate viewing after processing.

Some care is needed to sort out the frames for left and right eye viewing. If exposed via a stereo attachment on a normal rollfilm camera the uncut frames are correctly orientated when held so that the image pairs are right way up and seen with the emulsion facing away from the viewer. A stereo twin-lens camera will give frames which are incorrectly orientated when held this way (Fig. 3.10). Frames must be cut separately from the film, sorted first into pairs and then left and right pictures.

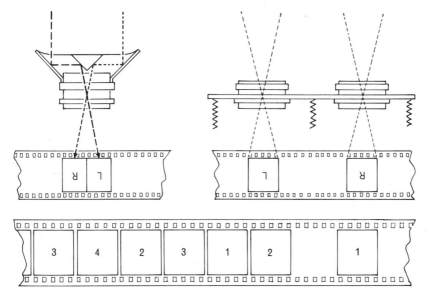

Fig. 3.10. Top left: A beamsplitter stereo attachment fitted over an ordinary camera lens. Top right: A stereo camera, utilising a pair of matched lenses with linked shutter. Note the orientation of left and right hand images, relative to the beamsplitter pair. Bottom: A 35 mm film exposed in a 22 × 24 mm format stereo camera. Between exposures the camera winds on a length of film equivalent to two frames, thus interlinking pictures and leaving just one blank frame near the beginning of the film (ANSI Standard).

Remember that the left hand picture of a pair will always contain slightly more of the left hand side of the subject and vice versa.

The sorted pairs can now be viewed in various ways:
(1) By simply staring at the two prints or transparencies from a convenient viewing distance, forcing each eye to image only its appropriate photograph. This is difficult to achieve, as the eyes must be relaxed if they are not to converge

49

together on one common point. When relaxed they tend to focus on infinity. Immediately we focus on the closer stereo pair they converge again. A piece of card placed between the pair at right angles to the page helps to limit each eye to its appropriate image, but the method causes considerable eye strain and most people are totally unable to fuse the images.

(2) By using a simple stereo viewer. Many forms exist, but the most common ones comprise two lenses in a spectacle type frame with a stand to support it over the prints or transparencies. The lenses are usually at a distance from the photographs equal to their focal length. They therefore project parallel light to the eyes, which can then view in a relaxed position. Most viewers of this type allow limited focusing of the lenses to compensate for short or long sight. They are easily obtainable from government surplus stores. For strictly accurate recreation of perspective the focal length of the viewing lens should equal the v distance in the original camera, times any linear enlargement in printing. Alternatively, focal length of viewer $= (M + 1)F$. This is not however critical.

(3) By printing each of the stereo pair in a different image colour, appreciably overlapping the images and viewing through coloured filters. The client is given spectacles containing narrow cut filters of the same colours as the images. If, for example, the left hand image is printed in red and right hand in blue-green, then the filters over the left and right eyes must be blue-green and red respectively. In this way the left eye will be unable to distinguish the right hand image from white paper (or clear glass if a transparency). In contrast the left hand image will be dark and bold. Similarly the right eye will only 'see' the right hand picture.

These bi-coloured stereograms are termed *anaglyphs*. They sometimes appear in children's books and magazines, being easily produced by mechanical printing. They can also be made by superimposing appropriately toned photographic images, or even two-colour dye transfer (see page 185). Stereograms viewed by this filter system appear virtually monochromatic, making colour photography impractical.

(4) By projection, thereby allowing viewing by larger audiences. Here an anaglyph system (as discussed under (3),) can be used with two projectors, see Fig. 3.11, left. Instead of toned images black and white transparencies may be projected through colour filters. Either way, the projectors throw offset images onto a white screen and the audience is issued with appropriately coloured spectacles. Alternatively polarized light (page 325) can be used. The two projectors then each carry a filter – one polarized vertically, one horizontally. By projecting offset images onto a metallized screen the pictures are reflected to the audience as still polarized. The audience is supplied with spectacles carrying polarizing filters, one eyepiece being polarized at right angles to the other. The left hand eye-piece absorbs the right hand image and transmits the left hand image; similarly the right hand eye-piece only transmits the right hand image. By this use of polarized light instead of colour filters stereo colour photography may be projected.

Apart from the nuisance of spectacles, an inherent problem of stereo projection is that the audience extends over a range of distances from the screen. People at the back of the group will require greater offsetting of the projected images to achieve

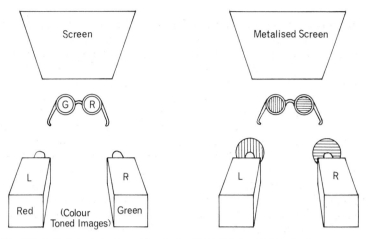

Fig. 3.11. Left: Projected coloured anaglyphs. Right: Polarised light projection system.

stereo vision than people at the front. A compromise displacement must therefore be made, suiting the viewer near the middle of the audience.

The objections to stereophotography have always centred on the inconvenience of wearing spectacles or peering through viewers. Wearers of glasses find themselves at a disadvantage; older people and anyone with slight defects in the vision of one eye will have difficulty in 'fusing' the two images. The commercial development of stereophotography for the general public is therefore likely to lie in an economic system which does not require special viewing equipment.

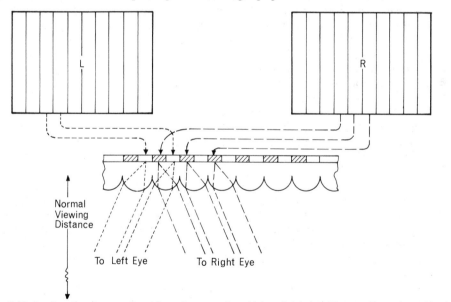

Fig. 3.12. Parallax stereogram made up from alternate strips of left and right hand images. The embossed lenticular screen ensures that (at normal viewing distance) the left eye sees only left hand strips, and vice versa.

Parallax stereograms. This system allows the production of prints and large transparencies which appear 3D to the unaided eye. The principle is shown in Fig. 3.12. Basically each image of a stereo pair is shredded into minute vertical strips. These are reassembled as a mosaic of alternating left and right hand image strips. A plastic sheet embossed with fine cylindrical lenses (like reeded glass) is sealed over the mosaic surface. Lenses and strips are parallel to each other, and related in width.

Due to interocular separation each eye will look at the picture through the cylindrical lenses at slightly differing angles of incidence. So the left eye tends to see all the component strips forming the left image, and the right eye the right hand image. (Equally parallax stereograms can be made from sequential rather than stereoscopic pairs. This way a portrait can be made to 'wink' as your viewing angle changes.)

Pictures can be taken by any of the methods already described, then dissected optically into vertical parallel strips by a special process camera. They can be reproduced mechanically in thousands for viewcards, or showcards, even magazine covers. Using the Steriflex system, page 48, a low cost lenticular plastic sheet is mounted directly over the processed colour transparency or print, turning it from a blurred and 'spread' multi-image into a sharp, 3D result. A simpler, pocket camera system (Nimslo) uses a row of four lenses at roughly half inch intervals. The camera records four negatives simultaneously of each scene. Enlargements are made through a costly four-lens enlarger, which dissects the images and reforms them into one mosaic on a sheet of colour paper faced with a lenticular surface.

Parallax stereograms lose their 3D appearance if they are viewed held on their sides. And even with the best twin image viewers or spectacles you can never, by moving position, see a continually changing 'rounded' 3D image matching reality. The camera position was fixed and results tend to have a 'cardboard cut-out' appearance. Large plate 'holography', which does not use a camera as such at all, comes closest to achieving a truly three-dimensional result. This has not yet been sufficiently developed to form a practical, versatile method of image making.

Related reading

SPENCER, D. A. *The Focal Dictionary of Photographic Technologies*. Focal Press 1977.
VALYUS, N. A. *Stereoscopy*. Focal Press (London) 1966.

Chapter summary – image quality and calculations

(1) Resolving power offers a figure (lines per mm) to express just resolvable detail at a particular position in the lens image field. Such figures cannot accurately indicate visual image sharpness, which is greatly influenced by *contrast* of detail.

(2) The correction of aberrations in any one lens can be balanced to give low contrast high resolution, or higher contrast lower resolution images. The latter will visually appear to have greater 'definition'.

(3) Along with other performance requirements of a lens, the designer must anticipate the relative priorities of resolution and definition. He must also consider the influence of the sensitive material with which the lens will be used.

(4) A lens's local image contrast relative to resolving power can be expressed graphically by plotting modulation against frequency of image as a Modulation Transfer Function curve. This is primarily used to check standards in lens manufacture. It is possible to

compare lens MTF curves with MTF curves for emulsions, to achieve optimum matching of lens and sensitive material.

(5) Other factors influencing image 'quality' include mechanical errors; type of subject, lighting and colour; and conditions under which final results are viewed. Understandably, there is no one numerical figure which will adequately express photographic sharpness.

(6) Elementary lens testing is justified for comparing lenses, checking for damage and for limitations of field. A rear illuminated pinhole and resolution chart provide convenient test devices for curved field, spherical aberration, distortion and astigmatism, decentred components, and flare.

(7) Simple supplementary lens elements–diverging or converging–allow conversion of a compound lens to longer or shorter focal length respectively. Supplementary focal length may be quoted in diopters–or reciprocals of 100 cm. Effective f-number should be re-calculated.

(8) Converging supplementaries allow close subject approach with limited bellows extension; slightly wider angle of view; or intentional aberration distortion. Diverging supplementaries yield larger images of distant subjects, and require extra bellows extension.

(9) Stereoscopic pairs of 'stereograms', based on binocular vision (65 mm separation), are usually produced with a normal camera displaced or fitted with a beam splitter, or by a stereocamera. Applications include technical illustrations and aerial survey.

(10) Stereograms may be 'fused' into a single 3D image by the aid of simple magnifying viewers; as *anaglyphs* or polarized images viewed through spectacles; or as parallax stereograms.

(11) *Hyperstereoscopy* (or extended displacement in shooting the two images) exaggerates three dimensional relief–normally in distant subjects. Separation $= \dfrac{u}{50}$. For subjects closer than about 25 cm displacement is usually reduced (*hypostereoscopy*). Separation $= \dfrac{u}{4}$ or $\dfrac{65\,mm}{M}$

Questions

(1) Briefly explain two of the following pairs of terms:
Resolving Power and Modulation Transfer Function Curves (applied to lenses).
Anaglyphs and Parallax Stereograms.
Hypostereoscopy and Hyperstereoscopy.

(2) A stereo pair of negatives must be made showing the internal layout of a small watch. The images must be $1\frac{1}{2} \times$ the size of the subject. You have a 90 mm lens and a stand camera. Calculate:
(a) The lateral shift required between the two exposures and
(b) The factor by which the meter indicated exposure must be multiplied in view of the close-up arrangements.

(3) Describe tests you would give a secondhand wide-angle lens, to assess its suitability for architectural photography. No information is available regarding its field coverage.

(4) A plate camera fitted with a 125 mm lens has bellows extending to a maximum of 30 cm. A macrophotograph must be produced in which 1 cm on the subject is imaged 2 cms on the negative. Positive supplementary lenses of 1·5, 2 and 3 diopter focal lengths are available.
–Calculate which supplementary lens would most efficiently be used.
–If it is decided to make the exposure at an effective f-number of $f16$ to what position on the engraved f-number scale should the diaphragm be set?

53

(5) List all the main factors which contribute to one photograph appearing 'sharper' than another.

(6) Describe a method of producing a stereogram of a bowl of fruit using a normal studio camera. Explain how a stereogram can be viewed (*a*) by projection and (*b*) as a paper print.

(7) (*a*) Describe a method of accurately determining the focal length of a lens.

 (*b*) A camera fitted with a 10cm focal length lens will focus down to 50cm. What will be the maximum magnification possible when a 3 diopter positive supplementary lens is used?

(8) A lens is stated to offer axial resolving power of 120 lines per mm. Discuss the limitation of this figure as a description of the practical performance of the lens.

4. SHUTTERS AND RELATED CAMERA EQUIPMENT

The camera lens and the shutter are traditionally associated. This is of course due to their combined influence on exposure and, in the case of 'between lens' shutters, their physical integration. Whilst the development of lenses has been the more spectacular of the two, shutters have also steadily improved. Speed range and efficiency have been increased, flash synchronization incorporated . . . and all with considerable reduction in physical size. Focal plane shutters with acceleration compensation are now commonplace. Shutter speeds and diaphragm settings may be mechanically linked, with or without photocell exposure automation. From the early 1960s onwards the availability of small electronic components has brought about a generation of shutters with radically new electronic speed control systems; these can be made to form part of a circuit with automated exposure devices.

Most of the electronic innovations are found in small and medium format cameras. But at the same time more thought has been given to the design of shutters and associated equipment which will allow the photographer to use his stand camera with greater efficiency. These are discussed towards the end of the chapter.

Electronic shutters (bladed or Focal plane)

If we take the shutter to be one component in an automated exposure system it has disadvantages in being a mechanical–partly 'clockwork'–device. Changing shutter speeds require the physical changing of spring tensions, or the bringing into play of trains of gears to delay the closing of the shutter. Setting the shutter means transferring energy from the finger through the setting lever to tension the firing spring. The mechanical forces needed for these controls are not easily operated electronically–a necessary stage if the shutter is to be automatically monitored (along with the aperture) by a photo-sensitive cell.

The situation is improved by doing away with the mechanical gear train altogether. The shutter has two fast acting electromagnets. One releases the blades or blind which have been pre-tensioned by the film wind lever or a similar device and the other electro-magnet releases the return mechanism or second blind. The timing between these two release signals is controlled by a capacitor fed from a small battery through any of a range of transistors.

Acting like a 'storage tank' the capacitor will only close the shutter when fully charged. Its rate of charging is accurately controlled by choice of transistor. Change of shutter speed is therefore carried out by switching from one transistor to another, instead of engaging or disengaging mechanical gears. A tiny circuit can give accurate timing between 1/2000 sec and 8 sec. Using appropriate electronic components the change of circuit can easily be controlled by the current signal from a photo-resistor cell which is positioned to read image brightness, and set for the appropriate emulsion speed.

Individual makes of electronic between-lens and focal plane shutters vary in detail. The general practical features of this type of shutter control are as follows:

(1) Control of speeds by electronics makes the shutter capable of linkage with any

other electronic circuitry – including speed and aperture displays by light signal read-out in the viewfinder, or (large format camera) external digital scales. See Fig. 4.3.

(2) The reduction of moving parts means less wear and greater consistency, also fast reaction to cell signals. Some small format camera shutters have sufficiently low inertia to close under the control of a photo-resistor cell when just sufficient light has entered the lens, even when using flashbulbs. A cell circuit capable of integrating *intensity* and *duration* of light is known as a 'photo-multiplier' system.

(3) It is possible to charge the condenser very slowly. The speed range on large format bladed shutters in particular is greatly extended at the slow end of the scale. Exposures continuously variable up to 32 seconds are common.

(4) Just as a remote cell may be wired to the shutter, so a manual speed selection dial can be located some way from the shutter itself. Such an accessory allows speeds to be selected for example from a control at the back of a stand camera.

Fig. 4.1. Left: electronic bladed shutter for a large format camera. R: Resistances. C. Condenser. T. Transistors. M. Electro-magnet. Right: an electronic shutter with remote control for shutter speeds and aperture.

(5) Electronic shutters are now found in most advanced small-format SLR cameras. Low cost miniaturised integrated circuits can be housed in any convenient part of the camera body. They form a vital part of automatic exposure-control systems, discussed opposite. Shutters for large-format cameras are sold in much smaller quantities. Electronically timed shutters for this size are therefore much more expensive than traditional types and have not yet been generally adopted.

Shutters and exposure control systems

Fullest integration of shutter and exposure measurement systems is to be found in modern small format SLR cameras. Through-the-lens metering is well established, light measurement behind the lens having advantages of automatically taking into account aperture, extension tubes, and filter factor (subject to variations between the colour response of cell and emulsion). TTL meters also allow measurement of light from inaccessible subjects, as in photomicrography. However, there are problems in harnessing a fully automatic fast-reacting meter/shutter system to the SLR.

Most cell positions (Fig. 4.2) are in the deflected viewfinder lightpath, such as the pentaprism, which 'blacks out' when the mirror rises at the moment of exposure. The answer to this is to have a memory circuit which stores the right charge to be fed to the electronic shutter timer after the mirror rises.

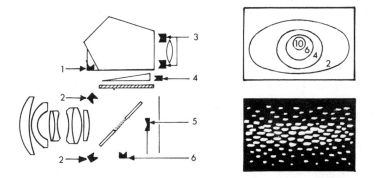

Fig. 4.2. Left: some alternative cell locations for through-the-lens exposure measurement in an SLR camera. 1. Adjacent to pentaprism. 2. Facing the emulsion. 3. Near the eyepiece. 4. At the focusing screen (with semi-reflector). 5. On a hinged probe behind a light transmitting patch on mirror. 6. Below a right-angled reflector behind mirror. Cells at (2) only function when the mirror is up. Top right: image measuring zone of a 'centre-weighted' TTL exposure system. Figures denote percentage response. Bottom right: reflective pattern on shutter blind used when camera has cells in location (2).

Another solution is to have fast reacting cells inside the body below the lens, pointing towards the film. These measure the image actually projected on the film surface during exposure and close the shutter immediately enough light has been received. The system is fast enough to work with flash and slow enough to take into account changing lighting conditions during a time exposure. For occasions when a narrow slit is in use, so the whole focal plane is never revealed at one time, the shutter blind itself carries a 'typical' reflective pattern. (See Fig. 4.2.)

Mostly silicon cells are used, blue filtered to correct their over-response to red (therefore called silicon blue). These have an instant response and function through a very wide range of light levels, although needing a tiny amplifying circuit to boost their low output current.

According to the positioning of the internal cells, the exposure system may measure (1) from the whole image area; (2) from a local 'spot' area shown by a circle on the focusing screen, or (3) mostly from the central zone ('centre-weighted). Of these (2) is the most useful arrangement for the professional, who is experienced enough to know the key areas he needs to measure. (3) gives a high percentage of successes when time does not permit one or more localized readings. Several top quality cameras have a double system, with a selector switch for changing between spot and centre-weighted methods.

Cameras with electronic shutters often use the cell read-out as part of an aperture-preferred exposure system. This means that the photographer chooses the aperture and the TTL meter sets the shutter speed. Usually both the aperture and shutter settings in use are displayed alongside the focusing screen.

From the professional's point of view it is vital to be able to over-ride any system of automatic exposure setting, in order to intentionally increase or decrease density,

57

produce blur, shallow depth of field, etc. Amateur originated systems of automatic exposure control are therefore a mixed blessing. They certainly facilitate quick handling of the camera but manual over-ride is essential. Most photographers also consider a separate meter indispensable.

Shutters as part of large format camera systems

Large format stand cameras have a different set of priorities for operator aids. The manufacturers assume that virtually all users are professional photographers. Exposure automation is a debatable virtue, for reasons already stated. The professional is more interested in linked systems which allow more convenient camera manipulation and faster shooting.

Any work study assessment of the number of actions required on a stand camera between composing on the focusing screen and actually exposing reveals its inefficiency. Groping forward to stop down the lens, close, select speed and set the shutter; insert the dark slide and draw the sheath. . . . These actions may all be simplified by appropriate linkages.

The aim of most systems is to allow the photographer easy operation of all controls from behind the camera. For example, large bladed shutters for use behind the lens panel of stand cameras have over-size speed selection scales facing the back of the camera. The shutter is linked by bowden cable to the lower edge of the springback focusing screen. Shutter blades remain open during focusing, but the action of the slide entering the camera back closes and sets the shutter via the cable link. When the slide is removed the shutter opens again for focus checking. Where an electronic between-lens shutter is in use, mechanical links to the camera back are replaced by electrical circuitry. This can also form part of a remote diaphragm and shutter change control, and an exposure reading system.

Fig. 4.3. The settings on this electronic shutter are designed to be read from the back of the large format camera. Although a bladed shutter, it is designed for use with a whole range of lenses, and fits between lens panel and bellows. Electrical connections are made with the lens aperture settings; also with the spring back to close or open the shutter as the filmholder is inserted or withdrawn.

Fig. 4.4. Large format camera aids. Left: 'probe' spot meter. Unit is pushed into focal plane in place of filmholder. Right: Sliding back arrangement to allow rapid interchange of focusing screen (S) unit and film holder attachment (F). L: Mechanical link between back and shutter. Hood H has mirror for inverting image, and a magnifying eyepiece. (A) is *f*-number setting unit on lens, usable from the back of camera.

To take mechanical linkage further a sliding back may be used carrying focusing screen and darkslide (or rollfilm holder) side by side. The back contains a built-in sheath, so that the darkslide can have its own sheath removed once it is attached. The photographer composes and focuses his image with the focusing screen opposite the lens. By sliding the back, the cable links stop down the lens and close and tension the shutter. Also, as the darkslide moves into position, the built-in sheath slides away to expose the emulsion to the inside of the camera. (See Fig. 4.4.)

After firing the shutter the sliding back is returned to its original position, reversing the sequence. The focusing screen is returned, and reveals the image at full aperture.

These examples of linkage between camera controls illustrate the direction of professional camera development. Whilst through-the-lens exposure measuring devices exist for large format cameras, these tend to be of the 'spot' measurement type. (i.e. A CdS probe movable over the lens side of the focusing screen, or a CdS meter adapted to read local areas *through* the screen.) It is not usual to link cell and exposure controls, as the professional user will normally wish to interpret his readings.

Shutter efficiency

To be 100% efficient a shutter should *instantaneously* reveal the emulsion to the *whole* of the light beam passing through the lens. It should remain fully open for the exact period marked, and then totally obscure all the light, instantaneously.

The light passed by this ideal but physically impossible shutter can be compared with the light passed by an actual shutter, starting and finishing its action at the same points in time. The actual shutter takes some time to fully open and fully close, and therefore less light reaches the emulsion during these periods. The shutter will in effect pass a total amount of light equivalent to the light passed by an 'ideal' shutter set to a faster speed. Most modern shutters have their speeds marked in terms of this effective shutter speed.

59

No practical shutter has 100% efficiency, typical figures (for fairly fast shutter speeds) being between 60% and 90%. Higher efficiencies are possible using special shutters (e.g. Kerr Cell, page 330) devoid of any moving parts. These are however designed for photographing extremely high speed scientific subject matter, and would not be used for general photography.

Between-lens shutters. The efficiency and therefore the effective exposure given by a between-lens shutter is influenced by:

1. *Diameter of aperture.* As the lens is stopped down, a narrower beam of light is left for the shutter blades to uncover. For example, when the lens is stopped down by two *f*-numbers the light beam is halved in diameter. The shutter blades are now in effect fully open at the 50% position. The shorter time taken to open and close the smaller aperture means that the shutter efficiency increases and effective exposure is slightly longer than at full aperture. Typical values at 1/125 second (8 ms) are 8 ms at *f*2 and 12 ms at *f*16.

2. *Shutter speed set.* Normally a between-lens shutter takes the same period to open and shut, whatever the shutter speed. The shorter the shutter speed the greater the *proportion* of time taken up by this opening and closing period, and therefore the lower the efficiency. At a shutter speed of 1 second for example, opening and closing makes up such a small proportion of the start to finish period that efficiency may be over 98%. The same shutter, at the same aperture, shows an efficiency drop to 68% when set to 1/250 second.

To a slightly lesser extent, between-lens shutter efficiency is also affected by:

3. *The shutter position and design.* A shutter positioned right next to the diaphragm chops a narrower light beam than a separate bladed shutter positioned in front of or behind the whole lens. An interchangeable bladed shutter is therefore inherently less efficient than one built into the lens. If the mechanism of the shutter provides fast blade acceleration, efficiency rises. Powerful springs are therefore desirable. Cheaper shutters usually have weak blade actuating springs–often indicated by the lack of a separate setting lever.

A between-lens shutter then functions with greater efficiency when located close to the diaphragm, with the lens well stopped down, and set for relatively long exposure times.

Focal plane shutters. The efficiency of a focal plane shutter depends upon rather different factors, owing to its position relative to the lens. Efficiency is influenced by:

1. *Blind position.* If the blind was truly in the focal plane–i.e. running over the surface of the emulsion–it would intercept the light from the lens focused to a point (Fig. 4.5). Seen from any one part of the emulsion the leading edge of the blind slit would reveal all the light from the lens instantaneously. The 'trailing' edge would obscure all the light instantaneously. The shutter would therefore have a performance equivalent to our ideal bladed shutter, with 100% efficiency.

For obvious physical reasons it is not practical to run the blind actually in the focal plane. According to the design of the camera it will run some way in front of the emulsion–intercepting a focused *cone* of light from the lens. The leading edge of the blind slit will pass into the cone allowing a point on the emulsion to receive

a gradually increasing quantity of light. Only when the whole width of the cone of light is able to pass through the slit does the emulsion receive full image intensity. Similarly a 'fade out' of illumination occurs as the trailing edge of the slit passes into the light cone. A focal plane shutter performance graph is broadly similar to that for a between-lens shutter.

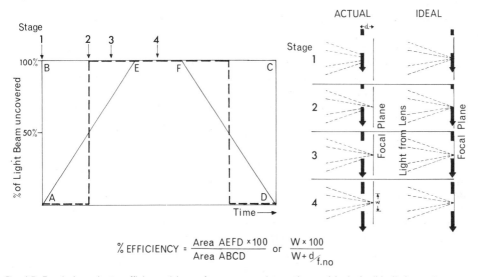

$$\% \text{ EFFICIENCY} = \frac{\text{Area AEFD} \times 100}{\text{Area ABCD}} \text{ or } \frac{W \times 100}{W + d_{f.no}}$$

Fig. 4.5. Focal plane shutter efficiency (shown for any one point on the emulsion). An 'ideal' shutter (extreme right) would run in the focal plane—its performance can be shown by the broken line on the graph (left). An actual shutter cuts into a broader light beam, plotted in graph line AEFD. Shape ABCD denotes an ideal shutter which begins and stops its light admitting action at the same points in time as the actual shutter.

2. *Slit width.* Assuming the same blind position, a narrow slit will have a large proportion of its exposing action taken up with uncovering and covering the cone of light. A wide slit takes the same time to intercept the light, but this is now a smaller proportion of its total action. Focal plane shutter efficiency therefore increases with slit width.

3. *f-Number.* As the lens is stopped down the cone of light narrows. The edges of the slit take a shorter time to admit and extinguish total light from the lens. Similarly this will happen if we change to a lens with the same diameter aperture but longer focal length. We take both aspects into account by saying that focal plane shutter efficiency increases with higher *f*-number.

A focal plane shutter conforms most closely to its marked exposure time when positioned close to the emulsion, and used with a wide slit and a lens set to a high *f*-number. Incidentally, blind *speed* has no appreciable effect on efficiency. Whatever the speed, the proportion of slit movement time taken up by passing into or out of the light cone remains the same.

Practical significance. Efficiency and particularly the effect of the opening and closing periods have practical photographic importance when:

(1) Accurately recording fast moving subject matter. Any calculation of the

61

distance the image of the subject will move during exposure must bear in mind that *brighter* but not darker areas will still record during the partially open periods, because of the high level of exposure they produce. Image highlights appear as if they have received a longer exposure time (i.e., show greater movement) than darker areas. If the moving subject is light in tone subject blur will extend further than expected. If the background is lighter than the subject it may 'eat into' the moving image, reducing the length of blur. In the case of the focal plane shutter the result will also be influenced by the direction of slit travel relative to image direction.

(2) Synchronizing flash illumination. Flash should be synchronized to emit its peak illumination whilst the blades of a between-lens shutter are fully open, or the blinds of a focal plane shutter reveal the full width format to the image. Synchronization is discussed in detail in Chapter 6.

Shutter testing

The four main sources of shutter error are low efficiency; calibration errors; inconsistency; and mechanical defects such as inertia and bounce. With a focal plane shutter due regard must also be taken of uneven travel due to acceleration.

Calibration errors tend to apply to the high end of the speed range. Marked speeds of say 1/300 may in fact be an effective 1/250. For most forms of photography these errors can be ignored – provided that they are consistent. It is therefore more worthwhile to test an unknown shutter for inconsistency and mechanical damage.

Inconsistency – particularly at higher speeds – can pass unnoticed until photographic results are examined. Its presence makes the shutter completely unreliable. for professional work. Bearing in mind the high cost of labour, models and photographic materials it would be foolhardy to trust an inconsistent shutter on an assignment. Similarly with 'bounce' defects (momentary reopening of the shutter blades after closing) which can result in double images.

Fig. 4.6. Three methods of checking shutters. Left: An oscilloscope system fed from a time base and from a photocell receiving light via the shutter under test. Centre: Use of a gramophone turntable. Right: Testing a focal plane shutter using film on a steadily moving drum. Negative shows sluggsh start to blind travel.

For a small fee a competent camera repairer will test a between-lens shutter on equipment linked to an oscilloscope. Basically a condensed light source is projected through the shutter under test, onto a photo-cell. The cell's signal is amplified and fed to the oscilloscope, where it creates vertical deflection of the illuminated spot on the tube face. An electronic time base also feeds to the oscilloscope, causing horizontal deflection of the spot at a pre-determined speed.

By triggering the time base to synchronise with releasing the shutter a performance graph is automatically traced on the tube face. This of course shows the opening, fully open and closing periods, indicates any bounce or irregularity, and allows a series of firings to be compared for inconsistency (Fig. 4.6).

Modified optics allow similar testing of a focal plane shutter for one position on the emulsion. To check movement of the slit over the whole focal plane the shutter can be arranged to run between a light source and photographic film wrapped around a steadily revolving drum. The drum surface moves at right angles to the slit movement. The processed film shows an oblique strip of density, which is distorted where slit motion is subject to acceleration or deceleration.

When it is necessary to quickly improvise a between-lens shutter test a moving object of known speed is required. This might be a car travelling at a steady known speed at right angles to the lens axis, photographed with a stationary camera. If the side of the car carries a white patch or light the overall time between start and finish of blade movement can be calculated from the formula

$$T = \frac{L}{M \times S} \text{ second}$$

When T = total time
 L = length of streak recorded (mm)
 M = magnification
 and S = speed of the subject in mm per sec.

For example: Using a car moving at 20mph (8940mm per sec), shot with an 8-cm lens from 10 metres away $M = \frac{8}{1000} = \frac{1}{125}$ gives a streak 2mm long.

Total open time is therefore $\frac{2}{1/125 \times 8940} = \cdot028$ second or 1/35 second.

If only shutter consistency is suspect calculations are not strictly necessary – a number of frames can be exposed at the same setting and the lengths of streaks compared. This formula is also useful in reverse – for calculating the shutter speed needed to record a moving subject with a particular length of blur.

A gramophone turntable can also form a handy test object. Use adhesive tape to fit a small torch bulb to the turntable near its perimeter, connected to a battery at the turntable centre. Photographed from directly above, the bulb records as an arc of density on the processed film. Draw lines connecting the ends of the arc to a point at the centre of the turntable and measure the angle subtended. Total exposure time can be calculated as:

$$T = \frac{D}{S} \quad \text{When D = degrees subtended,}$$

and S = speed of turntable in degrees per second.

78 r.p.m. (468° per sec) is the most useful turntable speed for shutter speeds 1/125–1/8 sec; 45 r.p.m. (270° per sec) for speeds of about $\frac{1}{4}$ sec; and 33 r.p.m. (198° per second) for exposures up to 1 second.

None of these improvised tests give information on the *proportion* of time the blades are actually fully open, but unlike strictly laboratory tests the images do at least give some idea of practical results to be expected.

Chapter summary – shutters and related camera equipment

(1) Electronic shutters utilize time taken to charge a condenser to control the *duration* of exposure. Features include ease of electronic linkage as part of an automated exposure system; greater consistency; fast reaction to cell signal; extension of slow speed range; remote control.

(2) Users of small format cameras with auto or semi-auto exposure control must consider the location of the cell and its effect on exposure measurement. The most common systems use through-the-lens metering with an aperture-preferred exposure setting arrangement.

(3) The general trend in small format camera systems is towards the use of fast reacting silicon blue cells, memory circuits, and choice of both 'spot' and 'centre-weighted' image measurement.

(4) The design of shutters for large format cameras is directed towards a co-ordinated system which includes lens aperture and even insertion of the film slide – with everything manipulated from the back of the camera.

(5) The 'efficiency' of a shutter is the ratio of light passed by the shutter under test, to light passed by a 'perfect' shutter. (Both shutters to start and finish their actions at the same points in time.) Efficiency is usually expressed in terms of percentage.

(6) No shutter is 100% efficient. To be so would require a bladed shutter with opening and closing actions literally instantaneous; or a focal plane shutter travelling in the actual emulsion plane.

(7) Between-lens shutter efficiency increases with smaller aperture; with slower speeds; with positioning across the narrowest light path in the lens; and with mechanical spring strength.

(8) Focal plane shutter efficiency increases the closer the blind runs to the emulsion plane; the wider the slit width; and the higher the *f*-number.

(9) The principal shutter errors are low efficiency; calibration errors; inconsistency; uneven focal plane speed; and mechanical failure.

Questions

(1) What *practical* advantages are offered by electronically controlled bladed and focal plane shutters, over conventional versions of these shutters?

(2) Explain the layout and action of a coupled (i.e. semi-automatic) camera exposure system, using 'through-the-lens' measurement of illumination. Assess the value of your described system from the point of view of professional users.

(3) Explain the following terms
Silicon cell.
Centre weighted exposure measurement.
Aperture preferred exposure setting.

(4) Discuss the advantages of electronic rather than mechanical systems in shutters and related equipment (*a*) In small format cameras, and (*b*) Large format stand cameras.

(5) (*a*) What is meant by the efficiency of a between-lens shutter?
(*b*) Explain how, in the absence of special electronic shutter testing equipment, the shutter speeds of a between lens shutter could be determined. Any necessary mathematical calculation should be given.

64

5. TUNGSTEN AND FLASH LIGHTING EQUIPMENT

Apart from the basic floods and spotlamps, there are a whole range of other important atificial light sources. They include tungsten halogen lamps, flashbulbs, and various types of studio and location electronic flash. This chapter concentrates on tungsten and flash lighting equipment itself, introducing some new terms and comparing the advantages and disadvantages of different designs. Having seen how the equipment works, practical aspects such as synchronization, exposure measurement and general handling of flash will be discussed in Chapter 6.

To begin with it helps to understand three technical terms which often appear in technical data on photographic lighting. These are colour temperature, light output and efficiency, and polar distribution curves.

Technical specification of light sources

Colour temperature. When a solid body is heated it becomes incandescent (glows with heat). Sources like these–which include the sun, tungsten lamps and flashbulbs–emit light of all wavelengths and are said to have a continuous spectrum. However, this does not mean that light from all continuous spectrum light sources matches in colour. The *relative proportions* of short and long wavelengths emitted can vary quite widely and depend upon the temperature of the source.

Compare for example two 100-watt lamps, one run at its correct mains voltage, and one under run by 30 volts. The latter is not only less bright but also *more red* than the correctly run lamp. Its illumination contains a higher proportion of red wavelengths and a lower proportion of blue wavelengths. Similarly if we compare a 500-watt photographic lamp with a 200-watt domestic lamp, the weaker source is found both less bright and proportionally richer in red.

As the colour of the light produced by a source is very important when we come to colour photography, some means of expressing it accurately is needed. One answer is to use graphs plotting relative energy emitted at each wavelength. These *spectral energy distribution curves* (Fig. 5.1.) give plenty of detail, but it is much quicker to relate the colour content of a light source by quoting a single figure related to its temperature and called 'colour temperature'. *The colour temperature of a white light source is the temperature in kelvins (K) of a perfectly radiating black body when emitting light matching the source under test.* The 'body' simply means a piece of metal, dark enough not to reflect incident light, and able to radiate evenly in all directions when heated. As it is heated it begins to glow a cherry red, then orange... and slowly the predominant wavelengths tend to move towards blue ('white hot'). At any point the light emitted can be described by the temperature of the body expressed on the Absolute scale ($273°A = 0°C$) and quoted in kelvins, after the originator of the system, Lord Kelvin. Remembering the appearance of metal when heated, a light source very rich in red and yellow wavelengths has a low colour temperature; a light source with less red and more blue wavelengths has a high colour temperature. This means that a candle has a colour temperature of about 1,800 K, a 100-watt domestic lamp 2,800 K, and mean noon sunlight about 5,400 K.

Table 5.1 shows the colour temperature of most continuous light sources used in photography. Note particularly the figures of 3,200 K (photographic lamps); and

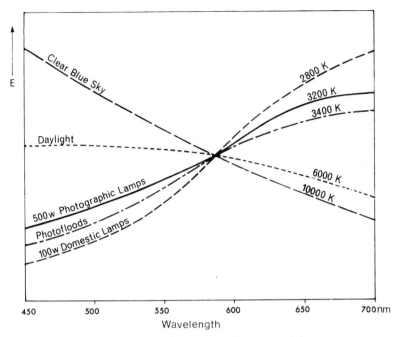

Fig. 5.1. Spectral energy distribution curves for common light sources.

6,000 K (daylight). Different types of colour films are made, balanced for one or other of these colour temperatures, see Chapter 13.

In catalogues, a lamp's colour temperature is usually quoted along with details such as cap, wattage, voltage, etc. The quoted colour temperature assumes that the bulb is burnt at the exact voltage, has an undiscoloured glass envelope and is not used with a coloured reflector, diffuser or Fresnel lens. Lamps of different colour temperatures should not be mixed when lighting a set for colour photography.

In passing, note that 'daylight' colour temperature is difficult to define as it varies considerably with weather conditions, geographical location, time of year and time of day.

Limitations to colour temperature. The whole concept of colour temperature is based on comparison with a heated metal; therefore non-incandescent light sources (e.g. most fluorescent tubes, sodium or mercury vapour lamps) creating light by other means cannot be given a colour temperature figure. In fact spectral energy distribution curves show these sources to have discontinuous spectra in either *line* or *band* form – the gaps denoting that at certain wavelengths no light is emitted at all.

A few fluorescent tubes specially intended for colour work have a continuous

66

TABLE 5.1.

THE COLOUR TEMPERATURE OF SOME LIGHT SOURCES

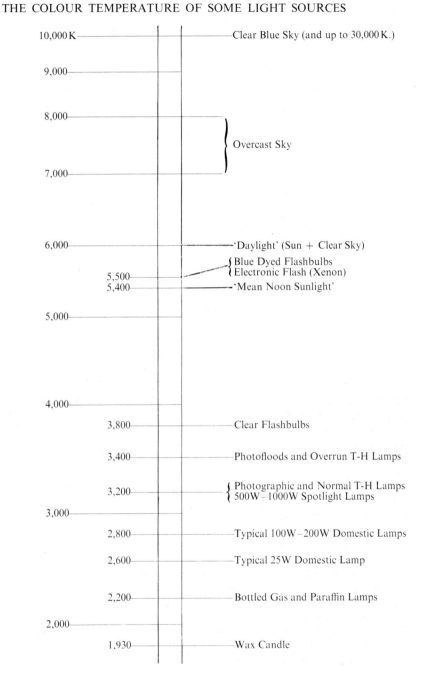

67

spectra overlaid with an intense fluorescent spectrum from the tube coating (see Fig. 5.2). Such sources are quoted as having an 'equivalent' colour temperature. Electronic flash tubes have line spectra due to their gas filling, but because of the

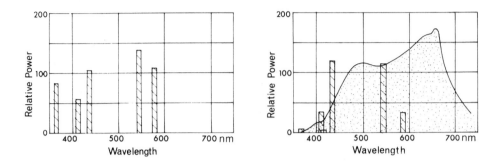

Fig. 5.2. Spectral energy distribution graphs for two non-incandescent sources. Left: A low pressure mercury vapour lamp—showing total absence of many wavelengths, notably red. Right: A fluorescent tube for colour matching work (equivalent CT = 4,000 K).

pressure and high density of electrical discharge the lines broaden into bands which overlap to appear continuous. They can therefore be given an equivalent colour temperature. Much the same applies to modern metal halide arc lamps. In practice both these and flash tubes are made to give a colour temperature within the range of average daylight. The colour temperature of light sources as they apply to colour photography is discussed in more detail in Chapter 13.

Light output and efficiency. Other figures we will meet in reading technical literature on lamps refer to light output (usually in thousands of lumens) and efficiency (in lumens per watt). A lumen is a measure of the luminous energy emitted by the source. A light source of one candle power placed at the centre of a hollow sphere one metre in radius will give the power of one lumen on each square metre of the sphere's inner surface. The light outputs of two lamps can therefore be related by comparing their lumen figures.

Efficiency relates to the rate at which a lamp converts electrical energy into light. Theoretically, if a lamp could convert all the electricity consumed into white light it would have an efficiency of about 220 lumens per watt. In practice tungsten lamps waste most of the power by emitting long wavelengths (heat). A domestic lamp for example has an efficiency of about 15 lumens per watt—wasting over 90% of the energy supplied! Fluorescent tubes have an efficiency of around 50 lumens per watt. Hold your hand near the envelopes of these two light sources when they are on, and check their differences in temperature. This explains why a 40-watt fluorescent tube gives as much light as a tungsten lamp of over 100 watts.

As the voltage supplied to a lamp is increased (Fig. 5.3) the lamp's colour temperature rises, together with light output and efficiency, but it suffers a shortened life. This gain in efficiency is one of the advantages of overrun lamps such as 'photofloods', which give 34 lumens per watt against 27 for 500 watt 3,200 K photographic lamps.

68

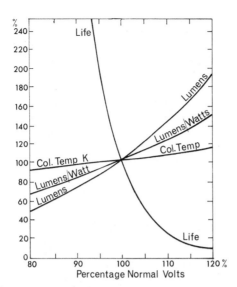

Fig. 5.3. Graphs showing the effects of varying the voltage applied to a lamp. All units are expressed as percentages of the normal rated values.

Polar curves. A light source fitted in a reflector, or with its own built-in reflector, becomes directional in character. It is useful to be able to show the spread of light from the complete lighting unit–and the way in which angle of illumination is influenced by reflector shapes, fresnels, etc. For this purpose polar diagrams are used.

A polar diagram is simply a graph plotting luminous intensity against lines radiating out from a centre point where the centre of the source is located. (The luminous intensity is normally measured in candela units, where one sq cm of a black body at the temperature of the solidifying point of platinum is defined as

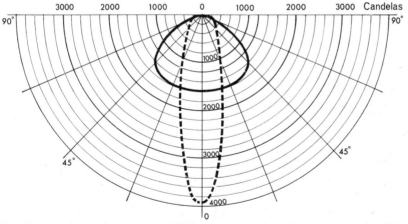

Fig. 5.4. Polar curves for two lighting units. Solid line denotes the light distribution from a floodlight; broken line from a typical photographic spotlight. Because of the symmetrical form of most lamps and reflectors it is often only necessary to publish one half (left or right) of this diagram. In the case of non-symmetrical units separate curves are needed for horizontal and vertical planes.

69

having a luminous intensity of 60 candelas.) In practice a small photocell is placed at a set distance from the lighting unit and candela readings taken at 5° intervals all around the unit, maintaining the same distance. Each reading is then plotted where its radial line crosses the appropriate intensity line. In this way a curve showing light distribution is built up (Fig. 5.4).

If the lamp was a bare, truly point source without reflector, the polar diagram would be an undistorted circle. The more directional the light distribution the more elliptical the graph becomes. Thus we can see at a glance what sort of spread of illumination different lighting equipment will give.

Polar curves are useful wherever lighting is being planned – in estimating the distance and type of units to achieve a certain level of illumination (and exposure) in a studio, theatre, workshop, etc.

Tungsten halogen (including quartz iodine) lamps

The principle of designing general purpose incandescent filament lamps has always been to get the most light for the least amount of power, and for the longest possible lamp life. The efficiency of lamps (see Fig. 5.3) increases with increase in filament temperature, but then lamp life is greatly reduced. This is due to the great increase in evaporation of the filament metal at high temperatures. Furthermore, the evaporated metal deposits itself on the inside surface of the glass envelope, reducing light transmission. (Traditionally powerful lamps have very large glass envelopes, giving a larger area for metal deposit.) Many lamps include nitrogen or argon gas within the envelope, to reduce evaporation by causing molecular collisions.

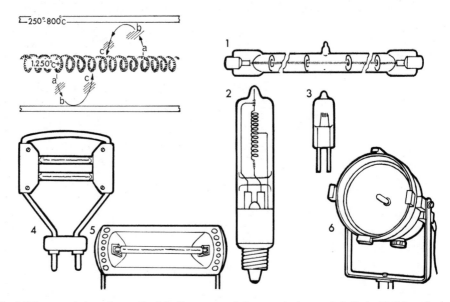

Fig. 5.5. Tungsten halogen lamps. Top left: The tungsten halogen cycle (see text). 1. Typical T-H lamp for horizontal use. 2. Single ended type. 3. T-H projector lamp. 4. Adaptor to carry two T-H lamps in a bipost spotlight fitting. 5. Reflector unit for a double ended lamp. 6. Reflector unit for single ended lamp.

70

Since about 1960 it has been possible to design filament lamps of greatly improved performance by making use of the *tungsten halogen cycle*. The principle is simply this: between temperatures of 250°C and 800°C tungsten metal and a halogen such as iodine vapour combine to form tungsten iodide vapour. But above the temperature of 1,250°C they split up again into tungsten and iodine.

A tungsten filament lamp containing iodine vapour is therefore needed, in which the filament has a temperature of over 1,250°C, and the envelope reaches a temperature between 250°C–800°C.

When the lamp is used the following cycle takes place (relate to Fig. 5.5):

(*a*) Tungsten evaporates normally from the filament towards the envelope.

(*b*) Iodine vapour reacts with this tungsten, forming tungsten iodide.

(*c*) Gas convection streams carry the tungsten iodide vapour back over the higher temperature filament, separating the tungsten (which re-deposits on the filament) and iodine vapour (which becomes free to collect more tungsten as in stage (*b*)).

This continuous process is so efficient that the lamp envelope never blackens and the filament never loses tungsten. In fact the lamp would be everlasting were it not for the fact that the iodine vapour does not put the tungsten back on the filament in exactly the same place from which it was taken. Deposits are made on the slightly cooler parts, so that the hottest areas still evaporate and eventually the filament does break.

Now to get this cycle working the filament must be rather hotter than a normal lamp, and the envelope must be fairly close and equidistant from the filament. Glass will not stand this heat so a tube made of quartz or similar material is used instead. The earliest lamps using the halogen cycle contained iodine within a quartz envelope, and were termed *quartz iodine* lamps. Today many manufacturers use bromine or other halogens instead of iodine. A silica base material called Vycor is often used instead of quartz, as the latter transmits too much U–V radiation. The genetic name for these lamps is therefore more accurately 'Tungsten Halogen', although some equipment makers still call them quartz iodine lamps. (Similarly car headlamps based on this principle may be called Q.I. lamps.)

One advantage of the tube-like envelope surrounding the filament (Fig. 5.5) is that its small size and mechanical strength allow the manufacturer to increase the

TABLE 5.2

THE PERFORMANCE OF TUNGSTEN HALOGEN LAMPS
RELATIVE TO OTHER LIGHT SOURCES

	Watts	Light Output (lumens)	Efficiency (lumens per Watt)	Av. Life (hr)	Colour Temp. (K)
Photographic lamps	500	11,000	20	100	3,200
Photofloods	500 (overrun)	14,500	29	6	3,400
Tungsten halogen	1000	26,000	26	15	3,200
	650 (overrun)	21,000	32	15	3,400
	1000 (overrun)	33,000	33	15	3,400
Fluorescent tubes	125	5,750	46	1000	4,000 (Equiv.)
Sodium lamps	140	10,000	70	2,500	—

pressure of the gas filling, slowing down filament evaporation and increasing life still further. The compact size of tungsten halogen lamps means that the smaller tubes come close to point sources; conversely long tubes are well suited to trough reflectors for the lighting of backgrounds.

The tungsten halogen lamp is therefore an improved form of tungsten lamp. Its practical features can be summarised as:

(1) No bulb blackening and discoloration occurs throughout the whole of its life. This is important in colour photography.

(2) Greater light output (about 25% lumen increase) is achieved for the consumption of current, yet without the very short life associated with overrun lamps.

(3) The unit is more compact and lightweight than a conventional tungsten lamp of the same power. This feature plus the moderate amperage required make the lamps attractive for location work. (Features which also make tungsten halogen lamps useful for slide and film projectors.)

(4) Despite their efficiency (22–34 lumens per watt) these powerful lamps still emit a great deal of heat. This heat, plus their high intrinsic brightness, can be uncomfortable for models in the studio.

(5) In general the more powerful the lamp, the longer is its tube. This limits tungsten halogen lamps for high powered spotlights. To approximate a point source two small tubes may have to be used close together, or a single cap lamp positioned end-on in a suitably shaped reflector.

(6) The filament is easily broken by physical knocks, particularly when it is emitting light. Since the units are lightweight it is tempting to move them around quickly when the lamp is on. Longer tungsten halogen lamps should always be burnt horizontally. Avoid switching on lamps for short periods, as the tungsten halogen cycle needs time to begin functioning.

(7) When replacing lamps the outside of the tube should not be handled with the fingers. When the lamp is switched on, the high temperature at which it operates will fuse-in natural grease traces, creating black marks and weak areas in the tube which may shatter.

(8) Tungsten halogen lamps are more expensive than orthodox tungsten lamps of equal rating.

Tungsten halogen lamps are marketed in a range of voltages and ratings up to 10,000 watts. However the lamps specifically designed for photographic purposes are usually between 500 and 1,000 watts. They have a colour temperature of 3,200 K or (overrun types) 3,400 K. The latter have a life of about 15 hours. Blue filters are available to give an effective colour temperature equivalent to daylight.

Tapped transformer systems for tungsten lamps

Tapped transformer equipment such as 'ColorTran' overcomes the problem that a lamp is under greatest strain and most frequently 'blows' when it is first switched on, owing to the sudden surge through the cold filament. On switching on the lamp through a tapped transformer circuit a low voltage is applied, prewarming the filament and preventing the current surge which occurs when full mains voltage is applied to a cold lamp. Prewarming therefore helps to extend lamp life. Also, the photographer seldom requires his lights at full power until just before the moment

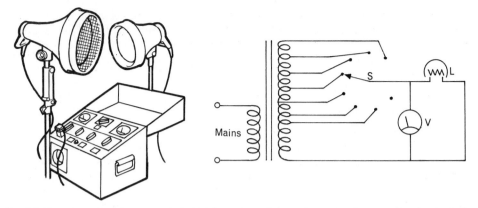

Fig. 5.6. Tapped transformer systems. Left: Lighting units and a transformer box for up to four heads. Each lamphead contains a spot or flood type sealed beam lamp; alternatively tungsten halogen lamps can be used. Right: A tapped transformer circuit. S: Rotary switch. V: Voltmeter calibrated in terms of colour temperature. L: Lamphead.

of shooting. Much of his time is spent setting up lighting, judging modelling etc. All this can be done with the lamps underrun—then overrunning them just before photography.

Lamps designed for 120 v and of various wattages are used, each connected through a tapped transformer to 220–250 v mains (Fig. 5.6). Set to the lowest tapping, the lamps are supplied with 115 v. This prewarms the filament and produces sufficient light for setting up. On this tapping the lamps have almost twice their 120 v life.

For the relatively short period when the shot is actually being taken, the voltage is taken up in a series of steps operated by a switch on the transformer—up to and beyond mains voltage. This overrunning gives an enormous increase in light output (Fig. 5.3) although shortening the working life of the bulb. Also the increase in efficiency when overrunning the lamps means that a great deal of light is produced without drawing an exceptionally high amperage. Cables and lamps can be quite light duty.

The equipment is made even more compact by using sealed-beam lamp heads incorporating their own reflectors, or using tungsten halogen lamps. The latter add their own efficiencies to the system.

On the transformer box an ammeter shows the amperage drawn from the mains as power is increased to the lamps. Another meter indicates the colour temperature, based on the voltage being supplied to the heads.

Using this system it is possible to produce the equivalent of ten thousand watts of normal lighting yet draw only 13·7 amps on 220 volt mains. This makes it attractive for the location TV or film unit. It also forms a useful alternative to flash for industrial work and studio fashion photography in colour.

Flash illumination sources

Flash is one of the photographer's most important and efficient light sources. It can give a great deal of illumination just at the moment it is needed; equipment is extremely portable and may be independent of electricity outlets; it can freeze action and camera

73

movement; also light output and colour temperature are remarkably consistent. Of course, none of this has happened overnight. Before the evolution of today's electronic flash equipment the only source of this type of lighting was the flashbulb ('expendable' flash). Flashbulbs themselves are derived from that much older source of flash illumination – flashpowder.

Expendable flash equipment

Expendable flash has a history almost as old as professional photography. Long before electricity supplies reached our towns collodion photographers were using magnesium ribbon as an alternative light source to daylight. Magnesium ribbon is difficult to light, and burns slowly. Ground into a powder it could be puffed into

Fig. 5.7. Flashpowder devices. Left: Advertisements from the British Journal Almanac 1890. Right: Flashpowder tray used for professional photography up until the 1930's. Powder was poured liberally into the tray, and the clockwork motor (M) wound up. When release (R) was squeezed, an abrasive wheel spun against a flint, and with luck ignited the flash.

a spirit flame to give an instantaneous flash. Understandably, accidents were common. Eyebrows and Victorian whiskers were frequently singed.

The flashpowder used this century (and still marketed) consists of magnesium powder mixed with an oxygen producing chemical such as potassium perchlorate. The latter ingredient is needed because, on its own, a pile of magnesium powder only burns on the outside. Lack of air inhibits combustion inside the pile. But when mixed thoroughly together the two powders will ignite even from a spark, burning out in a brilliant flash and a great deal of smoke.

Flashpowder was used in a gutter shaped tray and measured out according to the f-number and speed of plate to be used (Fig. 5.7). It would be ignited either by lighting a fuse paper, firing a cap as in a child's pistol, or setting off a type of spring tensioned gas lighter. (The lens being opened hopefully just before the flash.)

In practice the main disadvantages of these primitive weapons were their fire risk; the smell and unpleasant white ash fallout they created; the impossibility of use outdoors when windy or raining; the difficulty of keeping stored powder 100% dry; and the virtual impossibility of synchronizing the flash with the shutter at 'hand held' speeds.

Spreading out the powder into a line instead of a pile makes the flash burn from

end to end, giving a very diffuse light. Perhaps this feature, plus its cheapness relative to equivalent output flashbulbs, explains why flashpowder is still sold. But for most practical purposes today the disadvantages of flashpowder have been overcome by enclosing the combustible material in a glass envelope and igniting it electrically.

Flashbulb construction. The first commercial flashbulbs were introduced about 1930 and were broadly similar in principle to the bulbs in use today. In order to burn quickly, the magnesium must be well mixed with oxygen or an oxygen producer.

Fig. 5.8. Expendable flashbulbs. Left: large professional 'M' peaking bulb (FP type is similar). Centre: MF bulbs, including flashcube containing four bulbs. Right: multi-MF bulb flip-flash array—this one allows eight flash pictures per unit, see text. A. Blue safety spot. B. Lead in wires from cap. C. Ignition filament. D. Explosive paste. E. Aluminium/magnesium wire filling. F. Oxygen. G. Glass envelope that is blue lacquered inside and out. Z. Zirconium wire filling.

The easiest way to do this in a flashbulb is to fill the whole bulb with a low pressure atmosphere of oxygen and distribute the metal throughout the interior as a fine wire crinkled up in a loose mass. Aluminium/magnesium wire has good physical properties for this form of filling and is still used in large size flashbulbs, see Fig. 5.8. Small and midget-sized bulbs use zirconium wire filling. Zirconium produces more light,

<div align="center">

TABLE 5.3

FLASHBULBS–COMPARATIVE LIGHT OUTPUT

</div>

Bulb type (All blue tinted)	Light output (lumens) at moment of peak	Delay period (ms) to peak emission	Effective flash duration (ms)
M type (large bulbs)	1,000,000	17	20
MF type (incl. flashcubes, 'flip-flash')	130,000	13	15
'Magicube'	150,000	7	10
FP type	450,000	15–20	20–25
500W Photographic lamp	11,000 (but continuous)		

and therefore less wire is needed. All flashbulbs are supplied blue tinted to convert their normal colour temperature (about 3,800 K) to match that of daylight at 5,500 K.

Electricity is applied through two wires directly protruding from the bulb's base or attached to cap contacts. In the centre of the bulb each wire terminates in a blob of explosive paste. A single, hair-like wire filament joins the two wires between the paste blobs. Provided that the firing current is sufficient (at least 3 volts for large bulbs) the filament glows and burns out, igniting the explosive paste. This throws hundreds of burning particles into the surrounding wire, which in turn burns in the oxygen as a brilliant flash.

The Magicube flashcube has an unusual firing arrangement. Each tiny tube contains primer paste and an external striker spring which is released by a *mechanical* link to the shutter button. When the tube facing the subject is struck the primer ignites, reaching peak illumination in about half the time of other similarly sized bulbs. See Table 5.3.

Flip-flash multi-bulb arrays such as Philips Topflash use eight or ten wire-filled bulbs which fire sequentially. A special printed circuit terminates in electrical contacts at the top and bottom of the unit. By plugging the bottom contacts into a special camera socket one bulb fires every exposure up to four, as numbered in Fig. 5.8. As each one fires current-steering heat-sensitive switches close the path to the next bulb. You then flip the unit upsidedown to use the other four flashes. With flip flash array units it is possible to fire up to three bulbs simultaneously by first breaking an exposed wire at the rear of each bulb holder. This increases light output by a factor of 1.7, explained on page 103.

To reduce the slight risk of bulb shattering glass envelopes are coated with cellulose lacquer inside and out. (This often blisters with the heat of the bulb firing.) The real risk is that a slight crack or faulty seal will allow a small quantity of air to enter and form a mixture with the oxygen which is effectively explosive when ignited inside the bulb. A small detector spot (normally cobalt chloride) is therefore located inside the bulb—should outside air enter, this purple spot turns pink due to reaction with water vapour.

Flashbulb performance. The sequence of events that must take place between applying electricity and the flashbulb emitting maximum ('peak') illumination takes up an appreciable time. This *delay period* ranges from 1/140 sec (7 milliseconds) for a small bulb, to 1/60 sec (17 milliseconds) for a large one. This is of great importance when synchronizing the flash with the camera shutter. As can be seen from Fig. 5.9, more time must be allowed for the flash to reach full brightness with the larger bulbs.

Irrespective of brand, flashbulbs are divided into 'classes' according to their delay period and general performance:

'*Magicube*'. The fastest peaking bulb, at 7 ms. Because of the special mechanical firing arrangement needed—limited mostly to simple cameras—this type of flash is least likely to be used by the professional.

'*MF*' or medium fast. Equally small bulbs, but because of the fuse and wire burning sequence the delay period to peak is about 13 ms. Most flashbulbs, including flip-flash units, are now of this type.

'M' or medium. Large bulbs such as the M22B screw cap type. Delay period is 17 ms. These are useful for lighting large areas, particularly when used in clusters, Fig. 5.11.

FP or focal plane. As Fig. 5.9 shows, these special bulbs have a rather flatter 'plateau peak' light output, intended to give even illumination with focal plane shutters even at fast speeds (narrow slit settings). FP bulbs are intended mostly for small-format cameras where shutter blind travel takes 10–20 ms. Other bulb types can be used with focal plane shutters too, provided that slow speed settings are used. See page 94.

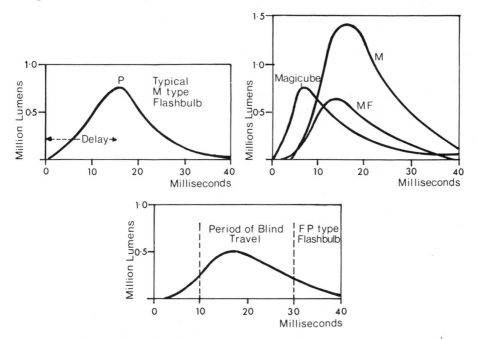

Fig. 5.9. Top left: typical flashbulb performance curve shows delay period before peak output (P). Top right: curves for three types of bulbs, having delay periods of 7, 13 and 17 milliseconds respectively. The M type bulb here is twice the power of the one shown left. Bottom: the flattened curve of an FP flashbulb.

Note that the colour temperature of flashbulbs is not dependent upon the voltage applied. Electricity simply serves to ignite the fuse, and provided that voltage is sufficient to do this the bulb fires–always at the same colour temperature.

For scientific and other purposes bulbs may be coated with a filter dye which absorbs all visible light and transmits only infrared. Often it is easier to use a bag made of the required dyed filter material and slip this over a clear flashbulb.

Flashbulb firing gear. Only a low voltage is needed to fire a flashbulb. For flashcubes and flip-flash units it is possible to manage without a battery system and use instead a tiny piezo-electric crystal set in the shutter release mechanism. When this is physically struck a small electric pulse is produced which is sufficient to fire the bulb. Piezo-electric firing is built into most low-cost cameras.

77

For other bulbs an electrical battery circuit of at least 3 volts is required, triggered by contacts which come together within the shutter. On the other hand, when using several separate heads (some fairly distant from the camera) you must take into account the resistance built up from the connecting wires, contacts etc. as well as the 3 volts needed per bulb. Circuits of 30 volts, or 60 volts or over are therefore more common for professional firing gear. (It is not normally advisable to fire flashbulbs on mains voltage. During the actual flash the lead-in wires may touch together, blowing mains fuses.) The disadvantage of using a simple dry battery circuit arrangement is that at the moment of contact a sudden load is imposed on the battery. Unless the battery is new or unnecessarily powerful and bulky it often fails to deliver enough current. The system then becomes unreliable.

For this reason *capacitor circuits* are used to fire flashbulbs. The basic arrangement (Fig. 5.10) consists of a battery which feeds through a resistor and the flashbulb itself, into a capacitor. The capacitor acts as a storage tank. Current from the battery is reduced by the resistor to a level at which it flows through the flashbulb fuse without firing it, until the capacitor reaches the same voltage as the battery. (This may take a few seconds, depending upon the state of the battery.)

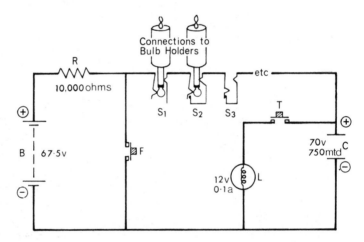

Fig. 5.10. A battery capacitor circuit for the cable firing of flashbulbs. B: Battery. R: Resistor. S: Sockets to accept connecting plugs to flash-heads (assumes up to 3 m (10 ft) cable per bulb). C: Capacitor. F: Firing contacts (e.g. connected to shutter). L: Test lamp. T: Test button.

To fire the bulb a circuit is closed between capacitor and bulb. It is therefore the capacitor and not the battery which fires the bulb. The system is rather like a WC cistern which, even if it takes a long time to fill when the water mains are at low pressure, always delivers a full quantity of water.

As the battery grows older the capacitor simply takes a little longer to charge– until a point is reached where a suitable voltage cannot be built up at all. Note that until the first flashbulb is plugged in, the circuit is open and no current can flow. The capacitor will not charge if a bulb or lead is failing to make contact. A number of bulbs can be connected, usually in series, for simultaneous firing. All connecting sockets are self shorting, except one used for the first flashbulb.

Most capacitor flash firing boxes include a test lamp or neon which confirms that the capacitor is charged and so tells us that there is continuity through all the bulbs. This is never quite foolproof. Occasionally wire filling the bulb wraps around the paste-tipped wires, shorting out the filament fuse. The fault remains undetected by the test lamp, but the bulb will short across instead of firing.

A firing box made up as shown in Fig. 5.10 may contain up to half a dozen connecting sockets for flashbulb holders. The wire connecting each socket to each bulb holder can be of considerable length–providing that total resistance does not cause too great a drop in voltage. Each head contains a reflector and may accommodate one or several bulbs.

Another way of eliminating the resistance build-up in long wires is to use self contained heads. Each head has a small battery-capacitor circuit triggered by a light-sensitive photo-cell mounted on the outside of the holder. One holder only is wired to the camera–all the other heads 'see' the light from this flash and fire in unison. (Practical aspects of slave firing, synchronisation and exposure calculation are discussed in chapter 6.)

Flashbulbs have been largely replaced by the more convenient electronic flash. However, they are still important in two main areas: (1) For industrial location photography where plenty of light is needed and the equipment must stand up to rough handling. (2) For general use with simple cameras where equipment cost must be kept as low as possible. Against this the flashbulbs themselves can only be used once, making running costs far higher than the use of electronic flash.

Fig. 5.11. Commercial flashbulb firing equipment. 1. Single holder, which contains its own battery/capacitor circuit. 2. A similar but scaled up system, to fire up to four bulbs. 3. Photo-cell trigger which can be plugged into these units in place of the shutter synchronisation lead.

Electronic flash equipment

Electronic (also known as strobe or speedlight) flash has become the most important location light source in contemporary photography, and in the 1960s almost revolutionised the techniques of studio fashion and advertising work. Yet it began as a few simple experiments about 100 years ago using an electric spark as a light source. A spark formed in air creates a short duration but very weak photographic light (unless a gigantic power source is used). However, when formed between electrodes within a discharge tube filled with a rare gas a very much brighter flash occurs.

This is not unlike neon and other fluorescent tubes in which a gas is caused to glow by the passage of an electric current. But in the case of our flash tube a powerful capacitor is discharged in one 'burst' to give a brief and intense flash of light. Many thousands of flashes can be produced from the same tube.

Fig. 5.12. Studio type electronic flash tubes and head units. 1. A ring flash, used in place of a lens hood. 2. Spiral tube enclosing a tungsten modelling lamp. 3. Spiral tube with modelling lamps. 4. Grid tube for enlarger use. Complete heads: 5. Focusing flood. 6. Umbrella head. 7. Reflector board unit. 8. Cross section of strip or 'window light' head. Fluorescent tubes provide the modelling light. 9. Cross section of flash spotlight. (The smaller the iris diaphragm the closer the unit matches a true spotlight. Unfortunately this also lowers illumination).

80

It was not until the Second World War that advances in electronic components, and the ability to produce appropriate gases at an economic price made electronic flash a practical proposition. Even so, equipment from the immediate post-war era now has a museum appearance–being clumsy, heavy and inefficient.

Flashtube characteristics. Physically today's flashtubes are made of toughened glass or quartz, filled with xenon gas, and have a tungsten electrode at each end. Tubes may be any shape, almost any length, subject to mechanical strength. Five foot strips, coils, rings (encircling the camera lens) and square grids are common. Tubes can be custom built. Some special units for scientific purposes may even be made with gas valves on the tube to blend in other gases such as argon and krypton, which yield a flash with particular characteristics.

Flash tubes for studio use are usually designed to have tungsten modelling lamps located as close as possible. The tube may be made as a cylindrical coil, and so allow room for a 100 watt lamp actually within the coil (Fig. 5.12). Obviously the closer the tube and the modelling lamp can be together in a reflector the more accurately the flash will match the direction and quality of the modelling light. The lighting of the set can then be established visually.

Finally, the flashtube will probably have an uninsulated wire loosely coiled around the outside of the glass tube. This is part of the trigger system and will be described shortly.

In performance a flashtube has the following characteristics:

(1) The flash is virtually instantaneous as soon as a capacitor is discharged through the tube. (In practice as soon as the flash unit is triggered by camera shutter or switch.) Unlike the flashbulb there is no delay whilst fuses ignite paste etc. This feature makes an electronic flash simpler to synchronize with a shutter or another electronic flash.

(2) The colour of the flash is determined by the type of gas used. All modern xenon flash tubes for general photography give a combination of line and continuous spectra. This has an equivalent colour temperature of about 5,500 K, acceptable for daylight balanced colour film.

(3) The duration of an electronic flash is shorter than a flashbulb. Depending upon the voltage and type of tube the flash will be of constant duration somewhere within 1/300 second–1/1500 second. Generally the small, low powered amateur units give the longest duration flash. A limit of about 1/1000 second is usually set for professional equipment because of reciprocity failure of the film (particularly colour film–page 240). Scientific purpose flash tubes may be designed to flash at 1/500,000 second or even less. Some professional units allow the user to select flash duration as well as light intensity.

(4) The power required to energize a flashtube is much higher than the 3 volts needed for a flashbulb. Even 'low voltage' tubes work on about 200 volts. The types of tubes used in the studio operate at 500–3,000 volts, according to equipment design.

(5) The light output of the tube depends principally upon the energy discharge it receives from the capacitor, rated in (watt-seconds) joules.

TABLE 5.4
LIGHT OUTPUT COMPARISON
OF SOME ELECTRONIC AND EXPENDABLE FLASH SOURCES
(Used in similar reflectors, and under identical conditions)

	Joule rating	Lumen Secs	Effective Exposure Time	f. No. (400 ASA film and flash at 3 m)
Electronic				
A portable unit	100	4,000	$\frac{1}{500}$	*f*8
A studio unit	1000	50,000	$\frac{1}{1000}$	*f*22
Expendable				
'M' flashbulb		22,000	$\frac{1}{60}$	*f*16–22

A joule $J = \dfrac{C \times K^2}{2}$ where C is the capacitance in mfd and K is the voltage in kilovolts.

These figures used *alone* can be deceptive as measures of practical exposure effect – the efficiency of the flash tube, type of reflector, flash duration (and hence reciprocity effect), all exert a considerable influence. This is why electronic flash manufacturers more often quote flash factors, normally relating to 50 ASA film. Small amateur type units often have joule ratings in the 50–250 range; powerful studio units may be 5,000 joules or more. The maximum energy discharge from a capacitor must not exceed the maximum a tube can handle, e.g. a 3,000 joule tube used with a capacitor giving 5,000 joules is over-loaded and may only last a few flashes.

(6) Light output can be varied. Whereas a particular flashbulb always gives a set amount of light when it fires, a flash tube varies according to the energy we decide to switch through it. Therefore electronic flash units can be switched to half or quarter power where less illumination is needed. Equally a fast-reacting photo-cell can be used to 'clip' the flash when the subject has received enough light. See page 103.

(7) Theoretically a flashtube could go on producing flashes almost indefinitely. In practice physical handling and heat often produce minute leaks of gas through the glass-to-metal seals, until the tube becomes erratic or fails to flash. A life of ten thousand flashes would be taken as reasonable.

(8) The capital cost of a flash tube is much higher than a single flashbulb.

Electronic flash power units. The function of a power pack for electronic flash is simply to store electricity, and deliver it accurately and safely to the flashtube when required. High voltages – hundreds or even thousands of volts D.C. – will be used to charge the storage capacitors. To achieve this it is usually necessary to use a step-up transformer (which operates on A.C. current only). If the pack is to be portable the basic current may come from an accumulator (D.C.). We therefore have to include other components which will sort out and change A.C. to D.C. or vice versa. The typical line (Fig. 5.13) up for an accumulator based portable unit is:

(a) A nickel-cadmium rechargeable accumulator giving a low voltage D.C. current. (Sometimes a trickle charger is built into the pack, so that connection can be made direct into the mains to recharge the accumulator from time to time.)

(b) A 'vibrator' to convert the low voltage D.C. into low voltage intermittent current that simulates A.C. current. This gives a characteristic charging 'hum'.

(c) A step-up transformer which converts the low voltage A.C. current into A.C. current at the required high voltage.

(d) A rectifier system to change the high voltage A.C. current into high voltage D.C. current suitable for charging capacitors (capacitors will only store D.C.).

(e) A capacitor or bank of capacitors which charge up with electrical energy over a period of time (3–10 seconds depending upon the charging circuit and type of capacitor). The capacitor discharges all this built-up energy through the flash tube, when triggered.

The above sequence of components is frequently used in hand-held units of about 50–200 joules. Often transistor circuits are used for the vibrator and rectifier stages, to reduce size. When using a pack with a rechargeable accumulator it is always important to assure that this accumulator is fully charged before going on a job.

Fig. 5.13. Top: Component line up for an accumulator powered portable, and a mains powered studio power pack. Bottom: A commercial 5000 joule studio console. Capacitors are housed in the base unit. F: Cable to flash head. S: Firing lead to camera shutter. (Right) Control panel showing selectors which determine the number of capacitors directed to each socket.

83

An alternative arrangement for a lightweight power pack of about 100 joules is to use a small high tension dry battery and a low voltage flash tube. Stages (*b*), (*c*) and (*d*) are then redundant. The battery charges the capacitor direct–typically at about 300 volts. This type of pack is more expensive to run, as batteries cannot be recharged. Some low output packs can be run off a mains supply when this is available. If the mains are A.C. a rectifier is switched in to give the capacitor its essential D.C. supply.

Studio type large electronic flash power packs have to produce several thousand joules, and usually operate at the highest voltages. It is therefore much more practical to draw on the normal A.C. mains supply, cutting out stages (*a*) and (*b*), and doing away with the inconvenience of regularly recharging accumulators. Each of the flash-heads is also easily equipped with a mains operated tungsten modelling lamp. The A.C. current entering the pack is stepped up through a transformer, rectified, and stored in banks of capacitors.

Power packs delivering several thousand joules often use oil filled capacitors. These are highly reliable but more bulky and heavy than the electrolytic capacitors used in shoulder power packs. A 5,000 joule studio console as shown in Fig. 5.13 may weigh over 100 pounds.

In practice all power packs have some form of (neon) indicator light which comes on when the capacitors are sufficiently charged. The indicator is housed in the pack or the flash head. Charging time varies between about 2 and 10 seconds, according to the unit's charging current and size of capacitors. Generally the smaller packs are the fastest to charge. Most studio packs have a switch for 'fast' or 'slow' recycling. The fast (2 sec) setting is useful for shooting fashion etc with a rapid wind camera, but the tube and other components can soon overheat and the pack may draw so much continuous current that a mains fuse blows. Usually we are limited to a certain maximum number of flashes before giving the equipment a short rest.

If a power pack is fired before the capacitors are fully charged a weaker flash results. Most studio units contain an audio device which 'clicks' when the capacitors are ready. This is useful when working as it is not then necessary to keep glancing at the neon indicator.

All capacitors begin to leak away their charge after a short period of time. The result is erratic light output. Professional equipment therefore contains automatic charging circuits which cut out when the capacitors are fully charged, and cut back in again if the charge leaks away more than a small percentage (e.g. 2%). The flash is thus always maintained at a constant level ready for use.

One or more flash heads are plugged into the power pack using heavy duty cable. As light output cannot exceed the joule rating of the pack, power is shared between the heads; e.g. three heads connected to a 1,200 joule pack receive 400 joules each. Large units often have selector switches allowing more joules to be directed into one head than another, again up to the maximum limit of the pack.

It is usually possible to switch out certain banks of capacitors so that the pack gives half or quarter power. Used in this way the pack has a shorter charging time.

Low powered, battery or accumulator electronic flash is often used with a single head–the pack is carried on the shoulder, or forms part of the head unit itself. Some makers arrange that special additional heads can be used, each head containing its own capacitor which is charged up by the parent pack. With this arrangement each head *adds* illumination instead of sharing it–virtually expanding the powerpack.

Studio units are either designed around a single console feeding several heads, or a smaller power pack for each and every head. The latter arrangement makes each lighting unit self-contained, apart from connection to the mains, and some form of synchronising device. A wide range of reflectors is now available for the flash heads (see Fig. 5.12). Note that the flash head by one manufacturer is seldom compatible with the power pack by another maker. This is not just a question of swopping plugs– voltage and power consumption will probably be quite different. Similarly care must be taken if trigger leads from different packs are being combined.

Studio power packs contain a quite separate mains circuit to the modelling light in each head. Each modelling light may be separately switched. Sometimes each modelling light can be dimmed or brightened, according to the joules directed to the tube in that particular head.

Triggering electronic flash. In view of the current used it would be highly unpleasant (if not lethal) to fire the flash via a switch in the high tension circuit between capacitors and tube. Instead, an indirect method is used, such as the induction system shown in Fig. 5.14. The capacitors are connected direct to the flash tube, but the circuit is so adjusted that the resistance of the gas in the tube is just too much to allow capacitor discharge. A wire is given a few loops around the *outside* of the glass tube. By passing a current through this quite independent wire the gas within the tube can be slightly ionized (i.e. made electrically conducting). The capacitors are immediately able to discharge within the tube, creating the flash.

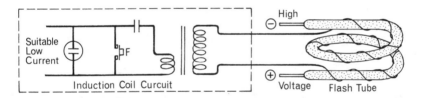

Fig. 5.14. The triggering electrode method of firing electronic flash. The whole circuit is isolated from the high voltage capacitors permanently connected to the tube. F: Firing switch (e.g. camera shutter contacts).

This explains the bare wire wrapped around most flashtubes; small tubes use a conductive transparent coating. Current for triggering often comes from an induction coil, powered by a suitable voltage from a transformer in the pack circuit. The wires going to the shutter, press button or other firing contacts simply energise the coil and are therefore *quite separate from the heavy current circuit*. The current carried is so low that there is no risk of arcing of contacts or electric shocks. Total time taken to fire the tube is a few millionths of a second–the trigger can be regarded as instantaneous.

Safety precautions. The design of many power packs is such that when the pack is switched off a discharge resistor automatically connects across the capacitors, draining them harmlessly. Without an auto-discharge device it is necessary to fire the flash once more after switching off, and so drain the capacitors this way.

Electronic flash in general *and powerful studio units in particular* can be highly

dangerous if tampered with. Safety devices are built into equipment from reputable makers, but even these will not stop the photographer electrocuting himself unless he watches the following points:

Never attempt repairs or modifications, even with the equipment completely drained of power. And do not expect an amateur electrician friend to do them–this equipment needs a competent electrical engineer.

Never attempt to connect or disconnect leads or flashtubes when the capacitors contain even the slightest charge. Switch off and discharge first.

Never use or store the equipment in conditions which could create moisture condensation.

Never 'lash up' a mains connection using only two pins. The equipment must always be properly earthed.

Check the condition of leads regularly–particularly high tension leads from console to heads in studio flash systems. Insulation often wears thin where leads join plugs.

Avoid buying home made equipment. If you must make it up yourself choose a reliable circuit–and after building ask an engineer to check everything over before using the gear.

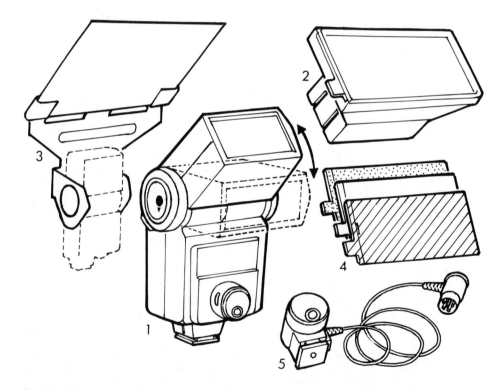

Fig. 5.15. Compact electronic flash system, comprising: 1. Basic flash unit, including powerpack, re-chargeable battery, pivotting head and exposure sensor. 2. Filter holder, also accepting fresnels to alter light beam width. 3. Reflector board holder. 4. Plastic colour filters and fresnels. 5. Remote lead for exposure sensor.

86

Comparing expendable and electronic flash

Having looked at the basic equipment for the two types of flash, in the next chapter practical problems of synchronising flash and assessing exposure are discussed. Already it can be seen that each form of flash–expendable and electronic–has its own advantages and disadvantages.

Advantages of flashbulb equipment:

(1) Owing to its simplicity, capital outlay is much lower than for electronic gear.

(2) A very high level of illumination is possible, with complete independence from mains. (Powerful electronic flash requires a portable generator if used on locations without a mains supply.)

(3) Relative to light output the equipment is much smaller and more lightweight than electronic flash.

(4) Flashheads are robust. This, plus cheapness, makes them ideal for knockabout work in industry.

(5) The rather longer duration flash makes it possible to record some motion in fast moving subjects–thus avoiding a 'frozen', perhaps artificial effect.

Advantages of electronic flash equipment:

(1) Cost per flash is much lower than bulbs, each of which give one flash only. In still life work a number of flashes can be given to build up exposure, without multiplying cost.

(2) Pictures can be taken more rapidly. Time is not spent in going around 're-bulbing' each head after every shot. Nor is it necessary to carry bulky flashbulbs–and dispose of them afterwards.

(3) Synchronisation is easier than with bulbs, as there is no practical delay period between closing contacts and the flash going off.

(4) Studio equipment contains modelling lights. There is also a very wide range of heads and attachments for both studio and hand-held units. These allow versatile lighting effects.

(5) The duration of the flash is brief enough to overcome camera shake and most subject movement.

(6) Electronic flash can be linked to a self-regulating exposure control system, page 103.

Advantages of both forms of flash over tungsten lighting:

(1) Colour temperature is consistent. It does not vary with the supply voltage or age of the lamp.

(2) Continuous, glaring lights and heat are avoided, making conditions more comfortable for photographer and subject.

In professional photography electronic flash is used extensively for studio work. It is ideal for animate subjects, foods and items easily affected by heat. Electronic flash is standard equipment in advertising, fashion, portrait and still-life studios–particularly for colour. As technology gives us power packs with better power/weight ratios, hand-held electronic flash is steadily replacing bulbs for location work.

Flashbulbs on the other hand are still useful for industrial and commercial location photography. Here the photographer may have to balance up his lighting with sunlight, working under rough conditions and without convenient mains supplies.

Recent history suggests that flashbulbs for the professional have reached their limit of development; electronic flash gear is continually improving.

Chapter summary—Tungsten and flash equipment

(1) Colour temperature is a convenient method of describing the spectral content of a continuous spectrum 'white light' source. The temperature, quoted in kelvins (Absolute scale), relates to a perfectly radiating black body heated until the colour of its light matches the source under test.

(2) Light sources which do not have a continuous spectrum cannot strictly be given a colour temperature, but those which offer a reasonably wide range of wavelengths may be described by an 'equivalent' colour temperature.

(3) The higher the colour temperature the greater the proportion of blue wavelengths present. Typical colour temperatures–Photographic lamps 3,200K; Photofloods 3,400K; Daylight about 5,000–6,000K. However the colour temperature of tungsten lamps varies with voltage, age of lamp and colour of reflector; 'daylight' varies with weather conditions, place and time.

(4) Lamp light output is normally quoted in lumens, and efficiency in lumens per watt. Theoretically a lamp should give 220 lumens/watt. In practice a domestic lamp may give 15 lumens/watt; a fluorescent tube 50 lumens/watt; lamps increase in efficiency when overrun.

(5) The distribution of light around a lighting unit can be shown on a polar diagram, usually plotting intensity against direction for a constant distance. Polar curves are useful in comparing units, also in planning the lighting of a fixed area to a predetermined level.

(6) Tungsten halogen lamps have greater efficiency, reasonably long life and do not discolour or blacken. Vaporising tungsten combines with a halogen present in the tube–then is attracted back to the filament, where it is redeposited as tungsten. This cycle only works efficiently with the lamp envelope close to the filament and at a high temperature. A silica based material is used instead of normal glass.

(7) Tungsten halogen lamps are compact, efficient, very hot, and easily damaged when alight. Tubes must never be handled direct with the fingers.

(8) By using a tapped transformer system a lamp filament can be prewarmed, then overloaded for the actual period of shooting. The system gives high light output without heavy equipment and cables, yet maintains long lamp life.

(9) Flashpowder–magnesium powder plus oxygen producer–is the cheapest flash source relative to power, and can be arranged in a trail to give a highly diffuse source of illumination. It also represents a serious fire risk, creates smoke and dust, is impractical to use in wind and rain, and cannot easily be synchronized with the shutter. Stored flashpowder quickly becomes damp.

(10) A flashbulb contains magnesium/aluminium or zirconium wire in an oxygen environment. Electricity (3 volts minimum) supplied through lead-in wires burns out a filament which sets off explosive paste, igniting the wire filling. Never use bulbs which have leaked air–check the safety spot.

(11) Total delay between applying electricity and maximum illumination is 13ms (MF type bulbs), 17ms ('M' type bulbs). FP type bulbs have a long plateau peak for even illumination during the blind travel. The colour temperature of blue dyed flashbulbs is about 5,500K, or 3,800K if the envelopes are clear.

(12) Flashbulb firing gear normally utilizes a capacitor circuit. A battery charges a capacitor which, in turn, is used to fire the bulbs. A 'capacitor-charged' indicator is often built-in, which also checks the total circuit through bulbs and connecting wire. Several dozen bulbs may be wired to one box for synchronous firing.

(13) Midget bulb flashcubes and flip-flash units can be fired from a battery-less circuit, using a piezo-electric crystal struck by mechanism in the shutter. Flip-flash arrays may be 'doctored' to fire three bulbs at once.

(14) Electronic flash tubes come in various shapes, and are usually filled with xenon between two tungsten electrodes. A high voltage discharge from a powerful capacitor produces an instantaneous short duration flash, having a colour temperature equivalent to daylight. Each tube should give several thousand flashes. Energy supplied to the tube is rated in watt-seconds (joules).

(15) Power packs for electronic flash draw their basic electricity from a rechargeable accumulator, from the mains, or from small low or high tension batteries. The first three types use transformers to step up the current. Other components convert D.C. to A.C. or vice versa. The pack charges up capacitors—it is the power capacity and voltage of these storage banks which determines the total maximum joule output to the flashhead(s).

(16) Capacitor charging time is only a matter of seconds, full charge being signalled by neon and audio devices. Professional packs often have auto-circuits which 'top-up' capacitor charge to a steady level. Switches allow power output to be halved or quartered by cutting out some capacitor banks; similar controls direct more joules to one flash head than another. Mains operated units usually include a separate modelling lamp circuit.

(17) To avoid passing excessive current through synchro lead and shutter, the flashtube is triggered by a separate circuit, which slightly ionises its gas content. Triggering is virtually instantaneous.

(18) All electronic flash power packs are potentially dangerous, owing to the voltages and energy levels used. Professionally built high voltage studio equipment has elaborate safety devices including auto condenser discharge—but this is not proof against amateur repairers, moisture condensation and abuses such as connecting and disconnecting heads when the capacitors are charged.

(19) Flashbulb equipment has the advantages of low capital cost; powerful illumination; independence from mains; highly mobile and robust hardware; consistent colour temperature; and flash durations which still allow some movement portrayal. Main uses—industrial and commercial location photography.

(20) Electronic flash equipment has a low cost per flash; allows rapid repetition; is easier to synchronize; has consistent colour temperature; often contains modelling lamps; and is brief enough to freeze camera and subject movement. Main uses—studio advertising, fashion and portraiture, and general location work.

Questions

(1) (*a*) What is meant by the term colour temperature?
(*b*) Arrange the following light sources in order of colour temperature, the highest first: a photoflood, a clear flashbulb, mean noon sunlight.
(*c*) What is the colour of a filter required to convert tungsten light to approximate daylight?
(*d*) Name two light sources in common use that have a non-continuous or 'line' spectrum.

(2) Fig. 5.16 (overleaf) shows light output plotted against time for two types of flashbulbs. List all the practical points of difference between the two bulbs.

(3) (*a*) Explain the changes that occur in the performance of an ordinary tungsten lamp as the voltage of the supply is raised.
(*b*) What are the practical advantages of a tapped transformer system?

(4) You are submitting estimates for expendable and/or electronic flash equipment for a new department handling general photography in the studio and on location. Write a short report to the accountant justifying your choice of one or both forms of flash. (Figures not required.)

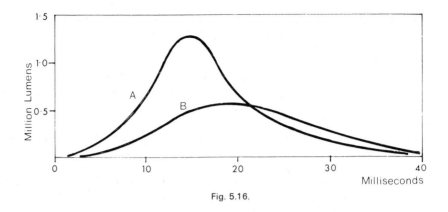

Fig. 5.16.

(5) Briefly explain the principle of the tungsten halogen cycle used in certain tungsten lamps. What are the practical differences between tungsten halogen and conventional tungsten lamps?

(6) (a) By means of a table compare all the different practical characteristics of a flashbulb and a flashtube.

(b) Why is the power pack for electronic flash more complex than a flashbulb firing box?

(7) Explain the practical functions of each of the following:

(a) Polar diagrams of lighting units.

(b) The capacitor method of firing flashbulbs.

(c) The purple 'safety spot' inside a flashbulb.

(d) The bare wire looped around the glass of a flashtube.

(8) Two heads plugged into a 1,000 joule power pack each give *half* as much light as a single head. Yet two flashbulbs attached to a 30 volt firing box each give the *same* light as a single bulb. Explain why this is so.

(9) State the field of photography you intend to enter. Make a detailed list of the lighting equipment you would purchase for this work, bearing in mind all the various forms of photographic lighting available and the need to spend money wisely.

90

6. FLASH SYNCHRONIZATION AND EXPOSURE CALCULATION

In knowledgeable hands, flash is perhaps the photographer's most convenient and versatile form of lighting. Equally it can produce badly-lit, incorrectly-exposed pictures more easily than other light sources, and has a reputation for harsh frontal lighting–due mostly to the way units are positioned close to the camera lens.

Having dealt with the construction of flash equipment in the last chapter, it is now appropriate to look at the way flash is used in conjunction with the camera. This includes various methods of ensuring synchronisation of flash with camera shutter, and ways of measuring exposure. Finally a number of job case histories show how technical problems are solved when using one or several flash heads, either alone or in conjunction with other light sources.

Shutter synchronization

The whole point of synchronization is to ensure that the flash of light (or major part of it) occurs whilst the shutter is fully open. The crudest way of arranging this is to use 'open flash', i.e. open the shutter, fire the flash, and close the shutter again. Normally a tripod is needed to support the camera whilst all this is going on. The subject must also be relatively still.

Of course if other light sources such as daylight are also illuminating the subject, open flash exposure will probably record their effects too. Sometimes this is useful– for example when flash is simply introducing illumination into the shadows, the other lighting being dominant. At other times the existing lighting may be coming from the wrong direction or illuminating the wrong areas. Then it may be necessary to suppress the lighting by shooting at a fairly fast shutter speed, closely synchronized with the flash.

All modern shutters contain synchronization contacts for flash. Usually a co-axial socket on the outside of the shutter casing or camera body accepts the firing lead from the flash equipment. Additionally or instead connection may be made through the camera accessory shoe ('hot shoe'). Inside the shutter the socket is wired to two contacts. One is on a moving part of the mechanism, touching the other contact at an appropriate moment in shutter travel and thus firing the flash.

What is the 'appropriate moment'? We shall have to recall bulb and tube firing delays.

Synchronization for electronic flash

An electronic flash is effectively instantaneous with closure of contacts. Full synchronization with a bladed shutter is therefore achieved by arranging that the contacts come together as the shutter blades reach the fully open position. Any shutter speed can be used; even at the shutter's fastest setting the flash is unlikely to last longer than the period the blades are fully open. (Fig. 6.1.)

In the case of a focal plane shutter, contact is made just as the first blind reaches the end of its travel. On a typical focal plane 35-mm or 6×6 cm camera, with the shutter

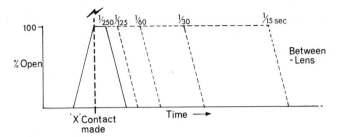

Fig. 6.1. 'X' synchronization of a between-lens shutter for electronic flash. By closing contacts the moment shutter blades are fully open synchronisation is achieved at all speeds.

set to about 1/60 second (this varies slightly with shutter design) or longer exposure, the gap between first and second blinds is the full width of the frame. The full frame is therefore uncovered at the moment of the flash. If however the shutter is set for shorter exposures a narrow slit will be in use—uncovering only part of the frame at any one point in time. Only a slit area of image (the part uncovered at the moment of the flash) records, at one end of the frame. See Fig. 6.4.

The internationally agreed coding for synchronisation suitable for all electronic flash is 'X synchronization'. A camera with focal plane shutter usually has a coaxial socket or hot shoe marked X, and a similar coding on the shutter speed dial to denote the fastest permissible speed. Although to be limited to a top speed of 1/60 sec seems frustratingly slow, remember that in practice the exposure duration is the flash duration and not the marked speed. Camera shake or subject movement only occurs if there is also a high level of existing light present.

On bladed shutters a switch located near the coaxial socket may be marked XM (or VXM). This switch must be set on X to bring into use the appropriate internal contacts for electronic flash. The V (Verzögernung: German for delay) setting present on some switches has nothing to do with flash—it brings into play a gear train for delayed action of the shutter. When the shutter finally fires X flash synchronization occurs. (Warning: always be careful not to fire electronic flash on M. This results in no exposure from the flash, see page 95.)

Testing 'X' synchronization. Occasionally you may find a shutter with a synchronizing socket which is unmarked. More often than not this is 'X', because electronic flash synchronization is the easiest and most convenient to fit. However this assumption can easily be tested by connecting the shutter to an electronic flash unit.

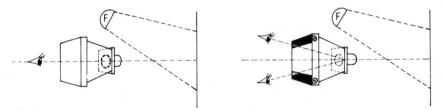

Fig. 6.2. Visually testing 'X' synchronization. Left: Between lens shutter. Right: Typical focal plane shutter. Provided you can see light passing through the lens (in the case of the focal plane shutter check both ends of the picture format) synchronization is correct.

92

Open the lens diaphragm to full aperture, open the back of the camera and look through the camera at a light toned surface illuminated by the flash head. When the shutter is fired a circular patch of light should appear momentarily through the lens. If the shutter is a focal plane type ensure that the speed set is just within the range for electronic flash. The patch of light should extend over the whole negative area – check it by viewing successively from all four corners of the film aperture, (see Fig. 6.2).

Synchronization for flashbulbs

The synchronization of flashbulbs creates some difficulties – instead of firing instantaneously there is a delay period before they burn to peak output, and this varies according to the class of bulb, page 76.

The problem is overcome in a bladed shutter by closing the bulb firing contacts and then having a delay device to retard the start of blade opening by a few milliseconds until the bulb has started to burn. Most shutters therefore have a bulb synchronization circuit quite separate from 'X'. On many large format camera shutters for example there is a selector switch marked X and M. Switching to M brings into use firing contacts which close about 15 milliseconds before the shutter blades reach the fully open position. As can be seen from the top part of Fig. 6.3, M synchronization used with an M (medium) class flashbulb gives fully open blades at peak light output. Provided that speeds shorter than 1/125 second are avoided the majority of the flash output is utilised.

Note that the gear escapement used to delay the shutter blades in most between-lens mechanical shutters is often part of the shutter's delayed action assembly. This explains the frequent grouping of VXM controls, and why it is not possible to fire such shutters by delayed action *and* at the same time achieve M synchronization.

Some cheaper cameras with between-lens shutters have an arrangement known as 'F' synchronization. Here internal contacts come together as the shutter is released (no retarding gear is therefore required). The period between closing the contacts and the shutter being fully open varies according to design, but is typically 7–10 milliseconds. As shown in the lower part of Fig. 6.3, this suits magicubes and to a large extent MF bulbs. It also allows M type bulbs to be used provided you select about 1/60 sec or slower.

To synchronize a focal-plane shutter with flashbulbs, contacts are closed before the first blind starts to uncover the film. Provided that FP bulbs are used and the time taken for the slit to cross the emulsion does not exceed the bulb's plateau peak

TABLE 6.1

SHUTTER SYNCHRONIZATION

Shutter & sych:	Flash source: Electronic	MF bulbs	M bulbs	FP bulbs
Between-lens, on X	OK, all speeds	$\frac{1}{30}$ sec or slower	$\frac{1}{30}$ sec or slower	$\frac{1}{30}$ sec or slower
Between-lens, on M	No flash exposure	$\frac{1}{125}$ sec or slower	$\frac{1}{125}$ sec or slower	$\frac{1}{30}$ sec or slower
Between-lens, on F	No flash exposure	$\frac{1}{60}$ sec or slower	$\frac{1}{30}$ sec or slower	$\frac{1}{30}$ sec or slower
Focal plane†, on X	$\frac{1}{60}$ sec or slower	$\frac{1}{30}$ sec or slower	$\frac{1}{15}$ sec or slower	$\frac{1}{15}$ sec or slower
Focal plane†, on M	No flash exposure	$\frac{1}{60}$ sec or slower	$\frac{1}{30}$ sec or slower	OK all speeds

†Varies according to construction. Some FP shutters allow synchronization at faster speeds than these.

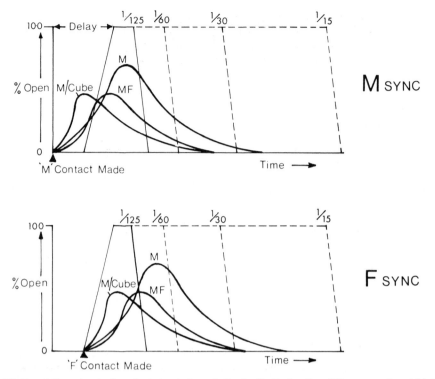

M SYNC

F SYNC

Fig. 6.3. M and F synchronization of a between-lens shutter for flashbulbs. Top: 'M' contacts close 16 milliseconds before shutter blades are fully open, allowing time for the M bulb to reach its peak. Bottom: 'F' contacts close as the shutter is released. Typically this synchronizes full opening with the fast peaking magicube flashbulb. M bulbs are best used at shutter speeds of 1/30 sec or slower.

(see Fig. 6.4), exposure is reasonably even. Since slit width rather than blind velocity is normally altered to change shutter speeds, this arrangement means that bulb and shutter synchronize at all speeds. Remember that FP bulbs are the only flash sources which can be synchronized with the fastest speeds (usually 1/125 sec and faster) of focal plane shutters. You can use other bulbs, such as M type, but even results are only obtained when the shutter is used at a setting (such as 1/30 second or longer) which exposes the complete picture format and is held open for sufficient length of time. This is similar to using electronic flash.

Testing 'M' (or 'FP') synchronization. Usually the main reason for testing synchronisation is to check whether the contacts are arranged for M or X firing. This can be done by a process of elimination–test for X and if the result is not positive assume that the synchronization is M, or FP.

To obtain more accurate and detailed information (e.g. is 7 or 17 ms delay occurring?) ask a camera repair firm to test the shutter on a time based oscilloscope.

Alternatively you can carry out crude tests yourself. For checking M synchronization, photograph the actual flashbulb (on bromide paper to avoid overexposure). At 1/125 second the bulb should appear filled with burning matter. If only part

94

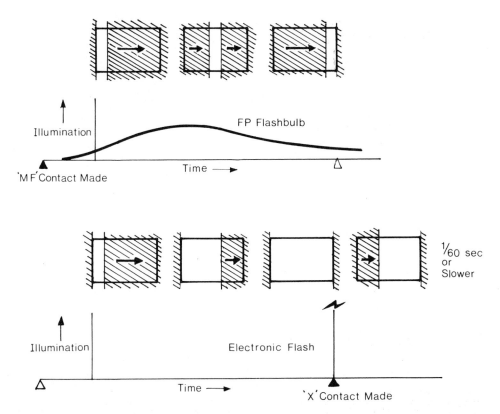

Fig. 6.4. Synchronization of a focal plane shutter. Top: a long-peak flashbulb is triggered before the blinds begin moving. This allows the bulb to reach a useful level of illumination before the shutter slit crosses the film. Bottom: the X contact socket fires electronic flash only when the first blind reaches the end of its travel. Set to relatively slow speed (i.e. full width slit) this exposes the whole image.

of the interior is shown burning the shutter is opening before or after peak. To test FP synchronization, photograph an even toned flat surface uniformly lit by the bulb. The negative should show an even density across the whole of the format.

Effects of mis-synchronizing. When a bladed shutter is accidentally switched to M and used with electronic flash, the flash will be fired before the blades are fully open. As electronic flash is almost instantaneous each flash will be over before the blades even start moving. Every frame will be blank and unexposed (a little existing light might record, depending upon the shutter speed). *Always be on your guard against this mistake – on an unrepeatable assignment it can be quite disastrous.*

A bladed shutter switched to X and used with flashbulbs will mean that the bulbs are not triggered until shutter blades are fully open. Results depend entirely upon the shutter speed set (Fig. 6.5). At 1/125 second the shutter will close before the bulb has started to emit much light, giving gross underexposure. But if set to 1/30 second (M bulbs) or slower speeds, the shutter will remain open long enough to coincide with the useful part of the flash. The negative will be normally exposed.

95

Notice from Table 6.1 the usefulness of X synchronization. A shutter with this facility can be used with *all* forms of flash illumination, provided you remember to use slower speeds for bulbs – the larger the bulb the slower the speed. More and more cameras are produced today with only X synchronization.

If a focal plane shutter is being used and electronic flash is accidentally plugged into the FP socket the result will be total failure. The flash has fired before the first blind even begins to move. FP bulbs fired via the X socket will only give a result if the shutter remains open long enough to overcome the bulb delay period. Usually 1/15 second or longer is required. M bulbs can also be used at these speeds.

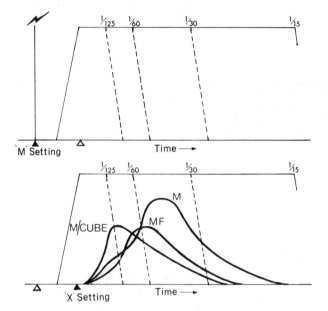

Fig. 6.5. Effects of mis-synchronizing Top: Electronic flash fired on 'M' setting gives no exposure. Bottom: Flashbulbs fired on 'X' setting can give fully exposed results, provided that slow shutter speeds are used – e.g. 1/30 for M bulbs.

Synchronous firing of 'slave' flashes

When several widely spaced flash heads must be fired in synchronization with the shutter a number of methods can be used to link them together. The most obvious linkage is wire. Flashbulb heads can all be wired to one firing box linked to the camera; electronic powerpack trigger leads could each be joined to the shutter through an adaptor. In practice this is not always the most convenient method. Wires take time to layout, get in the way, and the proliferation of cables and connections results in breakdowns.

One or more heads may be required actually within the picture area where wires would show. Certain heads may have to be mounted on a moving subject – lighting for example the interior of a vehicle, aircraft or boat, whilst other heads illuminate the outside. The two most useful 'invisible linkages' are photo-electric cells, and radio.

96

P.E.C. linkage. Circuit closing photo-electric cells are fairly inexpensive and virtually instantaneous in their action. The types used for flash work respond to sudden increase in illumination level.

Imagine we are using three electronic flash self-contained units. Only one has its trigger lead fitted to the camera shutter; the other two have P.E.C. valves wired to their trigger leads. Each cell responds to the illumination emitted by the camera linked flash, and fires its own unit. As no appreciable time delays occur at any stage all three flashes are synchronized with the shutter, even at its fastest speed.

The 'slave' cells must be carefully positioned so that they are neither too far nor excessively shaded from the 'master' flash. (Beware of people blocking light to the cell.) Sometimes it is possible to adjust cell sensitivity on each 'slave' unit to compensate for distance. However, if the cell is made too sensitive it may accidentally fire the flash due to some quite slight rise in illumination such as a door being opened.

Photo-cell linkage of slave electronic flash is used extensively in the studio because of its convenience, and the easy pick up of illumination by the cell. Most medium size studio power packs have a photo-cell built in, ready for use as a parallel alternative to the camera synchronization lead.

In practice then the photographer may either choose to have one console power pack triggered by the camera and wired to several heads; or a smaller self-contained powerpack at each head, only one being wired to the camera and all others operating via their photo-cells. The two systems can even be used together, making all the smaller power packs slaves to the big console. Further units can be added almost indefinitely.

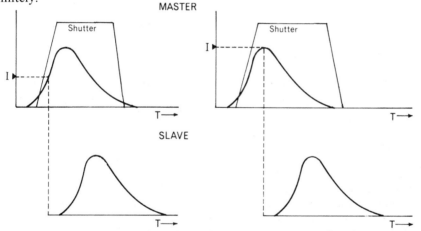

Fig. 6.6. The effect of distance on a photocell slave flashbulb system. Left: Working fairly close, half peak illumination from the master is enough to trigger the cell and fire the slave. Right: When further away the master bulb has to achieve peak illumination to fire the slave—the camera shutter must stay open longer to receive useful illumination from both flashes.

P.E.C. linkages are less successful with flashbulbs for the following reasons:
(1) The firing delay inherent in each bulb creates a chain delay. The master bulb must emit an appropriate level of illumination before the photo-cell triggers the slave bulb . . . which must then reach its peak . . . and so on. A slow shutter speed must therefore be used—typically 1/8 second (M bulbs).

97

(2) The *distance* if each slave affects the total delay period. The more distant the photo-cell the greater the light output needed from the master to activate it. This means a longer period of time because the master bulb must burn nearer to peak before the cell works. Bring the cell closer and the slave fires when the master is barely at half peak (Fig. 6.6). Unless the cell has adjustable sensitivity the whole system is limited to very slow speeds, or even open flash. (The disadvantages of (1) and (2) are partly overcome by using an electronic flash on the camera as master. The shutter is set to M so that the electronic flash does not itself record.)

(3) Under industrial conditions where flashbulbs are commonly used it is difficult to ensure that each cell has an unobstructed view of the master flash. The set up is expensive to test because of the cost per bulb–yet without testing the photographer cannot be sure that everything will go off.

Radio linkage. Thanks to miniaturized components it is physically possible and economic to use a small V.H.F. radio transmitter on the camera, transmitting a pulse to receivers on each slave flash-head or group of flash-heads. The camera shutter triggers the pulse; a valve in each receiver functions as a fast relay to fire the flash. Equipment is similar to that used for controlling model aircraft.

Unfortunately wireless licensing authorities in some countries (e.g. the G.P.O. in Great Britain) actively discourage the use of radio for photography. Frequencies are too congested by other more important services. Whilst the professional *can* get a licence this limits him to one location only, so that radio is really only practical for special jobs.

Radio may have little to offer over P.E.C.s for electronic flash in the studio, but it offers two advantages to the flashbulb user in industry. Firstly all the bulbs go off at the same time–no intermediary master flash is needed. Secondly reception between receiver and transmitter is less easily interrupted than the reception of light by a P.E.C.

Many other devices–microphones, trip wires, and broken light beams–can be arranged to fire one or more flashes in synchronization with some event. They are used for specialist work such as the photography of bullets in flight, and natural history subjects.

Recapping synchronization

The practical aspects of flash synchronization can be boiled down to this:
(1) When using an internally synchronized bladed shutter switch to X for electronic flash and use any speed. Switch to M for M class flashbulbs–1/125 second will neatly utilize peak illumination, shorter or longer speeds (down to 1/30 second) will result in less or more exposure; begin by maintaining 1/60 second.

(2) The X setting on bladed shutters can be used to fire MF and M bulbs as well at slow speeds (say 1/30 sec or slower). The M setting cannot be used for electronic flash. Unmarked synchro sockets are usually X or (cheap cameras) F.

(3) When using an internally synchronised focal plane shutter use the X socket for firing electronic flash. The emulsion must be momentarily completely uncovered, so keep to slower speeds (usually 1/60 sec or longer). Use the FP or M socket for firing FP flashbulbs–most shutters allow their use at all speeds. The FP socket could be used for firing M bulbs at slow speeds.

98

(4) The X socket on focal plane shutters can be used to fire all types of flashbulb, provided you keep to very slow shutter speeds. (usually 1/15 second or slower). The FP or M socket cannot be used for electronic flash.

(5) Electronic flash is the most simple to slave synchronize as it has no firing delay. One pack triggered by the shutter will synchrononously fire all other packs within reasonable sight of the flash, via built-in photo-electric cells. The same system can be used for bulbs, although a slow shutter speed is then needed to capture both master and slave flashes.

Exposure calculation

When using flash as the main light source you are usually concerned with measuring only the lens *aperture* needed. Exposure *time* is already determined by the duration of the flash.

You can ensure correct exposure by any of the following methods:

(1) By using a special flash exposure meter.

(2) By using guide numbers, basing exposure on flash-to-subject distance.

(3) By using an automatic self-quenching electronic flash unit, or camera with TTL fast-reacting shutter-speed control.

(4) By using an ordinary exposure meter to measure light from modelling lamps (having established the relationship of modelling lamp to flash).

Instead of (or in addition to) one of these methods a trial exposure can be made on instant picture film.

Fig. 6.7. Three flash exposure meters designed for incident light reading. The required *f*-number is shown by lit arrow; digital readout; or a needle reading which is translated via a calculator dial. Right: measurement is made from the subject, pointing the meter towards the camera (or with some designs, towards the main light).

Flash exposure meters. The normal exposure meter is unsuitable for use with flash. It measures intensity only, whereas the exposure effect of a flash depends upon its intensity and duration.

Special flash meters are therefore made which contain a photomultiplier cell, usually feeding a capacitor. Generally, they react to a sudden surge of light and ignore ambient illumination, although a few models have facilities for taking this into account. Flash meters measure incident light – the cell is covered by a diffuser and it is designed to be positioned near the subject pointing towards the camera or with some designs towards the main light. Most meters can be used with or without a cord. By plugging a long cord between meter and the flash firing pack the photographer can hold the meter near his subject, then press a button on the meter to fire the flash and produce a reading. In the cordless mode the meter is similarly positioned at the subject (perhaps held by the model) then the 'open flash' button on the flash power pack pressed. A cord is the most useful way of working when you are alone and the subject is beyond arm's reach of the flash.

Film speed rating is pre-set on the meter and the device then registers the flash by reading out the f-number required. Readout is by light emitting diodes or a needle moving to a number on a scale. See Fig. 6.7.

Sometimes the photo-multiplier cell itself is a plug-in unit. This can be detached and used on a lead or fibre-optic cord as a measuring probe – especially useful if a very small enclosed subject is being photographed.

Flash meters can be used with all types of electronic flash. They also measure light from flashbulbs, although this wastes a bulb per reading. Also the meter reads the whole flash duration, and this may need interpretation if the camera shutter is then used at speeds shorter than the bulb's flash period.

Used intelligently, flash meters are so accurate they are now generally considered an essential part of the photographer's electronic flash kit, in the studio or on location.

Guide numbers. A guide number (known also as a flash factor) is the distance in metres or feet between flash and subject, multiplied by the f-number required at that distance. For example, the film manufacturer may recommend that a particular flashunit under certain conditions has a guide number of 33 (110). This means that if fired 3 m (10 ft) from the subject $f11$ is required; at 1·5 m (5 ft) from the subject $f22$ is needed, and so on (Fig. 6.8). It can be seen that the system is based on the inverse square law (half the distance, four times the light). The flash is assumed to be a point source.

In addition to:

$$G = D \times F \tag{1}$$

Where G = guide number
D = distance between flash and subject
F = f-number

the following simple variations are useful in practical work:

$$F = \frac{G}{D} \tag{2}$$

$$\text{and} \quad D = \frac{G}{F} \tag{3}$$

100

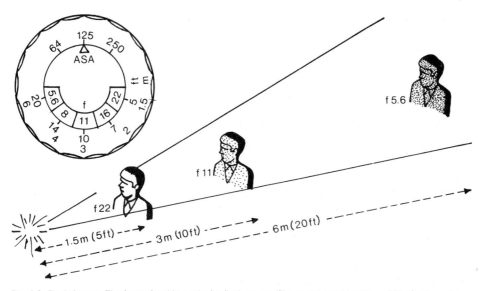

Fig. 6.8. Flash factors. The factor for this particular flash source/film speed combination is 110 (feet), as shown on the flash exposure calculator, left. Doubling the flash-to-subject distance calls for an exposure increase of two stops.

Most flashguns have a simple calculator (see Fig. 6.8) which shows apertures needed for various flash-subject distances once the film speed has been set. This is adequate for average conditions, but the professional really needs to establish a more accurate guide number for the job in hand. You have to take into account each of the following:

(1) The light output of the bulb or flash tube.
(2) The effective speed of the film, i.e. taking intended development into account.
(3) The shutter speed to be used (flashbulbs only).
(4) The type of reflector used.
(5) The reflective properties of the subject and its local surroundings.

(1), (2) and (3) are taken into account by flash and film manufacturers, who publish figures which make assumptions about (4) and (5). It is therefore important to read the small print at the bottom of a table of guide numbers, to see just what working conditions they have assumed.

A highly polished chrome reflector will reflect more light at the subject than a matt reflector, but only within a restricted angle. It may even give a 'hot spot' of light which can be given a high guide number, but is hardly realistic if the rest of the subject imaged by the lens but outside this area is thereby underexposed.*

The reflective properties of subjects and surroundings which can be regarded as 'average' vary enormously. At one end of the scale there is a white uniformed nurse in a small white painted room – at the other a dark piece of machinery out of doors at night, well away from any reflective surfaces. Using identical equipment for both, the machinery may easily require three stops more exposure than the nurse.

As far as the professional photographer is concerned, manufacturers tend to be

*A standard has been published which combines watt/sec output and tube and reflector efficiency in one figure – *Beam Candle Power Second*. The square root of BCPS × ASA speed, divided by four, equals the flash factor (feet).

101

TABLE 6.2

TYPICAL FLASHBULB FACTORS – Metres (feet)
(Small Satin Chrome Reflector)

Flashbulb (blue)	Between-lens Shutter (M sync.)	Domestic, Light Toned Surroundings	Large Rooms, Halls	Outdoors, or Dark Factory Interiors
(B & W or Daylight Colour Film 160 ASA)				
MF type (M25B)	$\frac{1}{60}$	43 (140)	30 (100)	21 (70)
MF type (M25B)	$\frac{1}{125}$	37 (120)	27 (90)	18 (60)
M type (M22B)	$\frac{1}{60}$	79 (260)	58 (190)	40 (130)
M type (M22B)	$\frac{1}{125}$	67 (220)	52 (170)	34 (110)

optimistic in their published factors. This is due to the valid assumption that the amateur more often than not shoots flash pictures of people in ordinary domestic surroundings. It is therefore sensible for the professional to make his own experiments to establish guide numbers for his own conditions of work.

To start with, simplify variables. Reduce the range of emulsions used. Keep to one shutter speed as far as possible. Maintain the same reflector. Categorise subject and surroundings into the simplest possible divisions – for example light domestic; dark factory interior; or exteriors.

The most economic way to establish guide numbers is to set up a series of large, identical grey scales, at differing distances from the flash. The distance is clearly written on each scale. Guess the aperture required for a scale about midway between the nearest and furthest scales (base this on film manufacturers' guide numbers) and expose the picture. The processed negative shows each grey scale at different densities, owing to their different distances from the flash. Note the distance of the scale judged to be correctly exposed; this distance multiplied by the f-number used is the correct guide number.

Similar tests can be made for each of a range of conditions. Guide numbers for other bulb sizes or joule ratings can then be calculated by comparing published light outputs. In this way a table can be built up to suit our own working conditions, and which is far more useful than anything published.

Fig. 6.9. Establishing guide numbers.

102

Occasionally you may find that no one flashbulb has the necessary high guide number (the subject may be very dark or distant, or a very small aperture may be essential). A large reflector which holds several flashbulbs can then be used. When several bulbs are used together in the same reflector it is convenient to give a guide number to the whole head, as follows:

Using 2 bulbs in a reflector, multiply the guide no. for a single bulb by 1·4
Using 3 bulbs in a reflector, multiply the guide no. for a single bulb by 1·7
Using 4 bulbs in a reflector, multiply the guide no. for a single bulb by 2

For example, two bulbs, each having a guide number of 160, give an overall guide number of 224, *not* 320.

In other words you multiply the guide number of a single bulb not by the number of bulbs but *by the square root of the number of bulbs*. This is reasonable when you think about it–two flashbulbs give twice the light output of one bulb, but doubling the guide number makes a difference of *two* stops. You therefore use a scale which makes one stop difference when doubling or halving numbers of bulbs.

This rule does not of course apply to electronic flash heads if by doubling the heads you merely split the same total joule output from the power pack. As shown later it also does not apply to flash sources used in quite separate reflectors, as each source then lights a different part of the subject.

Finally, remember that guide numbers are only *guides*. Unless pictures have been taken previously under identical conditions 'spot on' accuracy cannot be guaranteed. The system works adequately for monochrome materials of normal latitude, but with colour reversal film a series of bracketed exposures is advisable.

Exposure–automated flash. Most hand-held electronic flash units now incorporate an automatic-exposure control circuit. This uses a light sensor which measures the flash illumination reflected from the subject and instantly 'cuts off' the flash when it has issued sufficient light. The basic layout is shown in Fig. 6.10. The flash is started by the normal camera shutter. During the flash, illumination is received by a fast-acting phototransistor positioned to view the subject. This information is interpreted by a tiny solid state analog computer which acts like a miniature capacitor– when enough light has been received to accumulate a preset voltage the flash is terminated. The termination trigger voltage depends on the film speed and lens aperture settings pre-selected by the photographer on an external dial.

The nearer the flash is to the subject (and the greater the subject reflectance) the shorter the flash duration. Typical exposure times range from 1/1000 second to 1/30,000 second. A thyristor switch extinguishes the flash by cutting the circuit between main capacitors and flash tube, preserving the unused part of the charge. In this way the capacitors need little if any extra charge for the next flash. (Cheaper systems use a simpler circuit which wastes the remaining charge by directing it into a 'dumping' tube.)

The normal way of using exposure automated flash units is to set the ASA film speed and the aperture needed for subject depth of field. The device then gives consistantly exposed negatives over quite a wide range of subject distance. To shift this range closer, simply stop the lens down more; to use it further away, open up the lens. In each case a small neutral density filter or aperture in front of the sensor is

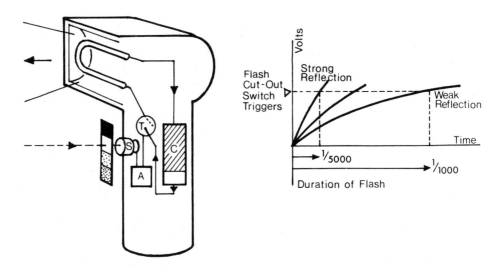

Fig. 6.10. Left: the basic control circuit of an exposure automated electronic flash gun. S. Light sensor behind a preset neutral-density filter (some types use apertures of varied sizes instead). A. Analog computer chip. T. Thyristor switching device. C. Main capacitor, feeding the flash tube. Right: light reflected from the subject to the sensor causes a small charge to accumulate. When this reaches a set level the flash is terminated. A very close or light toned subject results in briefest flash.

moved to a darker or lighter value (see Fig. 6.10). The filter device also has one setting which obscures the sensor completely, converting the flash unit to ordinary 'manual' operation. (This means it gives its longest duration flash each time.)

The sensor takes an integrated measurement of the subject, over about 20° angle of view. In difficult subject conditions it is therefore prone to the same exposure reading errors of a conventional meter – for example large dark or light backgrounds behind a relatively small area subject have an excessive influence.

Some cameras with TTL exposure measuring cells read the light on the actual face of the film during exposure, page 57. This system can be coupled to the thyristor circuitry of an automatic electronic flash gun to take the place of the sensor. It also takes direct account of the lens aperture in use.

Exposure automated flash units give a high percentage of acceptable results, and are excellent for press and similar 'candid' photography. However remember its two potential disadvantages:

(1) The closer the flash (or more reflective the subject) the more 'frozen' the appearance of moving subject matter. For example, a close-up of a spray of water appears as splinters of ice.

(2) Reciprocity failure effects may occur (particularly on colour film, page 240) when working with very short flash durations.

(3) The sensor must always be directed towards a relevant area of subject. On many guns it can be detached on a long lead and aimed independantly (see Fig. 5.15).

Measuring from the modelling lights. When electronic flash gear includes a tungsten modelling lamp in each head it is possible to measure this illumination with a con-

104

ventional exposure meter and then calculate the *f*-number needed for flash. First of all the relationship between modelling light and flash has to be established viz:

(1) Set up flashheads around a subject in the normal way. Each flashhead should receive an equal number of joules and have modelling lamps of equal intensity.
(2) With an ordinary exposure meter, set to the box speed of the film, read the illumination on the model. This should preferably be an incident light reading. Set the calculator dial to the reading and put the meter to one side.
(3) Take a series of flash exposures at different *f*-numbers. Note the apertures carefully.
(4) Examine the processed film to find the correct flash aperture. Refer to the exposure meter and note the *shutter speed* found opposite this *f*-number on the calculator dial.

In future this shutter speed acts as a datum mark from which to read the *f*-number for flash. For example, suppose our correct flash aperture proved to be *f* 11, and the meter dial showed 1 second against this *f*-number. Next time you use the equipment (probably on an entirely different set) simply take a meter reading as in stage 2. Now look at 1 second on the shutter speed scale and use the *f*-number shown opposite this for the correct flash exposure.

If a different type of film is used the meter is simply re-set for the new film speed. If the heads are used at a higher joule rating the equipment may allow adjustment of modelling light intensity to compensate. The meter then takes the change into account. If this is not possible another datum mark must be used, pro rata to the change in joules. It can be seen that the same principle–measuring the modelling lighting–also allows the use of a camera TTL meter. This must be calibrated in a similar way, for example by setting the shutter to 1 second when taking a reading.

This method of assessing exposure is sufficiently accurate for black and white work; when using colour it is still wise to bracket exposures or run a Polaroid exposure check.

Handling assignments using flash

There still remains a few exposure problems–in fact every new job brings its own challenges. The use of one, two, or more flash sources on assignments is bound to bring up matters of exposure, along with other aspects. Unless stated, remarks apply to both expendable and electronic flash.

Single flash-head–diffuse lighting. A single flash source can produce abominable lighting. Flashguns are often mounted on the camera (many cameras even have them built in) . . . yet no photographer would regularly use a single tungsten lamp in the studio right next to his lens. Camera mounting may be convenient, and therefore perhaps justified for press work, but gives flat harsh, monotonous illumination with a hard black shadow directly behind the subject. Also when a small light source is used from a position very close to the lens axis for portraits, the pupils of the models eyes often record as red. This 'red eye' effect is due to light reflecting from the retina surface at the back of the eyes. It is most apparent with blue-eyed people, particularly in dim ambient illumination when the pupils are enlarged.

Single flash-heads are far more useful as sources of diffuse light. But putting a diffuser just over the flash-head has limited effect, because the head is itself fairly small. It is more effective and convenient to tilt the flash and 'bounce' its light off a white ceiling, wall, or similar surface. Bounce flash gives an effectively much larger light source, so that soft even lighting is spread over a large area of the subject.

The flash-head should be at least 25 cm (1 ft) or so from the bounce surface – direct light from the source being prevented by the reflector from reaching the subject. In assessing exposure first halve the flash factor to allow for light absorption by the

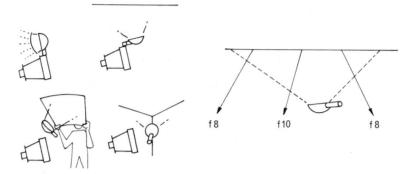

f 8 f 10 f 8

Fig. 6.11. Left: Various ways of using a single flash-head for diffuse lighting. Right: Bouncing flash from the ceiling of a small, light toned room results in a fairly even exposure level everywhere.

surface. (It may even have to be quartered if the ceiling is coloured or dirty.) Calculate flash distance by measuring the entire flash-to-bounce-surface-to-subject light path. You will find that by bouncing off the ceiling the same f-number is required almost anywhere in the room (Fig. 6.11). If shooting in colour it is essential that the bounce surfaces are completely colourless, or an overall cast results.

Sometimes a suitable bounce surface is not readily available. It may be easier to carry white board with you. Some hand flash systems include a 'bounce board' which clips onto the (tilted) head, see page 86. The inside surface of an umbrella, lined in white, forms a usefully large yet portable reflector. Umbrellas fitted to heads well off the camera give soft directional lighting, and form an important part of most electronic flash studio outfits.

Alternatively the flash may be fired through an opal sheet of plastic or umbrella covered with translucent fabric. The effect on exposure depends upon the density of the material – check by comparing meter readings of a tungsten lamp undiffused and diffused by the material.

Of course, an exposure automated electronic flash unit gives faulty readings when diffused or 'bounced' if the sensor then reads the diffusing surface instead of the subject. Either use a unit which allows the head to tilt without tilting the sensor, or use it switched to manual mode.

Like any form of diffused light, diffused or bounced flash is used wherever gentle modelling and absence of hard shadows are desirable. This will include fashion and still life assignments, groups of people (see Plate 13), individual portraits, and reflective subject matter such as silverware and jewellery.

106

A ring flash (a circular flash tube placed closely around the front of the lens) is another source of almost shadowless lighting. It is rather limited in power owing to space restrictions and is therefore most often used for close-up work.

Single flash-head – hard lighting. Occasionally the subject may call for extremely hard lighting, and here again a single head can be used. Dramatic empty shadows may be required in an industrial shot, or the texture over the surface of a subject may need emphasis. Hard light from a position well off the camera also cuts through smoky atmosphere which would otherwise throw back direct light from the camera like headlights in fog.

A small zirconium flashbulb without any reflector acts as an almost point source of light, giving extremely hard illumination. (Similarly a very compact flashtube.) Shadows are quite featureless unless there are nearby reflective surfaces. Any existing illumination can be minimized by the use of a short shutter speed. Very exciting dramatic pictures can be produced this way – but be careful, as the source is so critical that it is easy to underlight some vital area, resulting in total failure. Halve the guide number when the reflector is not used.

If using bulbs try not to change to a larger flashbulb to get sufficient illumination – its extra size lessens the hard quality of the light. An alternative way to create a small flash source is to mask down a head so that light is only emitted through a small hole. This drastically reduces the illumination level. (Masked down flash tubes go off with a mild bang, owing to trapped shock waves.)

A single flash-head used with other sources. Normally our subject matter is also illuminated by some form of existing light source. The lighting may be wholly undesirable – uneven, or from the wrong direction, or illuminating unwanted areas. You may decide to quench it completely by using flash of much greater intensity, stopping down and using a short shutter speed to underexpose the competing lighting.

At other times the existing illumination may be valuable. You may want to preserve it either as the main light source, or as a fill-in light source, or because it forms an integral part of the subject such as flame, hot metal, or daylight coming through windows. By judicious choice of exposure duration it is possible to accurately control the balance between flash and other lighting.

The general rule to remember is that the aperture affects both the flash and the existing light; shutter speed (unless it is very short) can be arranged to affect the existing light only. Undoubtedly the easiest way to work is to use a conventional exposure meter for measuring existing light, and a flash meter for the flash. You can then establish which source predominates at a particular combination of aperture and exposure time. Actual visual apperance can be finally checked by making a test exposure on instant picture material.

However it is also useful to know how to work purely by flash factors. When calculating this way, it is often easiest to first work out exposure arrangement for an exact balance between the two sources, then modify it if necessary to make one or the other predominate. The principles can best be illustrated by looking at three case histories:

Assignment 1: A modern architectural interior which must include a sunlit

view through large windows in one wall. The luminance range between the interior of the room and the view through the window is well beyond the range of the emulsion.

You first establish how far the lens must be stopped down to give adequate depth of field—in this case it proves to be $f16$. Through the window the part of the view seen by the camera is measured by meter and found to be $1/60$ second at $f16$.

You are going to need a flash to illuminate detail in the room, whilst preserving the light from the windows as dominant. The flash should not itself form distinctive shadows. It could therefore be placed close to and just above the lens, or bounced off a ceiling/wall just behind the camera. The distance between the camera and a point midway between the nearest and furthest parts of the room included in the picture is 4 m. If you use a flash on the camera with a factor (at $1/60$ second) of $4 \times 16 = 64$, shooting at $1/60$ second at $f16$ will result in a balance of 1:1 between the illumination inside and outside. (In fact subject matter nearer or farther from the camera than the room centre is slightly over or under lit by the flash—but this is the best compromise that can be achieved).

You must now make the daylight dominate. On black and white film a suitable ratio would be 8:1 (on colour reversal film about 4:1). To achieve 8:1 you can decrease the flash, or increase the daylight exposure time; or combine a little of both, viz.

(a) Change to a flash with a factor of $64 \div \sqrt{8} \simeq 23$. Do this by changing bulbs, turning down the pack, or bouncing or diffusing to give an equivalent effect. Alternatively you could just move back the flash to $4\,\text{m} \times \sqrt{8} \simeq 11\,\text{m}$, but this may not be practical.

or(b) Increase exposure *time* to $1/8$ second. (If a bulb flash is being used it will give slightly more light—about 50%—at $1/8$ second. It may be better to use $\frac{1}{4}$ second and stop down a further half stop.)

or(c) Compromise by increasing exposure time to $1/30$ second and using a flash with a factor of 32 at this speed.

Each method gives a negative differing in density, but all having about the same 8:1 ratio of lighting.

It is possible to use the same principles when photographing a scene which includes self luminous objects. You would probably then carry out (b) in order to make the luminous object dense on the negative; a rather higher lighting ratio may also help to give emphasis.

Assignment 2: An outdoor fashion shot requiring a sunny effect must be taken under very dull, overcast conditions. Flash will be used to simulate 'sunshine'.

$f8$ is the widest aperture you can use to maintain depth of field. A meter reading of the daylight illuminated subject matter, excluding sky, measures $1/15$ second at $f8$. The 'sun' flash source needs to be undiffused and very carefully placed. It is probably best placed off the camera to give modelling, and high to suggest summer sunshine. If placed too low the result looks like evening light. The illumination must also be sufficiently far away to light all those parts of the models and their local environment included in the picture. (A low camera viewpoint may be needed to avoid showing the fall-off in illumination over the immediate background.) A wide angle reflector on the flash-head is helpful.

In this case suppose the minimum distance for the flash to safely cover the required area is 3 m. If you set the camera to $1/15$ second at $f8$ and use a flash source with an

(outdoor) guide number of $3 \times 8 = 24$ at this shutter speed, a 1:1 ratio is achieved. But you require the daylight to be less dominant than your flash. A ratio of about 1:16 is desirable for a sunny black and white shot. This might be achieved by various methods:

 (*a*) Change to a flash source which has a guide number of $24 \times \sqrt{16} = 96$, at 1/15th second. (If necessary combine several bulbs in the same reflector.)

or(*b*) Reduce the exposure to 1/250 second and use a flash with a 24 guide number at this shutter speed.

But (*a*) will give dense, burnt-out highlights whilst (*b*) risks loss of detail in shadows. The best solution is a compromise between the two. e.g.

 (*c*) Reduce exposure to 1/60 second and change to a flash with a guide number of about $24 \times \sqrt{4} = 48$ at this shutter speed.

In both types of balancing problem it is wise to err towards *under* use of the flash rather than over use. Too much flash for the interior shot gives a night effect through the windows. Too much flash in the simulated sunshine shot looks like flash used at night. In black and white work at least, correct ratio is even more important than the general exposure level. Within limits an overall thin or dense negative can make a successful print–shading or printing in to convincingly 'patch up' incorrect balance is often very difficult.

It can be seen that even a single flash source has an exceptionally wide range of uses. Furthermore, if the subject is inanimate and the camera on a tripod, a single flash-head can be fired repeatedly from various positions to build up the same result as would be given by many heads, viz:

Assignment 3: The interior of a long corridor must be recorded. One of its features is the ornate ceiling. The only existing illumination comes from occasional and unimportant small windows.

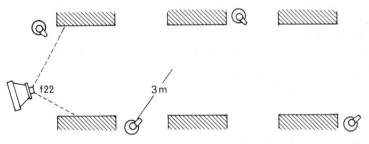

Fig. 6.12. Assignment 3, see text.

Both walls have numerous doorway alcoves, from which it should be possible to fire a flash onto the ceiling and immediate surrounding without being seen by the camera. The approximate distance between concealed positioning in any alcove and the centre of the corridor ceiling is 3 m. Alcoves are so spaced that with a fairly wide angle reflector you should be able to light the corridor evenly by flashing from alternate alcoves, on each side.

The camera is set up at one end of the corridor. An aperture of $f22$ is necessary for depth of field. As far as possible existing light is minimised by pulling curtains over windows. You now expose the film by leaving the lens open and walking from

alcove to alcove firing the flash-head–each time pointing it away from the camera and slightly upwards. The flash will have to possess a guide number of $3 \times 22 = 66$ with open flash shutter conditions. Obviously an electronic flash handset would be the most economic and convenient choice for this job–you must just be careful to allow time for the pack to fully recycle between flashes. After the last flash walk back to the camera and close the shutter.

Similar techniques can be used to light the exterior of a house (or whole street) at night, see Plate 14. On a smaller scale a still life set can be lit with the one flash-head from various positions, using open flash. Some of the flashes can be bounced to give soft fill-in illumination. For the main light remember that it is usually possible to give several flashes from one position, thus building up exposure intensity. Some additional flashes will also be needed to overcome 'intermittency effect'–as a guide use one extra flash per four flashes.

Simultaneous use of several flash-heads. When a set calls for flash lighting from several directions simultaneously is it wise to consciously establish the lights one at a time, in the same manner as tungsten sources. If flash-heads carry modelling lamps things are made easier. (But remember that the relative flash output of the heads may not necessarily be matched by similar relationships in modelling lamp intensities.)

With flashbulbs it will be necessary to imagine the effect you are producing. The simplest two headed arrangement is to use a keylight high and to one side of the camera, plus a fill-in close to the lens. The fill-in will have to be on the opposite side of the lens to the keylight if all parts of the subject are to receive illumination from one or other of the heads.

Putting a size larger flashbulb (or doubling the joules) in the keylight head relative to the fill-in, gives a reasonable if slightly low contrast lighting arrangement. Alternatively arrange the same light output in each head, but diffuse the fill-in. One layer of white linen handkerchief is often enough to diffuse and halve light output. A further alternative is to use a fill-in slightly more powerful than the keylight, but bounced off a suitable surface.

If you wish to establish the exact intensity relationship of the two heads you can compare the *f*-numbers they would each require separately–either by comparing effective guide numbers or using a flash meter on each separately. In practice, when one light is putting more light on the subject than the other, it is satisfactory to *base exposure on the guide number of the key light only*. The fill-in is primarily lighting shadows. If using a flash meter take the usual incident light reading of both flashes at once, from the subject facing the camera.

Other heads may be added to do particular local jobs–light the background, illuminate the odd corner, emphasise some key area within the subject (see Plates). It is usually possible to check how much of an area is illuminated by a particular flash by setting up the head and checking whether it can be seen from all parts of the area in question. Card screens clipped to the flash reflectors can be used to prevent light reaching unwanted background etc. Walk from side to side of the background area included in the picture checking that all bulbs or tubes are concealed.

You should try and restrain yourself from using too many undiffused heads to light the same area. Each head creates shadows, which may then overlap confusingly. When using guide numbers still base the exposure on what is intended to be the

110

keylight. Arrange the illumination levels of various heads relative to the keylight, by the size of bulb, distance, or diffusing device used.

As previously discussed, the heads may all be wired to one box or power pack linked to the camera, or wired to several packs which are triggered by photo-cell or radio from a flash or pulse transmitted from the camera.

Safety precautions

Whilst modern flash equipment and materials are remarkably safe, never forget that they can inflict injury. A flashbulb *could* explode near the subject's face (very few photographers use guards over flashbulb heads because of their inconvenience). A third party *could* receive a serious electric shock from a faulty electronic flash.

A spark can occur within an electrical circuit; flashbulbs emit considerable heat at the moment of combustion. Both can cause serious explosions if used in conditions where there is a low flash point. These conditions can exist in distilleries, chemical plants, garages, aircraft hangars, and all forms of underground areas such as mines. If there is any chance of having to work on location in such a risk area always check with the local safety officer first. Special heat/spark proof housings for both types of flash are available. These are cumbersome but may be the only way to use flash safely in locations such as coal mines.

If accidents do occur you may be found liable for heavy damages, as well as injuring yourself. The professional should always be insured against third party claims under these and similar conditions. Premiums are not large because the risks are not great if equipment is used knowledgeably. Do not let talk of accidents dissuade you from using flash – its photographic advantages still far outweigh its dangers.

Related reading

TIME/LIFE ed. *Light and Film*, Library of photography series. Time/Life New York 1975.
SPITZING, G. *Focalguide to Flash*. Focal Press 1977.
EDGERTON, H. *Electronic Flash, Strobe*. McGraw-Hill 1970.
Current technical literature by the major electronic flash and flashbulb manufacturers.

Chapter summary – flash synchronization

(1) Electronic ('X') shutter synchronization closes contacts when the shutter blades are fully open, or focal plane first blind reaches the end of its travel. The flash therefore fully synchronizes at all speeds of the bladed shutter, and on speeds at which focal plane blinds open to the full width of the format (usually 1/60 second or slower).

(2) Test X synchronization by looking through the back of the camera – check if light from the flash can be seen through the lens from all parts of the format. VXM bladed shutters used on delayed action give X synchronization.

(3) Flashbulb ('M') synchronized bladed shutters close contacts about 17 milliseconds before the shutter blades are fully open. Flashbulb (FP) synchronized focal-plane shutters close contacts in time for the bulb to reach plateau peak before the first blind begins to uncover the film.

(4) The amount of flash utilised by a bladed shutter on M depends upon the shutter speed used. FP bulbs should be used at 1/30 second or slower. M bulbs can be used with a focal

111

plane shutter, but may give an uneven exposure unless about 1/30 second or slower is used.

(5) Test M synchronization by oscilloscope means for accuracy. Photographing an actual flashbulb gives a rough guide, or (focal plane) shoot an even area illuminated by flash.

(6) Electronic flash used on M or FP at any shutter speed results in no exposure. Flashbulbs (MF, M, or FP) used on 'X' can give satisfactory exposure when the shutter is used on slow speeds. X is therefore the most universally useful form of synchronization.

(7) Several slave flash units may be remotely fired by photo-cells which respond to a 'master' flash; or radio receivers responding to a transmitted pulse from the camera. Electronic flash is instantaneous and therefore most easily slave synchronized. Bulbs create difficulty owing to the chain effect of their delay periods. Photo-cell links, excellent in the studio, have practical limitations on location. Radio links may be limited by licence regulations.

(8) Flash exposure calculation is variously based on flash meter measurement, guide numbers, use of self-regulating electronic flash, or measurement of modelling lamps by ordinary meter.

(9) Flash meters contain photo multipliers to measure the flash intensity and duration. They usually measure incident light at the subject. Flash meters are highly accurate and are standard equipment for studio electronic flash, but are considered less practical for flashbulbs.

(10) Guide numbers (f-no. × distance from flash), vary with light output of flash source, effective film speed, type of reflector, and reflective properties of subject and surroundings.

(11) Work out your guide numbers for each film, for a limited range of bulbs, joule settings, your particular reflector, and typical subjects classified into simple groupings. To check guide numbers use subjects at varying labelled distances, the expected correct distance for the f-number in use being about central in the range.

(12) When using several bulbs together in a reflector find their collective guide number by multiplying the guide number for one bulb by the *square root* of the number of bulbs.

(13) Exposure automated flash units each contain a sensor which measures light reflected from the subject and terminates the flash when appropriate illumination has been issued. The nearer the flash – and lighter the subject – the shorter the flash duration. The sensor device takes an overall subject reading.

(14) Using guide numbers when diffusing or otherwise bouncing flash illumination, remember the light absorbency of the diffuser, and measure the *total* distance of light travel. Avoid coloured bounce or diffusing materials when shooting colour. Convenient diffusing material includes the surfaces of ceilings, walls, white lined umbrellas, and (using transmitted light) translucent plastic.

(15) To produce harsh flash lighting use a reflectorless head with a physically small flash source, or mask down a larger one.

(16) When using flash in conjunction with another light source, first work out f-number and exposure time to balance the two sources. Then adjust balance one way or the other by altering flash distance, flash light output, or shutter speed.

(17) One flash-head can do the work of several if fired repeatedly from different positions during a camera time exposure. When using several heads simultaneously exposure may usually be based on the guide number of the key light only. Whenever justified check the effect of multi-light sources via an instant picture test shot.

(18) Remember, even good modern flash equipment could start fires in explosive conditions, or cause injuries in other ways.

Questions

(1) A static subject is to be photographed using flash. The light source is to be placed 12 m from the subject, and a single exposure is to be made with either:·

(a) A 400 joule electronic flash with a guide number of 90 or

(b) A flashbulb holder containing 4 expendable bulbs, each with a guide number of 120. Calculate the *f*-number which would be used in each case.

(2) State the photometric law upon which guide numbers are based, and indicate practical conditions under which guide numbers may not be reliable.

(3) An object is to be photographed lit with direct sunlight. The viewpoint chosen includes very strong shadow areas receiving negligible illumination. The correct exposure under these conditions is found to be 1/125 second at *f*11. However, a lighting ratio of 4:1 is required and flash fill-in with an electronic flash unit of which the guide number (flash factor) is 36 (metric) is to be used.

Calculate the flash to object distance, and the lens aperture required, assuming that the shutter speed remains unchanged. Show your calculations.

(4) (a) List any advantages that expendable flash has over electronic flash.

(b) Draw curves showing the variation of light intensity with time for a type 'M' flash bulb and for electronic flash. Explain fully the synchronization of these two flash sources with a between lens shutter.

(5) Describe, with the aid of curves showing the variation of light intensity with time, the characteristics of the type of flash source suitable for use with X synchronization, M synchronization and FP synchronization.

(6) Discuss how you would base your calculation of exposure when an M class flashbulb (metric flash factor 30) is

(a) Used as the 'key' light, with two other separate flash-heads providing fill-in and background illumination.

(b) Used alone but 'bounced' from the ceiling.

(c) Used with two other identical bulbs in one reflector as a main light.

(d) Used to balance (1:1) a view seen through a window 3 m from the camera (Meter reading of view = 1/50 at *f*16).

(e) Used to give 'sunlight' in outdoor portraiture under overcast conditions. (Meter reading as (d)).

(7) Explain the practical handling of each of the following:

An exposure automated electronic flashgun,

A flashmeter.

(8) Specify the information given by a flash guide number. The guide number for a certain flashbulb is 85 when used under certain conditions with a film rated at 300 ASA. What should it be, under the same conditions, when the film being used is rated at 150 ASA?

(9) (a) Explain two alternative methods for the estimation of correct exposure in a studio lit by electronic flash.

(b) Explain how electronic flash units may be remotely fired in synchronization with the camera shutter, without any direct wire linkage.

(10) When using expendable flashbulbs or electronic flashguns from more than one direction to photograph a subject it is necessary to calculate the lighting ratio (i.e. the relative illumination on the subject). Discuss this problem and methods of solving it.

(11) Describe an effective method of using flash:

(a) To light a scene dramatically showing the pouring of iron, without losing the self-luminous quality of the metal.

(b) To create a sunlit effect when photographing a small car outdoors during overcast conditions.

(12) Using electronic flash sources exclusively explain how you might simulate each of the following *qualities* of lighting when working in black and white in the studio:

(a) Even, diffuse overcast daylight,

(b) Sunlight plus sky,

(c) Hard lighting from a distant street lamp.

(13) You are reconnoitring a commission prior to shooting. One general interior shot must be taken of the south facing glass fronted foyer of a modern office block. The day is overcast and a meter reading in well illuminated floor areas is 1/125 second at *f*8 (ASA 400). The foyer shot also contains dark corners reading 3 seconds at *f*8. The day you are to shoot may be sunny and it will not be possible to pick either time or weather conditions. Specify two alternative lighting kits you would organise to take on this job, stating the reasons for your choice, and your methods of estimating exposure.

(14) When working on location your lighting equipment breaks down with the exception of a single electronic flash unit (guide number of 25 with the film in use). Explain how you would use it for each of the following shots:

(*a*) A still life set requiring one key light and diffuse even fill-in illumination.

(*b*) A general view of a cellar store room 6m long, *f*16 is required for sufficient depth of field.

(15) A black-and-white shot is required of the moving figure of a boy. The image should consist of horizontal blur ending with recognizable detail of the running boy. Explain how you would achieve this effect in one shot, using tungsten and flash sources combined, if necessary. How would you calculate exposure?

(16) Together with other photographers, you are to shoot a press picture of a famous personality entering through the glass doors of a building. The camera position allocated to you is inside the rather dark building, looking out through the doors at the sunlit street. Using a portable electronic flash, explain how you would arrange lighting and calculate exposure to give reproducible detail in the figures, yet maintain the natural appearance of the scene.

114

Section II

PHOTOGRAPHY IN MONOCHROME

7. IMAGE STRUCTURE, DEVELOPERS AND FIXATION

The object of processing the camera exposed image is of course to amplify the latent image into appropriate densities of black metallic silver. Most general purpose developing solutions contain developing agents, alkali, preservatives and a restrainer. Often formulae use the super-additive pair of developing agents Phenidone and hydroquinone, or metol and hydroquinone. In the case of high contrast developers hydroquinone may be used in the presence of sodium hydroxide. All developing solutions vary in their effect with condition, dilution and temperature, the time they are allowed to act, the type of emulsion being processed and the amount of agitation given. (These principles and the structure of general purpose and high contrast developers were described in Chapter XVI of *Basic Photography*.)

The following sections look more closely at the processed image structure, discuss the principles of fine grain development, and briefly examine developers for high definition or maximum emulsion speed. There are also some less common processing cycles such as direct reversal, and monobath develop/fix solutions, and instant picture processes. To avoid breaking up the text with formulae, these have been collected together under Appendix V, page 343.

This chapter also deals with the commercial possibilities of regenerating an exhausted fixing solution and reclaiming its possibly valuable silver content. Perhaps savings are also possible by using stabilization instead of fixing, or turning to silver diffusion materials and so doing away with liquid processing altogether?

Image structure

When you look at the mid-tones of a developed photographic negative through a microscope (say × 250) it is easy to see the very uneven distributions of black metallic silver it contains. (You cannot easily distinguish individual grains–this would require a powerful electron microscope.) What is the cause of the 'mealy' irregular pattern of black, grey and clear areas that you see? Firstly, the original silver halide grains of the emulsion were not evenly spaced in the gelatin. Secondly, exposure has caused latent image specks to form mostly in the larger grains. Most chemical developers encourage these grains to produce a filamentary growth of black metallic silver, matting individual grains into 'clumps'. Thirdly, the image is not just recorded on one layer of grains–the emulsion thickness (particularly in fast films) may be sufficient to contain grains ten or more deep. When viewed these grains overlap to give a further, optical effect of clumping.

Why do mid-tones tend to show up image structure most noticeably? Highlight areas of a correctly exposed, normal negative material contain so many overlapping silver grains that when printed to give an appropriately low highlight density graininess is not readily apparent. Shadow areas of the negative contain silver grains only at the top layer of the emulsion. Less optical clumping therefore occurs, and when printed to a deep shadow density these grains become even less apparent, as the eye has limited reading power in dark image areas. Therefore it is in the mid-

tone areas that graininess is likely to be more noticeable–particularly in a large area of even tone, such as the sky or a plain grey studio background.

Overexposure of the negative increases apparent graininess. Mid-tones are exposed more deeply into the negative and the flattening characteristics of both overexposure and irradiation call for hard printing paper. When mid-tones are printed to an appropriate density, overlap clumping is very apparent–the unevenness being exaggerated by the contrasty paper.

In describing the mealy appearance of a photographic image the two terms 'granularity' and 'graininess' are frequently used. They are easily confused, but are not interchangeable.

Fig. 7.1. Granularity measurement. A micro-densitometer trace across an apparently 'uniform' density.

Granularity is an objective measurement. It is based on microdensitometer trace measurements across a negative, e.g., an 'even' area of mid-grey tone. The irregular fluctuations read by the machine as it tracks across the emulsion are expressed as a wriggly line on a graph, such as Fig. 7.1, and enable a numerical physical characteristic to be calculated for the sample.

Graininess is a more subjective term, taking into account the overall *visual* appearance of a developed image under practical viewing conditions. It can in fact be defined as the reciprocal of the magnification at which the grainy appearance reaches some low standard value, under standardized conditions of observation. Strong image detail tends to reduce graininess, as does overall sharp focus. A negative image with 'soft focus' is more likely to display its grainy structure, as this may be the only sharp detail on the print. (A sharp negative printed with a soft focus lens will of course have grain detail diffused along with image detail.) 'Grain', or more strictly graininess, is the generally accepted term used by photographers when describing the appearance of the basic structural pattern in a photographic image.

In commercial and technical record photography the appearance of graininess is usually objectionable, breaking up detail and masking intrinsic qualities of the subject–particularly its finer textures. Graininess may also clash with the half-tone screen pattern (Chapter 15) if the final print is photomechanically reproduced. But graininess can also be used creatively. It can simplify images by destroying unimportant detail; evoke atmospheric conditions; break up large monotonous areas of tone. Like every other special effect graininess can be abused to the state of becoming a cheap gimmick. Therefore any photographer aiming to master his medium should have control of image graininess–producing it at will, and not by accident.

118

In practice the eight main factors controlling graininess are:
(1) The negative emulsion used; size of grains and thickness of coating. Large grains in thick layers collect more light and result in fast emulsions. The finest grain materials–microfilm, for example–are also slow.
(2) The image itself–its overall contrast, the proportion of mid-tones, the amount of fine detail, its optical sharpness.
(3) The exposure level. Exposure wholly on the toe or shoulder of the curve calls for contrasty printing paper which emphasises grain pattern. Over-exposure increases irradiation.
(4) The type of developer and degree of development. Energetic formulae and overdevelopment both increase graininess.
(5) Chemical after-treatment of the negative. Most reduction or intensification solutions increase graininess (page 347).
(6) The degree of enlargement and type of enlarger (condenser or diffuser).
(7) The printing paper grade and surface texture. (Note that the printing paper emulsion is extremely fine grained and is not in itself a factor.)
(8) Conditions of viewing the final print.

These points are worth bearing in mind, for example when using a small format camera on subjects where we are free to control lighting. By using more contrasty lighting than normal, slightly increasing exposure and giving, say, only 2/3rds normal development, a negative of good printing density and contrast may be produced with *reduced graininess*.

When shooting the exceptional job which requires maximum grain you might start with the following line up: A small format camera; fast film (e.g. Kodak Recording); flat lighting on the subject, which is as distant as possible and arranged to have broad areas of mid-tone; slight overexposure; processing in an energetic M.Q. developer; reduction in Farmer's Reducer; and enlargement in a point source condenser enlarger, onto contrasty, glossy paper.

Fine grain development

The main object of fine grain developer is to reduce grain clumping. This is usually achieved by partial development, so that each exposed grain converts to a small particle of silver only. Inevitably partial development gives insufficient density without some compensating increase in exposure. Many fine grain developers therefore reduce emulsion speed to a greater or lesser extent. Each formula is a compromise between minimized graininess and loss of film speed.

Low alkalinity F.G. developers. The classic type of fine grain developer is M.Q. or P.Q. based, but is slowed in its activity by containing a low alkalinity accelerator such as borax or sodium metaborate (pH 9) instead of sodium carbonate (pH 10). Examples of this type of formula are D 76, ID 11. The result is a finer grain than normal M.Q. development, with only slight loss of emulsion speed. This type of developer is relatively cheap to make up and has excellent keeping properties (about 3 months in a 13 litre tank). It therefore remains popular for professional darkrooms, particularly for sheet film and 6×6 cm processing.

Low alkalinity developers often contain a high concentration of sodium sulphite.

D23 (page 343) is a classic example. Sulphite acts as a slight solvent of silver halides, turning the developer into a mild solvent type, as explained below.

Solvent developers. By adding a silver halide solvent to a developer some parts of the silver halide grains are dissolved away during development, reducing eventual grain size. Some of the silver ions released into solution tend to 'plate back' (physical development) on to developing grains, but as growth is not filamentary the risk of clumping is slight. The resulting negative is less grainy than if simply processed in a low alkalinity developer, but suffers greater loss of film speed. The solution itself is usually M.Q. borax plus a small percentage of sodium thiosulphate or potassium thiocyanate. Solvent developers can produce dichroic fog on modern thin emulsions. Follow the fine grain recommendations published by the maker of the film.

Low energy developers. In addition to low alkalinity, a fine grain developer may also rely on low energy developing agents–for example, P.P.D. (paraphenylene diamine.) This type of developer is now rather old fashioned. It is very slow working (half an hour or more) and greatly reduces emulsion speed.

Modern branded F.G. developers. Formulae are now seldom published for proprietory brands of fine grain developers. In general developers such as Microdol X, Microphen and Promicrol tend to use mixtures of high and low energy developing agents in a low alkalinity solution. These suit modern emulsions better than solvent or low energy formulae. Some aim at maintaining the film's rated speed; others give finer grain but with some speed loss. All modern fine grain developers keep well in solution. Replenishers are available for most of them, and used on a 'topping up' or 'bleed off' basis. (A small quantity of developer based on the square footage of film processed, is bled off and replaced by an equal quantity of replenisher solution).

When a large tank of developer is kept for general use over several weeks try to use it regularly. Left standing for long periods between processing batches the pH rises (as opposed to a *lowering* of pH produced by developing films). The hazard of erratic pH is minimized in most formulae by the preservative and chemicals which give a 'buffering' effect, but regular use still helps to give predictable results.

Finally remember that sales literature for proprietary fine grain developers sometimes makes exaggerated claims. The photographer's choice of emulsion always has greater influence on final graininess than his choice of developer. No solution will induce a thick, coarse-grained high speed emulsion to yield grain-free enlargements.

High definition ('acutance') developers

A fine grain developer generally aims to reduce graininess by partial development, and in doing so it tends to give a low contrast image. But you know from our coverage of lens image definition that new thinking on 'sharpness' has shown that local contrast is just as important a factor as actual resolving power. Interesting new high definition developers such as 'Acuspecial' have been formulated to give maximum emulsion definition–but only when used with modern thin emulsion films.

120

These developers should therefore be considered as an integral part of the general progress in emulsion technology.

A high definition developer minimizes loss of detail due to diffusion within the emulsion, by producing an image concentrated near the *surface* of the film. It discourages filamentary growth of silver, giving isolated rather than matted clumps of grains. Most high definition developers contain an energetic developing agent – typically metol – which is considerably diluted (formula page 343). Activity is maintained by a high alkali content.

On a thin emulsion film this gives a moderate gradation surface image, with virtually no loss of original emulsion speed (the top layer of grains received most of the image light anyway).

In addition, most high definition developers make use of the 'mackie line' effect (see Fig. 7.2) to further improve acutance. Along severe boundaries between shadows

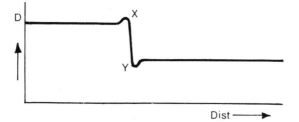

Fig. 7.2. Mackie line effect in negative development. Active developer from the shadow gives a line of extra density (X) to the highlight border – bromide from the highlight locally restrains development of the shadow (Y).

and highlight areas active developer (from shadows) gives a line of extra density to the highlight, whilst discharged bromide from the highlight restrains development of the shadow. The formation of emphasized boundaries between areas of high and low exposure due to this macrobromide effect helps to exaggerate fine detail. It is usually necessary to curtail agitation, but not to the extent of producing patchiness – follow the manufacturer's instructions carefully. Made up solutions do not have a long life.

Films which work well with high definition developers tend to be fine grain and medium contrast, without giving a high maximum density. Examples include Ilford Pan F, Kodak Pan X, and most slower speed professional films. Developers of this type tend to increase emulsion speed by a factor of $1\frac{1}{2}$–2.

Note that, unlike fine grain development, negatives processed in high definition developers do not have a particularly low granularity – in fact the mackie line effect gives an edge-emphasized grain structure. However the overall improvement in image definition reduces the visual appearance of graininess.

Apart from general purpose small format photography, high definition developers are often used for photomicrography and aerial survey work – allowing full exploitation of high definition lenses in picking out fine detail. It is pointless to process thick, fast emulsions such as Royal X Pan in a high definition developer as the result would be grainy and generally flat, and development times excessively long. High definition developer is also unsuited to microfilming and photomechanical reproduction work, where high contrast and maximum density are needed. Thin film, high contrast, high resolution emulsions such as Kodak Microfile and lithographic

121

materials are used for these applications, suitably processed in caustic hydroquinone and lith type developers respectively.

Lith developers

These very high contrast developers are intended to process lithographic emulsions as used for photomechanical reproduction, and line work. Used with such emulsions they can easily produce a gamma of 10. The developer is based on a formaldehyde-hydroquinone formula and makes use of an important principle–'infectious development'. The image begins to build up very slowly at first, and then suddenly gains density more rapidly. This is because the particular developer oxidation products formed in the exposed areas are themselves highly active developing agents (semiquinones). Whereas an M.Q. developer formula contains sulphite to reduce oxidation (inactivating such by-products), a lith developer purposely has a relatively low sulphite content.

Care must be taken not to take this infectious development to excess, as this can reduce resolution due to image spread within the emulsion. To reduce image spread lith films are normally coated with thin emulsions. Lith developers have very poor keeping properties and are usually stored in separate A and B component stock solutions. Lith materials are discussed further on page 161.

Developers for high emulsion speed

When emulsion speed has had to be up-rated in order to take pictures under very poor lighting conditions, a maximum energy developer such as 'Acuspeed' may be needed to produce the negatives. Results will be grainy, particularly since high speed film will probably have been used. However if maximum speed is more important than graininess a caustic metol-hydroquinone developer can be used. Alternatively hydrazine plus an anti-fogging agent can be added to a conventional M.Q. developer. High energy developers understandably have poor keeping properties–caustic M.Q. in fact deteriorates within a few minutes.

Monobath solutions

Although it may sound unlikely, fixing agents can be combined with a developer so that both development and fixation simultaneously occur in the one solution. The balance between developer (often caustic P.Q.) and fixer (sodium thiosulphate) is quite critical. The formula is so arranged that the fixer has a long induction period and only begins its action after the film has developed to finality. Care has to be taken to avoid dichroic fog. Due to their critical formulation monobaths are normally bought in solution form.

In practice monobaths are remarkably easy to use. Developer temperature is not particularly critical as both functions of the solution are equally affected. Timing too is relatively unimportant–the film is simply left in the solution until all activity ceases. The solution tends to maintain an even balance between development and fixation rates until exhausted. This is because as the consumption of developing agent and formation of oxidation products increases, so the fixing agent concentration is lowered by the silver released into solution.

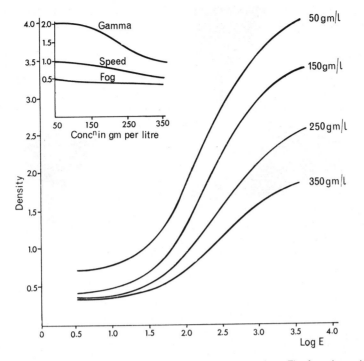

Fig. 7.3. Performance of a monobath solution at various hypo concentrations. The formula used appears on page 344. Curves relate to Ilford Pan F—in each case the film was processed for 6 min at 20°C. (Courtesy The Polytechnic of Central London).

Monobaths are convenient for processing under difficult conditions on location; they are sometimes used in processing machines for special rapid-access applications. On the other hand a different monobath formula has to be used for differing degrees of development, or to process differing emulsions to the same gamma. The relationship between solvent concentration and development gamma is shown in Fig. 7.3. Monobaths do not produce very fine grain results, and are fairly expensive to buy.

Monobath formulae have been known since the early days of photography, but were notoriously unreliable. Modern chemistry has improved their performance and in the early 1960s particularly, a number of new monobaths were introduced. They have not proved very popular for day-to-day use with conventional materials, but note the effectively monobath processing of instant pictures, page 125.

Black and white reversal processing

By using a suitable sequence of solutions it is possible to process a camera exposed film direct to a positive black and white transparency. This can be used, for example, for black and white cine films. In conjunction with a 35-mm camera it also offers a convenient method for making black and white slides direct.

123

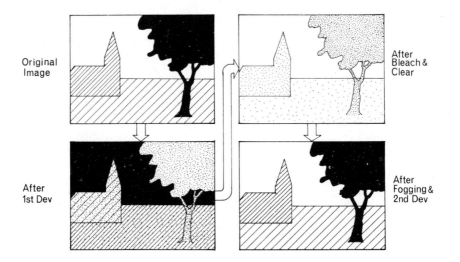

Fig. 7.4. Black and white reversal processing.

Most black and white emulsions of moderate or high contrast can be reversal processed satisfactorily. However, for best results a limited range of 35-mm and cine materials are actually designed for the purpose (e.g. Agfa 35mm Dia-Direct).

The processing sequence takes about 40 minutes and is as follows (See page 345 for detailed formulae):

(1) Development in an M.Q. type developer at about three times normal strength with the addition of sodium thiosulphate (about 0·3%). This gives a contrasty silver negative image, the weak fixer destroying density in shadow areas.

(2) Rinse and bleach in a potassium bichromate + sulphuric acid solution. This causes the black metallic silver negative image to become soluble, without however affecting the remaining undeveloped silver halides. Stages 3–5 can take place under yellow safelights conditions.

(3) Rinse and clear the yellow bleacher stain in sodium sulphite + sodium hydroxide solution. The emulsion now carries a positive image in the form of undeveloped silver halides. The remaining stages simply convert this to a black silver positive.

(4) Exposure to a (100-watt) tungsten lamp. (Chemical blackening in a thiocarbamide solution is an alternative and often more convenient method particularly when the film is wound on a spiral.)

(5) If the emulsion was exposed to a light for stage 4 it must now be developed to finality in M.Q. paper developer or stage 1 developer then, fixed and washed.

If a normal negative emulsion is used for reversal processing its rated speed will often alter (typically reduced 50%). Its exposure latitude is also less. Some fine grain emulsions yield a greenish image colour which, whilst satisfactory for negatives, is unacceptable as a reversal projection-positive. Materials which effectively reversal process include Kodak Pan X; Fine Grain 35mm Positive film; and Pan F; as well as most line emulsions.

124

Diffusion transfer (solvent transfer) processing

Diffusion transfer chemistry allows rapid processing of special negative material with simultaneous production of a positive–usually without the use of liquids as such. The most well known examples are the various instant picture materials; some forms of document copying; and specialist processes such as Kodak Bimet Transfer Film for in-flight processing of aerial photography.

Instant picture material (black and white). This, the most familiar diffusion transfer system used by professional photographers, was invented by Dr. Edwin Land and first marketed by the Polaroid Corporation in 1948. Basically three units are used. (1) Light-sensitive material consisting of silver halides plus developing agents, in a gelatin emulsion coated on a film or paper base. (2) Positive print material, usually paper or permeable plastic (but may also be film if projection transparencies are required). This contains trace elements, e.g. a few atoms of silver, which form *catalytic* sites, for reasons shown later. The quantity of these elements is so small that the material still appears clean white. (3) a 'pod' containing a powerful alkali plus a silver halide solvent, in viscous (jelly) form.

Special film holders or camera equipment are so arranged that after exposure to the image the light sensitive material is brought face to face with the positive print material. Rollers then break the pod, spreading its contents evenly between the two sheets like a sandwich filling. Up to this point the developing agents in the light sensitive emulsion have been inert, owing to absence of alkali. But now viscous alkali (caustic type) rapidly penetrates the gelatin, activating the developing agents which develop up a negative black metallic silver image within seconds (see Fig. 7.5).

The solvent content of the pod, overcoming an induction period, now acts on the remaining silver halides. These are converted to soluble silver ions which, if they were in a conventional fixing bath, would diffuse out into solution. Here, however, they can only diffuse up out of the emulsion and transfer into the receiving surface of the positive print material.

Whilst the viscous alkali was penetrating in one direction into the silver halide emulsion, it was also absorbed in the other direction, into the positive layer. It is soon joined by excess developing agents diffusing out of the other emulsion–mostly from shadow areas where there has been little to develop. The active developing agents donate electrons to the catalytic sites distributed throughout the receiving layer, making them negatively charged. (Think of them as trace silver atoms similar to a silver halide emulsion evenly fogged to light and then fixed–leaving the silver atoms of the latent fog image but no silver halide crystals.) When, a few seconds later, soluble silver ions begin to diffuse over from the negative emulsion, they are attracted to the charged atoms, combining to form black metallic silver. In other words, a form of physical development occurs in areas where silver has diffused from the negative. Most silver will diffuse from shadow areas of the negative and least from highlights. A positive, right-reading print is thus formed on the receiving material.

After the processing period has elapsed (about 30 seconds, but varies with film type) the materials are peeled apart. The positive may be formed on white plastic which incorporates an underlying layer into which alkali and other chemicals sink

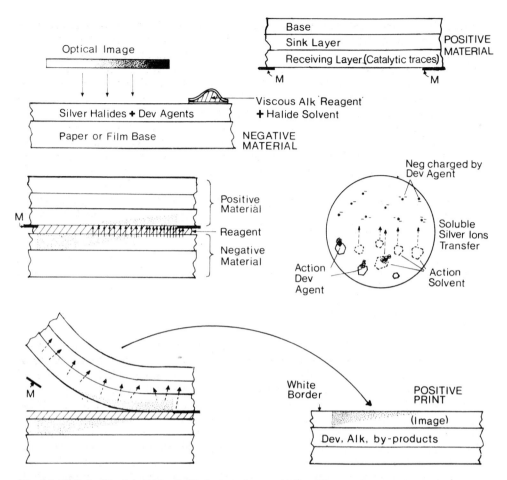

Fig. 7.5. Black & white Polaroid Land diffusion transfer material. Top: The negative material is exposed to the camera image. (M – Moistureproof paper mask to prevent silver transfer and so give white borders to the final print.) Centre: After exposure the positive and negative materials are placed in face contact, and the contents of the pod spread between them. Bottom: With processing complete, the print is peeled from the negative, and paper mask discarded. By-products are absorbed into the sink layer.

and become neutralised, leaving a 'clean' metallic silver image anchored above. The paper negative is thrown away.

Some earlier type Polaroid materials using a paper or film base print material do not have the 'sink' layer shown in Fig. 7.5. These require the print to be coated with a swab containing acidified fast drying lacquer as soon as it is peeled from the negative. Coating neutralises by-products and helps to protect the silver image from scratches.

Instant picture materials which have the *negative* sheet on a clear film base give both a print and a negative suitable for conventional printing. After peeling from the positive the negative must be placed in a weak alkaline solution (15% sodium carbonate) to destroy its anti-halation coloured backing. Remaining viscous chemicals must also be swabbed from its emulsion surface. The *positive* may instead be

126

formed on film base material – giving a transparency ready for projection immediately it has been coated. Diffusion transfer *colour* film is described on page 000.

Various instant picture backs are available for professional large and medium format cameras, including instrumentation equipment. They also fit specially made direct vision viewfinder cameras. The materials are made as special film packs, or individual exposure 4 in × 5 in packets (Fig. 7.6). Black and white Polaroid materials are extensively used for exposure and lighting balance checks in most forms of professional photography. The immediate availability of results also makes these diffusion transfer materials useful for nonphotographic personnel shooting technical and scientific records. Always remember however that processing is influenced by temperature – working outdoors in wintertime the material may need warming in order to work.

Diffusion transfer document copying systems. Diffusion transfer chemistry is used in a few document copying processes, e.g. Agfa-Gevaert; Kodak 'chemical transfer'. Paper containing silver halides plus developing agent in its emulsion is suitably exposed to the document (in contact or by projection). It is then wetted in an alkali solution whilst in face contact with receiving paper containing a solvent and a small quantity of finely divided silver. When peeled apart the receiving paper carries a positive image – the negative paper is thrown away.

Fixing, and Silver Recovery

The purpose of fixing is to render the image permanent by converting the silver halides remaining in the emulsion after conventional development to soluble compounds. Fixing solutions usually contain acidified sodium thiosulphate; the chemical contents of most popular fixers were discussed in *Basic Photography*.

Surprisingly perhaps, the chemistry of fixing is most complex in action. More inaccurate theories have been advanced by scientists to explain fixing than for most other sections of photographic processing. Modern research suggests that thiosulphate ions in the fixing solution diffuse through the gelatin to the surface of the silver halides. Here they are 'adsorbed' to the surfaces of the grains to react with silver ions in forming fairly insoluble argentothiosulphate compounds. These quickly react with further thiosulphate ions to give a much more soluble argentothiosulphate complex. This 'desorbs' from the grain surface and out into solution.

The halide (e.g. bromide) ion content of the grains, liberated by removal of the silver ion content of the crystal lattice, also diffuses into solution. In fact the diffusion of soluble argentothiosulphate complexes and halide ions out of the emulsion takes up the longest stage of the fixing process. Emulsions containing fine grains offer up a much larger surface area for fixing than an equivalent weight of silver halides in coarser grain sizes. Fine grain emulsions are therefore the fastest to fix.

The soluble halides accumulated in solution will vary according to the type of emulsion – chloride from contact paper, iodide and bromide from negative materials, etc. Some of these halides are inherently more soluble than others. Chloride emulsions have the shortest 'clearing' period, then bromide, and finally iodide content emulsions. Accumulation of soluble iodide in a fixing bath for negatives soon has the effect of reducing silver ion concentration and slowing the fixing action. This is one good reason for using a two-bath fixing technique for negatives as well as prints. The

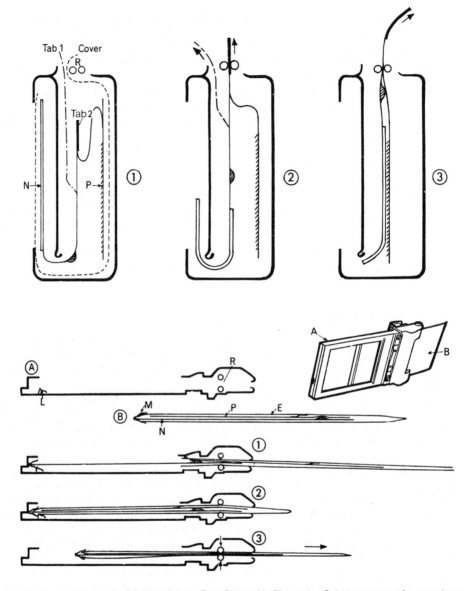

Fig. 7.6. Mechanical layout of Polaroid backs. Top: Disposable film pack. (Only arrangement for one picture shown here). Rollers (R) are a permanent part of the camera. Once in the camera the pack cover is removed. After making the first exposure tab 1 is pulled, causing tab 2 to emerge between the two rollers. This is then pulled, breaking pod and bringing negative and positive material right out of the pack. Bottom: (A) Sheet film back which fits spring-back 4×5 cameras as any ordinary slide, and accepts envelopes (B) containing the sensitive material. R—Rollers which may be opened or shut. L—Locking lip. E—Light-tight paper envelope. M—Metal cap attached to one end of the negative material (N). Positive material (P), tab-attached to the envelope. Stage 1. The back (fitted to the camera) accepts the envelope, which is then partly withdrawn leaving the negative material locked in the focal plane by lock (L). Stage 2. Following exposure the envelope is again fully inserted. Stage 3. Squeeze rollers are sprung together, which also releases locking lip. The whole envelope is pulled from the back, spreading the reagent. The envelope is then torn open.

128

bulk of soluble argentothiosulphates and halides diffuse out into the first bath. An equal period spent in the second, fresh, fixing bath removes the small residue which might otherwise remain in the emulsion, owing to the concentration of these byproducts in the first bath. The film will then leave the second fixer with little more than hypo to be washed from its emulsion.

As a tank of acid fixer is used, the following changes occur in the solution:

(1) The fixing agent content grows weaker due to its ionic action in fixing emulsions, and dilution by carry-over of solution (water rinse, stop-bath or developer) from the previous stage of processing.

(2) Accumulation of soluble argentothiosulphates formed by the action of fixing agent on silver ions in the emulsion.

(3) Accumulation of soluble halide ions released from the emulsion.

(4) Rise in pH from acidity towards neutral.

Silver is a valuable metal. Rather than tip quantities of it down the drain by discarding spent fixing baths containing concentrated argentothiosulphates, it may be worthwhile to reclaim this silver content from solution.

Some forms of reclaiming allow silver to be removed without contaminating

TABLE 7.1

FIXING BATH EXHAUSTION

One litre of Acid Hypo will fix up to 1·5 sq metre (16 sq ft) which is equivalent to any one of the following:—

60—35 mm (20 exp) Cassettes
30—35 mm (36 exp) Cassettes
30—120 Rollfilms
120—4 × 5 in Sheet films
30—8 × 10 in Sheet films

the solution with other chemicals. This allows the residue to be 'regenerated'–a routine involving the addition of an appropriate amount of fixing agent (checked by measuring specific gravity), plus acid components to restore the pH to a working level of about 5·0. The solution then goes back into use as a fixer. (Eventually its life is limited by the halide content it accumulates, unless this is precipitated out by adding appropriate chemicals such as 5% thallous sulphate solution).

Silver recovery can be applied to plain, acid, and acid hardener sodium thiosulphate solutions; similarly ammonium thiosulphate rapid fixer solutions. The main recovery methods are:

(1) Full precipitation ⎫
(2) Metal exchange ⎬ Usually destroy the solution as a fixer.
(3) Partial precipitation ⎱
(4) Electrolysis ⎰ Allow regeneration.

Full precipitation. The cheapest method of precipitating silver is to tip the exhausted fixing solution into a container such as a plastic dustbin, make it alkaline (e.g. with a small amount of sodium hydroxide), and add an appropriate quantity of 20% sodium sulphide solution. The amount of sulphide needed depends upon bath

129

silver content, and can be calculated by first testing the fixer with special indicator papers.

After adding the sulphide and stirring, the solution is allowed to stand for about

Fig. 7.7. Silver recovery arrangements. Left: Full precipitation of silver sludge in the presence of sodium sulphide and alkali. Centre: Metal exchange. Exhausted fixer rises through the steel wool, slowly changing it to silver. Right: Electrolysis. A low density current is allowed to flow from A to C for a long period, plating out the silver from the solution on to the large cathode.

24–36 hours. During this time a thick sludge of silver sulphide precipitates at the bottom of the container (Fig. 7.7). The solution also gives off hydrogen sulphide gas, which apart from having a revolting smell has a strong fogging effect on photographic materials. The whole job should therefore be undertaken out of doors. Sludge can be run off from an outlet near the bottom of the container, dried and sold to a refiner. As a more expensive alternative to sulphide, either sodium hydrosulphite or ferrous hydroxide can be used as reagents to precipitate silver sludge.

Metal exchange. If a copper coin is dropped into a tank of silver loaded fixer it becomes silver plated. Apart from being amusing (also illegal) this leads to another method of silver recovery. Silver is a *noble* metal, less easily dissolved than iron, copper and zinc, which are *base* metals. When a base metal is placed in a solution of silver salts it slowly dissolves and is replaced by silver, deposited from solution in exchange. The crudest way of utilising metal exchange is to add zinc dust or copper turnings to exhausted fixer, precipitating a sludge containing silver. However, if silver recovery is to be regularly practised it is much more convenient to use iron in the form of 'steel wool'.

A large porcelain mixing vat or plastic container is filled with large pads of steel wool (e.g. disc pads as made for floor cleaning machines). The wool stands on a perforated platform about 5 cm (2 in) above the bottom of the container. Under the platform is an inlet pipe for the spent fixer. The solution is allowed to rise through the packed charge of steel wool and overflow into a waste pipe near the top. As the steel wool is wetted by the (normally acid) fixer it blackens and forms iron sulphide, giving off hydrogen sulphide. The process must therefore take place outside. Over several weeks the steel becomes converted to silver, changing to a light grey colour progressively upwards through the tank. When the top pads also appear grey the unit can be emptied and the steel wool—now almost entirely silver—scooped out.

130

In practice 4·5kg (10lb) of steel wool yields about 10·5kg (23lb) of silver (60% efficiency). The silver is dried and sold to a refinery. Warning: Take care if, for any reason, you empty the unit of steel wool pads before full exchange has taken place. A tightly stacked pile of damp pads left out of solution for 30 minutes or so may spontaneously catch fire.

Partial precipitation. If the amount of silver a spent fixing bath contains can be accurately forecast, the quantity of reagent (e.g. sulphide) used may be kept just below what is necessary for complete precipitation. The result is that only the lower part of the container of spent hypo produces sludge. If an outlet is made about two-thirds down from the top of the container, the upper contents can be drawn off. This liquid may then be brought up to strength with hypo and acid to form a regenerated fixing bath. It can be seen that, unless the silver content of the original exhausted fixer is really accurately assessed, there is always a strong risk of precipitation going too far.

Electrolysis. When a weak electric current is passed between two electrodes placed at either end of a tank of exhausted fixer, silver plates out on the cathode electrode. This is therefore a very elegant method of removing silver without in any way contaminating the solution with chemicals. Unfortunately the capital equipment is rather expensive, although it may be hired. The anode is usually made of carbon, and the cathode consists of a large surface area of stainless steel. Over a period of days the silver appears as a grey scaling which can be chipped from the cathode and sent for refining.

The silver concentration left in solution must be checked regularly. When this drops to about 0·5 grams per litre the electrodes are removed, appropriate quantities of hypo and acid added, the solution returned to use as a fixer. Where large recirculation tanks are in use (e.g. in a large D & P works where fixer is piped to various machine rooms) an electrolytic silver recovery unit may be working continuously in the flow of hypo.

Because of the cost of equipment and time, and sometimes inconvenience, recovery of silver is really most practical for large users of fixer. Small scale commercial studios and units must carefully compare outgoings with income before deciding to recover silver – many will find that it is not worth the trouble. However, in some industrial areas the studio can be within easy reach of a refinery. In these circumstances the refinery may be willing to collect a reasonable number of barrels of exhausted fixer as they stand, doing all the breaking down of solutions themselves.

Stabilization

Photographic material which is fixed and then blotted and dried without washing is considerably more permanent than material which is fixed and badly washed. (It is not however as permanent as properly washed material.) This may seem an odd statement, but the fact is that when a high concentration of thiosulphate ions is present in an emulsion the argentothiosulphate complexes present are less likely to revert to silver ions and thiosulphate ions. If breakdown does occur the silver

ions soon react with hydrogen sulphide in the atmosphere to give silver sulphide–the picture goes brown. A strong solution of ammonium thiocyanate or, less frequently, acidified thiourea can also be used to 'stabilize' photographic materials on this basis. Ammonium thiocyanate converts the halides to silver thiocyanate complexes–which are even less affected by light than the silver thiosulphate complexes.

Apart from cutting out the washing stage stabilisers work very rapidly–sometimes within seconds. This feature makes them very useful for special rapid-processing bromide papers (see page 160), document copying machines, and rapid access photography generally. The disadvantages of stabilizers are:

(1) Whitish compounds remain as a deposit in the emulsion layer. This is why stabilization tends to be limited to prints on white based paper, which naturally disguises this effect.

(2) A stabilized image is not permanent, having a life of between a few weeks and about two years, even when protected from light. However most commercial stabilizers allow the material to be conventionally fixed and washed later if a more permanent result is required. Its life then matches normally processed materials. (Stabilization should not be followed directly by washing. Removal of excess stabilizer leaves insoluble silver thiocyanate or argento-thiosulphates which are unstable.)

(3) A stabilized print, being saturated with chemical, can contaminate and even bleach other materials with which it comes into contact, e.g. handwritten correspondence, office stationery, certain fabrics. Prints also feel unpleasantly 'thick' and leathery to the touch for some considerable time owing to moisture absorbed from the atmosphere by the deliquescent chemicals in the emulsion.

Machine processing (black and white)

The general tendency in processing during the past ten years has been towards the use of automatic machinery e.g. 'Versamat' and 'Veribrom' processors for films and plastic-based papers respectively. These machines work at relatively high temperatures and use a roller transport system which is self-agitating and self-threading, allowing it to accept individual roll and sheet films, and various sizes of prints. Chemicals are automatically replenished according to the amount of material fed into the machine. A film can be processed dry-to-dry within 4 minutes; prints within 2 minutes.

Modern pre-hardened emulsions and special developers are designed to stand up to roller processing at around 24°C (75°F). The fully permanent negatives produced this way have a quality similar to that given by a general purpose fine grain developer. Machine processed bromide paper gives print quality similar to conventional processing. Stabilization prints have therefore lost many of their 'rapid-access' advantages, and in fact produce prints of inferior quality.

Automatic processing machines are labour-saving and give very consistent results. On the other hand, they are expensive to buy and wasteful to run if your weekly through-put is less than a certain minimum figure. Mechanical and economic aspects of machine processing are discussed further in the colour section, see pages 253 and 254.

Related reading

JACOBSON, K. & JACOBSON R. *Developing*. Focal Press 1975
JACOBSON, R. *The Manual of Photography*. Focal Press 1978
Current technical information published by Eastman Kodak, Polaroid Corp. etc.

Chapter summary – Image structure, developers and fixation

(1) The structure of a processed photographic image consists of a random distribution of black metallic silver grains. The camera exposure affects larger grains first, and chemical development encourages filamentary growth from these grains into 'clumps'. Add the optical overlap of grains and light scatter within the thickness of the emulsion, and the effect is a mealy break-up of tone, or 'graininess'.

(2) Mid-tones exhibit graininess most noticeably – particularly if the negative is overexposed and flatly lit, and has to be printed on contrasty paper which exaggerates pattern.

(3) *Granularity* is the objective description of processed image structure measured by micro-densitometer. Measurement is made across an area which received an even (mid-tone) optical image.

(4) *Graininess* describes the overall visual impression of a processed image under practical conditions and is therefore subjective.

(5) Factors controlling graininess in practice include – structure of the emulsion; the subject contrast and detail; the definition of the optical image; exposure level; developer type and amount of development; chemical aftertreatments; size of enlargement, type of enlarger, and lens quality: grade and texture of printing paper; and conditions for viewing the final print.

(6) Most fine grain developers aim to avoid clumping by only partially developing the exposed grains. Usually this reduces emulsion speed. 'Classic' F.G. developers include low alkalinity P.Q. formulae, solvent types, and solutions using low energy developing agents. Many modern branded developers combine low and high energy developing agents in low alkalinity form. They keep well in solution.

(7) High definition/*acutance* developers (for thin emulsion materials) are intended to process the surface of the film only. They use energetic developing agents in diluted form. Most formulae and processing procedures aim to encourage 'mackie line' effects to accentuate detail. The resulting negative may not have low granularity, but its graininess will appear low due to the improved image definition produced.

(8) Lith developers utilize *infectious development* – the formation of local byproducts which are themselves active developing agents. They give exceptionally high gamma and maximum density on lith emulsions, but if mishandled may result in stains and image spread.

(9) Developers to give maximum emulsion speed are high energy based. Solutions are often caustic M.Q., or M.Q. plus hydrazine and anti-fogging agent. Results are often grainy and the solution has poor keeping properties.

(10) Monobath processing solutions usually combine caustic P.Q. and sodium thiosulphate. The film is virtually developed to finality before solvent action takes over. Within reasonable limits neither time nor temperature is critical. The exhaustion rate of the developer component is formulated to match that of the fixer. A different monobath must be used for differing degrees of development. Monobaths are not particularly fine grain.

(11) Black and white reversal procedure allows the camera film to be processed direct to a positive transparency. Applications include cine film and slides. The basic cycle comprises – strong (solvent) first development; silver bleach; clearing of the bleacher stain; fogging exposure; re-development to finality. The film may be chemically fogged in place of the last two stages. Only minor variations in processing are possible, and exposure latitude is slight. Not all monochrome films give a satisfactory image colour when reversal processed.

133

(12) Diffusion transfer processing gives a negative with simultaneous production of a positive. The light sensitive emulsion may contain developing agents, activated by an alkali applied (in viscous or some other 'non-liquid' form) at the time of processing. A silver halide solvent also present with the alkali dissolves unexposed silver ions which then diffuse over to a nucleated receiving surface. Here they are physically developed to give a positive image. This is the principle of Polaroid black-and-white instant pictures. Other systems use developing agents in the activator, and thus allow diffusion transfer processing of conventional negative materials.

(13) Diffusion transfer materials and chemistry are useful for instant pictures of all types of professional photography, for in-flight processing of aerial film, document copying, and photo-instrumentation readout devices.

(14) Research into fixing suggests that thiosulphate ions react with silver ions in undeveloped crystals to first form argentothiosulphate compounds. These are not very soluble, but quickly react with further thiosulphate ions to give very soluble argentothiosulphates. The latter compounds, plus the halide ions from the crystals, diffuse out of the emulsion, mostly into the first fixing solution. Fine grain emulsions fix more rapidly than coarse grains. Chloride is the fastest type of halide to fix; iodide is the slowest.

(15) As a fixer is used its fixing agent grows weaker; it accumulates soluble argentothiosulphates and soluble halide ions from emulsions; and it rises in pH.

(16) Silver may be reclaimed from the argentothiosulphates accumulated in a used fixing bath. Some methods (full precipitation or metal exchange) destroy the solution as a fixer. However, electrolysis or partial precipitation allows 'regeneration' of the solution. Acid (to restore pH) and hypo (to replace fixing agent) are added, and the solution returns to use.

(17) To precipitate silver sludge from exhausted fixing solution a reagent such as sodium sulphide, sodium hydrosulphite or ferrous hydroxide is normally used. Metal exchange requires steel wool (iron), zinc dust or copper turnings which slowly dissolve in fixer, to be replaced by silver from solution. Equipment for electrolysis is fairly costly, but as a 'silver plating' system it is clean and free from obnoxious fumes.

(18) Commercial justification for silver recovery depends upon the volume of fixer regularly used; capital equipment required; time and nuisance; and distance from the nearest refinery.

(19) Stabilization is based on the fact that an emulsion containing a concentration of thiosulphate ions as well as argentothiosulphate complexes is more stable than an emulsion fixed but only briefly washed. In rapid processing a sequence of stabilize/dry is quicker and more permanent than fix/curtailed wash/dry.

(20) Emulsions which have been stabilized have a whitish appearance (least noticeable in paper prints); are less permanent than fully fixed, fully washed work (but may be refixed and washed later); and being saturated in chemical may contaminate other materials.

(21) Roller transport machines are gradually replacing most of the laborious aspects of processing. Advantages are speed, consistency, and permanence. One disadvantage is the capital cost.

Questions

(1) Briefly describe the general function, type of solution, and practical disadvantages of each of the following:

> Maximum energy developers,
> Monobath developers,
> High acutance developers.

(2) Discuss the problem of graininess in negatives. What factors contribute towards minimising graininess?

(3) (*a*) Explain and show, with the aid of diagrams, what happens to the emulsion at each stage of the reversal processing of a continuous tone black and white film.

(*b*) List the constituents of each bath necessary for the above reversal process.

(4) The recovery of silver from fixing baths is becoming more widely practised by large photographic units. Write an account of two methods of recovery—one which allows fixer regeneration and one which destroys the fixing properties of the solution.

(5) Explain the principle of silver diffusion processing and list its main commercial applications.

(6) Write notes on three of the following, in terms of black and white photography:

<div align="center">

Emulsion 'Acutance',

Granularity,

Stabilization,

Instant picture process.

</div>

(7) Describe fully the series of tests which you would undertake to evaluate a monochrome film when processed in various speed-enhancing developers.

(8) If a general-purpose fine-grain developer is used in a 13-litre tank without replenishment, describe the chemical changes which occur and the effects on negatives processed in it when:

(*a*) Batches of film are developed every morning and afternoon for a week.

(*b*) One batch is developed, followed by a second batch one month later.

(9) (*a*) Explain the changes which occur during the working life of an acid sodium thiosulphate solution used to fix negatives.

(*b*) After using electrolytic methods to recover silver from an exhausted acid fixing bath how would the solution be 'regenerated' to form a working solution again?

8. TONE REPRODUCTION

No one would suggest that scientific analysis such as sensitometry will predict a successful photograph – in practice too many subjective factors are involved. But the scientist can valuably predict such things as a film's exact response to light and to processing. Even more important, he can estimate the overall tone reproduction you might expect from a combination of subject, lighting, lens, exposure, processing and printing conditions. All these can be expressed on diagrams or graphs. Such knowledge helps you, for example, in understanding what combination of factors to aim at or avoid when making technical decisions on assignments.

By now you are fairly familiar with 'reading' characteristic curves in terms of practical photography. This chapter takes a closer look at graphs to explain the practical reasoning behind speed ratings. It should also be possible to combine graphs and other diagrams to see what happens when printing from under or over-exposed negatives, and when making duplicate negatives, or 'masking', to give better prints.

Speed systems

The basic problem. The aim in devising a speed rating system would, on the face of it, seem simple enough. It is necessary to fix some criterion of measurement which will give you a figure indicating each emulsion's sensitivity to light, in terms of its response under practical camera and processing conditions.

Given a subject lit at a set intensity, perhaps you could use the *exposure time* needed to yield a particular density measurement on the processed negative as a convenient criterion? But immediately you have to remember that the colour content of the exposing light relative to the film's colour sensitivity may affect its response. Similarly the light's intensity relative to the time it is allowed to act (reciprocity law failure) will have different effects on emulsions 'balanced' for particular $I \times T$ ratios. There is also the influence of type and degree of development. All these factors have first to be standardized in establishing a film's speed rating – but once set they cannot then be said to match every condition of practical photography.

There is a further difficulty. Exposing a film to an image normally means submitting it to a whole range of luminosities (or 'brightnesses') at once. If you are to judge speed from the exposure needed to give just one set density this hardly simulates practical conditions. How have all the other subject luminosities recorded? Shadows and highlights may differ completely between two emulsions. One may be an unprintably contrasty negative, the other hopelessly lacking shadow gradation. Can both be said to have the same speed just because of coincidence at one mid-point in their density ranges?

But then if you are to counter this by using a *range* of subject luminosities as your exposing criterion what range is typical . . . 10:1 . . . 100:1? Subjects and lighting vary so enormously in photography that inaccurate speed ratings could result when conditions depart from any set 'standard'.

What is a 'good' printing negative anyway? If your speed rating criterion is to

137

finally tell you the exposure level needed to give a good printing negative, you must surely consider the actual conditions of printing. What type of enlarger, paper, and print size can be considered typical?

The more you look into speed rating criteria the more difficult it is seen to be. Add to this a country's preferences for its own national system, and the fact that any improved speed system cannot be introduced overnight because the old system is perpetuated in millions of exposure meters already in use. All these points have been faced by photographic scientists over the years, and it is interesting to trace the varied systems that they have devised to try to give film speeds which are valid in practice. It has all been a subject of great controversy.

H & D speeds (British) 1890 – Arithmetic, based on inertia point. F. Hurter and V. C. Driffield, pioneers in scientific evaluation of emulsion performance, appear the first to have published a system of speed rating. (Very overoptimistic figures put out by some early manufacturers of 'dry plates' made this work an urgent necessity.) A sector wheel driven by an old sewing machine treadle was set up between a candle and the printing frame containing the emulsion under test, one metre away.

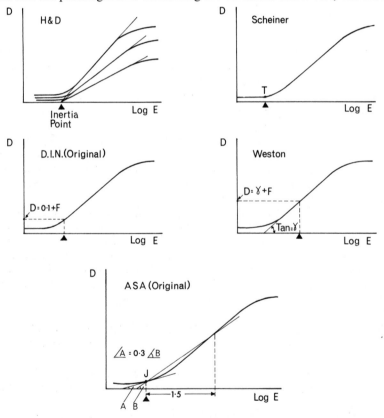

Fig. 8.1. Previous speed systems. In each case the black triangle denotes the exposure at the speed point chosen by the system.

138

The spinning sector wheel gave the plate a range of exposure times. Exposed plates were then processed for different times in the (then) standard pyro developer and a characteristic curve plotted for each one (see Fig. 8.1).

By placing the family of curves on one graph their straight line portions could be continued downwards to meet at one point (the *'inertia point'*) on the log E axis. Hurter and Driffield therefore argued that the position of this point was unaffected by development and varied only with speed – being further to the left the faster the emulsion. To get a speed number the exposure time at this inertia point (in metre candle-seconds) was divided into a standard number, 34. If, for example, the exposure time given by the sector wheel was equivalent to 1/10 second the H & D speed would be 340. This form of calculation ensured that the greater the exposure required, the lower the speed rating.

H & D speeds were used for many years in Britain and Europe. But in due course the introduction of M.Q. type developers containing a restrainer, and the variety of new emulsions with long 'toe' characteristics produced inaccuracies. The inertia point became no longer independent of development. Fast negative materials today would have an H & D speed of about 25,000.

Scheiner speeds (German) 1894 – Logarithmic, based on threshold point. Meanwhile, in Europe a speed system devised by German astonomer Professor Jules Scheiner became generally adopted. He too used a sector wheel in conjunction with an artificial light source. His measurement point was simply the exposure time (\log_{10}) given by the sector wheel which resulted in a processed density 'just perceptible' above fog. To get a speed figure the exposure at this 'threshold' point was subtracted from a constant number. As a logarithmic sequence of figures is used doubling of speed is indicated by an increase of 3.

Unfortunately the simple plates of Scheiner's day were superseded by emulsions giving a variety of curve shapes. Two materials may now have the same threshold point but one can have a much longer toe, giving an overall thinner negative. Densities around threshold are in any case too low to be of any practical value in separating tones in the shadow areas of a photographic image.

Scheiner's development conditions are also obsolete and wide open to interpretations. Small wonder then that manufacturers, conscious of the sales power of high speed ratings for their products, 'interpreted' conditions which would give exaggerated Scheiner speeds. By the 1930s 'Scheiner inflation' as it was called became quite out of hand, to the embarrassment of the German photographic industry. Relative to emulsions and conditions in Scheiner's day, fast films today would be rated about 41° Sch.

Original DIN speeds (German) 1931 – Logarithmic, based on fixed density. This was the first *national* standard speed system to be adopted. Conditions of test included exposure behind a step wedge instead of a sector wheel (thereby more closely matching practical photographic conditions). The original development specified was to finality, although this was later changed to conditions closer to photo-finisher practice.

DIN speed is based on the exposure level (\log_{10}) represented by the wedge step needed to give a processed density of 0·1 above fog. To get the actual speed figure

139

this exposure is subtracted from a constant. The DIN speed point could therefore be fixed with far greater accuracy than Scheiner. It relied of course on only one point, so that an emulsion with a long toe might have the same DIN speed as a short toe material yet give a very different negative. Nevertheless the point chosen was higher above fog than Scheiner's criterion and gave at least some indication of toe response. Today's fast films would rate about 30° DIN.

Weston speeds (American) 1932 Arithmetic, based on latitude inertia. This system was devised by the makers of the Weston exposure meter to give more reliable speed figures. It was the first system to be specifically related to a method of exposure measurement – the integrated light reading. A position on the curve was chosen which, used with an integrated reading, resulted in an average range of luminances recording within the region of 'correct' exposure.

Weston speed was simply based on the exposure (metre-candle-seconds) needed to result in a processed density above fog equal to the gamma. This neatly became more-or-less independent of development, and related to a density of some practical use. Speed figures were arrived at by dividing the exposure time needed for this density into 4.

Modern materials with long toe characteristics rely more on average gradient than gamma to express their degree of development – and this can lead to misleading Weston speeds. The system was dropped in favour of ASA (see below) and is no longer used on Weston meters. A modern fast film would be rated about 650 on the old Weston system.

Original ASA speeds (American) 1943 – Arithmetic and logarithmic, based on fractional gradient. During the war, following work in the Eastman Kodak research laboratories by Jones and Nelson, the American Standards Association and (later) the British Standards Institution adopted a speed system based wholly on practical results. An image luminance range of 32:1 ($1 \cdot 5 \log_{10}$) was chosen as 'typical' – a figure based on an assessment showing that the average subject shot by amateur photographers had a luminance range of 128:1, imaged through a typical uncoated lens of the period (flare factor = 4). For each film under test pictures were taken of a scene giving this image luminance range, and the camera exposure level varied between very low and very high. The best possible print was made from each negative and a panel of observers asked to judge which print in the series was the first to have excellent quality (i.e. the minimum negative exposure necessary to give an excellent final print).

Results were then related back to the characteristic curve for the material, processed to conform with photo-finisher practice. It was found that the position of the selected negative relative to the curve was such that deepest shadows were recorded at a point where the curve slope was one-third of the average gradient over the whole $1 \cdot 5$ log luminance range. The speed was then based on the exposure level needed to place deepest subject shadows on the curve at this point (called the 'Jones point').

Speed figures themselves were arrived at by either dividing the exposure at the Jones point into a constant (giving an arithmetic scale) or subtracting it from a constant (logarithmic scale).

By the 1950s then, attempts to provide an effective speed criterion had changed

140

from simple sensitometric measurement (of varying practical significance) to a practical system which required quite complex plotting in the laboratory. It was difficult to draw up tables of comparative speed values owing to the different criteria used, safety factors etc. Two films could be of the same speed under system A but one could be twice as fast as the other under system B. Exposure meters were calibrated in speed rating systems popular in their country of origin.

Furthermore, international travel was now greatly increasing – particularly for holidays. The average holidaymaker, just coping with conversions from miles to kilometres for his motoring saw little merit in memorizing incompatible film speed ratings for his photography too. For these and other reasons all the speed systems outlined above have now been superseded by one internationally agreed rating method, as shown below:

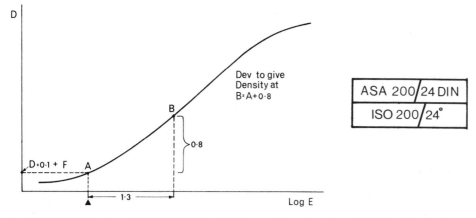

Fig. 8.2. Left: Criteria adopted for ASA/DIN/BS and ISO current international standard. Right: Speed ratings as printed on a film carton.

ASA/DIN/BS standard (international) 1960–2, based on fixed density. Taking an image luminance range of 20:1 ($1\cdot3$ range \log_{10}) as average practical conditions, the speed is based on the exposure (metre candle seconds) required to give a shadow density of $0\cdot1$ above fog. M.Q. type development must be sufficient to give a density of $0\cdot8$ above the shadow density at the highlight end of the $1\cdot3$ range (see Fig. 8.2). The speed figure is then calculated as

$$\text{Speed} = \frac{0\cdot8}{\text{Exposure (M.C.S.) to give } 0\cdot1 + \text{fog}}$$

for arithmetic rating used in America and Britain, or

$$\text{Speed} = 10 \times \log_{10}\left(\frac{1}{E}\right)$$

for logarithmic rating (doubling speed indicated by an increase of 3) still popular in Europe. No separate speed figure is given for use in artificial light.

The Swiss based International Organisation for Standards issues ISO film speed ratings which are closely in agreement with ASA/DIN/BS criteria and speed figures.

141

They are expressed both arithmetically and logarithmically (using a degree sign) and are sometimes presented separately as shown on the film box markings, Fig. 8.2.

For the first time direct conversion tables can be made out for the speed numbers used in various countries, due to their common basis. (400 ASA equals 27 DIN and pro-rata.) The ASA/DIN/BS international standard is much easier to plot than the original ASA Jones point. It is more accurate than the single density of original DIN as all films now have to be developed to the same effective contrast – note that this is not the same as gamma (Weston) and takes into account use of part of the curve toe (see also Appendix II). The ASA/DIN/BS standard for *colour materials* is discussed on page 210.

It can be seen that the system cannot be applied to line materials; image luminance range and final density requirements here are very different from the ASA specified conditions, and figures would be quite meaningless.

Incidentally, in 1970 the American Standards Association changed its name to the American National Standards Institute (ANSI). Despite this, most film cartons continue to use initials ASA. Remember both ASA and ANSI refer to the same organisation.

GOST speeds (Russian) – based on fixed density. This speed system is in common use in eastern European countries as well as the Soviet Union. The speed figure (Arithmetic scale) is based on the exposure level needed to produce a specific minimum density above fog. The developer and type of development vary with the type of emulsion, keeping as far as possible to typical practical conditions. The GOST speed figures are in practice numerically equivalent to the ASA/DIN/BS standard scale.

Remember that despite all this care in devising a speed rating which reflects practical performance, the figure printed on the film box or data sheet can only be a guide. It makes a number of assumptions – colour of the lighting on the subject; luminance range; imaging conditions; duration of exposure; development conditions; and type of negative required. (Always bear in mind too that the speed figure really does mean *minimum* satisfactory negative density.) As soon as you alter one or more of these variables, the film's *effective* speed is altered, for example, when increasing the development to get greater tone separation in a negative of a low contrast subject. Also when using a narrow cut colour filter, or when giving exposures of many seconds on an emulsion prone to low intensity reciprocity failure.

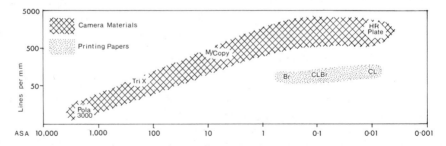

Fig. 8.3. The general relationships of photographic materials in terms of speed and resolution (after S. Ohue, Japan).

142

Predicting tone reproduction

You are now reasonably familiar with graphs plotting the characteristic curve of log exposure (and log image luminance range) against resulting negative density. You can also read characteristic curves for printing papers, where negative density range is related to print density range, see *Basic Photography* Chapter XVIII. Further graphs can be used to express other tone distorting influences such as camera lens flare.

It is possible to link all these response curves together, so that the data 'read out' from one graph becomes the 'feed' into the next. In this way a photographic image can be traced through the various stages which may modify tone reproduction. The final result can then be compared with the original subject tones. This does not of course tell us whether the picture as such is successful–only the accuracy of its tone reproduction.

Compounded graphs can give some useful technical guides, such as predicting:
(a) The degree of correction possible when printing from an incorrectly exposed or developed negative.
(b) The most appropriate negative density range to print onto various positive materials.
(c) The most appropriate technique for making a duplicate negative which has printing characteristics similar to the original.
(d) The effects of density masks.
(e) Predicting the effects of flare and of viewing conditions.

The basic cycle of tone reproduction can be broken down into 4 parts: (1) the original image luminosities (really two parts, i.e. original subject luminosities, which are then modified by flare); (2) the influence of the negative material, including the degree of development; (3) the influence of the positive material, and its development; and (4) the visual appearance of the final print. The graphic method of linking these four pieces of information together is called a 'quadrant' diagram (originated by L. A. Jones). This cleverly allows the final print tone range to be compared against the original image.

Negative material influence. Starting in the bottom right hand quadrant (see Fig. 8.4), a D/Log E characteristic curve is drawn for the chosen black and white material given appropriate development. Note that the Log E (Horizontal) axis is usually written in at the top of this graph instead of at the bottom. Evenly spaced positions for typical shadow, mid-tones and highlight image luminance can be marked in along this axis–the exposure level being 'normal' in the sense that shadow tones fall partly on the 'toe' of the curve. The four resulting densities can be read off the vertical Density axis and marked with horizontal dotted lines.

Positive material influence. The graph paper is now rotated through 90° so that the adjacent empty quadrant moves from bottom left to bottom right. The D/Log E curve of the chosen printing paper is now plotted in this quadrant.

The four values shown plotted on the density axis of the negative curve can be carried on downwards in vertical dotted lines to the new curve. Density is simply the reciprocal of transmission expressed as Log_{10}. Therefore the 'feed out' density

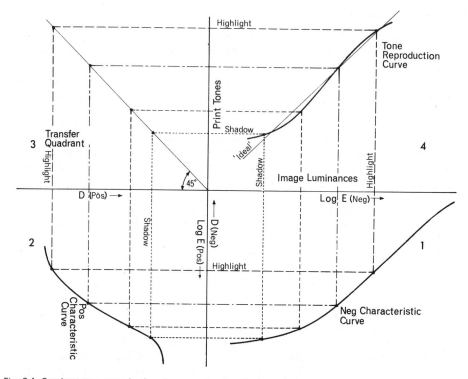

Fig. 8.4. Quadrant tone reproduction diagram—showing the interrelationship of exposing partly on the toe of the negative curve, and the characteristics of printing paper.

values of the negative directly give us the 'feed in' luminance log E values for the print–the highlights passing least light to the paper and the shadows transmitting most light. You are therefore expressing sensitometrically the effect of contact printing the negative.

The modern printing paper curve has its steepest slope near its top or subject shadow end. This is to compensate for the fact that most negatives are given minimum exposure (for reasons of speed and minimum graininess) resulting in some tone compression in shadows-to-midtones. As can be seen, 'correct' printing exposure helps to compensate for this compression, although some tone values in deepest shadow are inevitably still condensed. The resulting print densities for mid-tones and highlights are again more or less evenly spaced.

Transfer quadrant. Turn the graph paper back to its original position, with negative quadrant at the bottom right. In order to compare print densities with original image luminances, the dotted lines denoting densities must be turned through 90°. This is simply done via a straight line at 45° in the top left hand quadrant. The dotted lines (maintaining the same separation) can then run horizontally into the final, top right 'reproduction' quadrant.

144

Reproduction quadrant. The top right hand quadrant now has print tones in the form of densities fed into its vertical side and image luminances in the form of log E values available along its base. Extending density lines across and luminance lines upwards, the points at which each pair intersect can be joined up as a *tone reproduction graph*. If this graph line is a straight line at 45° you have produced a print with the same visual tone range and contrast as the original image. Straight lines at higher or lower angles indicate prints with increased or decreased tone separation respectively. In practice the characteristics of the printing material and the negative material never compliment each other completely – a 'more-or-less' straight line is the best that can be expected.

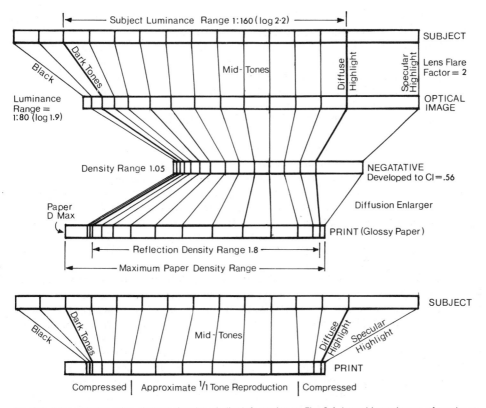

Fig. 8.5. A tone reproduction diagram showing similar information to Fig. 8.4, but without the use of graphs or characteristic curves. It relates four stages – original subject, camera lens image, processed negative, and final processed enlargement on bromide paper. Most compression occurs at the extremes of the tonal scale, similar to the tone reproduction curve section of the quadrant diagram. (Based on an original diagram by Eastman Kodak.)

Quadrant diagrams are not very easy to follow at first. Figure 8.5 may help by giving similar information in a different form of visual presentation. Notice how the 'important' subject luminance range of 1:160 is reduced by half due to lens flare (mostly compressing shadows), then compressed still further over-all in the processed negative density values. On the print the range is re-expanded. Typically correct

printing exposure and choice of grade reproduces diffuse highlights just marginally darker than the paper base; and darkest shadow tone at about 90% of its D max.

Overall then, tones marginally lighter than black are still compressed; dark midtones and highlight areas are slightly compressed; but midtones (which are considered visually most important) reproduce with hardly any compression at all.

Information obtainable from quadrant diagrams. The concept of quadrant diagrams is important because it shows again the value of sensitometry in monitoring technique. These sensitometric controls are almost indispensable in work such as movie film developing and printing, and all machine processing. The small-time professional photographer would not bother to plot his results this way as routine; nevertheless the ability to read a typical quadrant diagram gives him a number of technical facts worth remembering. Here are some examples:

(1) The (apparently) logical concept of exposing so that all image luminances fall on the 'straight line' portion of the negative characteristic curve does not give the most accurate tone reproduction on the final print. Worse still, overexposure will give compression of just that part of the negative density range which receives least tone expansion when printed. This results in a lack of 'sparkle' in highlights. In both cases the situation is aggravated when the original image has a wide tone range–so much of the negative characteristic curve is in use that any processing or printing modifications to help reproduction of some tones will worsen others.

(2) When you intend to print on material other than printing paper a slightly different type of negative may be required for accurate tone reproduction. The printing material may have a characteristic curve with a long straight line portion (i.e. another negative material), instead of the usual 'S' shaped curve. Under such circumstances it is better to expose the negative so that all densities are on the straight line portion of its curve. This is further discussed under duplicate negatives, on page 148.

(3) It may be possible for a negative to record an image with a very long tone range (many emulsions encompass an image luminance range of 250:1 (2·4 log) between lower toe and shoulder) maintaining just perceptible separation of tones. However a quadrant diagram will show that no printing paper exists which has a curve of suitable shape and length to give a print with acceptable separation of such a wide range of tones. The blackest shadow on the paper is little more than 30 times as dark as the whitest highlight. In fact you can plot the negative, transfer and required reproduction quadrants–then use these to trace back the sort of curve the printing material would require for the job (Fig. 8.6). All this bears out what you have probably experienced in practice–a wide tone range image may seem to have recorded satisfactorily on the negative, but gives a print which is either flat and 'muddy' or (on a harder grade) lacks subtle midtone values and requires much printing-in and shading.

(4) If you know the approximate luminance range of the image, the characteristics of the printing material, and final tone reproduction required it is possible to plot the ideal negative characteristic. In practice this gives a good guide to the gamma to which the negative should be processed.

146

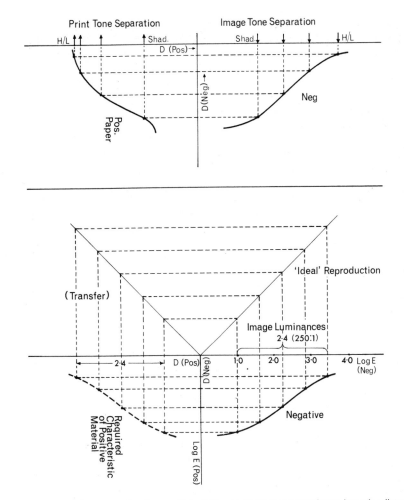

Fig. 8.6. Top: The result of overexposing the negative of this wide luminance range image is to give distorted print tone separation. Highlights in particular lack sparkle. Bottom: An extremely long image luminance range may just be recordable on the negative material (lower right). However, the quadrant diagram predicts the characteristics (lower left) of the positive material which would be needed to print it with exact tone reproduction. Commercial printing papers have neither this density range nor curve shape.

In short, quadrant diagrams represent a monitoring and predicting device for final image technical quality. Once again remember that they cannot tell you whether the image is visually satisfactory, because this almost always brings in much wider considerations than just tone reproduction.

Effect of flare. So far all the graphs you have been looking at deal with *image* luminance range, and consider printing in terms of *contact* printing. But if you are to trace tone reproduction right from the original meter readings off the subject, camera lens flare should be borne in mind. Similarly, professional prints are made by enlargement, which brings in the tone-modifying effects of enlarger lens flare.

147

Flare can be built into a quadrant diagram by using one quadrant for a flare curve and doing away with the transfer quadrant. If you are tracing reproduction from original subject luminance range (the negative being contact printed), the flare curve can be located in the bottom right hand quadrant. The negative and positive curves are moved clockwise to bottom left and top left quadrants respectively. If the negative is also being projection printed you obviously do not have enough quadrants to include an extra flare curve for the enlarger optics. Instead the 'readout' densities from the negative can be modified by readings off a flare curve outside the quadrant before 'feeding' to the printing material curve. Similarly the subject luminance range can be converted to image luminance range via a separate camera flare curve before being applied to the negative material curve.

A flare curve itself is simply a plot of subject luminance range against the image luminance range produced by the lens. (Negative density range against projected image luminance range in the case of the enlarger.) This can be made by comparative measurements of a whole series of representative luminances from highlight through to shadow detail. A typical flare curve for a camera lens having a flare factor of 2 is shown in figure 8.7. As expected (Chapter 1) the greatest tone compressing influence

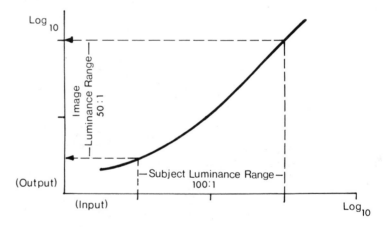

Fig. 8.7. Flare curve for a camera lens having a flare factor of 2. (See also figure 1.10)

is in the image shadows. A similar curve for an enlarging lens would show tone compression in the highlights (i.e. the image of the darkest part of the negative). In terms of compression of one end of the tone scale at the expense of the other, the flare curves for camera lens and enlarger lens tend to be self-cancelling – although they both contribute to a *reduction in tone range overall.*

Duplicating negatives

Quadrant diagram information can be most useful when black and white negatives are to be duplicated. 'Dupe' negatives may be required for distribution to various centres – their printing qualities should therefore all be identical and preferably identical to the original negative. Alternatively, a negative with high density overall

148

may require an uneconomically long exposure time in printing. If many prints are required it may be more convenient to reproduce the negative as a less dense duplicate, and print from this.

Negatives are normally duplicated by contact, in which case flare can be ignored. The duplicating material might as well be blue sensitive only—this allows the work to be done under convenient orange safelighting. There are several film emulsions of this type, having characteristic curves with long straight line portions.

First, you have to contact print the original negative on to one sheet of the film to give an intermediate positive. This in turn is contact printed on to a further sheet of film, giving the final negative. Care must of course be taken to avoid dust at every stage. If you are aiming at a duplicate with printing characteristics similar to the original negative, certain information noted from quadrant diagrams must be borne in mind.

(1) As you are using a negative material, and not printing paper for your final result, exposure of the interpositive should be such that only the straight line portion of the material's characteristic curve is used. The interpositive is then in turn printed with an exposure that places all densities on the straight line portion of the curve. The result should be a duplicate free of tone distortion. To achieve this you must use a material with a straight line portion long enough to encompass the whole density range of your original negative.

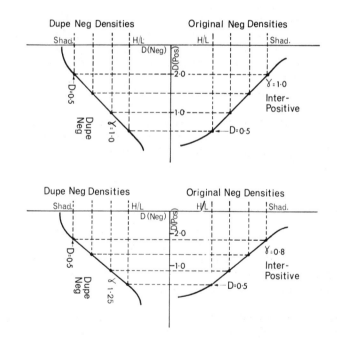

Fig. 8.8. Dupe negative making. Top: The result of developing both intermediate positive and duplicate negative to gammas of 1·0, and exposing each so that densities fall wholly on the straight line portions of the characteristic curves. Bottom: Results virtually identical to the above are possible when the inter-positive and dupe negative are processed to gammas of 0·8 and 1·25 respectively.

149

(2) To ensure that *all* the tones of the original negative fall on the straight portion of the emulsion's characteristic curve, sufficient exposure must be given (in both cases) to result in a minimum density well off the toe. A glance at a published curve for the chosen emulsion/developer combination will show this minimum density. Generally it will be found to be about 0·5.

(3) For the duplicate negative to have the same tonal range as the original, the slopes of the straight line portions of the interpositive and duplicate curves should both be 45° (Fig. 8.8). This is achieved by developing both to a gamma of 1·0. Alternatively, simple geometry shows that slopes (and gammas) can depart from this norm provided that the two add up to 90° (or gammas when multiplied together equal 1·0). For example, if the interpositive is measured and found to have a gamma of only 0·8, the dupe negative must be processed to a gamma of 1·25, which is the reciprocal of 0·8. Obviously it is easier to keep both to a gamma of 1·0 as processing can then be identical.

Recapping: You need an emulsion (which can be blue sensitive only) with a straight line characteristic which exceeds (on its log E axis) the density range of your negative original. It should also be capable of being developed to a gamma of at least 1·0. Developer is chosen which conveniently gives this gamma. By means of tests an exposure is given which just records highlight detail on the interpositive at a density of 0·5. The interpositive is checked for density range – if this is less or more than the original negative, gamma changes will be needed at the next stage.

The interpositive is then contact printed on another sheet of the film to give shadow detail density of 0·5 and gamma of 1·0. The resulting dupe negative will appear to have a slightly veiled appearance, (particularly noticeable in the normally clear rebate) owing to its minimum density, but should print on the same paper grade as the original.

Modifications: Improvements can be made to an original negative's printing characteristics during contact copying by altering gamma (overall density range change) or exposure level (changes restricted to sections of the tone range i.e. highlights) at either or both stages. Required modifications can be worked out previously with the aid of simple graphs. Chemical aftertreatment such as reduction (page 347) can also be carried out on interpositive or dupe.

Modifying tone reproduction by 'masking'

One very effective way of altering the tone reproduction of a negative is to combine it with a 'mask'. Masks can take the form of either positive or negative transparencies, and are bound up in register with the original negative. They may

(1) Reduce contrast, either overall or in certain tone areas only,

or (2) Increase contrast, overall or locally.

Masking to reduce contrast. If you make a positive transparency by contact with a negative and then combine the two together, the positive will add density mostly to the image shadow areas, so reducing contrast. In the extreme case of the positive exactly matching the negative in gamma and density, the combination will appear as a uniformly dark grey sheet of film – a '100% mask'.

150

The most common use for a black and white contrast reducing mask is simply to retrieve a negative of unprintably high density range – perhaps caused by over-development. An underexposed positive is used so that the combination remains dominantly negative, but has lowered density range. The result of masking can be shown graphically by characteristic curves but is more easily followed by a 'block' diagram (see Fig. 8.9).

Within limits, the greater the *exposure* given to the (normally developed) mask the more its contrast reducing effect extends into mid-tones and highlights. The greater the *development* given to an underexposed mask, the greater its effect on shadows relative to highlight tones. This can be exploited to give quite local effects.

Example 1: The all too frequent shot of a room interior in which window detail has been overexposed. Windows and part of the curtains are very dense and flat on the negative, although the room interior detail prints easily on grade 2 paper.

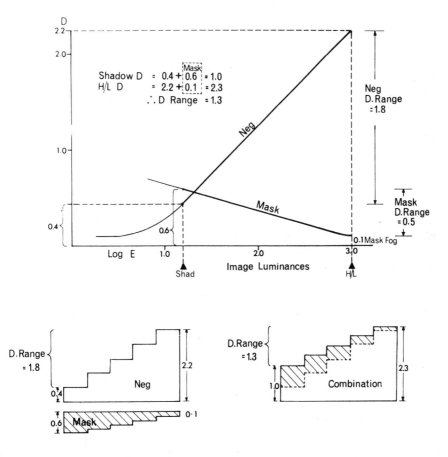

Fig. 8·9. Masking to reduce contrast. A negative with a density range of 1·8 (63:1) can be masked to a range of 1·3 (20:1) by the use of a 0·5 density range positive mask. This is expressed (top) by characteristic curves and (bottom) by block diagrams.

151

A very underexposed but normally developed positive mask is made (Fig. 8.10). The mask carries weak grey detail of the interior and has clear film representing window areas. Combined with the negative, the mask reduces the contrast and increases the printing exposure time needed for the interior detail part of the image only. The masked negative appears dense overall, but given sufficient exposure time on grade 3 paper interior and window detail print with equal contrast. 'Printing in' of complex window shapes (with that tell-tale blackening of curtains and window frames) is avoided or greatly reduced. See also Plates 24–25.

Example 2: A number of white iced cakes were photographed against a dark background. Due to bungling in the darkroom the negative was greatly overdeveloped and now carries an image looking like lumps of coal on a clear background. Low contrast tone separation can just be distinguished in the white cakes and, given a long exposure, would print on grade 4. But so much light is transmitted by the clear background areas during the long exposure in the enlarger that light scatter gives the cakes a grey, veiled appearance.

A mask is made by contact from the negative, exposure and development being sufficient to record a light grey background tone only. (Check that this density remains less than any density in the cakes on the original negative. If overmasked, the background will print grey.) Negative plus mask will now print on grade 4 to give the required black background on the print, but without the light spread which degraded the cakes on previous prints.

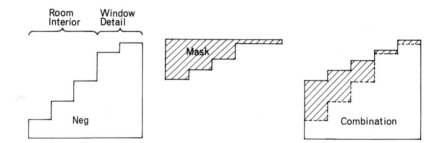

Fig. 8.10. Example 1: Room interior negative requires grade 2 paper, but window detail prints weak and flat. Centre: An underexposed weak positive mask is made. Right: The combination now requires additional printing exposure but all detail prints well on grade 3.

Masking to increase tone contrast. You have probably noticed how two thin underdeveloped negatives of an identical scene give a much more encouraging negative when superimposed. This is the basic principle of masking to increase contrast. The increase in tone separation is most marked in shadow areas (except deep shadows which recorded without detail on the original negative).

As the mask is this time negative in character it must be made via an interpositive. By controlling the exposure of interpositive and final mask it is possible to increase the contrast of certain shadow tones only. This selective boosting of tone separation, although used less frequently than masking to *reduce* contrast, can solve the occasional crisis in professional photography.

Example 3: An important wedding group negative has been somewhat under-

152

exposed and underdeveloped. On a hard grade of paper the bride's dress, other light clothing and people's faces print with acceptable tone separation. But dark suits merge with the background foliage in a sea of black. First a low density interpositive is made maintaining as much shadow gradation as possible and having detailless highlights. A weak negative is printed from this, resulting in a mask carrying separable tones in subject shadows, but detailless even grey tone over highlight areas. Mask and original negative when combined will require extra exposure to print through the neutral density over dresses and faces. But now subtle differences in tones between dark suits and background at last record in the print–the gain in quality is quite marked.

Practical mask making. When preparing contrast reducing masks the mask itself is often made slightly unsharp. There are two main reasons for this:

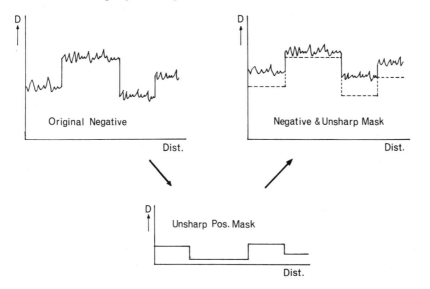

Fig. 8.11. An *unsharp* contrast reducing mask does not record fine detail variations in density. The combination therefore maintains original contrast in these local areas, whilst reducing the general density range.

(1) Slight diffusion of the image means that over areas of finest detail a simple 'average' even tone is recorded on the mask, whereas borders of larger tone areas record as tone changes. When unsharp mask and negative are combined contrast is reduced in all areas except the very fine (almost microscopic) detail, which more-or-less retains its original contrast, see Fig. 8.11. Visual sharpness or definition depends as much on detail contrast as actual resolution. A print from the combination, with its detail contrast relatively greater than its general contrast, appears slightly sharper than a print from the original negative. You have the curious fact that an unsharp addition to a negative improves its definition.

(2) Slight dimensional changes can occur in masks during processing and drying. Such changes could make registration between mask and original negative

153

impossible if the mask were critically sharp. An unsharp mask allows more registration latitude. This aspect of masking is less critical today owing to the more common use of non-stretch film bases such as 'Estar' or 'Mylar'.

The simplest way to prepare an unsharp mask is to separate original negative and mask emulsion by a clear sheet of 0·01 in acetate (fixed film). The 'sandwich' goes into a printing frame and is exposed to a very diffuse large area light source. Alternatively it may be exposed obliquely to a fairly small light source such as an enlarger with lens stopped down, but during exposure the frame is slowly rotated,

Fig. 8.12. Practical unsharp mask making. G: Printing frame cover glass. N: Negative, emulsion down. S: Clear spacer film. M: Mask film, emulsion up. (Alternatively the negative might be used emulsion up, without a spacer.) The sandwich is rotated during exposure to an oblique light source.

so that the light passes through the negative in a variety of directions, 'spreading' the image on the mask emulsion. The amount of spread is controlled by the number of spacers used and the obliqueness of the exposing light.

Contrast increasing masks are less frequently made unsharp, as the principle of enhanced definition cannot apply. However, as they are usually made via an interpositive, thought must be given to the way in which final mask and original negative can finally be registered emulsion to emulsion. Usually the mask is printed through the *back* of the interpositive, using a point light source centralized and some distance from the stationary printing frame.

Masking is one of those techniques which seems rather complicated when described in print, but is quite easy in practice. It has the great advantage of not hazarding damage to the original negative. The work can be carried out by trial and error in an ordinary darkroom. Masking also provides us with extremely useful methods of simplifying images for graphic effect (discussed in the next chapter) and for improving accuracy in colour photography (Chapter 12).

Related reading

JACOBSON, K. I. *Developing*. Focal Press 1974.
LOBE, L. and DUBOIS, M. *Sensitometry*. Focal Press 1967
JACOBSON, R. E. *The Manual of Photography*. Focal Press 1977
The British Journal of Photography Annual. H. Greenwood & Co.

Chapter summary – tone reproduction

(1). The aim of a speed rating system for monochrome materials is to provide figures which relate the light sensitivity of films, in terms of giving acceptable negatives under practical conditions. It should therefore take into account colour of light source; subject luminosity range; duration of exposure; degree of development; and the final negative quality required.

(2) Early speed systems were based on the exposure time required at the inertia point (H & D); the exposure to yield threshold density (Scheiner); the exposure to give a fixed density above fog of 0·1 (original DIN) or exposure to give a density equal to gamma (Weston).

(3) The original ASA system was based on the minimum exposure needed to give an acceptable negative of a 1·5 log luminance range subject. Although usefully related to practical results, plotting of the Jones point on the characteristic curve proved complex.

(4) ASA/DIN/BS/ISO international standard is based on the exposure to give a D minimum of 0·1 + fog and D maximum of 0·9 + fog from an image luminance range of 1·3 log. Speed figures derived from this exposure are expressed in arithmetic or \log_{10} terms.

(5) *Effective* film speed will always be influenced by colour of lighting, subject luminance range, imaging conditions, exposure duration, development and negative requirements.

(6) A complete 'graphic analysis' of final tone reproduction is possible by linking up image luminance range, negative characteristics, and positive characteristics in the form of a quadrant diagram. As all graph axes are calibrated in logarithmic terms the density readings from one characteristic curve can be applied directly as Log E figures to the next.

(7) Negative and positive curve relationships prove that the modern film emulsion is intended to be exposed partially on the toe of its characteristic curve to give most acceptable tone reproduction on the final print paper. When a negative is intended for printing on other negative material it may be advisable to expose all image luminances on the straight line portion of the curve.

(8) Whilst it may be possible to record a 250:1 image luminance range and maintain tone separation on the negative, no printing paper can handle the resulting range of densities. In fact, for a given image, quadrant diagrams can be used to estimate the most appropriate negative characteristics for the proposed printing material.

(9) Strictly, a flare curve plotting subject luminance range against image luminance range should be built into a quadrant diagram; similarly a flare curve for the enlarger lens when the negative is projection printed.

(10) Quadrant diagrams prove that when duplicating negatives by contact, we should use a material with a long straight line portion to its curve. Exposure of interpositive and dupe negative should be sufficient for the minimum density to be above the toe region (about 0·5). Both should be developed to a gamma of 1·0 (or gammas multiply to 1·0).

(11) Black and white tone reproduction may be further modified between the negative and print stage by 'masking'– the interposing of density to decrease or increase contrast, either overall or within a limited range of tones. Masking involves no risk to valuable original negatives.

(12) A weak positive mask is used to reduce negative contrast. The level of exposure and development of the mask determines whether all tones are masked or only shadow detail. To increase negative contrast a weak negative mask is needed – printed through the back of an interpositive.

(13) Contrast reducing masks are usually made 'unsharp'. This increases the apparent sharpness of the final print by maintaining fine detail at the original level of contrast; it also facilitates registration. Unsharp masks are printed with a clear spacer placed between negative and mask emulsion. The printing frame can be rotated during exposure to an oblique light source.

Questions

(1) Explain, with the aid of diagrams, how the printing quality of continuous tone negatives changes when exposure of the negative is varied from underexposure to overexposure.

(2) (a) Explain fully the making of an enlarged duplicate negative of similar printing character-istics to the original negative.

 (b) What difference, if any, would be seen between enlargements made from a duplicate negative and from a copy negative? The subject has a full tone range.

(3) An architectural interior subject to be photographed shows a brightness range of 1,000 to 1. The interior is too extensive for any auxiliary lighting to be effective. Outline a pro-cedure for producing a negative which may be printed on a normal grade of bromide paper. Use diagrams, where applicable, to illustrate your answer: assume a flare factor of 4 for lens and camera.

(4) A large number of prints are required from a client's negative which has been overexposed and which consequently needs an uneconomically long printing time in your enlarger. Discuss two ways in which this could be rectified and specify the action you would take.

(5) Describe the effect of flare in the camera on the relationship between gamma and printing contrast.

(6) What is an unsharp mask? Explain and illustrate graphically how it is possible to retain detail sharpness and yet reduce overall contrast when using an unsharp mask to improve the printing quality of an overdeveloped negative.

Fig. 8.13. Curves for Questions 8.

156

(7) A negative of unacceptably high contrast is to be masked so that the combination has a density range of 1·2. The original negative shadow density is 0·2 and maximum highlight density 1·9.

 (*a*) What shadow and highlight densities are needed for the mask?

 (*b*) The original negative required a printing exposure of 5 seconds. What exposure will be required to print the masked negative?

(8) You are required to make a (contact) duplicate negative with printing contrast characteristics similar to the original. The original negative densities are (shadows) 0·15; (midtone) 0·4; (highlights) 1·1. Fig. 8.13 shows characteristic curves for the material and developer to be used. By means of diagrams explain your technique, giving the density values you would expect to produce in interpositive and final negative.

(9) Write a short essay outlining the various speed rating systems which have received general usage since the original work of Hurter & Driffield, culminating in the current ASA/DIN/BS/ISO speed numbers.

(10) It is required to print a negative having a density range too great to be printed on the softest paper available, and so it is decided to make a duplicate negative to print on normal contrast paper.

 (*a*) List the steps in the production of this duplicate.

 (*b*) Show clearly, with graphs, how tonal distortion may be minimised.

(11) Explain and show graphically how the characteristics of negative and positive materials are inter-related in the final tone reproduction of an image.

9. PRINTING—UNUSUAL MATERIALS, EFFECTS AND TONING

This is the last chapter in the section devoted exclusively to monochrome photography. It gives an opportunity to look at a mixture of materials and methods which extend the scope of conventional monochrome printing. One or two less familiar printing materials offer special features or interesting visual effects. Both these and regular film materials can be handled in special ways to give startling results such as *bas-relief, posterization* and *solarization*. The print can also be toned various colours chemically. Finally there is a look at the conditions needed for maximum permanence of photographic prints and negatives.

Printing materials

By now you are familiar with the characteristics and handling of graded bromide paper, as discussed in Basic Photography, chapter XVIII. To these should now be added variable contrast papers, panchromatic and lith papers, and papers on coloured or translucent bases.

Variable contrast paper. Essentially, this is an ingenious way to avoid the need to stock paper in a wide range of grades (although, as you shall see, it has other advantages too). Variable contrast paper such as Ilford Multigrade and Kodak Polycontrast changes its contrast characteristics with the colour of the light source used for printing. Typically the emulsion is made up of a mixture of high-contrast blue-sensitive and low contrast green-sensitive silver halides. When exposed under an unfiltered enlarger both emulsions are affected, giving a contrast about intermediate between the two separate emulsions. If a pale yellow filter is placed over the enlarger lens (or in the filter drawer) the yellowish light has greatest influence on the green-sensitive silver halides and the paper becomes less contrasty. When a magenta or purple filter is used, the blue-sensitive halides receive relatively more exposure and the paper becomes hard. By having a range of filters which vary in the amount of blue and green light they absorb (Fig. 9.1), the same paper can be made to behave as any grade between the extremes of one emulsion and the other.

The advantages of variable contrast papers are (1) reduced paper stocks; (2) ability to shade a local part of the image, change filters, and then print it in again at a different contrast; (3) special applications such as D & P work, where a wide range of negatives must all be exposed on one continuous roll of paper for machine processing.

From the professional's point of view its disadvantages over regular graded papers are: (1) time wasted in sorting and changing filters, and adjusting exposure times; (2) the best possible print quality on variable contrast paper probably never quite reaches the quality of a graded paper. To help overcome (1) it is possible to use an enlarger with a dial-in colour head (page 261), then set different degrees of yellow or magenta filtration to control contrast. However, the colour printing filters may not be quite strong enough to shift contrast to its extreme limits. One manufacturer has produced a special enlarger head for variable contrast paper. This has two light sources—filtered yellow and magenta—which can be dimmed or brightened relative

to each other via a keyboard scaled in grade numbers. The control unit also automatically compensates exposure time so that tests made at one grade setting give the same print density on another.

Fig. 9.1. Top: Absorption curves for seven filters, ranging from yellow to deep magenta, used to control the contrast of Ilford Multigrade paper. On a colour head enlarger the equivalents are 45Y (for 1) and 170M (for 7). Bottom: Each filter gives slightly less than the equivalent of one full change of grade on regular bromide paper, shown below the line. NF indicates no filter.

Rapid processing papers. As mentioned in Chapter 7, some bromide printing papers (such as Kodak *Ektamatic*, and Ilford *Ilfoprint*) have a developing agent included within the emulsion. The developing agent remains inert in the absence of alkali. After exposure the paper is fed into a machine between motor-driven rollers which apply a powerful alkali or *activator* to the emulsion surface only. The alkalinity of this solution makes the gelatin of the emulsion highly absorbent, allowing the activator to permeate the emulsion very rapidly. The activated developing agents do not of course require the usual inertia time to penetrate the gelatin, and development is completed within 2–4 seconds.

The paper then proceeds to the second section of the machine where it dips briefly through a trough of stabilizer (commonly acidified ammonium thiocyanate). A slightly damp, stabilized print emerges from the machine having taken only 10–15 seconds for the whole processing cycle. The print should not be hot glazed – heating may change the balance of the stabilizing chemicals and also risks contamination of the glazer. Chemical aftertreatments such as toning should also be avoided.

Papers for activate/stabilize processing are made in almost as many grades and

160

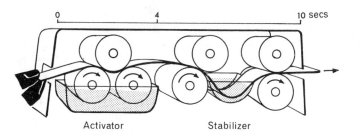

Fig. 9.2. Layout of an activate/stabilise machine for rapid processing papers. The exposed paper must be fed in emulsion down. Reservoirs are used to maintain the solution levels in the two troughs.

surfaces as bromide paper, which they can now equal in speed. Other, contact, papers are slow enough to be handled briefly in 'white' room lighting, avoiding the need for a darkroom. Image quality at its best is almost equal to conventional bromide paper but the stabilized print is impermanent (page 170). However it can be made permanent at any time by fixing and washing in the normal way. Prints may then be glazed.

These papers provide a release from the traditional dish methods of processing, which require plumbing facilities. In press photography they are perfectly acceptable for blockmaking and complement the increasing use of machine processing for negatives. Against this, roller processing can be *slower* than conventional dish processing for large numbers of prints which would otherwise be processed together in batches. The arrival of plastic base regular bromide papers, which process and wash within 6 minutes and give permanent results, has reduced the attraction of stabiliastion materials.

Panchromatic paper.　Black-and-white prints can be made directly from colour negatives onto ordinary bromide paper. However, conventional blue sensitive printing papers give inaccurate tonal reproduction – subject reds would print too dark and blues and greens too light (these colours are cyan, yellow, and magenta respectively on colour negatives). Special papers such as Kodak Panalure with a panchromatic sensitivity are available, and apart from some difficulty in handling (no safelight is permissible), processing follows the same routine as any conventional bromide paper. Colour correction filters can be used on the enlarger when it is necessary to modify tonal relationships between colours.

High contrast (lith) materials.　Strictly speaking lith materials are designed for lithographic photomechanical reproduction (Chapter 15) but their exceptionally high contrast and maximum density of about 3·0 offer interesting possibilities for some types of general photography, and particularly for making bold graphic images. Lith papers and films are orthochromatic in colour sensitivity in order to improve their otherwise very slow speed. Particular care must be taken in the printing room – deep-red safelighting is *essential*. Lith emulsions are thinly coated to preserve maximum sharpness, their characteristic curves have a very short toe and a long, very steep straight line portion giving a gamma of over 10.

161

Lith emulsions are intended to be processed in a special lith developer discussed previously (page 122). Owing to the 'infectious' characteristic of this developer, the image progresses very slowly during the early part of development, building up in maximum exposure areas only – then suddenly gaining density during the last 30% of development time. Beyond a certain point image spreading and veiling of clear areas occurs, so that overdevelopment should be avoided. Remember that the hydroquinone developing agent used has greatly reduced activity below about 10°C (50°F.) Developer temperature should be watched just as carefully as time. The solution also needs renewing frequently – it soon oxidizes and discolours.

Underdevelopment, or development in an exhausted solution, produces a lower contrast sepia-brown image, which on paper can be attractive. Try giving an enlargement on lith paper 4-5 times correct exposure, then develop by inspection in lith developer diluted 1:1. Unfortunately the interesting yellow-brown (even orange) black image is very difficult to reproduce photomechanically on the printed page.

Another advantage of lith papers is that, properly handled, they allow 'line' prints to be made direct from normal continuous tone negatives. Grey tones simplify to either black or white, according to the level of exposure given.

Lith emulsion on stripping film is coated over a sub-layer of special gelatin which softens easily in warm water. After processing the emulsion membrane can be floated off the support, manipulated, and floated back onto another support or over another processed emulsion prepared with a special adhesive. It offers interesting scope for distorting line images of lettering etc., or simply allows a line caption to be transferred onto a negative or print.

Lith film materials such as Kodak Autoscreen are specially made to produce a 'screened' image direct. This means that when exposed under an ordinary continuous tone negative and processed, the film gives a positive image in the form of tiny half-tone dots, over 40 per cm (100 per inch). (The principle of self-screening film is explained on page 307.) Coarse dot image prints can be made by contact printing 35-mm film on this material, enlarging a section of it back onto high contrast film and from this enlarging the final positive print.

Apart from lith materials, high contrast papers are made under the general heading of *document papers*. These are really designed for contact printing from books and other printed matter. Generally document papers are blue sensitive only, much slower than lith materials and may be processed in concentrated M.Q./P.Q. developers. They do not yield the high maximum density characteristic of lith emulsions.

Materials on unusual supports. Continuous tone bromide emulsion is coated on opal (milky white) film for making monochrome display transparencies. Opal film is exposed under the enlarger and processed conventionally, but exposure should be such that the image looks dense by reflected light. When a lamp is placed behind the film this gives an effective, full-toned transparency. No further diffusion material is required between lamp and film, so that the transparency is very convenient for display purposes in exhibitions, shop windows, etc.

A glance at photographic manufacturers' catalogues shows the range of film. fabric and paper based printing materials available. These include bromide emulsions coated on brightly dyed paper bases, eg Autone papers. Exposed and processed in

162

normal print developer the result is a black image on a coloured ground. Most manufacturers of these papers also market a special silver bleach. After normal processing this is used to change the black image to white paper, giving a white-on-colour reversed-out effect.

There is hardly any end to the supports possible for photographic printing if you are prepared to coat your own emulsion. Fabrics must first be sized, woods and metals sealed, glazed surfaces cleaned. 10% potassium bromide in warm gelatine is first applied and allowed to dry, then 10% silver nitrate is applied (under safelighting). The negative is contact printed onto the sensitive coating by daylight to give a barely visible image which is then amplified in a solution of 0·1% metol, 2% acetic acid. Fixing and washing follow. It is not easy to form an image which has satisfactory quality, and stands up to normal handling. Tins and aerosols of ready-made bromide emulsion, such as the US made Rockland 'E-Mulsion', are more satisfactory than home-made concoctions.

Special effects in printing

A very wide range of special and unusual effects is possible using ordinary printing materials, and has formed the basis of several books. In practice the main limiting factor is the *purpose* of the image. Many effects produce weird results which can easily seduce us into a world of gimmickry . . . the purpose of the picture is forgotten and techniques are practised for their own sake. Of course experimenting is useful in terms of experiencing what can be done, but remember that professional assignments requiring these effects are very rare. For this reason only bas-relief, tone-line, solarisation and posterisation are described here.

Bas-relief. If a same-size positive transparency is made from a negative, and the two are combined with slight lateral displacement, the image is given a pseudo *bas-relief* appearance. According to the direction and amount of displacement, the boundaries of tone acquire strips of lighter or darker density. In this way a flat, two-dimensional subject can print as if it has 'shadows' simulating a shallow depth embossed relief, lit from one side. The result is greatly influenced by:
 (1) The density and contrast of the positive relative to the negative. The greater the difference between the two, the less the bas-relief. If the positive is made denser than the negative the final print will have predominantly negative tones and vice versa.
 (2) The type of subject and lighting. Generally a subject containing various patterns, rendered sharp throughout and having mainly shadowless lighting gives a more interesting result than masses of conflicting shadows.
 (3) The direction and amount of displacement, relative to the subject and the intended degree of enlargement.
It is easiest to work with sheet film. Contact print the original negative onto a sheet of continuous tone film which can be conveniently handled under a red safelight. After processing and drying use an enlarger with a negative carrier having cover glasses to maintain the two films in total contact when exposing onto the final paper.

Tone-line effect. Basically this is a process to convert a continuous tone image

163

into a line (i.e. pen and ink) drawing. A 100% mask–a positive transparency on film exactly matching the original film negative in density and contrast–is first prepared. Negative and mask are then taped back-to-back in register and contact printed onto high contrast film using an oblique, moving light source. The positive and negative exactly neutralize each other's tone values. But owing to the two thicknesses of film base separating the emulsions, the oblique exposing light 'spreads' around the boundaries of tones to give a line effect. The high contrast film therefore carries a black 'ink line' image on a clear background, which prints as a white line on black. If the reverse is wanted the line image must be normally contact printed onto another sheet of line film, which is then used for printing.

The width of the final line depends upon:

(*a*) The thickness of the bases of original negative and mask.

(*b*) The angle of the exposing light (see Fig. 8.12).

(*c*) The amount of printing frame rotation or lamp movement during exposure.

(*d*) The exposure level and development of the line material.

(*e*) The degree of final enlargement.

Fine detail subjects produce interesting line images, but they must be sharp and preferably softly lit. Several variations are possible–for example making the mask less than 100% so that one or two of the darkest areas print as tones.

Solarization. Strictly speaking solarization is reversal, or partial reversal, of the image due to gross overexposure. The effect discussed here, although described by photographers as solarization, is the *Sabattier effect* or *pseudo-solarization*. Whatever the name, the effect is easily distinguished–the reversal of weakest densities, and the formation of a thin contour line around strong tone boundaries. It therefore contains some of the characteristics of the tone line effect, but is achieved quite differently.

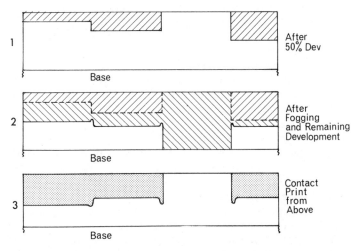

Fig. 9.3. Cross-section of an emulsion undergoing solarization (*Sabattier effect*). Silver formed during the first half of development influences the depth of emulsion affected by the fogging exposure. Stage 2 gives a very dense image. This may be contact printed onto film to give a less dense result–and at the same time contrast can be increased to emphasise edge effects.

164

A normally exposed negative is partially developed, fogged to light, and allowed to continue development. The previously unexposed (shadow) areas now develop up to a much greater density than the original midtones and may even exceed the highlights. At the same time a line of lighter density appears along the boundaries of fog exposure density and original image density. The reasons for these effects are not fully known, but are probably due to the physical masking of silver halides— developed silver protecting mid-tones and shadows from the effect of fogging. Also oxidation products formed during development in highlight areas 'densensitize' or reduce the light sensitivity of halides in these areas, so that they do not greatly respond to the fogging light. The border effects are caused by concentration of alkali bromide discharged from the original areas of high density restraining development of the fogged emulsion where the two boundaries meet.

In practice pseudo-solarization is quite difficult to control and therefore it is not advisable to try fogging an original negative. The negative is best either contact printed or (35 mm) enlarged onto a fairly contrasty film—preferably one with a thick emulsion i.e. line *not* lith material. About halfway through development the film is exposed *emulsion up* to a white light source. Use a safelight without a filter, or the enlarger as set up to print the image, but with the negative removed from the carrier. As a rough guide keep the enlarger lens at the same setting and give a fogging exposure equal to the printing exposure time. The negative can either be exposed lying in its dish of developer, or removed from solution and laid on black paper on the baseboard.

Development is recommenced, with occasional agitation, and given its full time. You will find that the image appears to fog over completely. Any attempt to curtail development may result in patchiness. After processing and drying the positive will be seen to have a mixture of positive and negative tones, some having light borderlines. The whole image will be very dense. This can be enlarged direct, or contact printed onto another sheet of fairly high contrast film and processed without solarization to give a printing negative of more acceptable density (Fig. 9.3).

Note that when working on an intermediate positive in this way it is the original image *highlights* which tend to reverse, and border effects are white on the final print (see Plate 22). Solarizing a negative (dupe or original) gives greatest reversal to image *shadows* and black border effects on the final print. Many variations are possible. For example, positive and negative may both be solarized—this gives double lines. The image exposure relative to solarization fogging exposure makes decisive changes in tone rendering. If fogging exposure is slight the tone values, except for weakest densities, remain substantially unchanged. Excessive fogging exposures reverse well into the mid-tones. The result may be so dense and low in contrast that border lines are barely separable in tone.

The contrast characteristics of the material used for positive and negative stages naturally affect the tone separation of the results; also the degree of final enlargement influences the width of the border lines. Solarization can be practised direct onto printing paper by fogging a print during its development. For best results use plastic base paper, then use this like a negative to run off contact prints on hard grade paper. Solarization is well worth trying. By using this technique, some exciting images can be made from ordinary pictures. Subjects should be pin-sharp, with well defined outlines.

165

Posterization (or extreme tone separation). It is possible to produce a print having a predetermined number of tones between black and white, each tone being non-graduated like a flat wash of poster colour. Where graduated tone existed in the original image, a posterized print simplifies this to a series of contours containing solid areas of flat tone (Plate 23). Once again this is a darkroom process, working from a continuous tone negative.

Imagine for example that you wish to make a posterized print with flat tones of black, dark grey, light grey and white only. Interpositives are made by contact or enlargement onto contrasty lith film processed in appropriate developer. The first positive is underexposed so that only subject shadows record; being lith material they appear dense black, with all other tones recording as clear film. The second positive receives

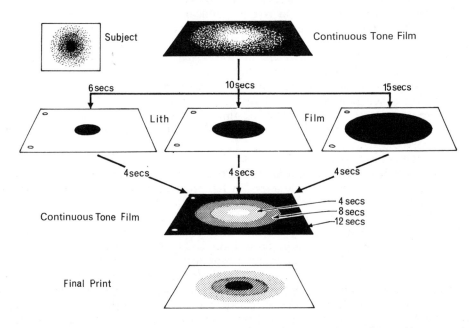

Fig. 9.4. Posterization. From a continuous tone negative three high contrast intermediate positives are made at different exposures on lith type film. In this way luminance is represented by *area*. Register punched positives are printed in turn onto one sheet of film, resulting in a negative with contoured areas of flat tone. (See Plate 23).

more exposure so that dark mid-tones merge with shadows as dense black. The third positive is overexposed, and shadows, dark mid-tones and light mid-tones record black. Only highlights appear as clear film.

Each positive is now printed in turn (and in register) onto one sheet of continuous tone film. The first positive is printed with just enough exposure to produce a light grey tone in highlight areas, if the continuous tone film were processed at this stage. The first positive is now removed and the second positive exactly registered in its place and exposed for the same time. Finally the third positive replaces the second, and the same exposure given again. It can be seen (Fig. 9.4) that each successive positive has smaller and smaller clear areas. Therefore only highlights have received all

166

three exposures, light midtones were covered after two, darker mid-tones were covered after one, and shadows were covered by all the positives. The result is a master negative with black, two greys and white in flat areas of clearly differential tone. The negative can now be printed normally, using a paper which gives good separation of these few tones (say grade 3).

Note how *three* separations are needed to give *two* grey tones, plus black and white. To give four greys, black and white, you would need five separations, and so on. In fact the more separations you make, the more the result looks like the original continuous tone image.

Registration is most easily solved by punching two holes in the rebate of each separation in exactly the same position relative to the image (register punches are sold for such a purpose). Register pins either in the enlarger negative carrier or printing frame are then used to ensure that each separation takes up precisely the same image position when printing.

There are several alternative ways of making a posterized print. For example the interpositives can be printed on separate sheets of lith film to give a set of negatives. These are then printed in turn onto the printing paper. Such a system involves an extra stage and makes final printing a slow business. The use of lith material twice does however ensure that each separation carries only dense black and clear areas, without a vestige of grey. A further short-cut alternative is to take the three lith inter-positives and print these onto three sheets of continuous tone film. The images must be grey and weak. All three negatives are then superimposed, held between glasses in the carrier, and enlarged directly.

All the special printing effects described here offer further opportunities in colour printing (Chapter 14). Extra permutations are then possible by giving the bas-relief positive or each posterized separation a differing colour balance.

Chemical aftertreatment of prints—Colour toning

The final image on the printing paper is normally described as 'warm', neutral, or bluish *black*. But black metallic silver can be toned a variety of colours such as sepia, green, blue etc., usually by conversion into some other, coloured, chemical compound. (Do not confuse toning with tinting. Tinting is application of colour wash which can stain the gelatin or base across dark *and* white areas of the image.) Prints or transparencies for toning should have:

(1) A density suitable for the process to be used. This often means plenty of highlight detail, as most sepia toners for example slightly reduce print density.
(2) A fully developed image. A print with curtailed development may be acceptable in black and white, but often yields a poor image colour when toned.
(3) Full fixation. Unfixed silver halides tone along with the image, giving degraded whites.
(4) Effective washing. Contamination produces uneven patches and stains. The dishes and water supply used during toning should similarly be free of rust or metallic particles. If in doubt use a filter over the tap.

The toning formulae still in practical use can be broadly divided into (a) sepia toners (b) metal tones and (c) colour developers.

167

Sepia toners. The black image is converted into sepia coloured silver sulphide or selenide. This is a very permanent image–more permanent than black silver, which itself tends to break down into silver sulphide over a period of time. The actual sepia colour varies with the type of emulsion (coldest with bromide, warm to the point of ginger with chlorobromide), also the original amount of print development and the toner formula used.

The most common sepia toner uses a silver bleach followed by darkening in sodium sulphide.

<div align="center">

Bleach: Potassium ferricyanide 2%
 Potassium bromide 2%

</div>

The solution keeps well stored in the dark, and can be reused until exhausted. This bleach 're-halogenizes' the silver image–the ferricyanide oxidizes the silver which reacts with the bromide and reverts to a silver halide. Bleaching is allowed to continue until *all* the black image becomes a faint yellow-brown. It is then rinsed for 1–2 mins to remove most of the yellow ferricyanide, and darkened in

<div align="center">

Sodium sulphide 2%

</div>

(Stored as 20% stock solution. Use well away from sensitive materials and in a well-ventilated area owing to the hydrogen sulphide generated.)

The sulphide changes the silver halide into silver sulphide. Alternatively, for colder sepia tones, selenide can be formed along with the sulphide by darkening in

<div align="center">

Sodium sulphide 1%
Selenium 0·1%

</div>

In both cases darkening must be taken to completion (about 3–5 minutes) and the toned image then washed for 15–20 minutes.

There are various other ways of sepia toning. For example the image can be toned without bleaching simply by leaving it for about 20 minutes in the sulphide or selenium darkener. Some photographers prefer to work with an odourless substitute for the sulphide solution, consisting of 0·2% thiourea plus 10% sodium carbonate (anhyd.). Other methods include formalin hardening of the print, followed by a period in a 53°C solution of hypo and potash alum (hypo-alum toning).

Metal toners. These toners convert the silver either into a coloured metal or a compound containing silver and a coloured metal. Most of them are impermanent, and almost all give rather garish red, green or blue colours. Most formulae combine bleacher and darkener in one solution. For example, an iron (blue) toner contains potassium ferricyanide, sulphuric acid, and ferric ammonium citrate. The silver is converted to silver ferrocyanide and then ferro-ferricyanide (prussian blue). This particular metal toner slightly intensifies the image.

Other colours are produced in solutions containing cobalt chloride (green); lead acetate (yellow); nickel nitrate (red). For formulae see Appendix V. Most metal and sepia toners can be bought in handy packs, ready to mix a few ounces of working solution.

Colour developers. The principle of toning by colour development is one of silver

168

bleach followed by redevelopment to create an image which is chemically colour stained. The black metallic silver image is first put through a rehalogenising bleacher. It is then redeveloped in a chromogenic or *colour developer* which reforms a black metallic silver image and in doing so produces special oxidation products which combine with *colour forming* chemicals in the solution to form an additional coloured image. The colour depends upon the colour formers present. The photographer chooses the required colour from a range of formers—where necessary mixing proportions of several formers together to get intermediate tints. At this stage the toned image is barely apparent, owing to the presence of redeveloped silver along with the colour. The final stage is therefore to remove the silver via Farmers reducer (page 347) and washing. Only the coloured image then remains. If necessary, this bleaching can be stopped when only partially completed, so that darker tones in particular retain some silver.

Toning by colour development is more permanent and flexible than metal toning. It is not really practical to prepare colour developer and formers from basic chemicals as complete kits containing developer, formers and bleaches are available.

Chemical reduction of prints

Generally speaking, the chemical intensification and reduction of prints is not worthwhile, because it is usually quicker (and therefore cheaper) to make the print again. In any case intensification usually produces a change of image colour which is unacceptable in a print. Sometimes when making single large prints local reduction over areas of heavy density is justified—if it can be done quickly and well.

Farmer's (ferricyanide/hypo) is still the most useful reducer for taking density down a few tones. The print should be fully fixed and given a few minutes wash before treatment. By means of scrap prints check that the reducer is diluted sufficiently for the required reduction to take a reasonable period of time (say 30–40 seconds). Otherwise there is risk of uneven action. Keep a dish of clean running water nearby and transfer the print to this every 10 seconds or so. Overlong continuous immersion in the reducer can produce permanent yellow stains.

If the reduction is only needed locally, place the print on an inclined plastic sheet and wipe off surface moisture. The reducer can then be applied using cotton wool. Use a hosepipe with plenty of running cold water to swill over the print at frequent intervals. Avoid using Farmers reducer in direct sunlight. After reduction re-fix the print and wash thoroughly.

Sometimes fairly heavy print density must be reduced right down to white paper, e.g. unwanted backgrounds bleached out etc. Farmers reducer often leaves a faint yellow stain when used for this purpose, and a strong iodine bleach is much more effective. The solution, which keeps well, contains:

Potassium iodide 1·5%
Iodine 0·4%

This is painted onto the unwanted areas of the nearly dry print, using a brush or cotton wool swab. The black silver rapidly bleaches under a yellow-brown stain. Work can continue for several minutes without rinsing, and there is no risk of the print acquiring a permanent stain. When the bleaching is finished swill the print

surface with water to remove surplus iodine. Bleached areas still retain most of their strong brownish stain The print is next placed in a dish of 20% plain hypo which clears the bleached area to a clean white. It is then washed fully.

Permanence of negative and positive monochrome images

Suppose you have produced a conventionally processed black-and-white photograph. The client may well ask how long will it last? In normal climates, with efficient processing followed by storage in dry, well ventilated conditions and away from direct sunlight, black metallic silver images should have a life of many years. If it is essential that the records last for about 20 years a spot sulphide test (*Basic Photography*, chapter XVII) for residual silver compounds should be made. No hypo should remain in the emulsion, particularly when the base is of paper. Use of a hypo eliminator (Appendix V) towards the end of the normal washing period will be essential for prints. Where possible store the printed material in air conditioned premises where relative humidity can be kept between 25 and 60%. Avoid high temperatures.

Archival permanence–storage without deterioration over some hundreds of years–is a rather different matter. With the increasing use of microfilm to store records of priceless documents it has become important to ensure that they pass on to our descendants intact. Governments have spent money and time on this problem, carving out film vaults deep under hills, and installing elaborate air conditioning plant. Eastman Kodak have suggested the following seven requirements for archival permanence, based on our limited experience of a process which is itself little more than 100 years old.

(1) Tests for residual silver compounds must be negative; residual hypo must not exceed 0·0007 mg per sq. cm.
(2) Paper based prints should be toned with sulphide or selenium, or gold.
(3) If prints are to be stored mounted, only dry mounting should be used. Mounting and packing boards must be of best quality material, least likely to contaminate the image.
(4) Photographic images should be stored in cans with loose fitting lids or in individual envelopes. If in the latter the paper must be free from harmful chemicals and must not easily absorb moisture from the air. Be careful of the adhesives along the seams of envelopes–they must not release acids or sulphur compounds under the action of mould or bacteria. Emulsions should face away from envelope seams.
(5) Images should be lodged in metal cabinets or drawers having open louvres to allow free passage of air. The envelopes or cans should be stored on edge, and not packed so tightly that sideways pressure is excessive. There should be space for free circulation of air around the metal cabinets themselves. Avoid storing photographs near fresh paint, raw woods and volatile substances.
(6) The store *must* be air conditioned with a relative humidity of 40%–50% and temperature near 21C (70F),
(7) The air *must* be filtered, cleansed of acid gases, and circulated under slight positive pressure to reduce incoming contamination.

It may also be worth utilizing a non-silver process (e.g. electrophotography or video-tape recording), which can give an inherently more permanent image.

Related reading

CROY, O. *Design by Photography*. Focal Press (London) 1971.
JACOBSON, K. I. and MANNHEIM, L. A. *Enlarging*. Focal Press (London) 1975.
HEDGECOE, J. *The Photographer's Handbook*. Ebury Press/Random House 1977
PETZOLD, P. *Effects and Experiments in Photography*. Focal Press 1978
The British Journal of Photography Annual. H. Greenwood & Co.

Chapter summary—Unusual printing materials, effects and toning

(1) Variable contrast papers are coated with two emulsions, differing in contrast and colour sensitivity, i.e. one blue sensitive and the other sensitised to green. Effective contrast is controlled by using yellow- and magenta-coloured filters to vary the colour of the enlarger light source. Filters which absorb blue cause the green sensitised emulsion to dominate contrast, and vice versa. Advantages include ability to print in local areas at a different contrast grade; and reduction of paper stocks.

(2) Rapid processing paper contains developing agent within the emulsion. The exposed paper therefore develops within seconds when alkali 'activator' is roller applied to its surface. Logically, this is followed by brief immersion in a stabilizer, giving a complete print processing cycle in 10–15 seconds. Stabilized prints should not be not glazed or toned, and are impermanent unless fixed and washed in the normal way. Applications include rapid proofing (contacts and enlargements) and prints for press reproduction.

(3) Panchromatic paper enables monochrome prints with acceptable tone reproduction of subject colours to be made from colour negatives.

(4) High contrast lith materials achieve a high maximum density owing to the infectious development effect of oxidation products when processed in special lith developer. Continuous tone negatives will print as 'line' or yellow/sepia images direct on lith paper, but as the paper is ortho sensitized (to boost speed) deep red safelights are essential. Lith emulsions are also coated on film, including stripping film and autoscreen materials. For high contrast prints with less maximum density and speed, but developable in orange safelighting, use document papers.

(5) Opal film based printing materials are available for making display transparencies which do double service as prints by reflected light. Coloured bromide papers are also available for display work. In exceptional circumstances printing emulsions can be coated on prepared surfaces of woods, metals, glazed materials, etc.

(6) By combining a negative and positive transparency, with registration displaced laterally, a *bas-relief* effect is created. When a 100% positive mask is registered back to back with a negative and printed onto line film with a moving oblique light source the result is a *pen-and-ink* effect.

(7) *Pseudo-solarization (Sabattier)* is partial reversal of tones combined with a line effect around tone boundaries. It is caused by fogging during development. A thick, contrasty emulsion film is used and given white light exposure (equivalent to image exposure) halfway through development. The dense solarized image is usually printed again on line film to give a usable negative.

(8) *Posterization* effects rely on separation of tones by exposing the image onto high contrast films at differing exposure levels. Each film is then printed separately in sequence onto continuous tone emulsion to give areas of flat tone—the number of tones being linked to the number of separations.

(9) Prints for toning should have suitable density, be fully developed and fixed, and properly washed.

(10) Sepia toning by conversion of silver to silver sulphide or selenide usually calls for a re-halogenizing bleach, followed by darkening in sulphide or selenium. Results are very permanent.

(11) Metal toners convert silver to green, yellow, red, blue, etc coloured metals or silver/metal compounds. Most are impermanent.

(12) Re-halogenized silver can be redeveloped in a *colour developer* containing a chosen *colour former*. Oxidation·products combine with formers to give a dye image together with the redeveloped silver. Finally the silver may be bleached away to leave the colour toned image.

(13) The two most useful black and white print reducers are Farmers (to lighten tones), and iodine (to bleach chosen parts of the image down to white paper). Both are followed by fixing and washing.

(14) To ensure reasonable permanence use hypo eliminator; give a sulphide test; store under controlled humidity; avoid heat. For archival permanence, add sulphide toning; arrange air conditioning (filtered) at 21C (70F).

Questions

(1) Give an account of two methods of sepia toning and state what factors affect the final image colour produced.

(2) How can each of the following be·produced:

(*a*) a photograph exhibiting the Sabattier effect or pseudo-solarization.

(*b*) a print exhibiting posterization or tone separation.

(*c*) a 'coarse-grained' print from an existing fine grained negative.

(3) What do rapid processing systems for black and white prints offer the professional photographer? Discuss the advantages and disadvantages of such systems compared with conventional processing procedures.

(4) Explain the function of the following:

Colour developer

'Rehalogenizing' bleach

Lith.developer

(5) For layout purposes a graphic designer requires a portrait to be reduced to very simple powerful tones including no more than one grey between black and white. Discuss an effective method of producing this result in terms of lighting, camera material, and printing material and technique.

(6) Photographs of an historic building are required prior to its demolition. Prints are to be lodged with the city archives and must remain in good condition indefinitely.

(*a*) Describe your technique to produce prints of archival permanence.

(*b*) Make recommendations to the authorities for appropriate storage of the work.

(7) What is the principle of variable-contrast bromide paper? Discuss the practical advantages and disadvantages of using this material instead of conventional graded papers.

Section III

COLOUR PHOTOGRAPHY

10. HOW COLOUR EMULSIONS WORK

Many hundreds of colour photography systems have been devised in the past. Early patents, including those for colour movies, range from the ingenious to the highly fantastic–and large sums were lost by those who invested money in hopeless processes. A whole book could be written on pioneer colour systems, some of which were quite widely used in their day. This chapter starts by looking at one or two which, in becoming obsolete, led to modern colour films.

Thomas Young suggested in 1801 that the human eye responds to colours by means of *tri-colour* receptors. He stated that the retina at the back of the eye appears to contain three types of colour sensitive receptor–one type primarily sensitive to blue light, one to green and one to red light. Varying signals from thousands of these three mixed receptors give the brain the sensation of any colour. This theory, later known as the Young-Helmholtz theory, provides one of the earliest foundations for systems of colour photography.

During the middle of the 19th century physicists such as Clark Maxwell and others demonstrated the formation of colours by combining three light sources. Each light source was filtered to transmit about one-third of the spectrum–the colours used being red, green and blue. These are known as the *primary colours* for light because by separately projecting each colour and making them overlap together on a screen, white and virtually all other colours can be simulated.

For example, if a patch of projected blue light is overlapped with green light a blue-green intermediate colour is seen. If green light is overlapped with red the appearance is yellow (intermediate in the spectrum). When red and blue lights are overlapped a magenta or reddish purple is seen. By varying the relative intensities of the three primary lights a very wide range of intermediate colours are simulated. If appropriate intensities of all the three primaries are overlapped the screen will reflect all colours and appear to approximate white.

Maxwell realized that photographic images could be used to modify the intensities of the three light sources. In other words three black and white negatives should be taken of a scene, one through a red filter, one through a green filter and one through a blue filter. A positive black silver transparency could then be made from each negative and projected in a lantern fitted with the filter used in taking that negative. The three images projected by the three lanterns should overlap on the screen, and reform all subject colours.

Unfortunately for Maxwell he worked at a time when the normal photographic materials were collodion plates, limited to little more than blue sensitivity. Some of his experiments to prove his ideas nevertheless gave encouraging results within the very severe limitations of his material.

Other scientists–notably Louis Ducos du Hauron in France–were also handicapped by the primitive state of photographic materials. In a brilliant book (*Les Coulers en Photographie*) published in 1869 he (independently) put forward many principles of colour photography systems, even forecasting some of the methods in use today. Very few could be followed up at the time, for the same reasons that frustrated Maxwell. It could therefore be said that it was Vogel's discovery of colour

sensitizing dyes in Germany during the 1880s that really opened the door to practical methods of colour photography.

Maxwell's system of analyzing the subject colours by making three negatives remains the basis for all current systems of colour photography. Using filters and panchromatic emulsions, the subject's red, green and blue content are recorded as colour separation negatives. (Today, the three records are usually formed with just one exposure, using film with three layers of emulsion.) The methods used to reform or *synthesize* the subject colours from these separation negatives have changed over the years. They can be divided into *additive* and *subtractive* methods.

Additive systems of colour photography

Principle. Look at Maxwell's early suggestions again more closely. Imagine that you have a subject consisting of red and yellow flowers with green leaves, in a black pot, against blue sky with white clouds (Fig. 10.3). From your experience with colour filters in black and white photography you know that a negative exposed through a deep red filter will record the red flower and the red content of the white clouds as density. Green light from the leaves and blue light from the sky is absorbed by the red filter and the negative records little or no density in these areas. Most of the yellow light from the other flower will be transmitted by the red filter, recording as density on the emulsion.

Yellow will also be transmitted by the green separation filter, recording as density on the green separation negative. This negative carries the green leaves and white clouds as density, and red flower and blue sky as relatively clear areas. On the blue filter separation negative sky and clouds produce density, flowers and leaves remain relatively clear. On all three negatives the black pot records as a clear area.

A positive black-and-white transparency (i.e. a lantern slide) from your red filter separation negative is placed in a projector with a red filter over its lens. The projected image is examined on a white screen. Red will appear strongly through the clear red flower and cloud areas of the positive image, and also strongly in the yellow flower area. No light will appear on the screen where the leaves, pot and sky should be.

A positive transparency from the green filter separation is placed in a green filtered lantern and projected onto the screen to superimpose exactly with the red image. Green light now reaches the screen in the area of the leaves and also the clouds (here it adds to the red light so that together they appear yellow). Green is also added to the yellow flower area, again superimposing with the red to appear yellow. Finally the blue separation positive, projected through its blue filter, places blue in the only remaining unilluminated colour area – the sky. It also adds blue light to the red and green light already in the cloud area, a combination which appears white on the screen. No light at all reaches the screen in the black pot area.

The result is a representation of all subject colours, each separation positive having added a proportion of the total image in coloured light. *Hence this type of synthesis – the adding or mixing of appropriate quantities of red, green and blue coloured light to reform image colours – is known as an 'additive' system.*

Screen materials. Now it is obvious that even if a photographer managed to take three separate shots of all his subjects, any system requiring three projectors

and accurate registration of three images to show the result just is not practical. Du Hauron suggested a solution to both these difficulties by the use of a *screen* material. The screen can be a sheet of glass or film covered with an extremely fine mosaic of red, green and blue transparent filters. In fact, seen from normal viewing distance the colour patches should be too small to distinguish individually and the screen should appear an even, more or less colourless grey. Medium contrast panchromatic emulsion is coated on one face of the screen.

The material is exposed in the camera with the screen facing the lens, so that the image light must pass through the screen before reaching the sensitive emulsion layer (Fig. 10.4, centre). In red areas of the image, light passes through the mosaic's tiny red filters but is absorbed by the green and blue filters. Red is therefore recorded as tiny areas of exposed emulsion just under the red filters in red image areas. Where the image is green, light passes through the green filters in that area but is absorbed by the red and blue filters. Light of other colours follows the same procedure.

The screen material is then given a normal black and white reversal processing so that the areas of emulsion that received light appear clear, and areas in which light was absorbed by the filters have silver density. When the processed material is viewed against white light the screen only transmits light through the red filters in areas when the image was red (all other filters in these areas are blocked). Each filter is too tiny to be resolved separately by the eye, so the whole red image area appears continuous.

Similarly, the red and blue filters are blocked in areas where the image was green. In white parts of the original image the light was transmitted through all filters onto the emulsion, and now since no density is present, all filters again transmit light. The additive effect of these tiny dots of red, green and blue filter colour give a visual impression of white.

Additive screen colour materials first came on the market in 1907 with the Lumiere Brothers *Autochrome* process, and by the 1920s there were many makes. Some screens used transparent starch grains, dyed in bulk and mixed up together. These were distributed at random over a sheet of glass, pressed and then dusted with carbon black to fill in gaps. Other screen materials used a film base bearing finely ruled lines of dye (about 500 per inch). The different coloured lines crossed in such a way that a geometric pattern of red, green and blue filters was built up, see Fig. 10.4, bottom right. The most popular make was Dufaycolor, available from 1930–1951.

These ingenious screen colour materials had the advantage of simple and speedy processing by colour standards. Why then have they all been discontinued for regular still photography? A list of the features that made additive colour photography materials too inconvenient for modern needs will show the justification for the *subtractive* systems that have now replaced them:

(1) Additive screen transparencies are inefficient in terms of light passing power. Even in the 'whites' of the image only one third of the possible illumination is transmitted (two-thirds is absorbed by each filter).
(2) It is technically most difficult to form an acceptable additive screen colour print on paper, i.e. a colour image which looks acceptable by reflected light.
(3) It is difficult to print one additive screen material onto another. Strictly the colour mosaic on one should exactly register with the same colours on the other, or the differing filters will stop light from printing the image. Registration is impractical and so some mild form of light diffusion has to be used.

177

(4) The pattern of the colour screen tends to show up on small format transparencies immediately they are projected.

Polavision movie film is the only colour photography system now utilizing an additive screen (rulings are about 1500 lines per cm). It was revived by Polaroid because the relatively simple processing needed lends itself well to instant picture chemistry. The additive principle is also used for colour television receivers, and the photo-mechanical printing of colour too has some additive aspects, discussed on page 301.

Principle of subtractive synthesis

Can a practical system of colour photography be evolved which avoids the defects of additive screen systems? Perhaps it is worth re-evaluating what is required. A single full-colour image is needed which could be shown in a single projector or placed against white paper to form a colour print.

Experiment 1: Return again to the three projector concept. If you took the blue separation transparency and its filter out of the projector and combined it with the other two transparencies and their filters into a multilayer pack, how would the combination look by transmitted light? The transparency from the blue filter negative carries black silver where no blue existed in the subject. Its function is simply to state where blue existed and where it did not. But it does so in a very crude way by stopping *all light* in the non-blue areas. Therefore in what should be the green and red areas of the image, light has no chance of penetrating further into the pack, Fig. 10.4 (top).

In areas such as subject blue and white, light is passed by the blue separation transparency, goes on through its blue filter and proceeds on into the pack as blue light. Next it reaches the green separation transparency, where it is either stopped by black silver or (subject whites) reaches the green filter. But each separation filter transmits only one third of the spectrum and absorbs two-thirds. The green filter therefore absorbs the blue light. It is obvious that the total pack cannot transmit any light at all.

Is it possible to arrange that each transparency in the pack just controls its third of the spectrum—without interfering with the monitoring effect to be performed by the other two layers. How about this:

Experiment 2: Change the black silver in the blue separation transparency for a dye which absorbs only blue from the spectrum, and take the blue filter away. The blue absorbing dye now does the same sort of job as the silver, in terms of denoting where blue did not exist in the subject. But now whereever blue *was* present in the subject the transparency remains clear and allows white light to pass on unaffected. (Fig. 10.5, centre). The dye needed to absorb blue but transmit the remaining two-thirds of the spectrum would be green plus red which is *yellow*.

Next is the green separation transparency and green filter. This can be replaced by the transparency alone, its black silver changed to a dye which absorbs green and transmits the remaining two thirds of the spectrum. The required dye must be blue plus red in colour, a purply-red called *magenta*.

Finally, the red separation transparency and red filter are replaced with a transparency image in red absorbing dye. A dye which absorbs red and transmits the

178

green and blue thirds of the spectrum appears a greenish-blue colour called *cyan*.

The pack has been reduced to three dye image separation transparencies and it looks a lot lighter. Will it work? *Check*. The original subject included blue sky. White light entering the pack in this area passes unaffected through the blue separation transparency and goes on to meet magenta dye in the green separation transparency. The dye subtracts green and transmits only the red and blue content of the white light. At the next (red separation) layer the red + blue light meets cyan dye (which subtracts red and transmits only blue and green). Therefore blue is the only colour emerging from the pack in the sky part of the image. Where the green leaves were recorded on the image, light first meets yellow dye (absorbs blue), no dye in the next layer, and finally cyan dye (absorbs red). Only green is transmitted by the pack. Try tracing the reproduction of the red flower yourself.

The yellow flower recorded as density on both the green and red filter separation negatives. Therefore the only transparency to contain dye in this flower area is the blue filter separation which is yellow in colour.

It really is important to grasp just why this works – why yellow, magenta and cyan dyes are used. This is the fundamental principle behind all modern colour materials for still photography. Read over *experiment 2* again, check Fig. 10.5. Draw what would happen if other dyes were used, with or without silver – every other combination gives an image which is either opaque, or in the wrong colours, or is in reversed tones. Learn the dye colour linked with each original filter colour, by remembering that the dye must be chosen to transmit the whole spectrum *minus* the filter colour.

Recapping: Three images each containing black silver and primary coloured dye cannot be sandwiched together and still give a full colour image. Light is totally absorbed – either by silver or by a combination of dyes, each of which absorbs two thirds of the spectrum. But if you make a yellow dye image from the blue filter negative, a magenta dye image from the green filter negative, and a cyan dye image from the red filter negative, each dye will subtract one unwanted primary colour from white light, without affecting the other two primaries.

The use of dyes to subtract unwanted colours from white light and thus reproduce original subject colours (instead of adding together required quantities of primary coloured lights) is known as subtractive synthesis. Yellow, magenta and cyan are called secondary or complementary colours. They are also sometimes referred to as subtractive primaries and (individually) as 'minus-blue', 'minus-green' and 'minus-red' respectively.

Colour images subtractively synthesised contain no mosaic screen and have greater light transmission than additive processes (i.e., white image areas contain no dyes at all). They can be formed on a transparent base as colour transparencies, or on an opaque white base as prints.

Modern colour materials

Irrespective of maker or brand, every film made for general purpose colour photography today is designed to do two things:

(1) Make separate records of the camera image in terms of its blue content, its green content and its red content.
(2) Form a final image in three superimposed dyes—one in yellow and related to the blue record, one in magenta and related to the green record, and one in cyan related to the red record.

The only way in which the various types of film differ are in the physical and chemical procedures of going from stage 1 to stage 2. They can be broadly divided into films designed to produce direct final results i.e. slides, which usually have a name ending in *chrome* (e.g. Ektachrome); and those giving a colour negative for printing, which usually have a name ending in *color* (e.g. Vericolor).

Multilayer (Integral Tripack) colour films for colour transparencies

Examples: Kodachrome, Ektachrome, Fujichrome, Agfachrome.

No photographer wants the limitations of having to take three separately filtered exposures of his subject. You can overcome this by using a multilayer film, i.e. a material with three integral emulsion layers, coated one on top of the other, and responding to blue light, green light and red light respectively, the three layers being exposed simultaneously by one exposure.

As Fig. 10.6 (top) shows, the top emulsion layer—the one nearest the lens—is a blue sensitive or 'ordinary' emulsion. The second emulsion layer is orthochromatic, but since this is sensitive to both green *and* blue a yellow filter layer is placed between the two emulsions. This prevents blue light from penetrating beyond the first layer and makes the second emulsion effectively green sensitive only. The third emulsion layer is sensitized to red but not to green. Due to the yellow filter which absorbs blue light, it responds as if red sensitive only.

Very considerable care must be taken by the manufacturer to see that the three emulsions are balanced in their sensitivity, bearing in mind their position in the pack. *Balance* means having equal speed to a given white light source, in all layers. Similarly contrast, graininess, reciprocity failure and latent image effects must all match. Later chapters look at the important influence these have on practical colour photography.

After exposure to the image then the multilayer film contains three colour separation latent images. The film next has to be reversal processed so that each layer forms a positive image in a dye complementary to its original sensitivity—no mean feat! The first stage of processing is simply black-and-white development, to produce a black silver negative image in each layer. With the exception of a few materials such as Kodachrome which will be discussed in a moment, the next main stage is to 'fog' the remaining, unexposed emulsion. This is done by using a chemical fogging agent. The remainder of the processing can take place in white light.

The film next goes into a colour developer. This begins to develop the fogged emulsion areas to a black silver (positive) image, and in doing so forms particular oxidation products. As development proceeds these byproducts react with colour couplers (similar to the type used in colour development toning, page 168), which were coated along with the halides in each emulsion layer. Couplers in the top emulsion combine with the oxidation products to form a positive yellow dye image

180

TABLE 10.1
BASIC* COLOUR PROCESSING STAGES
(INTERMEDIATE WASHES OMITTED)

Non-Substansive Reversal Transparencies (e.g. Kodachrome)	Substansive Reversal Transparencies (e.g. Ektachrome) Process E-6	Colour Negatives (e.g. Kodacolor) Process C-41
B, G & R sensitive emulsions +Y filter, but no couplers. Separate Y, M & C couplers in each of three col developers.	B, G & R sensitive emulsions +Y filter, and separate (colourless) couplers in each layer. A single col developer couples all layers simultaneously.	Layers as substansive transparencies but couplers in some emulsions already coloured (for masking purposes). Single col developer.
1 B & W first dev	*1* B & W first dev	*1* Col Dev
2 Fog (red light)	*2* Reversal (fogging agent)	*2* Silver bleach
3 Cyan col dev	*3* Col dev	*3* Fix
4 Fog (blue light)	*4* Conditioner	*4* Wash
5 Yellow col dev	*5* Silver bleach	*5* Stabilize
6 Fog (white light)	*6* Fix	
7 Magenta col dev	*7* Wash	
8 Silver bleach	*8* Stabilize	
9 Fix		
10 Wash		

Colour Prints from Colour Negatives (e.g. Ektacolor paper) Ektaprint 3 Process	Colour Prints from Colour Transparencies (e.g. Cibachrome) P-12 Dye Destruction process	Colour Prints from Colour Transparencies (e.g. Ektachrome paper) Process Ektaprint R14
R, G & B sensitive emulsions. Separate colourless couplers in each layer. No Y filter. Single col developer.	B, G & R sensitive emulsions with Y, M & C permanent dyes already present. Dyes are bleached in unwanted areas.	R, G & B sensitive emulsions. Separate colourless couplers in each layer. No Y filter. Single col developer.
1 Col dev	*1* B & W first dev	*1* B & W first dev
2 Silver bleach/fix	*2* Dye/Silver Bleach	*2* Stop bath
3 Wash	*3* Fix	*3* Fog, and Col dev
4 Stabilize	*4* Wash	*4* Bleach/fix
		5 Wash
		6 Stabilize

Stages which must be carried out in darkness (or suitable safelighting) appear above the broken line.
*These stages are typical but may vary as materials are improved.

181

there, together with the silver image. In the second layer a different coupler combines with the same oxidation products to form a magenta dye image with the silver, and in the third layer further couplers form a cyan dye image in the same way, along with silver. (This dye-forming action is known as *chromogenic* development).

The film at this stage looks extremely dense–the images it carries are (*a*) black silver separation negatives in all layers; (*b*) black silver positive separation images in all layers; and (*c*) dye positive images in yellow, magenta and cyan. All that is necessary now is to bleach away the black metallic silver (and yellow filter layer), to leave just the dye positive image in each layer.

Colour films discussed so far, have couplers in each of the emulsions and are described as multilayer colour films with incorporated colour couplers (or *substantive* colour film). A few multilayer materials (e.g. Kodachrome) do not contain incorporated colour couplers (are *non-substantive*). Unlike colour materials with incorporated couplers which can be processed by the user, non-substantive films require much more complicated processing. After first (black and white) development the film is fogged in one emulsion only, using red light. It is then developed in a colour developer containing cyan couplers, producing silver and cyan dye in the red layer. Next the front of the film is exposed to blue light and it is placed in a second colour developer–this one containing yellow coupler. The final (middle) emulsion layer is then either fogged to white light or chemically fogged, and the film placed in a third colour developer containing magenta coupler.

Including intermediate solutions and final bleaching, this 'differentially' colour coupled processing runs to several dozen stages. The photographer cannot tackle the job himself. Processing is carried out by the makers or specialist laboratories using elaborate continuous processing machines. (This is one reason why film with non-incorporated couplers is not marketed in sheet form–lengths of 35-mm film and movie film gauges are most easily fed onto such machines.)

The idea of using a pack of single sensitive emulsions was suggested by Ducos du Hauron. In 1912 the German chemists Siegrist and Fischer disclosed the action of *colour coupling* by combining appropriate developer oxidation products with colour former chemicals. But the practical problem of coating different couplers into each emulsion layer held up production of a reliable product. Research by American and German film manufacturers went on for many years. Apart from the technical difficulties of coating multilayer emulsions to have consistent characteristics, colour sensitisers and couplers available at the time tended to 'wander' from their correct emulsion layers. In fact largely for this reason the first multilayer film used non-incorporated couplers. This film was Kodachrome (1935) and was the result of 13 years work by Eastman Kodak, led by Leopold Mannes and Leo Godowsky. The first multilayer colour material with colour couplers successfully anchored in the emulsions appeared in Germany in 1936 (Agfacolor Neu, later renamed Agfacolor), sixteen years after du Hauron's death.

Agfa's chemists incorporated couplers linked to long chain hydro-carbon molecules. The chains are physically inert and function solely to 'anchor' the couplers in their respective emulsion layers. Most European manufactured colour transparency and neg/pos materials have since utilized Agfa's 'long chain' system for coupler anchorage.

Eastman Kodak chemists solved the coupler wander problem by using a resin

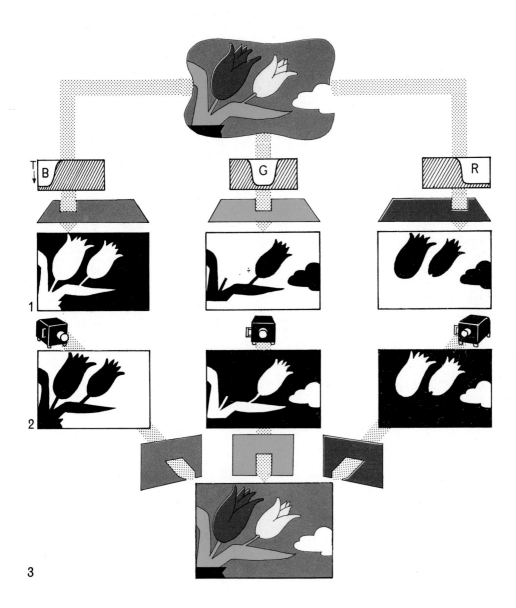

Fig. 10.3. Additive systems of colour photography. (1) Exposure made on pan materials through blue, green and red filters (note inset transmission curves) results in 'separation negatives'—containing an analysis of subject colours in black and white tones. (2) Positive black and white transparencies made from these negatives can be projected separately to register on a screen (3). Each projector is filtered with the same colour as the taking filter. The three contributions of primary coloured light now add up to reform subject colours. Note that white is made up from more or less equal additions of all three colours.

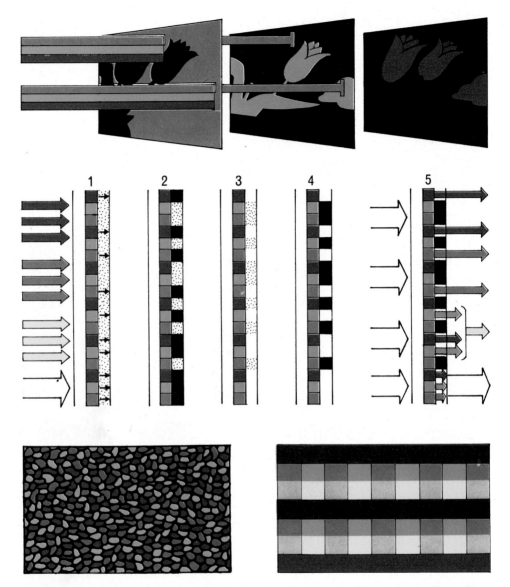

Fig. 10.4. (Top) The major drawback to synthesizing the coloured image by use of three separation silver positives and their primary filters is that they cannot be combined as one multilayer colour transparency, or print. Incident white light (shown here in terms of its blue, green and red content) is totally absorbed — either by silver or a combination of any two filters. (Centre) An additive screen material. (1) Cross section of film. The coloured image formed by the lens passes through the film base, through those filters in the mosaic which do not absorb the particular image colour, finally reaching the panchromatic emulsion coated behind the mosaic. The film is then given black and white reversal processing. (2) Appearance after first development, (3) after silver bleach and (4) after fogging and redevelopment. (5) When the processed film is viewed against white light, each area of the film transmits light matching the original image colours. Providing each filter in the mosaic is small enough, colour areas appear to be continuous. There is considerable loss of incident light, even in white areas. (Bottom left) Greatly magnified top view of one of the first screen mosaics using coloured starch grains, and (right) Dufaycolor, which used printed lines of dye.

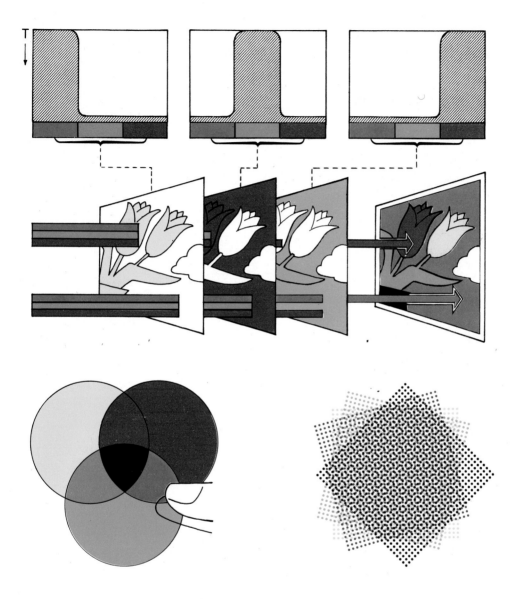

Fig. 10.5. Subtractive colour reproduction. (Top and centre) instead of the arrangement shown in Figure 10.4, each separation image might be formed in a dye which absorbs (subtracts) unwanted light of one primary colour—but without affecting the remaining two thirds of the spectrum. The dye images are seen to combine successfully to form a multilayer colour transparency or print. (Bottom left) Filters dyed in the three complementary colours (yellow, magenta and cyan) laid out on a light box. Note the overlap colours formed, and their relation to the filter absorption curves at the top of the page. (For clarity filter and dye absorption curves shown on these pages represent near-ideals).

Fig. 10.5(a) (Bottom right) Four colour photo-mechanical reproduction—greatly magnified. Each half-tone screen must·be rotated about 30° when making the screened separations, to minimise dot overlap and avoid strong moire patterns. Central area here represents neutral dark grey. Diagram also shows the basic ink colours used to print all the colour in this book. See Chapter 15.

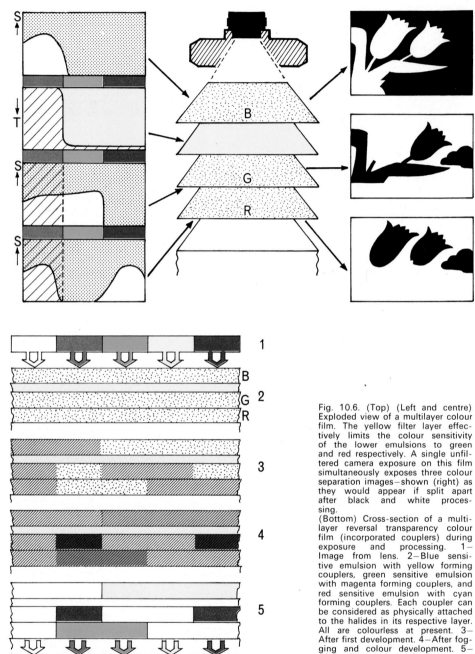

Fig. 10.6. (Top) (Left and centre) Exploded view of a multilayer colour film. The yellow filter layer effectively limits the colour sensitivity of the lower emulsions to green and red respectively. A single unfiltered camera exposure on this film simultaneously exposes three colour separation images—shown (right) as they would appear if split apart after black and white processing.

(Bottom) Cross-section of a multilayer reversal transparency colour film (incorporated couplers) during exposure and processing. 1—Image from lens. 2—Blue sensitive emulsion with yellow forming couplers, green sensitive emulsion with magenta forming couplers, and red sensitive emulsion with cyan forming couplers. Each coupler can be considered as physically attached to the halides in its respective layer. All are colourless at present. 3—After first development. 4—After fogging and colour development. 5—After silver bleach. 6—Appearance of transparency when viewed against a white light source. Relate to Table 14.1.

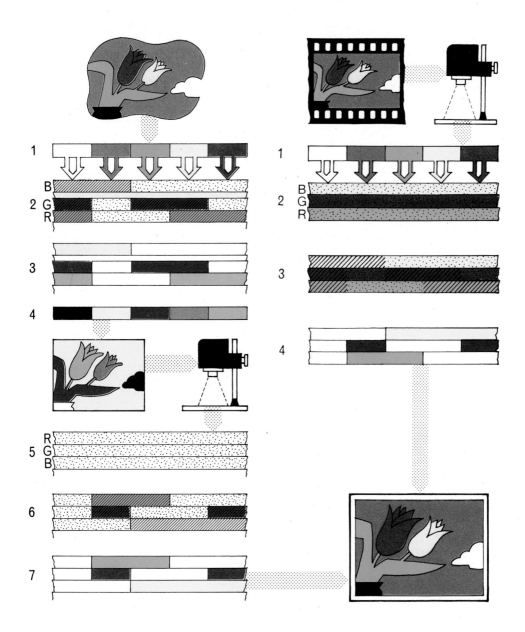

Fig. 10.7. (Left) Neg/Pos colour materials, 1 — Image from camera lens. 2 — Colour negative (shown for simplicity unmasked) after colour development. 3 — After silver bleaching. 4 — The appearance of the colour negative. 5 — The printing paper receiving exposure from the colour negative. Note that paper emulsions are reversed so that finally the visually heavy cyan image will form at the top and so enhance sharpness. Emulsions are sensitised to narrow spectral regions, 'keyed' to the transmission of dyes formed in the colour negatives. 6 — Paper after colour development. 7 — After silver bleach.

(Right) Dye destruction colour printing material. 1 — Projected image from a colour transparency. 2 — The print material, which has dyes incorporated in the emulsions during manufacture. 3 — After first development. 4 — After silver/dye bleaching. The result is a positive colour print direct from a positive colour transparency.

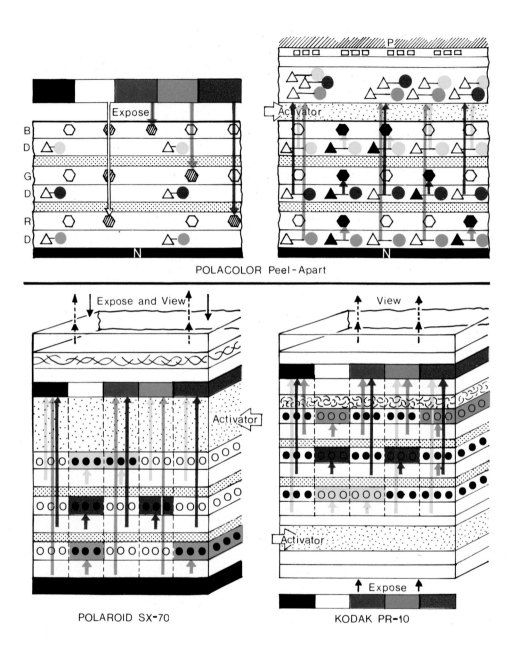

POLACOLOR Peel-Apart

POLAROID SX-70

KODAK PR-10

Fig. 10.8. Instant-picture colour print processes. Top: Polacolor peel-apart material shown (left) during exposure, and (right) after facing with the receiving paper and spreading alkali activator between the two. Small rectangles denote acid molecules. Bottom left: An SX-70 single sheet print during processing. Activator contents include opaque white pigment. Bottom right: A PR-10 single sheet print during processing. Activator includes black pigment. For details see page 188.

Fig. 10.9. A colour negative film with integral colour masks. (Left) Exploded view of layers in the unexposed film. 1—Blue sensitive emulsion with colourless yellow-forming couplers 2—Yellow filter. 3—Green sensitive emulsion with yellowish magenta-forming couplers. 4—Red sensitive emulsion with pink cyan-forming couplers. (Right) The resulting images after exposure and processing. The negative appears to have an overall orange cast. In fact the mask colour only remains in image areas where magenta or cyan dye is absent. The colour printing paper is balanced to compensate for this apparently off-balance negative. (See also Fig. 12.9, page 217).

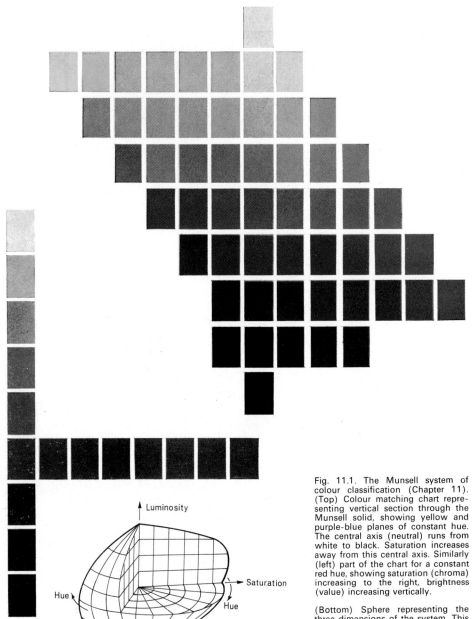

Fig. 11.1. The Munsell system of colour classification (Chapter 11). (Top) Colour matching chart representing vertical section through the Munsell solid, showing yellow and purple-blue planes of constant hue. The central axis (neutral) runs from white to black. Saturation increases away from this central axis. Similarly (left) part of the chart for a constant red hue, showing saturation (chroma) increasing to the right, brightness (value) increasing vertically.

(Bottom) Sphere representing the three dimensions of the system. This solid is rather lopsided because actual pigments are used rather than theoretical colours—and there are severe limitations to pigments at present available. Any colour patch can be referred to by quoting hue, value and chroma co-ordinates.

like substance to absorb the coupler molecules and form micro globules. Although the resin globules are insoluble in water, they remain permeable for the colour developer. In this way the coupler in its membrane is immobilised within the pores of the gelatin. All Kodak colour materials incorporating couplers (e.g. Ektachrome) use the resin-protected system. It is also used by Fuji.

The most obvious difference between the carbon and resin types of anchor is that the presence of the resin gives these materials a slightly opalescent appearance when wet. Final assessment of colour and density must normally wait until the material is fully dry, whereupon the whitish opalescence disappears. Also many firms using the resin anchor system give a final image which is less granular in micro appearance

Multilayer colour films for colour negatives

Examples: Agfacolor; Kodacolor; Vericolor; Fujicolor.

The basic structure of colour negative films is similar to reversal transparency material with incorporated couplers. The processing cycle however is shorter and consists of colour development, bleach and fix. The colour developer produces black silver negatives and, by the action of oxidation products on couplers, simultaneous dye negatives in each layer. After bleaching the silver and unused halides the dye alone remains – forming an image in negative densities and complementary hues relative to the subject. See Fig. 10.7, left half.

The negative is then printed onto further multilayer emulsions coated on plastic coated paper, or film (known as *print film*), using a similar processing routine. The printing operation not only allows many copies off one shot, but also changes in image size, in density (local and general), and in colour balance. It is also possible to do some masking of the colour negatives to improve the effective absorption of its chemical dyes. (Masking is 'built-in' giving the colour negative an apparent overall orange colour cast. The function of integral colour masking is discussed in detail in the next chapter.)

Special multilayer colour negative films are made to act as intermediates in making colour prints from colour transparencies. Internegative colour film has built-in masking devices to give the best possible final print from such an original. It will be looked at in more detail (page 221) when colour masking is discussed.

Colour negative materials were beginning to be manufactured in Germany and America at the outbreak of the Second World War (1939). These were a non-substantive form of Eastmancolor and Agfacolor negative respectively. They were first made for the motion picture industry – an integral tripack process giving good quality colour release prints for cinemas had highest commercial priority at the time.

'Kodacolor' colour negative-positive material for paper prints (the first neg/pos system using resin protected couplers) was introduced in the U.S.A. in 1942 and was processed at first only by Kodak. Because of the division of Germany after the Second World War and other factors, several years elapsed before Agfacolor materials became freely available. Ektacolor masked negative-positive materials for professional photography (user processing) date from around 1950. Vericolor negative films, similar in performance to Ektacolor but the first of a new generation of films specially formulated for machine processing at high temperature (page 253), were introduced in 1972.

Special purpose multilayer colour films

Examples: Ektachrome Infra Red; Kodak Photomicrography Color Film 2483.

There is no reason why a multilayer colour film should always contain normal contrast emulsions sensitive to blue, green and red. Emulsions which are of specially high or low contrast, or sensitised to other regions of the visible (or invisible) electromagnetic spectrum are perfectly practical. Similarly couplers can be incorporated in each layer to produce dyes other than yellow, magenta and cyan, or to form these complementary colours in abnormal sequence. Much depends upon the commercial demand for such films – obviously it would be extremely expensive to coat small batches.

One special multilayer transparency film – Infra Red Ektachrome – has its emulsions sensitized to green, red, and infra-red, instead of blue, green and red. (The film is exposed through a yellow camera filter to help suppress blue.) Couplers in each layer form yellow, magenta and cyan dyes respectively. The film gives a false colour record in that a green subject reflecting I.R., such as healthy green foliage, records magenta. Nón I.R. reflecting green pigment records bluish-purple, and subjects reflecting I.R. and red (such as red roses) yellow. See colour plates C.5–6.

Fig. 10.1. The false colour response of Infra-Red Ektachrome varies according to the infra-red content of the lighting. In direct sunlight the chlorophyll in living vegetation reflects infra-red along with green wavelengths from its surface pigment. The leaf image is therefore reproduced as magenta. Red paint reflects red and infra-red, which the film reproduces yellow. On an overcast day, or when in shadow, little I.R. radiation reaches the leaf. It then reflects green only, which reproduces as blue.

The film was originally made during the Second World War for camouflage detection purposes and used in aerial reconnaissance. Its bizarre colours clearly differentiate between camouflage such as branches cut from trees, painted material etc., and genuine living foliage. This material is useful for analysis in medical and forensic work, and biology (e.g. forestry), as well as enabling unusual visual images to be produced for fashion and editorial illustration.

Photomicrography reversal colour film has high contrast, high definition, and extremely fine grain characteristics. It therefore suits detailed, low-contrast specimens photographed through microscope optics; also coloured line drawings. Film speed is only about 16 ASA. Other special purpose colour films have layers which simply differ in speed, and so distinguish level of exposure in terms of colour.

184

Assembly colour print materials

Examples: Kodak Dye Transfer; Technicolor.

An assembly process 'constructs' a colour print by laying down quite separate yellow, magenta and cyan photographic images instead of forming them chemically within a multilayer film. Assembly processes date right back to the beginning of the century, with many wierd and wonderful ways of making the three coloured images from separation negatives. The only assembly processes still important and in considerable use today work on the principle of *imbibition*. Technicolor and dye transfer are both imbibition processes.

If for example you were to make a dye transfer colour print, you might start off by making three separate colour separation negatives, matching in density and contrast, and capable of exact registration. They may be taken direct from a (still life) subject or, more frequently, from a colour transparency. Each negative is enlarged onto a sheet of *matrix* film, which has a thick yellowish gelatin emulsion containing silver bromide. Exposure is made *through the base* of the matrix film. The film is next developed

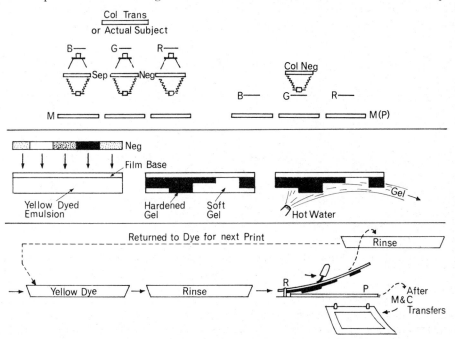

Fig. 10.2. Dye Transfer process. Top left: working from a colour transparency or an actual subject, colour separation negatives are made on pan material and enlarged onto three matrix films. Right: Working from a colour negative separations can be made direct onto *panchromatic* matrix film using separation filters on the enlarger. Centre: Matrix production. The thick yellow emulsion of the matrix film is exposed through the base and developed in a tanning developer. Gelatin is hardened to a depth representing light received. Unhardened gelatin is removed with hot water, giving a relief image. Bottom: Printing down. The matrix from the blue filter separation is soaked in yellow dye (left), rinsed, placed over register pins (R) and tightly squeegeed down onto suitably prepared white paper (P) (or film if a transparency is needed). Having discharged its dye the matrix is rinsed and returned to yellow dye for the next print. The paper now receives similar magenta and cyan transfers from the other matrices, and is then dried. This process will also make single coloured prints from ordinary black-and-white negatives and the image can even be transferred on to the face of an existing black-and-white bromide print.

185

in a tanning developer, i.e. one which hardens the gelatin in the same location and in the same proportion as the black silver formed. The films can be fixed (although this is not essential) and then placed in hot water, whereupon all the untanned gelatin washes away. Because of the original yellowish colour of the gelatin the depth of emulsion exposed will depend upon the quantity of light received. As the film was exposed through the base the various 'depths' of hardened gelatin all extend from the film base–none are undermined and wash off as 'islands', as would happen if the film were exposed emulsion up. You therefore have relief images in hardened gelatin, not unlike printing plates. (Fig. 10.2)

Each matrix in turn is now dyed an appropriate colour, e.g. cyan dye for the matrix from the red filter negative, then rinsed and squeegeed into contact with white paper so that the dye image transfers. The other two matrices have their dye images transferred in turn onto the paper and in exact register. The matrices are then rinsed, and either dried or returned to their dye bath to make further prints (several dozen can be made from one set of matrices).

The dye transfer imbibition process requires considerable skill. It is also understandably slow and costly to produce the first print off. Against this it allows considerable control over results, and by using pure rather than chemically formed dyes gives an image with rich relatively permanent colours.

As the quality of neg/pos colour has improved it has taken over the role of dye transfer printing. A few custom laboratories still offer this service to professional photographers–for top quality portrait and advertising work where cost is unimportant. Most dye transfer prints today are made from multilayer colour negatives. By using panchromatic matrix film and tri-colour filters on the enlarger lens separation positives are made direct from the colour negative.

The Technicolor process used for cinema release movies is another imbibition system–really a mechanised version of dye transfer. The usual routine is for the film producer to shoot on a multilayer colour negative film. This is printed via filtered light sources to give three separation positives on panchromatic matrix films, which are then dyed up and transferred in turn onto gelatin-coated film base. By making each matrix into a long loop corresponding to a reel of film the stages of dying up, rinsing, transfer, etc. can be carried out as a continuous cycle. The film picks up its image by travelling in sequence from one matrix loop to the next.

The mechanical equipment required for making Technicolor prints is of the highest precision–registration must be exact, bearing in mind the tremendous magnification the final image will receive in the average wide screen cinema. As in the case of dye transfer prints, the first technicolor print is very costly, but cost per copy for the several hundred prints needed for cinema distribution compares well with multilayer emulsion film prints. They are also able to give better image definition.

It is interesting to note that up until the beginning of the fifties and particularly during the 1930s assembly printing–from original separation negatives actually exposed in the camera–was the principal method of producing colour prints and professional colour movies. 'One shot colour cameras' were made for still photography of moving subjects. They used a single lens and shutter, behind which were located beam-splitting mirrors and filters directing the image simultaneously to plateholders at the back and two sides of the camera. One exposure produced a set of three colour separation negatives simultaneously.

Technicolor devised a similar colour separation movie camera with three 35-mm films running past a beam splitter device behind the lens. So much room was needed between the lens and film for these optical arrangements that a new type of lens – an inverted telephoto – was specially designed for the camera. Technicolor cameras and crew were hired out to film companies, until the introduction of suitable negative multilayer emulsion colour films allowed colour negatives to be shot with the unit's own black-and-white cameras.

Multilayer materials for colour prints from colour negatives

Examples: Ektacolor paper; Vericolor print film; Agfacolor paper and print film.

Colour papers designed to make prints direct from colour negatives consist of three emulsion layers with incorporated couplers, on a plastic coated paper base. Unlike film material, these are sensitized in the order of red, green and blue (see Fig. 10.7, bottom). The top layer of the print therefore carries the cyan image after processing, instead of the more conventional yellow image; this improves visual sharpness. Each emulsion is sensitized to only a narrow band of red, green or blue wavelengths related to the dyes formed in the same manufacturer's colour negative materials. This narrow sensitisation, combined with a fast blue-sensitive layer, eliminates the need for a yellow filter layer. This is shown in Fig. 14.10, page 263. It is however quite practical to print one manufacturer's colour negatives onto another's colour paper, given appropriate enlarger colour filtration. Papers are made with various surfaces such as 'silk', smooth lustre and glossy. As Table 10.1 shows, the processing sequence needed is similar (but shorter) to colour negative processing.

Print film materials are intended for making colour transparencies from colour negatives through the enlarger. They are made in sheets or wide rolls for large display transparencies, and 35mm film for projection slides. Some brands of sheet print film have a matt surfaced base – this has a slight light-diffusing effect and allows retouching. Print films are processed in either colour negative film or paper chemicals, according to individual manufacturer's instructions.

Dye destruction materials, for colour prints from colour transparencies

Example: Cibachrome.

So far all the multilayer materials that have been mentioned have formed their final image colours chemically in a colour developer. But the type of dyes that can be formed this way have spectral absorption characteristics which are far from ideal. Is it possible to do away with chemically formed dyes and choose permanent dyes with more appropriate wavelength absorption ... but without having to turn to a laborious assembly process like dye transfer?

One solution is to coat the coloured dyes into the appropriate layers of a multilayer colour material at the time of manufacture, and then arrange processing so that they are *chemically bleached* according to the colours of the image. Looking at this construction more closely, in Fig. 10.7 (right half). The top layer would contain blue sensitive halides plus yellow dye (instead of colourless yellow dye coupler). There is no yellow filter, as the yellow dye serves this purpose. The next layer carries ortho-

187

chromatic emulsion and a magenta dye, whilst the layer nearest the base contains panchromatic emulsion and cyan dye. Note that only red light can penetrate the yellow and magenta dyes of other layers to reach the panchromatic emulsion.

The unexposed emulsion appears black; if scraped with a sharp knife the coloured dyes in the various layers can be seen. The presence of dyes makes the material very slow in speed, but helps to reduce light scatter within the emulsion layers during exposure, giving improved image resolution. They are coated on an opaque white plastic or resin coated paper base.

The material is exposed, under the enlarger, to a positive colour transparency image. First development forms the usual black silver negatives in the three emulsions. But at the next processing stage a special bleacher removes the black silver *together with the dye from these image areas*. This is followed up by fixing and washing. As can be seen from Fig. 10.7, right, the result is a positive print in dye, direct from a positive original.

The advantages of dye destruction are (1) simplicity of processing (which makes it very popular for amateurs); (2) the use of more brilliant azo dye-transfer type dyes, which are also more fade-resistant than dyes formed chemically; (3) the convenience of working from transparencies, which can also be used for projection. Against this, slightly contrasty colour images tend to result in excessively contrasty prints.

Despite its extremely slow speed, dye destruction material can also be exposed in a large format–preferably 8×10 in–camera for making prints direct from artwork, and still-life subjects. This is a fast, convenient way to produce high quality colour pictures for reproduction, or short runs of colour illustrations for reports etc. Remember that a mirror or prism is needed over the lens, otherwise the subject appears laterally reversed.

The first workable dye destruction process dates back to the 1934 'Gasparcolor' movie film system, now long obsolete. The modern version, Cibachrome, was introduced by the Swiss dyestuffs organisation Ciba through their subsidiary Ilford, in the late 1960s. It was first named Cilchrome-Print. (Note that processes using dye-destruction are also known as silver/dye bleach or SDB processes.)

Reversal paper, for colour prints from colour transparencies

Examples: Ektachrome paper; Agfachrome paper.

Another way of making positive colour prints direct from colour transparencies is to use conventional type colour paper containing colour couplers, but designed to be given a reversal-processing sequence along similar lines to reversal colour film. Although solutions differ and processing times are much shorter than for film, Table 10.1 shows how the paper needs more stages than the dye-destruction process. Reversal paper also offers less latitude in exposure times and solution temperatures.

Instant print (diffusion transfer) colour materials

Examples: Polacolor; Polaroid SX-70; Kodak PR-10.

Diffusion transfer colour materials, like their black and white counterparts (page 125), allow the production of a finished print of camera-image size within a few minutes

of firing the shutter. Here the similarity ends, for the coloured image is transferred as dye, not silver. Polacolor is still a peel-apart process, but the newer SX-70 and Kodak PR-10 type materials consist of a single blank plastic sheet ejected from the specially built camera. A colour image gradually appears while you watch. (Even du Hauron did not think of this one).

Fig. 10.8 shows the three physical forms that current instant-picture colour materials take. These are:

(1) Polacolor sheet films to fit 8×10 in, and film packs fitting 4×5 in and 6×6 cm camera backs, as well as Polaroid cameras. Handled like the black-and-white material, a sandwich of exposed and receiving material is pulled from the camera, and after an appropriate timing period peeled apart to give a right-reading colour print. This is still the most useful instant-picture material for professional work. It allows checks of exposure, lighting and colour balance. The 8×10 size can be used as the final picture in urgent jobs.

(2) SX-70 self-developing material appears as a single 9×11 cm plastic card, ejected from specially built cameras. The image slowly builds up on the white face of this material, in normal lighting. The camera however must contain a mirror to reflect the image once before it reaches the sensitive surface. This is because the picture is formed on the same surface that faced the lens and it would otherwise appear reversed left to right.

(3) Kodak PR-10 self-developing material also ejects from special cameras or camera backs as a plain card, but builds up its colour image on the *back* of the material which faced the lens. It can therefore be used in a camera without a mirror (or with mirrors which reflect an even number of times).

To get some idea of how the process works follow through the colour diagram of the Polacolor peel-apart type material in Fig. 10.8. This has the usual blue, green and red sensitive emulsion layers, but beneath each is a layer of developer molecules linked to an appropriate dye. Hence developer-plus-yellow-dye below the blue sensitive layer, developer-plus-magenta below green, and so on. Note also the *spacers* of gelatin between the silver halides of one layer and the developer/dye molecules of the next above.

Exposure to a coloured subject affects the silver halides as shown in Fig. 10.8 top left. When the material is brought into contact with receiving paper and a pod of alkali reagent spread between the two, all the developer molecules are activated. Developer (and its linked dye) begins to move towards the top surface. It therefore first meets the halides directly above, developing any that were light-struck. Every developer molecule used to develop silver loses most of its electrons and therefore its mobility. Both developer *and its linked dye* become trapped in that spot.

Where the developer encounters unexposed grains it continues on upwards with its dye and diffuses over to the receiving layer. During its journey it may pass through other silver halide layers too. However, the delay caused by having to pass through spacer layers means that the exposed grains here are fully developed by developer sited directly below, and so able to reach them first.

Over in the receiving paper the outer layer accepts and holds the molecules able to diffuse out of the negative. The remaining reagent slowly makes its way through the next layer – a spacer – to reach an inner layer of immobile acid molecules. These

189

receive and neutralise the alkali, generating water which helps remove further active alkali and compact the positive dye image. By this time the processing period is up and the two materials are peeled apart, to give a finished right-reading colour print and a fast decaying dye-plus-silver negative.

The non-peel self-processing materials (Fig. 10.8, bottom) have a similar arrangement, but here the receiving layers are all part of the same assembly. After exposure the contents of a pod of activator are injected into the assembly where marked, as the card is ejected from the camera. In the SX-70 material the activator contains a thick white pigment, which 'shuts off' the exposed layers from light which would otherwise fog them outside the camera. This also forms a background through which dyes gradually diffuse to form a visible positive image as they are released from below. They are seen through a top transparent plastic window, which also gives it the appearance of a glossy surface print.

In the rival Kodak material the injected activator contains carbon black to seal off the exposed face of the material from fogging light. Unusually, direct-reversal halides are used, which develop only in areas unaffected by the image light. The developer/dye relationship is such that when developer agents are oxidized they *release* a chemically bound image dye. (The whole system is diametrically opposite to Polaroid, to avoid breaking patents. However the overall image migration is the same). Released dyes diffuse through a permanent black, then through a white layer to the final image receiving zone. They therefore appear as a colour image at the back of the material, viewed through a similar plastic window. Both of these self-processing materials contain chemical arrangements to automatically neutralize the alkali and so stabilize the whole complex.

Polaroid instant-picture colour materials, introduced in 1963 (Polacolor) and 1972 (SX-70), were the result of brilliant original research by a team led by Dr. Edwin Land and Howard Rogers. The first Kodak materials, developed by a research team under Dr. Albert Sieg, appeared in 1976.

Trends in multilayer colour materials

It has been shown, particularly in instant picture materials, how modern technology can be used to accurately coat many layers on a sheet of photographic paper or film. Each silver halide layer in a colour film may be coated a bare two microns (0·002 mm) thick. Manufacturers, whilst maintaining the 'classical' concept of blue, green and red sensitive emulsions, now often put down five or more emulsion layers in a general-purpose colour film. The main reasons for this are:

(1) by double coating a low and a high speed layer to form any one colour sensitive emulsion the characteristic curve is extended. Greater exposure latitude is possible.
(2) integral colour couplers which serve a masking function can be distributed over two layers of the emulsion. If one emulsion is fast and the other slow the relative amount of masking in highlights and shadows may be separately controlled (see page 216).

Further developments have centred on designing materials to allow faster processing conditions. Todays toughened emulsions, plastic-based films, and plastic-

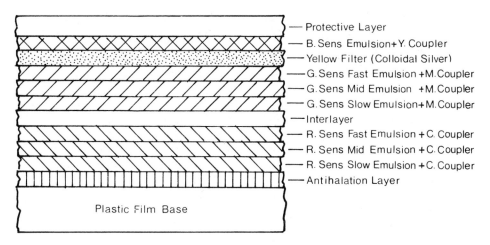

— Protective Layer
— B. Sens Emulsion+Y. Coupler
— Yellow Filter (Colloidal Silver)
— G. Sens Fast Emulsion +M. Coupler
— G. Sens Mid Emulsion +M. Coupler
— G. Sens Slow Emulsion+M. Coupler
— Interlayer
— R. Sens Fast Emulsion +C. Coupler
— R. Sens Mid Emulsion +C. Coupler
— R. Sens Slow Emulsion +C. Coupler
— Antihalation Layer

Plastic Film Base

Fig. 10.11. The complex multilayer structure of a modern colour film (Kodak Ektachrome 400). Relative thickness of the layers is only approximated here.

based papers are designed to withstand the high temperature used in modern roller-transport processing machines. Seconds and minutes are still being clipped from over-all processing times by improvements ranging from more efficient chemicals to improved washing methods, etc. At the same time colour film emulsion speeds are gradually becoming as fast as those of black and white materials, and giving final image colours of much greater purity and permanence. This has to be done without making emulsions thicker, which would result in poorer image definition.

The tendency is for all new colour films to suit an existing form of colour processing chemistry. Eventually this may narrow down the number of processes to about four—for negatives; reversal transparencies; prints; and either dye-destruction or reversal prints—compatible with all brands of these materials. Such processes would then be universally adopted. Obviously rationalisation is important to laboratories which have invested very large sums in automatic machinery, often designed exclusively to work one process. In fact the general trend towards smaller-scale machine processing of films and papers in photographic studios too (page 252) will further encourage standardization.

Comparing colour materials

It can be seen that colour films and papers are still youngsters compared with their parent black and white materials. Processes are still growing-up—constantly being improved in one or more directions such as speed, definition, latitude, dye quality and permanence, time and convenience in processing. This means for example that at any one point in time manufacturer 'A's film may give more acceptable, richer reds than manufacturer 'B's film, but its greens may tend towards cyan. One make may give a more objective recording of certain pastel colours, another bold brilliant hues. One hundred per cent accuracy in all hues and shades is still a long way off, so you have to accept compromises and options chosen by the manu-

191

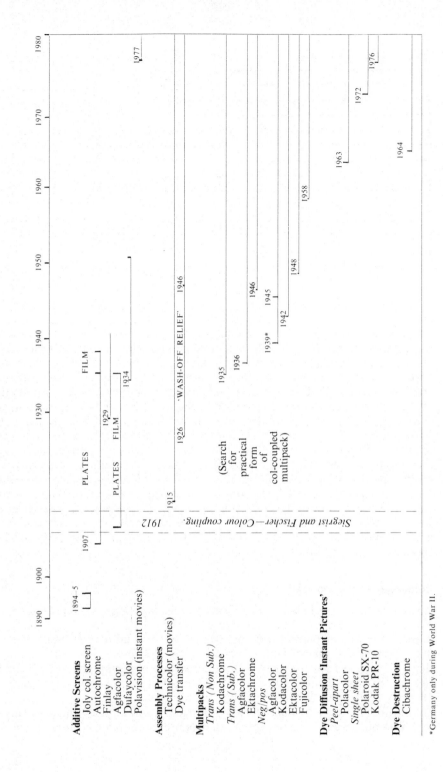

TABLE 10.2

HISTOGRAPH OF MAIN STREAM COLOUR PROCESSES

192

*Germany only during World War II.

facturers in formulating dye couplers etc. The problems of 'objective' colour reproduction are discussed in the chapter which follows.

The real test is to shoot several exposures of what is for you a typical subject, using several types of colour film. Results can then be compared side-by-side, and will be found to show interesting differences.

The following general points are worth bearing in mind when choosing materials:

(1) Batch-to-batch variations in a multilayer material still occur, even today. This is a strong point for using a large-scale manufacturer of colour materials – the firm tests each batch and, in the case of sheet film, may pack special speed rating and correction filter recommendations within the film box. Even so, it is usually wise for the professional photographer to buy up enough film of the same coating number to last several months (subject to suitable storage being available). Thorough tests can then be made under working conditions – once any necessary speed and filter modifications are made they will remain constant until all the batch is used up.

(2) In choosing between reversal transparencies and colour prints remember that as the former is a 'one stage' process it gives the photographer less chance to manipulate results. Nevertheless a transparency will always offer a wider density range (i.e. wide luminance range of colours) than the best reflection print. The choice is often decided by the customer – a picture for reproduction in print is still best handled by shooting on transparency film, whereas a framed portrait would be taken on neg/pos colour.

(3) Read all the small print in the instructions packed with the film, or the manufacturer's data books. The film is balanced for particular exposure conditions – type of lighting, and duration of exposure. These things are more important than in black and white photography and can easily be overlooked. (See Chapter 13.)

(4) In neg/pos work the film by one maker can be printed onto another maker's paper. In general it is better to keep to one maker's products, although occasionally 'cross printing' can give improved results. Correction devices incorporated in one make of colour negative (masks, particular dyes, etc.) are specifically designed to give improved results when coupled to the characteristics of the same maker's printing paper. This is known as *keying*.

These practical considerations will crop up again in more detail during later chapters.

Related reading

MANNHEIM, L. A. and HANWORTH, VISCOUNT. *Spencer's Colour Photography in Practice* (paperback edition). Focal Press 1975.
HUNT, R. W. G. *The Reproduction of Colour*. Fountain Press 1975.
Color. Life Library of Photography. Time-Life Books 1972.
Current professional information handbooks on colour by Eastman Kodak, Agfa, and Kodak Ltd.

Chapter summary—colour emulsions

(1) All workable colour processes first analyze subject colours into blue, green and red separation records.

(2) To form a colour photograph these records must then synthesize subject colours again on a suitable support. Methods of doing this are broadly divided into additive and subtractive systems.

(3) Additive systems use varying quantities of primary blue, green and red colour lights which, added together, reform subject colours. For example, black silver positive transparencies from separation negatives could be used to modify light from blue, green and red lanterns projected onto a common screen.

(4) Commercial additive colour material in fact consisted of screen mosaics of minute coloured filters in front of a panchromatic emulsion. After exposure and black and white reversal processing, this formed a positive transparency by controlling the light passed through the filters in each colour area. The eye's limited resolving power fused the dots of primary colours into areas of coloured image.

(5) Additive screen transparencies absorbed too much light, showed mosaic patterns when enlarged and were difficult to duplicate. It was not possible to form acceptable additive photographic prints.

(6) Yellow, magenta and cyan are *complementary* colours to the blue, green and red primaries respectively. Each complementary colour absorbs the light of its primary and transmits or reflects the remaining two thirds of the spectrum.

(7) Subtractive systems of colour photography form a coloured image by removing from white light varying quantities of unwanted spectral colours. Normally a composite of positive complementary dye images is formed from separation negatives. Each complementary dye then subtracts a primary colour in areas where this colour was absent in the original subject.

(8) All current colour materials for photography work on a subtractive basis–recording the subject in terms of blue, green and red and presenting a final picture in yellow, magenta and cyan positive dye images.

(9) Multilayer colour materials basically comprise three permanently superimposed emulsion layers, each differently sensitized so that separation images can be simultaneously recorded. Emulsions may be arranged (top) blue sensitive; (middle) green and blue sensitive; (bottom) red and blue sensitive. By using a blue absorbing filter between the top and middle layers each emulsion effectively responds to one primary colour only.

(10) A multilayer colour film with integral couplers may be processed to give a colour transparency by developing to a black silver negative, fogging and colour developing to form positive black silver and (by coupling) dye images, and finally silver bleaching. Different couplers must be present in each emulsion layer to form yellow, magenta and cyan. The couplers are anchored in their appropriate emulsion layers either by resinous globules or hydro-carbon molecules. Alternatively (films with non-integral couplers) separate emulsion fogging and colour developments must be given for each dye layer.

(11) Other integral coupler films are designed to be colour developed and silver bleached to give a colour negative (reversed tones, complementary colours). This may then be printed onto a multilayer emulsion coated on paper, film or plastic to form a final positive colour image.

(12) Colour prints and transparencies may be assembled from physically separate complementary dye images. Purer and more permanent dyes can be used and many controls are possible; but first print cost is high. Assembly processes still current use black and white matrices printed from colour negatives through separation filters (or from direct separation negatives). Matrices are processed to give a relief image in gelatin. By means of *imbibition* each gelatin image takes up a coloured dye, transferring it in register onto a final paper or film support.

(13) Multilayer colour materials based on dye destruction principles contain complementary coloured dyes (instead of couplers) in the emulsion layers. The image is formed by bleaching away unwanted dye in each layer. Dye destruction print materials allow positive-from-

194

positive results by a simple sequence of silver image development and dye silver bleach.

(14) Instant-picture (dye diffusion) colour materials contain primary colour-sensitized silver halide emulsion layers. But a layer of developer-linked complementary dye molecules is associated with each emulsion. Following exposure an alkaline reagent allows dye to diffuse up out of the negative except where the linked developer molecule reaches exposed silver. Released dye diffuses as a positive colour image to a receiving layer–this may either be a separate sheet (peel-apart materials) or part of a single complex multilayer material.

(15) Special multilayer colour emulsions can be manufactured, such as infra red reversal film. They are limited only by the permutations of emulsion colour sensitivity and the dyes used in each layer. Most current multilayer materials use more than three emulsion layers, coated in a variety of orders.

(16) Colour materials of various makes differ in their results due to differences in dyes used and the manufacturer's balance of speed, definition, operating latitude and processing convenience. When possible stick to material of the same make and batch number; work strictly under the conditions specified for the product; bear in mind how the final colour image is to be used.

Questions

Fig. 10.12.

(1) Fig. 10.12 represents the magnified cross section of a modern reversal colour film in which colours are formed in the various layers. What are the colours to be seen in the areas 1 to 8 when the film is viewed by projection?

(2) Draw diagrams to show how primary and secondary colours, black and white are produced in a subtractive reversal colour film. Your answer should show the state of the film at each major stage of exposure and processing.

(3) Differentiate between additive and subtractive colours. Show how, using subtractive coloured dyes, the additive primaries are produced. Draw the (ideal) spectral absorption curves of a typical set of subtractive dyes.

(4) Describe the principle of *two* of the following systems of colour photography:
Reversal multilayer film (non substantive)
Dye destruction printing
Imbibition assembly printing.
In each case name a commercial material based on the system.

(5) Why were the first colour transparency materials to be generally used based on the principle of 'additive screens'? Explain how additive screens work and the reasons why they became obsolete.

(6) A multilayer reversal colour transparency film carries emulsions effectively sensitive to blue, green and red. Why then are dye images formed in these layers *in complementary colours?*

(7) Explain briefly the differences between each of the following pairs of terms:
Colour analysis; Colour synthesis
Dye coupling; Dye destruction
Dye transfer; Dye diffusion
Primary colours; Subtractive colours

195

RED
GREEN
BLUE

Fig. 10.13.

(8) (*a*) Fig. 10.13 represents strips of filters of the three primary colours as seen on an illuminated viewing box. Draw similar diagrams showing the appearance of these strips when seen through the following filters, using shading to indicate that no light passes: (1) Primary red, (2) Primary green, (3) Primary blue, (4) Yellow, (5) Cyan, (6) Magenta.

(*b*) How are the following colours formed additively:

(1) Yellow, (2) Magenta, (3) Red, (4) White?

(9) A special multilayer colour film is manufactured containing the normal blue, green, and red sensitive emulsions and yellow filter layer. However, the top emulsion contains *yellow* dye couplers, the middle emulsion contains *green* dye couplers and the emulsion nearest the film base contains *red* dye couplers. If white, yellow, red and blue subjects are photographed on this film, and it is then given normal (reversal) colour processing, what will be the colour of the images of each of the subjects?

(10) Colour prints may be made from (*a*) colour negatives, using a dye coupling process, or from (*b*) colour transparency positives, using a dye destruction process. Show, with the aid of diagrams, how colours are reproduced in a typical process representative of either (*a*) or (*b*).

(11) In the form of a table list the differences between Polaroid and Kodak systems of 'instant-picture' colour photography.

11. ODDS AGAINST ACCURATE COLOUR PHOTOGRAPHY

On the whole, a modern black-and-white photographic material does a very acceptable job in recording a multicoloured world in monochrome tones. It is probably helped by the fact that most of us have grown up surrounded by illustrations in monochrome–you are quite at ease in 'reading' grey tones as luminance and colour symbols, even when they are only approximately accurate. You know for example how tones have to be compressed to record a wide luminance range subject on a paper print. Yet as long as tones remain reasonably separable most viewers accept the result without difficulty. Visual communication is achieved.

But as soon as you try to record subject colour in photographic colour the problems multiply. You are much more critical of variations of colour than of tone, and in judging what is 'accurate' each person is tremendously influenced by conditions of viewing, type of subject and background, and personal idiosyncrasies such as eye response, and emotional reactions. Judgement of colour varies from person to person–it is *subjective*.

Even if your eyes had machine accuracy in remembering and agreeing on colour the few chemical dyes used in colour emulsions will still never match the varied sources of colour found in subjects themselves. This chapter puts forward the case that your chances of producing accurate reproduction of actual colours are pretty remote. Luckily you can learn to live with these defects, and even use them constructively.

Colour—terms and objective descriptions

The simple terms 'dark red' or 'yellowish' or 'pink' are extremely vague descriptions of colours you meet in life. The three main variables used by physicists in describing a colour are its *hue*, its *saturation* and its *luminance*.

Hue: The name of the colour. The dominant wavelength expressed as a colour title such as green, yellow, orange, etc.–names which define different positions in the spectrum.

Saturation: The purity of the colour. The more white mixed with the colour the less its saturation. Pastel colours are desaturated (unsaturated); strong vivid colours are highly saturated.

Luminance (or Brightness): The brightness or brilliance of the colour. This is objective in the sense of metered measurement of light energy, and subjective in that colour brightness is often judged visually relative to its surroundings.

How do these terms relate in practice? Black velvet material has zero saturation, almost zero luminance. White chalk has zero saturation but high luminance. Imagine that a sheet of coloured card has half its area covered by a light shadow. In both halves hue and saturation remain the same, only luminance has changed. If part of the actual surface of the card reflects some of the incident white light direct, as a *hot spot*, the saturation of colour from this area will be greatly reduced.

Hue, saturation and luminance are used frequently in photographic technical literature on colour. Try to remember what each of them mean.

Although the eye cannot be used objectively to judge or measure a colour seen alone, it can fairly accurately match two colours when *seen together* under identical conditions. You know from the principle of the visual photometer that the eye can measure luminance level by direct comparison with a 'standard' source. Similarly the eye can be used to compare colours against standards set by two important colour classifying systems – Munsell (using charts) or CIE (compared against projected lights, using a colorometer).

The Munsell system. Imagine a sphere, with a band of fully saturated hues (from red through yellow, green, blue to red purple) around its equator. Each hue penetrates into the very centre of the sphere but with decreasing saturation. At the centre where all colours meet saturation is zero. The sphere's vertical axis therefore consists of a neutral grey scale going from black (southpole) to white (northpole). By dividing the whole sphere up into vertical, horizontal and radial lines any colour can be given a numerical reference relating to its position within the sphere. The nearer its (horizontal) position to the equator the greater its saturation; the nearer its (vertical) position to the northpole the greater its brightness.

This is the basic concept of the Munsell system. In practice the 'sphere' takes the form of charts of printed colour patches radiating out from a vertical grey scale (Shown in Fig. 11.1). Each chart carries planes of pigments of one hue, increasing in brightness bottom to top and in saturation centre to extremity. Numbered scales indicate a colour patch's position relative to brightness (Munsell term *value*) and saturation (Munsell term *chroma*). Each chart itself has a hue reference number. Hence a particular red pigment might be matched against patch 4R 4/6, meaning located in the fourth chart of the hue red, where four on the chart's value scale crosses six on the chroma scale. This would be its Munsell number.

There are over 40 Munsell charts, published as a handbook. By reference to the appropriate Munsell number manufacturers of paints, printing inks, wallpapers – in fact anyone using or marketing pigmented colour products – can work to a matching standard. As a method of objectively defining a colour the Munsell system has obvious limitations when you come to assess anything other than a pigment printed on a paper base.

The CIE system. Instead of basing a classifying system on pigments it is possible to match colours by comparing them with mixed quantities of red, green and blue coloured light. This is the basis of an important system introduced by the Commission Internationale de l'Eclairage (1931) – also referred to as the International Commission of Illumination.

The three CIE primary colours are red, green and blue, and are given designated letters, X (red), Y (green) and Z (blue). An ordinary two dimensional graph can be used to express their relative proportions in forming a particular colour. The vertical axis is scaled in Y values, the horizontal axis in X values, and Z maximum is located at the junction of axis Y and X. This gives us a triangle ZYX (Fig. 11.2).

Equal values of the three CIE primary colours give us a 'standard' white which is therefore located near the centre of the triangle. All colours have a place somewhere within the triangle – the more saturated the colour the farther it lies from the centre. Thus any colour can be described by simply quoting graph co-ordinates. Fig. 11.2

198

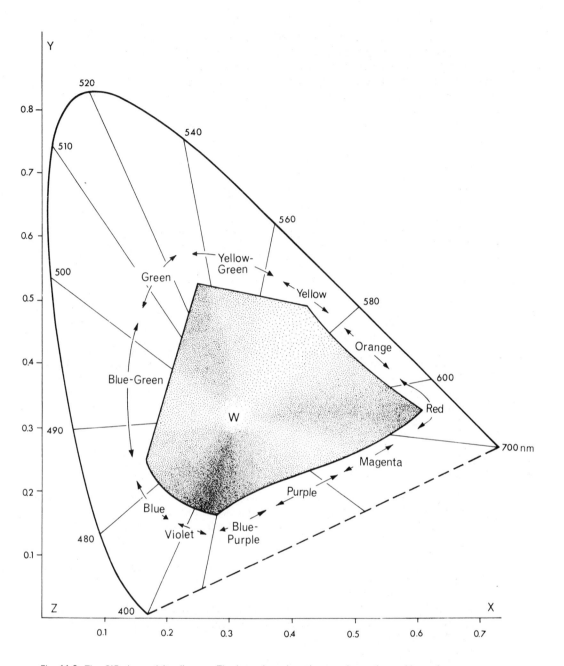

Fig. 11.2. The CIE chromaticity diagram. The horseshoe shaped curve shows the positions of pure spectrum colours, and figures around it indicate wavelength in nanometers. Colours grow more desaturated towards the centre area (neutral white). The shaded area shows the limited colours which can actually be reproduced by dyes or pigments in colour photography or photomechanical printing. Note the lack of rich greens, blue greens and violet.

199

shows just what a limited range of possible colours can be reproduced with dyes used in colour photography or inks in mechanical printing. (A more detailed layman's introduction to the CIE System forms Appendix III.)

CIE plots for particular colours are used frequently for calculations in masking for photomechanical reproduction (Chapter 15). The Munsell system is more often used for quick classification of pigments. Like the characteristic curve in photography, both serve the useful function for the technologist of attempting to replace vague descriptions by explicit numerical codes.

Colour sources

If you were to sit down and objectively analyze the sources of colour reaching our camera lens from subjects, you could probably draw up the following list:
 (1) Selective reflection, transmission or absorption of incident light by dyes and pigments. The colour appearance is greatly influenced by the colour composition of the incident light and the surface of the subject. If the subject surface is reflective, incident light and light from other colour sources will reflect unchanged off this surface and mix with colour selectively reflected from the actual pigment underneath.
 (2) Colours derived from white light by diffusion and scatter--for example the blueness of the sky, caused by scatter of the sun's shorter wavelengths by water and dust molecules in the atmosphere.
 (3) Fluorescent colours, emitted from certain materials whilst illuminated by wavelengths in the U-V region. Often this happens along with reflection of visible light–as for example fluorescent poster colours illuminated by daylight.
 (4) Colours formed by interference. These are rainbow-like irridescent colours (colours which change with the position of the viewer) seen for example on the surface of soap bubbles, or oil slicks on a wet road. They are caused by two reflections, from the inner and outer surfaces of a thin film, with half wavelength displacement between the two. As in the case of lens coating (page 12) this causes *interference*, suppressing some wavelengths and reflecting a coloured appearance.
 (5) Colours produced by diffraction, such as the irridescent colour reflected from an L.P. record or the sheen of some rayon fabrics. This is due to change in direction of some wavelengths in white light when reflected from the edges of a surface covered in finely engraved lines, or when passed through an aperture close to its edge.
 (6) Phosphorescent colours. Materials able to store energy from light and release it again as a colour after removal of the original light source, e.g. the hands of a luminous clock.

Any or all of these sources of colour may be present in your subject. No colour film can give accurate reproduction of each one–particularly when (as you have seen) most films contain just three chemically formed dyes.

Colour vision

The physical mechanism by which you see colour is by no means fully understood. The Young-Helmholtz theory of 'three-colour' vision was further strengthened by

Clark Maxwell's 1850 experiments in projecting mixtures of blue, green and red light to match all colours including white almost perfectly. Today it is well established that the retina contains many millions of rod- and cone-shaped cells. The rods are the more sensitive to light but have no colour discrimination, while the less sensitive cones do react to colour. It is just becoming possible for scientists to separate out the three types of cone reception by their chemical content. Some aspects of colour vision are not fully explained by the tri-colour theory, but Young's explanation is still the most reasonable and useful for understanding colour photography.

It is important to remember that the eye is virtually an extension of the brain–connected to it by an optic nerve containing over three-quarters of a million nerve fibres. In dealing with colour *vision* the brain's ability to interpret is as integral as the actual stimuli received from the eye. Physical vision is influenced by other psychological activities of the mind–experience and associations are recalled, priorities and standards imposed. A whole range of psychological reactions play their part.

Colour measured v colour seen

Human colour vision is obviously more complex than an objective, 'metered' measurement. From the point of view of practical colour photography the following features of colour vision are important.

(1) *Colour adaptation with change of light intensity:* As the lighting of the subject dims, first the iris of the eye opens (its range is about five stops, with resolution of detail deteriorating at widest openings). Next the retina adapts itself to increase its sensitivity. The total range accommodated by the combination of iris and retina sensitivity adaptation is about 1,000,000:1. However, the retina takes a long time to change to the extremes of this range, particularly going from light to dark conditions. (For example on entering the printing room from a brightly lit studio it takes *several minutes* before you can see your way around.) In adapting itself, the retina relies more and more on the highly responsive but colour insensitive rods, and less on the cones. Eye colour sensitivity changes ('the *Purkinje Shift*') firstly away from the red end towards the blue-green end of the spectrum . . . then drops to zero.

You may have noticed how, in a garden at dusk, the colour of red flowers becomes indistinguishable before equally luminous greens and purples fade into grey. Flash a torch on a red rose at dusk–its sudden colour brilliance emphasizes the loss of colour that is occurring elsewhere.

No colour film can adapt the response of its emulsions in this way. Expose colour film through an ultra fast lens to a dimly lit subject and it will yield a colour picture (despite reciprocity effects) although the eye may see little more than monochrome under these conditions. Which then is 'correct'–film or eye? Again when you view a scene having a very wide luminance range, your eyes are much less conscious of colour in the shadow areas than in mid-tones and highlights. (This fact should be remembered when making colour prints–if colour inaccuracies are inevitable they will be least noticeable if kept to the shadows.)

(2) *Colour adaptation, even when luminance does not change:* Visual judgement of 'white' light varies considerably. Walking from an area lit with daylight-type fluorescent tubes into a room lit at the same level with domestic tungsten lamps you are at first conscious of the 'yellowness' of the lighting. But within a minute or two

201

this is accepted as 'white' . . . return to the tube-lit area and the light seems 'blue'. In other words the eye quickly adapts its colour 'balance' so that the general illumination of its surroundings appears colourless.

This adaptation is useful in life but difficult from the point of view of colour photography. Colour film is designed to record colour objectively and will reproduce neutral subject tones as neutral only when exposed under illumination having a particular colour content (or other sources if filtered to match). You can too easily ignore the nature of the lighting you are using and end up with colour results which are unacceptably off-balance.

The eye's assessment of subject colour is also greatly affected by adjacent colours, surroundings, and preceding images. For example, if you stare at a bold green design in a book and then flip the page to a blank sheet, for a brief instant the design is seen on the blank sheet as magenta. Again, by mounting a colour print with a wide blue surround the picture appears yellower than when against a neutral background. In both cases the colour sensitivity of the eye has become temporarily adjusted. The green receptors in the retina that received the green image have become 'fatigued', whilst the blue and red receptors in these areas remain unchanged. On changing the eye's gaze to white paper the blue and red receptors briefly give a stronger signal than green and an 'afterimage' of the design appears in blue and red.

In the case of the print on a blue mount the effect is known as 'simultaneous colour contrast'–local sensitivity changes causing two adjoining colour areas to have exaggerated colour differences. Simultaneous colour contrast effects are used intenionally by most visual artists–for example in selection of background colours.

(3) *Individual variations in colour vision:* Everyone has slight differences in their response to colour. About 10% of the male population and 0·5% of women have some defective colour vision. Either their trichromatic response is somewhat uneven, giving abnormal vision, or more severely they are unable to differentiate between red and green.

The gristle lens of the eye is slightly yellowish in colour (a feature which limits the response to the blue end of the spectrum and assists in reducing the eye's chromatic aberration). In old people lens colour and consequent absorption of blue often increases, giving change of colour vision.

Obviously anyone undertaking colour photography should check whether their vision suffers any colour defects. Slight faults need not be serious in an operator provided that the individual knows his limitations and perhaps seeks help with critical subjects in certain colours. Colour vision faults are much more serious in colour printing, as decisions on subtle colour changes are constantly being made.

Defective colour vision among the photographer's clients should be detected diplomatically. Many people are extremely self-conscious about any suggestion of 'colour-blindness'. At the same time recognition of such difficulties by the photographer enables him to help the client tactfully.

(4) *Purely psychological influences on colour vision:* You are influenced in your judgement of 'correct' colour by your experience, by emotions, personal background, even race. You may *know* that the City buses are red and certain favourite flowers are yellow, and stick to these memories dogmatically irrespective of the conditions under which they are photographed. In some ways this influence of experience helps you to overlook slight errors in colour photographs of familiar things. But

202

certain subject colours–flesh tones and certain foods–are really quite 'critical'. The eye tends to detect quite small deviations. Conversely colour shots of unfamiliar subjects–e.g. technical macrophotographs or photomicrographs–are almost impossible to evaluate unless some reference (e.g. grey scale) is included with the subject.

It is an interesting point that colour can only be remembered by comparison. Can you describe the sensation of a colour without calling on comparisons; can you imagine a colour that you have never actually *seen?* Some colours have special connotations. Red suggests warmth; blue cold. Colour balances in these directions are of course used in advertising photography to emphasize sales points, e.g. a red bias in a picture of hot soup or an emphasis on green-blue for 'tingling fresh' toothpaste.

Limitations of Colour Photography Materials

The three dyes currently used in colour films and papers are still far from ideal. This applies particularly to dyes formed chemically by chromogenic development (discussed further in Chapter 12). Manufacturers therefore have to decide what compromises to make in producing a saleable product, trying to take into account the subjective visual aspects of colour too. Would it be better to opt for accuracy of flesh tones . . . or neutral greys . . . or brilliance of one or more saturated colours, since they are not all possible together?

Choice may be complicated by other manufacturer's chemical patents, and a preference for one colour bias rather than another which varies according to the part of the world where the material is sold. In the end the overall appearance of the colour photograph may be more important than great accuracy in certain regions of the spectrum only–but what then is the 'average' photographer's 'average' subject? It is doubtful whether one colour film can serve several objectives simultaneously.

This explains why each brand of film has its own slight but characteristically different colour appearance. Compare the results of photographing the same subject on Ektachrome, Agfachrome, and Fujichrome for example. Differences are clearly visible, yet each version seen alone appears acceptable.

Conclusions

Human response to colour is fickle. Colour film uses only three somewhat defective dyes. The chance of eye and colour photography coming to the same visual conclusion seems remote. In fact truly facsimile recording is only likely when the subject carries a limited range of colours, similar to colour film dyes; and when it has a limited luminance range and is illuminated by the same light source that is used to check the results. With the average multicoloured three dimensional subject it is virtually impossible to lay down a colour print or transparency next to the original and expect every colour to be an objective match.

The astonishing thing is that, despite all these odds, colour photography is so realistic. The preoccupation for 100% accuracy is in most cases unnecessary. Very few colour photographs are compared by the viewer direct with the original. Most viewers accept what 'looks right', so the photographer can go a long way by backing

his own visual assessment. As stated earlier, you can not only live with the limitations of colour photography–sometimes you can even turn them into advantages.

The colour photographer can help himself in various ways. For example:

(1) By using *colour* contrasts rather than great variation of brightness (as in black-and-white photography). Keep your lighting ratio low. Use the effect of simultaneous colour contrast, particularly where emphasis of the main subject is required.

(2) By creatively using the emotional responses engendered by dominant colours.

(3) By purposely presenting subjective interpretations (even colours startingly incorrect). Used with reasonable restraint the viewer is drawn to a fresh assessment of subject form, texture, etc. in a similar way to monochrome images simplified to line.

(4) By avoiding certain colours such as jade greens and purples, which are notoriously difficult to reproduce (see CIE chart).

(5) By displaying the final image under conditions least likely to allow comparisons with the original subject or other reference colours. This is best achieved with a projected transparency in a fully blacked-out room. As you know from black and white work, such conditions give you an image luminance range well beyond that of any print. Also the colour adaptation of the eye to the only prevailing 'white' helps to minimise colour deviations. Presentation of colour results is discussed further on page 283.

Related reading

MUELLER, C. and RUDOLPH, M. *Light and Vision*, Time-Life International 1969.
HUNT, R. W. G. *The Reproduction of Colour*. Fountain Press (London) 1975.
MANNHEIM, L. A. and HANWORTH, VISCOUNT. *Spencer's Colour Photography in Practice*. Focal Press 1975.
ISHIHARA, S. *Tests for Colour Blindness*. H. K. Lewis (London).

Chapter summary—'accurate' colour photography

(1) The eye is generally more conscious of 'inaccuracy' in a colour photograph than in black-and-white work. Detailed assessment of colour is highly personal unless the eye is being used to check the match of two colours seen together under identical conditions.

(2) The main variables used to specify a colour are hue, saturation and luminance or brightness. Hue is the basic colour title, saturation relates to its purity and brightness its brilliance.

(3) The Munsell system of colour pigment classification uses comparative charts. Each hue has a separate chart of colour patches which increase in luminosity from bottom to top of the chart and in saturation horizontally. A pigment is classified by the reference number of the Munsell patch it matches.

(4) The CIE colour classifying system matches colours visually by comparing them with mixed (imaginary) primary coloured lights. A colour is expressed on a CIE chromaticity diagram by graph co-ordinates–the more similar the three co-ordinate references the more desaturated the colour.

(5) Colour in our subjects may be the result of selective absorption by dye or pigments, scatter, fluorescence, interference or phosphorescence. It is impossible to objectively recreate all such colours with the limited range of chemical dyes available in colour film.

(6) The human eye appears to have a form of three-colour vision, the retina containing a mixture of cone receptors for red, green and blue light, plus highly sensitive rods which cannot discriminate colour. Being part of the brain, the eye's colour signals are *interpreted*.

(7) The eye's reception of colour 'adapts' or varies with the luminance level and colour of the general illumination. It is influenced by previous colour images (*afterimage*) and adjacent colours (*simultaneous colour contrast*). Colour deficiencies exist in individual eyesight. Colour judgement is further modified by our experience of subjects, and general cultural background.

(8) Photographic manufacturers have to work within the limitations of three dyes to reform all image colours. This means compromising between strict accuracy of some colours only, and acceptable reproduction overall. Each film brand therefore gives slight differences in colour appearance, even when used correctly.

(9) Truly objective colour photography of the normally wide range of subjects is not possible. Fortunately the human eye is highly subjective in measuring subject and results in isolation. Where realism is required the photographer can help himself by keeping down brightness range and instead creating contrast through colours; avoiding a few 'difficult' colours, and showing the final under the most favourable conditions. Things are easier when the brief allows interpretation rather than objective colour recording.

Questions

(1) Explain briefly the following:
>Tricolour vision
>Colour saturation
>Munsell colour classifying charts.

(2) Of two identical grey patches, one is placed on a bright red surround and one on a dark blue surround. What differences could you expect in the *visual* appearance of the two greys? Explain why this should occur.

(3) Discuss the limitations of using hue alone as the description of a particular colour.

(4) List the main factors limiting the ability of the human eye to assess a colour accurately.

(5) (Practical Assignments)·
>(a) Using small clippings from colour filters or spotlight gelatins make up colour patterns between the glass of transparency frames, and then project them. In this way check how a colour is visually affected by various adjacent colours; set up patterns simulating conditions in question 2. (Use fogged film for grey filters.)
>(b) Borrow a copy of Dr Shinobu Ishihara's *Tests for Colour Blindness* or similar colour tests from the library, and check your colour vision.

12. TECHNICAL PERFORMANCE OF COLOUR MATERIALS

You know from your experience of sensitometry applied to black-and-white materials that emulsion performance curves (*characteristic curves*) can give a lot of concise information. For anyone used to reading technical data they show at a glance an emulsion's relative speed, contrast, exposure latitude, fog level, maximum density, etc. In the same way experience of typical characteristic curves for colour films will help you to understand why certain aspects of practical colour photography discussed in following chapters are so important. Whilst dealing with graphs this chapter should clear up the method of speed rating colour reversal materials–and also explain the orange appearance of colour negatives.

Plotting colour characteristic curves

As in black-and-white work, each colour film undergoing sensitometric test must first be exposed to a range of luminances (brightnesses) under absolutely standardized conditions. After equally controlled processing the resulting dye densities are measured and plotted against log exposure.

Some special precautions must be taken in arranging exposure in the sensitometer. Firstly the light source used must have a spectral content matching the type of practical illumination for which the film is balanced. If the light source is too red for example the red sensitive layer effectively receives more exposure than the other two layers. Usually a tungsten lamp is used, and appropriately filtered.

The light passes through a shutter and reaches a step wedge which is contact printed on to the emulsion. The shutter must be arranged to open for a period matching the 'average' shutter speed likely to be used for the film in practice. Deviations may result in reciprocity failure in one or more emulsion layers.

The step-wedge creates even greater difficulties because it must be completely neutral in colour, absorbing all wavelengths equally. Special wedges made for colour work are necessary. Even wedges made of 'black' metallic silver tend to have some colour, as we know from the colour of printing paper images.

Following exposure in the sensitometer, and processing strictly in accordance with the manufacturer's instructions, densities are plotted in a densitometer (Fig. 12.1.) Now of course the three image layers in a multilayer film cannot normally be split apart for individual measurement. But by taking three readings of every step wedge image density through blue, green and red filters on an electronic densitometer, the effective or *integral densities* of the yellow, magenta and cyan dye layers can each be plotted separately. Narrow cut filters are used for measuring reversal materials. Somewhat different sets of narrow cut primary filters are used for measuring colour negatives, i.e. filters having transmission curves matching the peak colour sensitivities of the colour paper emulsions, so that the resulting graphs truly indicate printing density. The filters used must be regularly checked against a standard in case they become bleached.

Similarly the densitometer must have an appropriately stable tungsten light source and (very important) a photo-electric cell giving a good response in the filter

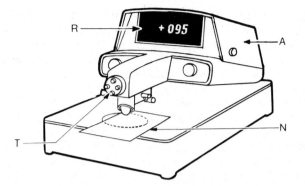

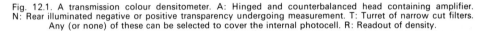

Fig. 12.1. A transmission colour densitometer. A: Hinged and counterbalanced head containing amplifier. N: Rear illuminated negative or positive transparency undergoing measurement. T: Turret of narrow cut filters. Any (or none) of these can be selected to cover the internal photocell. R: Readout of density.

transmission bands. Photo-cells having sufficient red response for the job also have high sensitivity to infra-red. As this could result in deceptive readings, an I.R. absorbing filter is always located in the light beam, normally near the lamp. The combined effect of light source, measuring cell, and filters could vary considerably between densitometers unless tightly specified. A commercial densitometer complying with Kodak specifications and fitted with AA filters is described as *Status A*. This is suitable for densitometric measurement of colour positives on film, such as reversal films. Changed to another filter set, M, the equipment is said to have *M status*, suitable for measuring colour negatives.

The three density readings of every step wedge on the film are plotted (on the D axis) against the log transmission of this step on the original grey wedge (on the log E axis). You can then interpret the resulting three graphs.

Basic characteristic curves of reversal colour films

Naturally, having been reversal processed, the curves slope in a direction opposite to the more familiar negative materials, see Fig. 12.2. The lighter end of the step wedge (i.e., greater log E value) produces least density on the transparency and vice versa. The three curves are labelled B, G, and R denoting the emulsions by their original effective sensitivities. The sets of curves give us some significant basic information:

(1) The slope of the centre parts of the curves is steeper than general purpose negative materials, having a gamma of around 2·0. D max is typically about 3·0. This is necessary to give a visually satisfactory transparency, containing a wide range of luminosities.

(2) The three curves coincide in position and shape along their centre straight line portions but tend to vary a little at each end–particularly at the shoulder. The spreading apart of curves denote that the reproduction of the grey scale is no longer neutral, and tends to be biased towards the colour of the dye in the emulsion layer with the highest graph line. In practice shadow parts of the image with densities above about 2·7 are too dark for colour bias to be noticeable to the eye.

208

(3) The minimum density is low, because the transparency should have veil free, brilliant highlights. All three curves should show matched densities at this end, for a colour bias in the highlights tends to be noticeable. You can see that when shooting subjects on colour reversal film it is most important to locate the subject highlights at as low a density point as possible. Too much exposure and highlight detail becomes desaturated, with neglible tone separation; too little exposure gives unacceptably veiled highlights. Because the eye is so conscious of highlight deficiencies most colour photographers gear their exposure meter technique to a highlight or white card reading (see Chapter 13). Couple this to the high gamma and the colour deficiencies inherent in shoulder areas (deep shadows), and it can be seen that the exposure latitude of reversal colour films is very limited. The graphs show that subjects giving an image

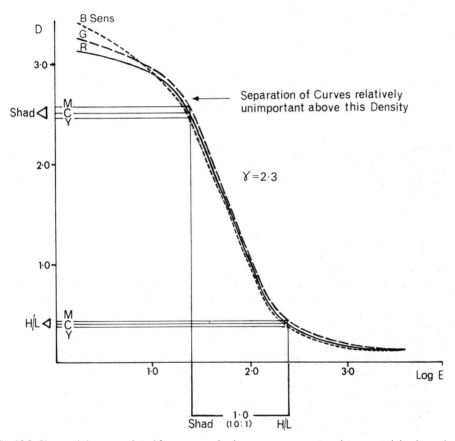

Fig. 12.2. Characteristic curves plotted from a reversal colour transparency exposed to a neutral density wedge, and measured by status A densitometry. R: Red sensitive emulsion response curve (i.e. principally the density of cyan dye, obtained by measuring with a red filter over the densitometer cell). G & B represent the response of green and blue sensitive emulsions read through filters of these colours. The highlight and shadow (both neutral grey) of an image having a luminance range of 10:1 is shown here plotted in terms of the resultant M, C & Y dyes formed. These results would appear acceptably neutral in colour.

209

Fig. 12.3. Reversal colour film characteristic curves showing the result of exposing to a neutral grey subject illuminated at a lower colour temperature than that for which the film is balanced. This lowers the effective speed of the blue sensitive emulsion relative to the other two—both shadows and highlights are shown to record with a strong yellow-orange cast. (See Plate C1)

luminance range beyond about 10:1 ($1 \cdot 0 \log_{10}$) represent about the maximum that can be accommodated without some losses at one end of the scale or the other. And since this luminance range spans the whole exposure range of the material exposure latitude is virtually nil. Similarly if one colour transparency is printed on to another sheet of the same material the density range of the first transparency will usually exceed the exposure range of the second. A contrast reducing mask is always necessary for facsimile reproduction by this route.

(4) If you use the film in such a way that one or more curves are displaced relative to the others, distorted colours and tones will result. This can happen if the lighting does not match the spectral content assumed by the manufacturer, making one of the colour emulsions effectively faster or slower than the others (denoted by sideways displacement on the graph). The result is a colour bias throughout the whole transparency (Fig. 12.3.). Again, a very long or very short exposure duration may create reciprocity failure which differs in its effect with each layer. One layer may then differ in speed *and contrast*–its curve crossing the curves of the other two layers, predicting that the material will show one colour bias in the shadows and a different colour bias in the highlights, see Fig. 12.4.

Speed rating reversal colour films

It is not practical to apply the current ASA/DIN/BS method of establishing black-and-white emulsion speeds to reversal colour film. The significance of minimum

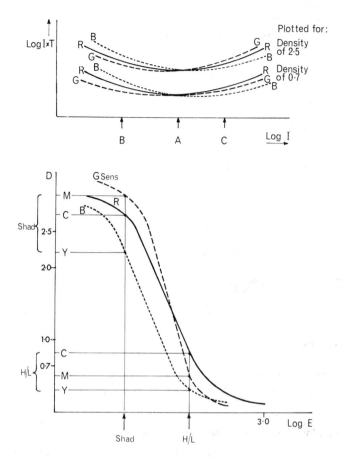

Fig. 12.4. Reciprocity failure in multilayer colour materials is far more serious than in black & white stock. For intensities around A the three emulsions have a matching effective speed, but at very low (B) or high (C) image intensity levels each emulsion may vary in its reciprocity failure. Worse still, response may differ between top and bottom of the characteristic curve (a layer changing in gamma as well as speed). The result of exposing at image intensity C is plotted on the graph (shown below). Whilst the shadows have a magenta-blue bias the highlights appear cyan. A yellow correction filter on the camera may for example help to correct the blue emulsion (moving its curve to the right) but any correction of the green to improve shadows will worsen highlights and vice versa. The film is said to have crossed curves. (See also Fig. 13.6.)

density is quite different; you cannot assume that an 'average' image would have a 1·3 log E range; and a final density range of 0·8 would not be suitable. It is more practical to base the speed on the exposures needed to give minimum and maximum useful densities appropriate to a colour transparency. This is the basis of the ANSI/BS (1974) standard. Speed is based on:

(1) the maximum exposure point, which is the point on the log E scale giving a minimum density of 0·2 above base plus fog, and
(2) the minimum exposure point, which is the position on the log E scale of the start of the curve shoulder (see Fig. 12.5) or opposite a density of 2·0 above base plus fog, whichever is the lower.

211

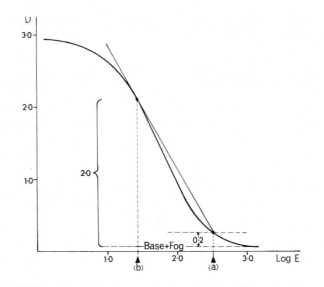

Fig. 12.5. ANSI/BS (1974) speed criterion for reversal colour emulsions. (Only a single curve is plotted, being the average of R, G & B curves). The exposure point is the square root of (b) × (a) on the log E scale, and is divided into a constant, see text.

The log E readings (*a*) and (*b*) are multiplied together, and the square root of the result divided into 8 to give the speed figure (arithmetic scale). Conditions of exposure are specified; processing is to manufacturer's recommendations for the product.

The speed rating of colour *negative* films is shown in Fig. 12.7.

Typical characteristic curves of colour negative films

Once again you find separate curves representing the performance of each emulsion in the multilayer film, Fig. 12.6. Most colour negative films incorporate an integral mask (giving an overall yellowish or orange appearance). This will be described shortly. The mask colour means that a straight densitometric plot shows the three curves displaced vertically, blue at the top and red at the bottom. (Alternatively the readings may be adjusted so that the effect of the mask is ignored, in which case the curves more closely coincide.) The basic information worth noting from these curves is as follows:

(1) The curves slope less steeply than reversal materials. Gamma is about 0·7 and maximum density (including the effect of masking dyes) around 2·8. This negative emulsion contrast takes into account the requirements of negative exposure latitude and the performance of the colour printing paper. It is essential that the three emulsions exactly match in contrast, otherwise the image may have one colour bias in its highlights and quite another in the shadows.

(2) The blue and green sensitive (yellow amd magenta dye-forming) curves have high densities. This mask colour is taken care of in printing, but it does give a

212

colour negative the appearance of being quite reasonably dense, when a closer examination shows by a tell-tale lack of shadow detail that it is really under-exposed.

(3) The curves all have long straight line portions. Although this (and the low gamma) suggests greater exposure latitude and ability to cope with a wider luminance range subject than transparency material, remember that any final colour print on paper has a restricted reflectance range. An image luminance range of about 10:1 ($1\cdot0$ \log_{10}) is about the maximum acceptable if the negative is to print well.

The three emulsions need not all be of exactly the same speed (i.e. they can be displaced laterally) as some corrections can be applied by filtering in printing, and may also be compensated for by the balance of the printing emulsions. This also means that (restricted luminance range subjects) considerable latitude in the colour temperature of the light used to shoot the negative is permissible in emergencies. Of course these deviations must never be so extreme that the toe or shoulder part of any curve is used in recording the subject luminances.

The dyes formed in a colour negative differ in detail from those formed in a transparency. Unlike the latter they are not intended to be viewed as the final result, and are more profitably 'keyed' to suit the colour response of the print material to come.

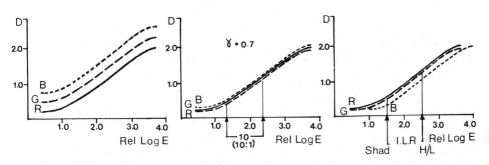

Fig. 12.6. Colour negative characteristic curves (Left) A masked colour negative film, exposed to a neutral density wedge and plotted by status M densitometry, shows vertical displacement of blue and green sensitive emulsion curves, owing to the orange mask. This is completely corrected in printing. (Centre) Adjusted plots which ignore the effect of the integral mask. An image luminance range of 10:1 shown correctly exposed onto the straight line portion of the curves. (Right) If exposed to illumination of lower colour temperature, the blue sensitive emulsion curve is displaced but still records on the straight line portions of all three curves and may be filtered back to normality in colour printing. An image luminance range greater than $1\cdot0$ however begins to fall on the blue toe (shadows) and R & G shoulders (highlight). The resulting distortions in highlights and shadow areas cannot be fully corrected by overall filtering. Minimum latitude in colour temperature occurs with a wide luminance range image.

Speed rating negative colour films

Unlike colour reversal materials, the method for determining the speed of colour negative films still differs between the various standardising bodies. Fig. 12.7 shows the fixed density system laid down by BS in 1975. After exposure and processing in a defined manner the usual three characteristic curves are plotted. Points on each curve are marked where density is $0\cdot15$ above the minimum density for that particular

213

layer. These points can be related to three values on the log E axis below. The average of two values are chosen (one relating to green, the other the slowest layer, normally red) and used to calculate the BS arithmetic speed.

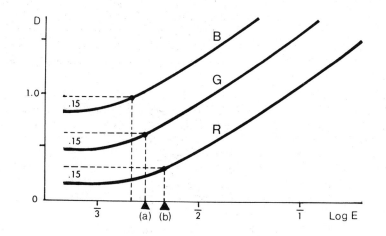

Fig. 12.7. BS (1975) speed criterion for colour negative films. Three curves are plotted. The exposure point is the average of (a) and (b), see text.

Characteristic curves of colour paper

The plots of characteristic curves for papers will vary slightly according to make, because their performance is designed with the characteristics of the maker's colour negative and conditions of printing in mind. (It is usual to plot paper response to a step wedge when exposed by a light source filtered to give the most neutral image. Plots showing paper response when an unfiltered enlarging lamp provides the light source may show considerable separation of the curves. This is due to 'built-in' modifications of sensitivities to suit mask dyes etc. in the same maker's negative) Certain general features include:

(1) Straight line portions strictly matching in gamma. The gamma of the emulsions will depend upon the actual material, being typically 1·5–2·2.
(2) Low and equal minimum density. Like black and white printing materials any noticeable veiling of subject highlights would be unacceptable. In addition any layer with a higher fog level than the others will stain the highlights with colour.
(3) Maximum densities of about 2·0 (paper print) or about 3·0 if the printing material is on a film base.

It can be seen how densitometric measurement of approptiate areas of a colour negative, linked to knowledge of characteristics of the printing paper (and equipment) could be used to help predict the required printing-filters and exposure. Practical methods of assessing negatives in commercial colour printing are discussed in Chapter 14.

214

Limitations of curves plotted from neutral wedges

Finally, any plotting of colour material performance by the use of grey wedges alone can only tell part of the story, owing to deficiencies in the dyes themselves. It is quite likely for example that the magenta dye absorbs some blue as well as the intended green light. Less yellow would therefore be needed to form a neutral image. Not only would the image of the grey wedge *look* neutral, but the blue filtered colour densitometer 'reads' some magenta along with the yellow dye and indicates that the yellow layer is denser than it really is. When actual subject matter is photographed on the film, image blues (which comprise magenta and cyan) will appear too dark.

The only way to detect these deficiencies is to expose further wedges onto the film using colour filters. (See control strip colour plate C.8.) By appropriate choice of exposure and nattow-cut measuring filters, the contribution of each separate layer of dye can be accurately determined.

The sets of curves based on exposure to a neutral grey scale (Figs. 12.2–12.6) are quite satisfactory for indicating the effect of the multilayer film as a whole. For more detailed information on images of coloured subjects, graphs plotting the dye densities formed in each layer are needed for each of three grey scales, exposed through primary coloured filteres.

Dye deficiencies and masking

Dye technologists today are still a long way from finding us the ideal coupled dyes for multilayer colour materials. Our main requirements are formidable:
 (1) The dyes must be capable of being formed chemically within the emulsions, usually by coupling with common oxidation by-products in colour development. None of the other processing chemicals should affect them adversely.
 (2) Each dye should absorb evenly all wavelengths within one third of the spectrum, completely and evenly transmitting the remainder.
 (3) All dyes should be fully permanent, capable of withstanding powerful projector light sources or daylight viewing conditions without bleaching; also suitable for storage over long periods without deterioration.
(You should also remember the basic limitation that even if the dyes did perform as above, tri-colour synthesis cannot produce all spectrum colours with full purity.)

The dyes used are compromises. In particular it is not yet possible to find dyes that fulfil (2) but are also stable. Different manufacturers research their own colour couplers but, generally speaking, the deficiencies of all dyes found in chromogenic coupled emulsions can be summed up as follows (Fig. 12.8):

Yellow – Reasonably satisfactory.
Magenta – Absorbs some blue along with the intended green light.
Cyan – Absorbs some green and (to a lesser extent) blue, along with the intended red light.

In practice this means that although yellows and reds reproduce reasonably well, saturated greens are too dark and blue-green hues tend towards blue (both principally due to over absorption by cyan). Purple reproduces too red and blue is dark and desaturated (see also Fig. 11.2). These appearances vary a little between products,

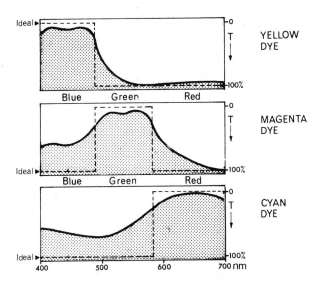

Fig. 12.8. Absorption curves of typical dyes formed via colour coupling in colour film emulsions. As the 'ideal' lines show, each dye should transmit two thirds of the spectrum and absorb the remaining third. In practice they do not meet this requirement—cyan and magenta being particularly poor in their transmission.

because each manufacturer strikes a different compromise in his choice of dyes. The usual aim (for general purpose colour emulsions at least) is to achieve a satisfactory rendering of skin tones. After all, who will buy film that records foliage splendidly but gives Baby Jane a greenish face?

Coloured integral masks. Whilst these colour deficiencies are bad enough in reversal materials, they are much more serious in negative-positive systems, because defective dyes are used twice—once in the negative and again in the print. Faults have an additive effect. But since the negative is only a means to an end, could some sort of masking device be incorporated at this stage to counteract the defective absorptions and transmissions?

Imagine that you have isolated the magenta dye image layer of a colour negative and are examining its effect on blue light (Fig. 12.9). Ideally it should transmit all of this light, but in practice it might absorb 25%. This means that, image-wise, the magenta dye is influencing blue light when it should really only influence green. But what you could do is to introduce a colour into the areas of this layer not occupied by magenta—a colour which would also absorb 25% blue light. Such a colour would be pale yellow. As far as blue light is concerned, the whole layer then evenly absorbs 25% (either by its magenta, or yellow, or mixtures of both in mid-tones). The magenta layer no longer influences the blue image—it simply absorbs blue equally throughout the layer. This can later be compensated for by increasing the blue sensitivity of the printing paper.

How can this required yellowish colour be introduced only into parts of the layer where magenta is not present? The original magenta-forming couplers, when first coated into the film with the green sensitive halides, were themselves colourless.

216

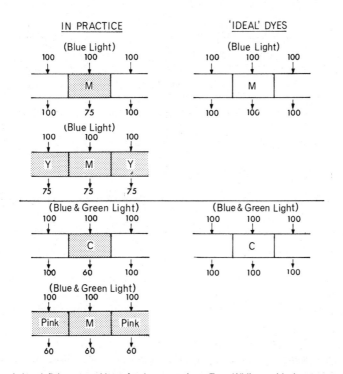

Fig. 12.9. Integral dye deficiency masking of colour negatives. Top: Whilst an ideal magenta should transmit as much blue light as clear film, in practice it absorbs some blue (in this case 25%). By incorporating into the clear areas of the magenta layer a dye which also absorbs 25% blue light—a dye yellow in colour—the whole layer acts as even density and no longer influences the blue image. Bottom: Similarly cyan dye should transmit blue and green light, but in practice absorbs a proportion of each. Pink dye is therefore located in the cyan layer, remaining wherever cyan is not formed. The whole layer then evenly absorbs blue and green. Check with colour figure 10.9.

What you could do is to make these original couplers pale yellow in colour instead. Then where the image dictates that they turn into magenta dye the yellow automatically disappears; but in areas where coupling does not take place the yellow stain remains. This does what you require in a very elegant way. In fact you are forming a positive pale yellow mask in with the magenta negative image. This is known in principle as an *integral colour mask*. (Check the same reasoning over again, with reference to Fig. 12.9).

Next take the cyan layer. A poor dye this, let us say that the cyan image absorbs about 40% green and 40% blue as well as the intended red light. A dye must be introduced into its clear areas which will also absorb these percentages of green and blue. You therefore require a desaturated mixture of magenta + yellow, or pink (in practice most cyans absorb more green than blue, so that the magenta content of the mask must be greater than the yellow). This will convert the cyan image into a layer of equal density from the point of view of green and blue light. Suitable increase in green and blue sensitivity of the colour paper can be made to compensate for the overall loss of light of these two colours.

Most colour negative films with integral colour couplers therefore basically

217

contain a top emulsion of blue halides plus colourless yellow couplers. (No masking is needed in this layer.) Next comes the usual yellow filter, and then a layer of effectively green sensitive halides with pale yellow coloured, magenta-forming couplers (Fig. 10.9). The lowest layer has effectively red sensitive halides with pink coloured, cyan-forming couplers. (A few materials derive colour masks by colouring unused couplers during actual processing. The couplers start out colourless. The principle and the final appearance of the colour negative remain as described.)

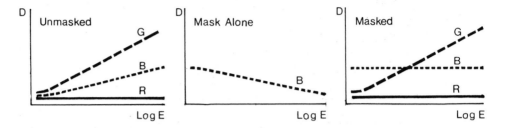

Fig. 12.10. A situation similar to Fig. 12.9 (top half) but now expressed by characteristic curves. These show, left, the magenta dye image of an unmasked colour negative measured in terms of its green, blue and red density. Note the unwanted blue image-wise response. Centre: the blue absorption of a yellow mask (yellow-dyed couplers in the green sensitive layer which effectively form a positive image). Right: The combined effect of the masked green sensitive layer is to give a high but consistent blue density throughout. This can be filtered out in colour printing.

Whilst these masks greatly help the reproduction of colour hue and saturation in the final print, their presence gives the colour negative a strange looking 'cast'. In clear areas (subject blacks, rebates etc.) the masks show as pale yellow+pink= orange appearance. At first glance the whole negative seems to have an overlying stain – but in fact this only exists where two couplers have not been used. The parts of the negative with cyan and magenta dyes fully formed do not carry the orange colour (Colour plates C3–4).

Many multilayer colour negative films today contain two layers for each of the green and red sensitive emulsions. The two layers vary in speed; the couplers are apportioned between them. By controlling the distribution of couplers it is possible to overcome previous problems of insufficient colour correction at high densities.

Separate silver masks. Although coloured integral masks improve the quality of colour negatives, they are not incorporated in colour transparencies. A large proportion of transparencies are considered as the final results, i.e. amateur colour slides, and the presence of a dye mask would be visually unacceptable. When a transparency is only one link in the chain of reproduction however (the next stage may be separation negatives, or a duplicate transparency) masks are often added to improve the final result. Such masks cannot be formed within the normal multi-layer colour transparency film but usually take the form of separate silver positives or negatives. They are usually made unsharp, like the masks used in black and white photography, page 153.

The photographer uses separate masks in conjunction with colour materials:
(1) To compensate for dye deficiencies (hue and saturation).

218

(2) To reduce the overall density range of a colour transparency to suit the next stage.

(3) To increase contrast and detail in the final reproduction of the subject highlights, which would otherwise be suppressed.

(1) **Dye deficiency masking.** The method of silver masking to correct dye deficiencies is mostly an exercise in logic. Imagine that you have a positive colour transparency from which colour corrected separation negatives have to be made. Due to the magenta tendency to absorb blue, a 'straight' blue separation negative will record magentas too light. You need a way of adding density to magenta areas recorded on the blue negatives. Now a green separation negative records all magentas as clear, and a positive from it carries magentas in the form of density. Therefore (Fig. 12.11.) you can either:

(1) Combine a weak positive from the green separation negative with the blue separation negative, giving it the required additional densities.

or(2) Combine a weak green separation negative with the colour transparency. This adds silver density to all colours except magenta, so that when the blue separation negative is made from the combination magentas record with the necessary extra density.

Similarly think about the green absorption by the cyan dye. This will give loss of density on the green separation negative, unless you can add to it an image in which cyan areas appear as density. You therefore turn to the red filter separation, taking a weak positive from this to combine with the green separation negative. Alternatively you could carry out (2) above, substituting red for the green, cyan for the magenta, and green for blue. As a general rule mask density range should be equal to the density of the unwanted absorption.

This may seem complicated at first reading, but when you look through it again carefully the system is really simple and elegant. Colour correction masking of transparencies is routine when separation negatives are being prepared from them prior to photomechanical printing in books and magazines (Chapter 15). It may also be carried out when a transparency is being turned into separation matrices for imbibition printing, into a colour negative for negative/positive printing, or when being duplicated onto other transparency material (together with a contrast reducing mask). The need for masking depends a good deal on whether it is a subject demanding a high level of accuracy, and the amount of time (and money) that can be spent on the job.

(2) **Contrast reducing masks.** It is seen that a reversal colour transparency has a high gamma, often resulting in a density range of 2·0 or more (Fig. 12.2). This may be visually effective but is too long a tone scale for duplicating onto other transparency material or even separation negatives if facsimile reproduction is required. A weak unsharp negative mask is therefore made from the colour transparency and bound up with it to reduce contrast when making the next stage.

The mask (its strength will depend upon the density of the transparency and the requirements of reproduction) can be made to white light. Alternatively some simultaneous colour correction is possible by filtering the exposing light. For example a

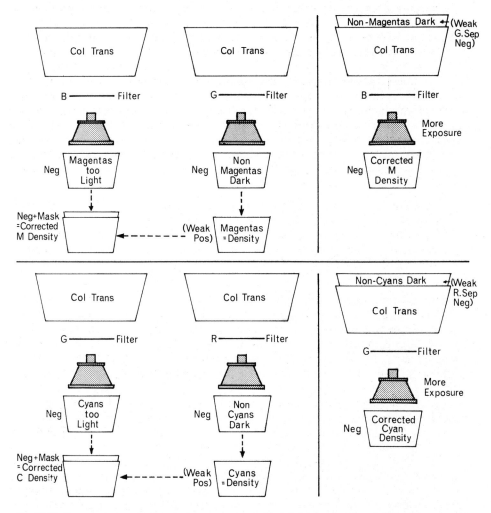

Fig. 12.11. The use of separate silver masks to compensate for dye deficiencies. Top: Owing to blue absorption by magenta dye in the colour transparency, the magenta content of the image records with too little density on a blue separation negative. A weak positive from a green separation negative (i.e. recording magentas as density) is therefore combined with the blue separation negative. Alternatively (top right) a weak green separation negative can be combined with the original transparency, darkening all colours except magentas. A correctly exposed blue separation negative made from this combination records magenta with the required relative density. Bottom: Similar masking routines can be applied when making a green separation negative—this time correcting green absorption by the transparency's cyan dye. In each case the mask density range should equal the density of the unwanted absorption.

contrast mask is often made to a red light source—when combined with the transparency this darkens the reds, effectively lightening the greens and blues. The over-absorption of these colours by the cyan and magenta layers is therefore given some correction.

(3) **Highlight masks.** You know that the highlight areas of a colour photograph are very important. The eye tends to take them as points of reference, and colour casts, excessive density and loss of detail are most noticeable. Conventional contrast reduction masking tends to diminish specular highlights and the resulting copy transparency may lack 'sparkle' and appear flat–particularly unfortunate if the subject highlights are critical. Highlights can be preserved by means of a highlight mask.

First, an underexposed negative is made from the transparency on contrasty panchromatic film so that it only carries density representing subject highlights, see Fig. 12.12. This is bound up with the transparency whilst the contrast reducing/ colour correcting unsharp masks are made. It is then disposed of. As a result the local contrast within the highlights is not masked at all, and on the final image this contrast and detail is preserved.

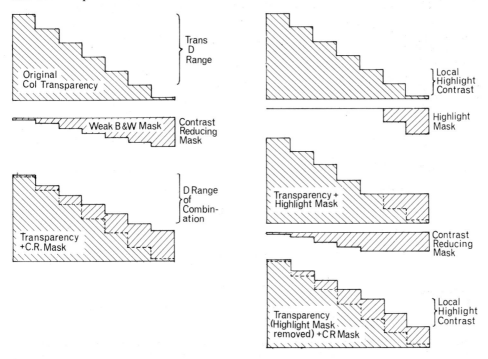

Fig. 12.12. Separate silver contrast masks for colour transparencies, Left: Contrast reducing mask. Often a colour transparency has a density range too wide for separation negative making or duplicating on other colour transparency material. A weak black-and-white negative combined with the transparency can reduce this range, whilst maintaining proportional separation of tones. Right: Use of a highlight mask. In order to retain brilliance (local contrast) in highlight tones a contrasty, very underexposed negative is combined with the colour transparency when making its contrast reducing mask. Masking of highlights is thereby prevented. Highlight mask is next discarded and the transparency and contrast reducing mask are combined. Note how density range of the highlight 'steps' has remained unaltered.

Multilayer internegative film

Special multiple layer film (Vericolor Internegative, Tri-mask, etc.) is made for producing colour negatives from reversal colour transparencies. The negative film

221

is designed to give colour, overall tone scale, and highlight corrections semiautomatically – so that prints on multilayer paper, print film or imbibition materials can be made without any supplementary masking. Internegative film carries a total of six layers, giving the following features:

(1) Blue, green, and red emulsion narrow-band colour sensitivities, which correspond to the maximum absorption of the three dyes used in the colour transparency.

(2) Yellow, magenta and cyan coupled dyes which have (in common with other colour negatives) absorption characteristics 'keyed' to the characteristics of the final print material.

(3) Integral colour masking using coloured couplers in the green and red sensitive layers – masking which takes into consideration the inherent dye deficiencies in the original transparency, as well as interneg and final print dyes.

(4) Emulsion characteristic curves which are upturned near the top (Fig. 12.13) – this gives higher contrast to subject highlights, acting as a built-in highlight mask. Curves of this odd shape are achieved by combining two emulsions per colour sensitivity, one being slower and more contrasty than the other. Lower parts of the curve have less slope than a normal colour negative, compensating for the wide luminosity range of the transparency, and designed to give a density range appropriate to the colour print material.

The double layer emulsions and other features of internegative film mean that its characteristics change considerably with level of exposure, filters etc. In order to

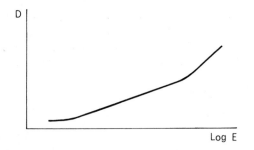

Fig. 12.13. Characteristic curve of the green sensitive layer of Vericolor Internegative film, exposed to a step wedge. The upturned upper section can be used as a built-in highlight mask.

get repeatable results highly controlled working conditions are needed. Multilayer films of this complexity are really designed for process laboratory use – trade firms specialising in colour printing, colour D & P houses and cine laboratories.

One final point on masking. No system of dye masking can give complete correction, owing to the law of diminishing returns. In other words, the dyes used for masking themselves suffer from deficiencies . . . A mask to mask the masks has deficiencies in *its* dyes . . . and so on, ad infinitum !

Separation negatives

Relative to the complexities of today's multilayer colour materials the performance required of separation negatives may seem simple and almost crude. However you

cannot use just any old panchromatic material. The basic requirements of colour separation negative materials are:

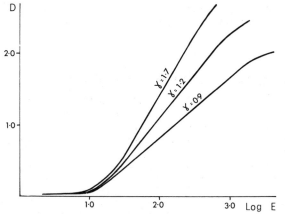

Fig. 12.14. Characteristic curves of a material designed for separation negative making, drawn at different degrees of development. (Kodak Separation Negative Film Type 1, exposed through a red tri-colour filter) Note the long straight line section. The recommended density range of separation negatives for Dye Transfer printing is 1·2, with a D minimum of 0·3 to keep tones off the toe.

(1) A panchromatic emulsion possessing a characteristic curve with a long straight line portion (Fig. 12.14). Proportional reproduction of colour by densities is only possible on the straight line portion – the longer this is the more flexible the materials will be in terms of exposure latitude, and the measure of control over final density range.

(2) A base which will not stretch or shrink during processing. Eventually the three images will be printed in register; any dimensional change will make registration impossible. Modern polyester (e.g. 'Estar') based film or even glass plates are quite suitable.

(3) The three separation images should all develop to the appropriate gamma in the same time, irrespective of the colour of the taking filter. Most panchromatic emulsions vary in gamma according to the colour of the exposing light, and in particular give a lower gamma for the blue filter image. Yet it is essential that all three negatives have the same final density range. Unless you wish to go to the trouble of juggling with development times in compensation, it is better to use specially made colour separation emulsions which give the same gamma with each filter, under the proposed light source. It is usual to include a grey scale with the subject matter or, if working from a colour transparency, taped up alongside the transparency. Measuring the reproduction of this grey scale to assess gamma, mask effects etc. is much more convenient than selecting various parts of the colour image.

In addition to the above, tri-colour filters must be chosen which are appropriate to the subject (separation negatives from colour transparencies require narrower cut filters than sets made from the much wider range of colours in an original subject). The colour sensitization of the negative emulsion and the transmission of filters should also suit the intended system of printing. Check the manufacturer's recommendations.

223

Related reading

HUNT, R. W. *The Reproduction of Colour*. Fountain Press 1975.
MANNHEIM, L. A. and HANWORTH, VISCOUNT. *Spencer's Colour Photography in Practice*. Focal Press 1975.
JACOBSON, R. *The Manual of Photography*. Focal Press 1978.

Chapter summary—technical performance of colour materials

(1) Any sensitometric analysis of colour material requires a light source of known spectral content and shutter speed appropriate to typical practical conditions. The grey scale printed on the film must itself be quite neutral in colour.

(2) Density readings of multilayer colour images are made through specified blue, green and red filters, using a photo-cell of appropriate colour sensitivity. Overall the densitometric system is given a *status* description. Three curves are produced, representing the integral densities of each of the three dye images.

(3) Reversal colour films have characteristic curves with steep slopes (γ 2·0) and high D maximum (about 3·0), which in the case of a grey scale image should coincide along most of their length. Minimum density is critical–it should be as low as possible and free of dominant colour.

(4) Reversal curves show that exposure latitude is limited; exposure readings should aim to 'pin' the highlights at the bottom of the curves; lighting of the wrong colour temperature will create an overall colour bias; and inappropriate exposure durations which give reciprocity failure may result in 'crossed curves'–differing colour bias in shadows and highlights.

(5) Speed ratings of reversal colour films are based on the mean average of the exposure to give 0·2 density + fog, and the exposure at the start of the curve shoulder (or 2·2 above fog).

(6) Colour negative materials have lower gamma (about 0·7) and D maximum (about 2·8) than transparencies. Overall density appears deceptively high due to the orange colour masks. Exposure latitude and permissible variation in colour of subject lighting exceeds that of a transparency. Dyes formed are 'keyed' in detail to the requirements of the print material.

(7) The speed criterion for colour negatives still varies according to the standardising authority. BS use fixed density points 0·15 above fog on each curve, then average the log E values for green and the slowest emulsion.

(8) Colour print materials must have curves which match in shape, have low and equal minimum densities, and maximum densities appropriate to a reflection print or transparency. Lateral displacement of the curves is controlled by colour filtration, compensating (within limits) for negative colour bias.

(9) Densitometric plots from netural grey scale images suggest that each dye has ideal spectral transmission and absorption characteristics. Grey scales exposed onto the film through filters and plots of actual coloured images show that the chemically formed dyes have deficiencies.

(10) Whilst yellow dye is fairly satisfactory, magenta dyes absorb some blue, and cyan dyes absorb some blue and some green. These deficiencies are particularly serious in a negative-positive system, as final image colours depend on dye formed twice.

(11) The blue absorption of magenta dye can be nullified image-wise by colouring clear areas of this layer pale yellow. Similarly the cyan dye layer has clear areas coloured pink to absorb the same percentage of green and blue as the deficient cyan dye. These colour masks can be formed integrally in a colour negative by colouring the basic magenta forming couplers yellow, and cyan-forming couplers pink. These colours dissipate wherever coupled dyes are formed.

(12) Alternatively dye deficiency masking can take place using separate, black silver unsharp masks. In making separation negatives from a colour transparency a green separation negative may be combined with a weak positive from the red separation negative, and the blue separation negative combined with a positive mask from the green separation negative. This takes time and may not always be justified.

(13) A separate silver *contrast* mask is often needed for reducing the overall tone scale of a colour transparency prior to reproduction. The weak positive may also function as a simple form of hue masking, e.g. by being printed to a red light source.

(14) A silver mask for highlights aims to preserve or improve local contrast in subject highlights. It functions by preventing these areas recording on the contrast reducing masks.

(15) Multiple layer internegative film is designed to give high quality colour negatives from transparencies. Containing integral colour masks, and dyes keyed to print materials, its emulsions are colour sensitised to suit transparency dyes and offer built-in highlight masking.

(16) Black and white materials used for separation negative making should have a dimensionally stable base, appropriate colour sensitivity, characteristic curves with long straight line portions, and an approptiate gamma which does not vary with the colour of the taking filter. Tricolour filters used should suit the type of original, the emulsion sensitivity, lighting, and the intended system of printing.

Questions

(1) Colour negative materials have an overall orange appearance, owing to the presence of an *integral dye masking system*. Using diagrams where appropriate, explain this appearance and explain why such a negative should give a more accurate reproduction on the final colour print than an unmasked negative.

(2) Two colour prints of the coloured diagram Fig. 10.5 (bottom left) have been made, one from an unmasked and the other from a colour masked colour negative. What differences would you expect to find, and why?

(3) Describe one corrective technique which may be used when copying a reversal colour transparency on a material similar to that used for the original; explain why correction is desirable.

(4) With the aid of typical characteristic curves explain the main differences in performance between multilayer (integrally coupled) colour films intended for making (a) reversal transparencies, and (b) colour negatives.

(5) Describe two applications of photographic masking in black-and-white photography, and two applications of masking colour materials.

(6) Write brief notes on each of the following:
>Coupled dyes
>Integral colour masks
>Dye colour deficiencies.

(7) (a) Draw a set of characteristic curves for a colour reversal film showing 'crossed curves', in which the magenta contrast is too low.

(b) Describe how a neutral density step-wedge would appear photographed on this faulty material.

13. PRACTICAL PHOTOGRAPHY IN COLOUR

It can be argued that any one learning photography should really start with colour photography, and then progress to black-and-white work. After all, you are used to seeing in colour, and it should be easier to assess results in this form – whereas monochrome is an abstraction of reality. This approach may hold good for someone lucky enough to concentrate wholly on the visual aspects of photography, with a technician at his elbow to warn him when things will go wrong. But in trying to develop sound technical and craft competence to back practical work – which is what this book is about – it is easier to become thoroughly familiar with black-and-white materials first. Fundamentally, colour photography is a triple form of black-and-white work.

There are differences though in the practical approaches to the two processes. Some, as you have seen, are due to the psychological effects of colour itself. Others are due to the differing characteristics of colour films. This chapter aims to be a basic conversion course for the experienced black and white photographer handling colour assignments for the first time.

Aspects the uniniated photographer will have to watch most carefully when using colour film include the colour and contrast of his lighting; his methods of measuring exposure; the *duration* of exposures; and tough disciplines in processing and printing. There is also the very important matter of economics – colour materials alone are over three times the cost of equivalent size black and white stock. With this last point in mind this chapter starts off by looking at some special points concerning colour film storage.

Storage of colour film stock

Colour materials are much more vulnerable to heat and moisture in storage than black-and-white stock. This is because slight speed and contrast changes usually affect each emulsion layer in a different way, causing changed in the delicate colour balance of the material. The professional photographer must be able to rely on consistant results. Proper arrangements for storage are especially important when technical colour photography requiring the highest attainable objectivity is being carried out – perhaps over a period of time.

Storage before exposure. Most makers pack colour film in moisture proof wrappings. But even this film may show changes from heat if stored for more than three or four weeks at temperatures over 21°C (70°F). It is therefore advisable to store sealed film in the main compartment of a refrigerator working at 13°C (55°F) or less. For very critical use or storage over several months, the sealed material can be stored in the unit's freezing compartment (about minus 20°C). In locations where the air temperature exceeds 24°C (75°F) regularly consider refrigerated storage as essential.

Film stock removed from the refrigerator for use must be allowed a period to 'warm up' at room temperature before being opened – otherwise moisture will condense onto the cold film surface. (Allow at least one hour for a 14°C temperature rise.) Once the sealed package of film or paper is opened it must not be replaced in

227

cold storage without first resealing with waterproof tape. Unsealed foil bags or cans must not be stored where they can be affected by harmful fumes such as formaldehyde from glues; solvents, cleaners, mothballs etc.

X-rays will fog film in any normal packaging. This is a particular harzard at airport security check points. X-rays used to inspect luggage are of low dosage, but their effects accumulate at each check. Always carry film in hand luggage and insist this is inspected visually. Metal detectors are harmless.

Storage after exposure. After it has been exposed the material should be processed as soon as possible, particularly if conditions are humid (over 60%) and hot (over 24°C). If this is impossible first dry the unsealed film by storing it for a day or so in a container together with some silica gel. It can then be sealed and re-stored in a refrigerator. As before exposure, protect materials from fumes and X-rays.

From this it can be seen that the expiration date stamped next to the batch number on all colour material boxes can only be a guide–much depends upon the storage history. Usually it is false economy to buy or use 'outdated' colour film and paper, even where storage seems to have been satisfactory. For one thing speed loss will mean that tests will have to be made to find out how many stops extra exposure are required. Always use a strict 'stock rotation' system, using up materials in the same order they were bought. Finally remember that moisture proof does not mean water-proof. Never use an old refrigerator without a drip tray–if an electricity or gas failure occurs the wretched thing will defrost itself, possibly soaking valuable stock.

Colour temperature and colour balance

Colour film manufacturers balance the colour sensitivities and speeds of the three emulsions to give a neutral image of a neutral subject. But this is only possible when the subject is illuminated by a light source having a continuous spectrum, as quoted by the manufacturer. You know that due to the accommodation of the eye you cannot accurately assess the composition of light sources by sight. The concise means of expressing the quality of light emitted by a 'white' light source is colour temperature (Chapter 5).

Film and lamp manufacturers therefore quote colour temperature figures to indicate balance of emulsions and colour content of illumination. Obviously it would not be economic to make a colour film for each colour temperature. In practice a film is balanced for one of three or four light sources (see Table 13.1). Subjects lit by sources at other colour temperatures can be shot on a colour film of the nearest balance, using correction filters over the lens or lamp to modify the colour tempera-ture of the light. This must be done absolutely accurately for reversal materials; some mis-match is permissible with colour negatives, which may be corrected at the printing stage.

'Tungsten' or type 'B' (or 'K') reversal, and type 'L' colour negative materials are balanced for 3,200 K studio floods and spots (500w–2000w) and tungsten halogen lamps. In other words, professional type studio lighting.

'Daylight' type (or type 'T') reversal and type 'S' colour negative materials are balanced for 5,000–6,000 K being a mixture of direct sun, blue sky and white clouds; or blue flashbulbs; electronic flash; or metal halide arc lamps.

TABLE 13.1
ILLUMINATION AND COLOUR BALANCE

		Colour balance of emulsion		
Colour temp. of illumination		'Tungsten' or Type B or K, or 'L' col. neg.	'Daylight' or 'T' types	'S' type col. neg.
5000–6000 K	'Daylight' Electronic Flash Blue Flashbulbs Suitably Blue Filtered Tungsten Lamps Arcs	Deep Orange Filter (85B)	Balanced	Balanced
3800 K	Clear Flashbulbs	Pink (81 EF)	Bluish (80C)	Bluish (80C)
3400 K	Photolamps (photofloods) 3400 K T-H Lamps	Pale pink (81A)	Pale blue (80B)	Pale blue (80B)
3200 K	3200 K Photographic Lamps, e.g., 500 w Spots, floods, etc., 3200 K T-H Lamps Daylight Filtered with Orange Acetate	Balanced	Blue (80A)	Blue (80A)

(Numbers refer to Kodak conversion filters)

The rated colour temperature of a tungsten lamp assumes that it is burning at the correct voltage, and has no discoloration of its glass envelope, reflector, spotlight fresnel etc. Voltage variations are the main source of worry (Fig. 13.1) particularly if the studio is in an industrial area and therefore subject to varied local loads on the electricity supply. Automatic voltage stabilizers can be bought for the studio, but such equipment is costly if it is to cope with more than a thousand watts or so. The colour temperature of flashbulbs and tubes is not affected by mains voltage fluctuations.

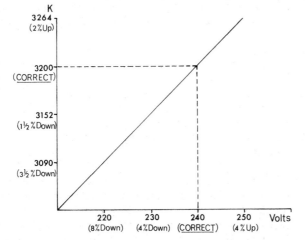

Fig. 13.1. Variation of colour temperature with mains voltage. plotted for a lamp giving 3200 K at 240 volts. For most practical purposes CT variations of 2% either way are acceptable on tungsten type films.

Colour temperature meters. A glance at spectral energy distribution curves (page 66) shows that as colour temperature rises the relative blue content of the light increases, and red content decreases. In fact the curves appear to 'pivot' about the plot for green wavelengths. This gives us a basis for colour temperature measurement—comparative readings of the red and blue content of the light source.

Colour temperature meters vary in mechanical detail but almost all work on this principle. Internally the meter may have two photo-cells—one covered by a red filter, the other by a blue filter. Each feed to the same meter but in opposition. The meter is pointed directly at the light source. If the red and blue content of the light is equal, the meter shows a reading at the centre of a scale. If red predominates (i.e. more light energy reaches the red cell than the blue) the needle moves in one direction. A predominance of blue has the opposite effect. The scale under the needle has colour temperatures marked off in kelvins (See Fig. 13.2).

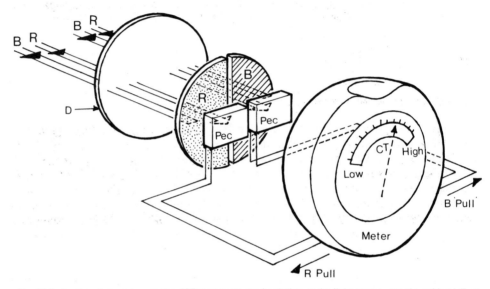

Fig. 13.2. A colour temperature meter. (CT meters are used pointing at the light source, *not the subject.*) Two cells are filtered by red and blue filters. Each cell output feeds to the meter in opposition, the blue cell pulling the needle to the right and the red cell to the left. The light shown being measured contains a greater proportion of blue than red wavelengths, causing the needle to indicate a high colour temperature. (D) Colourless diffuser.

Colour temperature meters cannot be said to be essential in a studio where the mains supply is stabilised or reasonably steady, and where care is taken to use bulbs of the right voltage for the supply, to change bulbs before they grow too old, and to keep reflectors free from discoloration. Meters have more value when working on location using portable lighting with uncertain electricity supplies, or assessing strange light sources. (Note that the colour temperature meter built into Color Tran transformer boxes is based on the supply of current—it therefore presupposes that the heads are free from discoloration, and are not fitted with filters.)

Remember that colour-temperature meters are not designed to be used with

230

non-continuous spectrum light sources (page 67). Some of these – sodium or mercury vapour tubes etc. – emit light in only a few, very narrow bands of colour. It can be seen from the way the meters work that a source radiating some red and blue bands but little else between could be measured in kelvins, when the light was really quite unusable for colour photography.

What happens if a meter reading shows that our lamps are running at too low or high a colour temperature to suit the film balance? (A variation in colour temperature of more than about 75 K at 3,200 K begins to give noticeable results in colour transparencies). Voltage could be raised, or lowered, but if all subject lighting is affected it is simpler to use a light balancing filter over the camera lens.

Mireds. You might assume that it is possible to buy filters giving 50 K or 100 K 'shifts' – but you then come up against another limitation to Kelvin's colour temperature scale. A filter which raises colour temperature by 100 K at 2,800 K has a 130 K effect at 3,200 K and 300 K effect at 5,000 K. This is because the blue content of a light source does not rise evenly with increase in colour temperature (Fig. 13.3).

Fig. 13.3. Filtration and colour temperature. Left: The relative blue content of an incandescent light source does not increase proportionally with colour temperature. This means that a blue filter, (which has a fixed upward influence on blue content) causes a greater change in kelvins when the illumination is 5,000 K than when 2,800 K. It cannot be given a fixed 'kelvin shift value'. Right: By converting kelvins into mireds you have a regular scale directly relating to blue content. A filter has the same 'mired shift value' at high and low positions on the scale.

A pale bluish or orange light balancing filter will increase or decrease blue content by a set amount, but this represents a different shift of colour temperature at different parts of the scale. From our point of view it would be better if the old colour temperature system had been based on proportional colour content instead of a physical temperature.

To solve this filter calibration problem you convert your kelvins into *micro-reciprocal degrees* (Mireds). As the name itself tells us,

$$\text{MIREDS} = \frac{\text{One Million}}{\text{Colour Temperature in K}}$$

The conversion gives us a scale of (lower) figures which regularly decrease with blue content. The *higher* the K the *lower* the Mired figure. A filter can therefore be given a mired shift value (+ or −) which applies irrespective of the colour temperature of the light source, see Fig. 13.3. How does this work in practice?

Example 1: A bluish filter which brings 2,800 K (360M) tungsten lamps into line with an emulsion balanced for 3,200 K (312M) has a mired shift value of −48. Used with photoflood lighting, 3,400 K (300M) this same filter would change the effective colour content to 252M or 4,000 K. Note how the first change of 400 k has become a change of 600 K, in terms of the C.T. scale.

Example 2: A meter shows that studio lamps, normally 3,200 K are in fact running at 3,050 K. The mired values for these colour temperatures are 312 and 328 respectively. You therefore need a light balancing filter of −16M (or as near as you can make it, see Table 13.3).

In practice the required mired shift filter can be calculated directly off the colour temperature meter, which usually has a mired scale printed alongside the kelvin scale. If a few gelatin mired shift filters of various values are held in stock they can be combined to add up to somewhere near the required shift value. Filtration can be checked by holding the chosen filters over the colour temperature meter and making another reading.

Colour conversion filters. Light balancing filters tend to be rather desaturated and mild in effect. Other, slightly stronger orange or blue filters are used to 'convert' a set light source to suit a colour material of another balance (e.g. to allow a subject

TABLE 13.2

CONVERSIONS FROM KELVINS TO MIREDS

Colour Temperature in Kelvins

5000	4500	4000	3800	3500	3400	3200	3000	2700	2500 K

200	250	300	350	400M

Mireds

TABLE 13.3

MIRED SHIFT VALUES FOR SOME KODAK WRATTEN FILTERS

Orange/Yellow Filters (Have Positive Values)		Bluish Filters (Have Negative Values)	
85B	+127	78A	−111
86A	+111	80B	−110
85	+110	82C+82C	− 89
85C	+ 86	82C+82B	− 77
81EF	+ 52	82C+82A	− 65
81C	+ 35	82C+82	− 55
81B	+ 27	82C	− 45
86C	+ 24	82B	− 32
81A	+ 18	78C	− 24
81	+ 9	82	− 10

232

TABLE 13.4

USE OF COLOUR CONVERSION FILTERS

When exposing on this emulsion	And the subject is lit by	Use a filter with mired shift value of (nearest Wratten number in brackets)	And increase exposure by
Daylight type Type T Type S	Heavy overcast sky Photofloods 3200 K lamps Clear flash	+ 50 (81EF) −120 (80B) −140 (80A) − 80 (80C)	$\frac{1}{3}$ stop $1\frac{2}{3}$ stops 2 stops 1 stop
Tungsten (type B) Type K Type L	Daylight/elec. F Clear flash Photofloods	+120 (85B) + 60 (81EF) + 20 (81A)	$\frac{2}{3}$ stop $\frac{1}{3}$ stop $\frac{1}{3}$ stop

illuminated by daylight to be shot on tungsten film). Since conversion filters are intended to do a particular job they are less commonly referred to by their mired shift values. The colour photographer quickly becomes used to the Kodak Wratten 85B (for tungsten film in daylight) and Wratten 80A (for daylight type film in 3200 K lighting.) Each filter calls for an increase in exposure of $\frac{1}{2}$–2 stops (or re-rating of effective film speed). (See Table 13.4.)

Fig. 13.4. CC filters can be used on the camera to alter the general colour rendering of a scene in any of the directions shown. CCO5 value filters give a just-perceptible change of colour rendering on reversal transparency materials. As a rough guide examine a processed unfiltered test transparency through likely filters until one of them gives the effect you need. Then reshoot using a filter *half the value* over the lens.

233

Colour compensating filters. Colour compensating (CC) filters absorb one or two primary bands of the spectrum by varying amount, according to their saturation. They are sometimes recommended by film manufacturers to correct the balance of a particular batch of film; they are extremely useful for giving a *slightly* warmer or colder colour rendering to a scene, see Fig. 13.4; also for various laboratory purposes. Their coding indicates their predominate hue and density. For example a Kodak CC 20 M filter is magenta with an average density of 0·2 in the green band of the spectrum. CC filters are sometimes used over the enlarging lens for colour printing purposes.

Problems with fluorescent light sources. Fluorescent tube lighting is now so common in shops, offices and public places it frequently has to be used as a light source for colour photography. Most general purpose tubes have combined continuous and line spectrum, but exact content varies according to type and brand. Their photographic effect is often quite different to their visual appearance, e.g. white looking light giving quite green results. On reversal transparency film the only really safe method of working is to pre-test using some of the filter suggestions in Table 13.5. Where this is impossible the best advice is to use tungsten type film with a CC40R filter for all types of tube. Give about two-thirds of a stop exposure increase.

TABLE 13.5

STARTING FILTERS AND EXPOSURE INCREASES FOR TEST
SERIES WITH FLUORESCENT ILLUMINATION

KODAK Film Type	Type of Fluorescent Tube (Switch on at least 10 mins before photography)					
	Daylight	White	Warm White	Warm White Deluxe	Cool White	Cool White Deluxe
Daylight Type and Type S	40M + 30Y +1 stop	20C + 30M +1 stop	40C + 40M +1½ stop	60C + 30M +1½ stop	30M +⅔ stop	30C + 20M +1 stop
Tungsten Type Type B and Type L	85B + 30M +10Y +1 stop	40M + 40Y +1 stop	30M + 20Y +1 stop	10Y +⅓ stop	50M + 60Y +1⅓ stop	10M + 30Y +⅔ stop

Problems of mixed lighting. Films of various colour balances, and colour conversion, correction or compensating filters over the lens give a good deal of latitude in the colour of our lighting, *provided that all the subject lighting is of the same colour temperature.* As soon as you have, say, daylight and artificial light (or photofloods and 3,200 K lamps) all lighting the same subject, any correction in the camera, processing or printing becomes virtually impossible. Never use mixed light sources when shooting *objective* colour pictures.

Sometimes of course a mixture can provide an effective method of localising attention. For example, a model may be photographed out of doors, under daylight but locally lit with 3,200 K lamps. If recorded (in longshot) on tungsten film she appears surrounded by an almost dream-like blue-biased environment. Similarly in industrial photography mixtures of clear and blue flashbulbs can be useful to give furnace light effects.

234

But far more often we have to face mixed lighting conditions which are not of our making–particularly when on location. The subject might for example be an architectural interior with heavy dark furnishings, and including a view through large windows. Supplementary lighting from the camera will be essential to reduce subject luminance range. Colour bias in any part of the picture is unacceptable. This job could be handled at least four ways:

(1) Shooting on daylight-type colour film using 3,200 K lamps filtered with sheets of blue acetate (Kodak 548/2) to convert them to the approximate colour of the daylight.
(2) As above, but balancing the daylight with blue dyed flashbulbs or electronic flash.
(3) Shooting on tungsten colour film, first covering the windows by shutters, curtains or black paper and exposing the interior lit only by 3,200 K lamps. The windows are then uncovered and lamps switched off. An orange colour conversion filter is placed over the lens and the exposure given for the windows.
(4) Shooting on tungsten colour film, lighting the interior with 3,200 K lamps and draping the outside of the windows with large sheets of orange (Kodak 558/13) acetate to convert the daylight to approximately 3,200 K.

Methods 1 or 2 would probably be the most convenient. In method 3 there is some risk of curtains etc. recording during the first exposure (particularly just under and around the windows). Method 4 is often used along with 1 for shooting colour movies.

In all cases you have to remember that the 'daylight' you are filtering for outside can range from winter sunlight (about 4,000 K) to light from a clear blue sky (10,000 K or more). Our blue dye flashbulbs, electronic flash and filtered tungsten lighting remain standardised at 5,500 K. Therefore an exact 'balancing up' of illumination colour is unlikely unless conditions outside produce the same colour temperature. If necessary the relative balance can be prechecked by exposing a sheet of instant picture colour film.

Subject luminnce (or brightness) range

You know from black-and-white work how the luminance accommodation of the eye greatly exceeds that of the photographic emulsion. Beginners have to learn to boost the illumination of shadow detail which they themselves can see but the emulsion cannot record, if it is also to retain tone separation in highlights and midtones. This is even more true in colour. Not only will parts of the subject beyond the exposure range of the emulsion record with poor tone separation–but highlight colours will be desaturated and shadows distorted in hue as well. Note that the maximum image luminance range the material can acceptably record is even further restricted when highlights and shadows contain strong colour which must reproduce with a reasonable degree of accuracy. The bottom of the curves cannot be used because there is insufficient dye present to form any strong colour.

Colour negative material allows a slightly greater image luminance range to be used, but not as much as might first appear from its curves. Like black-and-white stock you have to look at the negative in terms of what the eventual printing paper can

cope with. Images which fill the entire range from minimum to maximum density on the processed negative may give prints on paper with disappointing highlight and shadow quality.

The principal factors affecting the brightness or luminance range of the image placed on the film are:

(*a*) *The reflectance range of the subject matter:* Imagine you are taking a shot of rows of chocolate bars on a white background, under absolutely even, diffuse lighting conditions. The lightest part of the subject (the background) may reflect four times as much light as the darkest area (the chocolate). Subject reflectance range is therefore 4:1. Sometimes subject reflectance range can be effectively altered by choosing a viewpoint which does not include certain highly absorbant or reflective areas.

(*b*) *The subject lighting range:* This is the ratio between the highest and lowest levels of illumination falling on the subject. Imagine that you have a sheet of matt even toned, embossed ceiling paper. This is lit by one oblique 'key' light plus a fill-in farther back near the camera. The tops of the embossed areas receive light from both sources and may have three times as much light as the shadowed troughs which only receive light from the fill-in. The subject lighting range is therefore 3:1.

The example in (*a*) had a subject reflectance range but nil lighting range; the example in (*b*) had lighting range but virtually no subject reflectance range. In practice most of our subjects involve both (*a*) and (*b*) which, multiplied together, give subject luminance range. For example, apply the lighting given to the embossed paper to the chocolate bars and you get a subject luminance range of $4:1 \times 3:1 = 12:1$. In other words the lightest possible part of the subject can only be the white background illuminated by both light sources. The darkest part will be those areas of the dark chocolate shaded from the main light and illuminated only by the fill-in.

(*c*) *The flare factor of the lens.* You know (Chapter 1) that flare within the lens reduces contrast by diluting shadows with light, typically giving an image luminance range only half or one third that of the subject luminance range under unfavourable conditions.

To avoid confusion, manufacturers normally refer to subject luminance range assuming that flare will in fact reduce this range by the time it reaches the film. This explains why the characteristic curves of photographic material seem to show that the film cannot handle quite such a wide luminance range as is suggested for the subject. From a practical point of view you should concentrate on subject luminance range – simply remembering the reason for this data discrepancy, and the fact that lenses with exceptionally high or low flare factors could under certain conditions effectively alter the maximum acceptable range.

Controlling subject luminance range. As a general guide the overall subject luminance range (i.e. comparative meter measurements in highlight and shadow areas) should not exceed

About 10:1 for general purpose colour negative material intended for colour print making. (A conservative estimate to allow print filtering.)

About 20:1 for general purpose reversal colour transparencies (but 10:1 if final reproduction is to be on paper).

These figures assume that accurate reproduction (within the limitations of dyes) is required *throughout the range*. Where the picture is a subjective illustration it may

236

be helpful to have certain highlights desaturated or dark areas lacking detail – in which case the range could be greatly exceeded. Under these conditions the limits of the strict 'accuracy' range can be pre-determined by meter readings.

Obviously no hard and fast rules can be given about lighting range because this is just one contributory factor, and subject reflectance range can vary enormously Kodak suggest a lighting range maximum of 3:1 for neg/pos colour print materials assuming an 'average' subject. These sort of figures are much lower than those encountered in black-and-white work, where the lighting of subject form and texture often has to substitute for its colour. Reflectors and fill-in lights are therefore very frequently needed for colour photography.

In attempting to control subject luminance range the following points should be borne in mind:

(1) Sunlight on a completely clear day gives a *lighting range* of about 7:1. Unless the subject has an unusually limited reflectance range this will give excessive contrast – as well as bluish shadows, lit only from the blue sky. If the subject is reasonably small, reflectors or fill-in flash can be used. If this is not practical (i.e. large architectural exteriors) it may be better to wait for generally diffused sunlight or until the lighting becomes more frontal, reducing the size of the shadows. In the latter case however, important textures and three-dimensional quality may be lost. If the subject is very distant distorted highlights and shadows may be too small on the image to notice. Also atmospheric scatter will help to reduce image contrast (noticeable when looking through binoculars or a long focus lens).

(2) With sunlight/clear sky conditions you might be tempted to put the subject in the shadow cast by a convenient object such as a tree. This might give good results in black and white, but since the subject is then really only illuminated by the blue sky light (10,000 K or more) colour film will record a strong blue cast. Flesh tones are particularly unpleasant. The same thing applies if the sun's direct rays are diffused by a small cloud whilst most of the sky is deep blue. Conditions are much more favourable when the whole sky is covered by a thin layer of cloud, very slightly diffusing the sunlight. Texture revealing shadows are still cast but are soft edged and no longer have a blue bias. Lighting ratio under these conditions can be about 3:1.

(3) Completely overcast conditions may give a usefully low lighting range, but tend to have too high a colour temperature (see Table 5.1). A U-V absorbing filter may help (page 242). Overcast daylight or highly diffuse studio lighting also may desaturate the appearance of colours.

Look at this desaturation problem more closely. You know that colours always seem brighter on a sunny day. This is a part environmental, part physiological phenomena (cones give optimum response at high illumination levels) but is also tied up with surface reflection from objects. As discussed in Chapter 11, most coloured materials reflect light from two surfaces – a top surface which may be matt, smooth, etc., and its underlying coloured pigment. The more white light reflected off the surface instead of being selectively reflected by the pigment, the more desaturated the pigment appears. When the subject is lit with diffuse illumination, some light is bound to be reflected from the top surface towards the viewer. With direct lighting, and particularly with glossy surfaces, incident light is specularly reflected – giving a glaring appearance in just one direction. In all other directions the pigment alone reflects light and therefore appears saturated. (This is similar to the way the appearance of maximum black

in a monochrome print is affected by paper surface and illumination conditions.) A polarizing filter (Appendix II) may be useful to absorb the light reflected off the surfaces of (non-metallic) subjects at certain angles, and thus improve colour purity. Check its effect by looking through the filter whilst rotating it.

On the other hand you could be too carried away in absorbing reflections–sometimes the important surface qualities of fabrics, foods, etc. can only be communicated by their reflective sheen. Priorities have to be balanced.

(4) When reflectors are used to fill in shadows make sure that they really are colourless. (Sometimes a slight bluish tint is helpful when working on a simulated sunshine lighting set up in the studio.) Reflector material could be matt white paper or cloth, matt or polished aluminium foil, or stretched and painted fabric. When using live subject matter try to avoid poses which cause the model to look directly at large brilliantly lit reflector boards, causing the eyes to be 'screwed up'. The problem can be overcome by using fill-in flash–either directly diffused or bounced off reflector boards (page 86). Naturally colour temperature must be matched–for example if sunlight is the main lightsource use electronic flash or blue flashbulbs. In calculating lighting ratios bear in mind again the limited capacity of colour material. Any tungsten lighting used must be blue filtered.

Beware of 'unintentional' reflectors–light reflected off painted walls, green foliage . . . also the photographer's own coloured clothing when shooting close-up. Even when these surfaces cannot reflect coloured light directly at the subject, their light may enter the lens from just outside the field of view. The result will be general or local coloured flare, which may be slight but nevertheless noticeable in shadows and in near-neutral colours. If the coloured reflecting surfaces cannot be removed or shaded a lens hood will improve matters, provided it strictly limits light to the area of field used on the film. Not many do this.

Exposure

When you come to measure exposure, the fact that our colour film consists of three carefully balanced emulsion layers means that:
 (1) Colour materials have less exposure latitude. This and their much less flexible processing conditions mean that special care is needed in making meter readings, which should also bear in mind the differing characteristics of reversal and negative-positive films. Similarly even slight extra bellows extension when close working, and variations in equipment (i.e. shutter efficiencies), are much more likely to have noticeable effects on results than in black and white work.
 (2) Level of exposure affects colour saturation and hue reproduction as well as the reproduction of tone range.
 (3) The duration of the exposure may affect colour balance as well as the effective speed of the film, owing to reciprocity failure response which varies within the layers.

Meter reading routines; reversal transparencies. As you have seen already, when using reversal materials it is important to pin the density of the lightest tones of the subject near the bottom of the characteristic curve. For this reason the highlight method of exposure reading using a hand meter is most valuable. The meter

238

reading is taken either off a white card; or from the subject position through an incident light attachment; or off some convenient local highlight such as the back of the hand. With each method adjustments must be made in translating the reading into exposure terms (Fig. 13.5).

Typically, the exposure level indicated when reading off a white card under subject lighting conditions is multiplied by 5 to 8 times; or if read off a white skinned hand multiplied by 2. (An incident light attachment, by absorbing a certain amount of light, gives the result of a white card reading times about 8 direct.) The exact multiplication required depends upon intelligent assessment of the subject. If the subject has a wide luminance range, greater multiplication will be needed to get the shadow end of the scale on the characteristic curve. If subject luminance range is narrow too much multiplication may overexpose the shadows. Also bear in mind the type of result required – is it helpful to have certain highlights burnt out, and if so which highlight should just be 'on scale'?

Luminance range readings (darkest important shadow; lightest important highlight) are worth taking in any case to establish total range when setting up lighting etc. By setting the dials for the average of the two, the best compromise between shadow and highlight is indicated. These readings must still be interpreted. For example if the range is over long, highlights could be overexposed and shadows underexposed; if it is restricted the underexposed highlights may appear muddy.

Fig. 13.5. Exposure calculation for reversal colour material. (Curve represents the mean average of the three emulsions). The usual aim is to pin brightest important subject highlights near the bottom of the curve. A reading from a white card set as a normal reading on the meter dial would locate the highlight at 'A' position on the log E axis. Multiplying the meter exposure by ×5 should re-locate highlight correctly at the pegging point. At the same time subject shadow luminosities are moved to the right (down the curve). Although less important, their position must also be borne in mind when subject luminance range is very long (or short).

Where possible try to read from *neutral* highlights and shadows–slight differences between the colour response of some meter-cells and the actual emulsions can give errors if saturated colours are read. (This is a further justification for incident light reading.)

Meter reading routines; colour negatives. That old concept with black-and-white materials of exposing to get shadow detail applies equally well to colour negative materials. Exposure level which will ensure that shadow luminances record on the lower part of the curve's straight portion is of prime importance. The next priority is to arrange that the top end of the subject luminance range does not exceed the 'straight line' capabilities of the film, unless desaturated highlights are desirable for effect. It can be seen then that luminescence range readings probably give the most accurate exposure estimation for colour negative work. As a second best one 'key tone' grey card reflected light reading may give the same result, although not giving information about total range.

Effect of exposure level. Obviously meters have to be used with intelligence. As a general rule you can say that when in doubt err towards overexposure with colour negatives, and towards (slight) underexposure with reversal transparencies. If the colour transparency is for final reproduction on the printed page, more can be done if it is slightly dense than if overexposed. Slight underexposure may give a heavy transparency, but the photo-engraver (or an intermediary colour print laboratory) can still do more to lighten image information than with a transparency which is overexposed and has vital highlight detail 'burnt out'.

Since overexposure of colour films leads to desaturation of colour as well as tone crushing, this can be used intentionally for effect. An immovable background or unimportant part of the subject may have strong colours which draw too much attention, or clash with the visual concept of the shot. By overlighting these areas it is possible to dilute the unwanted colours and reduce details. Conversely, in objective industrial photography it is important to avoid overlighting or incorrectly exposing the surface of glowing metal as this will affect its saturation as well as luminosity. To the knowledgeable eye such distortion can signify an entirely inappropriate metal temperature.

Perhaps the most noticeable influence of exposure on colour and density can be seen by photographing a sunset on reversal film at a range of exposure levels. Instead of appearing as such, the resulting transparencies seem to show the sunset at various stages of development.

Effects of exposure duration. Reciprocity law failure in black-and-white work tends to be a 'textbook' item. When exposures of a minute or so crop up in commercial practice some extra time is given, and thanks to the latitude of the material the matter rests there. But with multilayer colour film one or other emulsion tends to be more affected than the others. If for example the most affected layer of a reversal colour film is the red emulsion, the results will probably be too dark and too cyan. A slight overall increase in exposure is needed, plus even more exposure for the red emulsion only (achieved by a pink colour compensating filter). But if this emulsion layer has also changed its gamma, the degree of extra exposure (or filtration) needed at one

240

end of the subject luminance range will be greater than at the other. In fact with extreme R.L.F. the curves might even cross so that the filtration required in the shadows is complementary to that needed in the highlights.

Manufacturers of reversal materials usually balance the emulsion layers in terms of minimum R.L.F. at an exposure time of about $1/1000-1/10$ second (daylight type), and $\frac{1}{10}-1$ sec (tungsten type). Where other factors permit, subject luminosity level and aperture should be adjusted to give this exposure time. Instructions packed with each batch of sheet film indicate the filtration and exposure increase in stops (or speed re-rating) necessary for longer exposures–up to the point where correction throughout the whole luminosity range is impossible, Fig. 13.6.

In the case of colour negative film exposure time should be about $1/1000-1/10$ second (type S), $1/10-10$ seconds (type L). 'S' denotes R.L. balance for short exposures; 'L' stands for long exposures. Note that flashbulbs and flashtubes should be used on type S film. Electronic flashtubes intended for colour work are limited to a duration of around $1/1000$ second, or have compensating gas content. Even within the ranges quoted speed re-ratings may be necessary, as detailed in data sheets packed with the film. The corrections possible are still limited by the advent of crossed curves. (This fault cannot be detected by visually checking the colour negative unless a densitometer is used. Therefore a negative may appear excellent in density and contrast, yet prove impossible to filter in colour printing.)

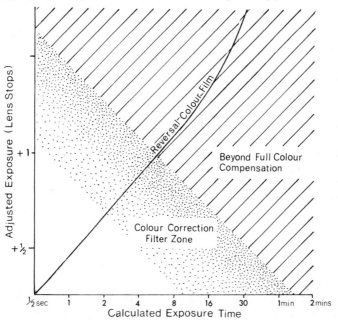

Fig. 13.6. Compensation for reciprocity failure. Meter calculated/Actual Exposure Curve plotted for a reversal colour film, nominally balanced for $\frac{1}{2}$ second. Not only is additional exposure required, but exposures longer than about 2 seconds necessitate a colour filter to counteract uneven reciprocity failure between the emulsions. Beyond 8 seconds no filter is able to correct both ends of the curves. This graph, although fairly typical, may not relate to other colour films–or even other batches of the same film. Manufacturers enclose specific batch recommendations in each box of professional film. For critical work test exposures can be made by the photographer, who can then make his own plots.

Unless the professional colour photographer keeps to conditions which give a fixed exposure time (i.e. flash) he must always keep reciprocity law failure in mind . . . and the manufacturer's batch data sheet in his camera case.

Use of colourless filters

Filters for colour photography are normally categorised as colour conversion, compensation, correction or printing. Other coloured filters are very seldom used – their tone control function in black-and-white photography no longer has value, and colour cast 'effects' are more conveniently achieved via coloured acetate sheeting over individual lights. But some camera filters used for monochrome photography continue to be usable for colour work, owing to their colourless nature. These include haze or U-V absorbing filters, neutral density filters, polarizing filters, and various special effects attachments such as 'starburst' and multi-image prisms.

Ultra-Violet absorbing filters. The top, blue sensitive emulsion layer of a multi-layer colour film is also sensitive to near ultra-violet radiation down to about 250 nm, see Fig. 13.7. Therefore any scene in which a high proportion of U-V radiation is present tends to overexpose this emulsion layer and record with a blue cast–

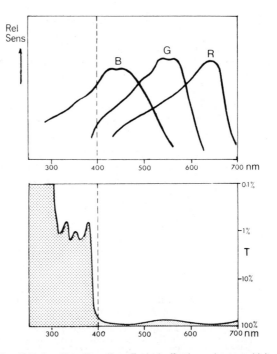

Fig. 13.7. The effect of a U-V absorbing filter. Top: Typical effective colour sensitivity curves of blue, green and red emulsions of a daylight balanced reversal colour film. The blue sensitive emulsion is seen to respond to wavelengths well down into ultra violet, beyond the furthest response limit of the eye (broken line). Bottom: Absorption curve of a U-V or haze filter (Wratten 1A). Visually this filter appears to be almost colourless.

242

although this U-V cannot be seen at the time of shooting. Photographs of scenes at high altitudes or over water, distant landscapes and pictures taken in overcast conditions all fall into this category.

An ultra-violet absorbing filter (haze filter) prevents this source of error. The filter only absorbs light to which our eyes are insensitive–therefore it appears colourless. The filter factor is so small that even on colour film it can be ignored. Note that when using tungsten film in daylight the necessary orange conversion filter also absorbs U-V and no additional filter is therefore necessary. This explains why daylight film without any filters sometimes gives a bluer result than the same subject shot on tungsten type with its conversion filter.

In monochrome photography the value of a U-V absorbing filter is debatable– a misty low contrast effect usefully separates out the planes of a distant view. But in colour the bluish cast often destroys subtle subject hues.

Polarizing filters. Another really useful filter for colour photography is a polarizing filter or *pola screen*. This is colourless grey (typically × 3 or × 4 filter factor) and has the following main uses:

(1) To suppress superficial surface reflections from non-metallic coloured objects, thus increasing their visual colour saturation. Similarly to suppress reflections from shop windows etc. The amount of suppression will depend upon the angle of the reflected light and the orientation of the filter.

(2) To darken a blue sky containing a strong proportion of polarized light i.e. at 90° to the sun. Apart from the limited effect of a U-V filter, this is the only means of darkening skies in colour photography.

(3) To control reflections off any surface illuminated by lamps carrying polarizing filters, another polarizing filter being over the camera lens. (The filter factor may greatly increase under these conditions.)

These filters also *introduce* interesting subject colours in stressed plastics. Certain plastics and other *birefringent* materials show colour fringes in stress areas when located between two polarizing filters. The way these filters work is explained in Appendix II.

TABLE 13.6

NEUTRAL DENSITY FILTER FACTORS

Density of Filter	Kodak Ref. No.	Filter Factor
0·1	ND 0·1	× 1$\frac{1}{4}$
0·2	ND 0·2	× 1$\frac{1}{2}$
0·3	ND 0·3	× 2
0·4	ND 0·4	× 2$\frac{1}{2}$
0·5	ND 0·5	× 3
0·6	ND 0·6	× 4
0·7	ND 0·7	× 5
0·8	ND 0·8	× 6
0·9	ND 0·9	× 8
1·0	ND 1·0	× 10
1·5	ND 1·0 + ND 0·5	× 30
2·0	ND 2·0	× 100
3·0	ND 1·0 + ND 2·0	× 1000

Neutral density filters. The function of neutral grey density filters in colour photography is really the same as in monochrome work–namely to reduce image brightness without having to make other alterations. For example, with the camera loaded with fast colour film, the smallest aperture and the shortest shutter speed (within the bounds of reciprocity effects) may still give overexposure of brilliantly lit subjects unless the filter is used. Again, under these conditions it may be necessary to use a wide aperture for differential focus effects . . . resulting in gross overexposure unless you use a neutral density filter. These filters are usually coded in terms of their density, from which we can calculate the filter factor (Antilog$_{10}$ × 10). An 0·6 N.D. filter has a factor of times 4; a 1·0 filter times 10, etc. See Table 13.6.

Practical colour application

How do these various factors, additional to monochrome photography, work out in practice? Take two very different assignments, described in terms of the points so far discussed.

Assignment 1: A studio still life of glazed coloured ceramics. Negative-positive prints are required. You are using a 4 × 5 in camera.

This might be handled with bounced electronic flash on type S colour negative film, but in this case you decide that tungsten spots and floods offer more flexibility. Check that all lighting units are fitted with 3,200 K photographic lamps of about the same age–preferably new. You use the studio regularly and know that voltage is steady (if this was strange territory a C.T. meter check would be made, and filters used if necessary). Window blinds are closed to exclude all daylight, and any general service ceiling lights switched off.

Fairly neutral background material has been chosen on which to stand the objects– a choice influenced by the colours in the ceramics themselves and the need to avoid a strong background colour being reflected from the glaze. Lighting is arranged according to the visual requirements of the picture, fill-in lights and reflectors being rather more powerful than if the picture were being shot in black and white. Yellowed muslin reflector boards and diffusers are re-covered with new white paper or colourless tracing paper.

A meter reading is made in the darkest important shadow and lightest important highlight. The Weston V reads 11 in the highlight, 7 in the shadow, (a range of four stops or 16:1). Reflectors and fill-ins are moved closer until the shadow reads 8 (range of 8:1). A quick check is made through a polarising filter, rotating it to see if removal of any reflections in the glaze are helpful.

The 4 × 5 in camera film holders are loaded with type 'L' sheet film which does not require a filter for 3,200 K lighting but should receive an exposure time between 1/10 and 10 seconds. Camera movements are being used (check that the important lens hood does not give cut off when the lens is stopped down) and about f32 will be required for overall sharpness. Set midway between 8 and 11 the meter calculator indicates 1 second exposure time. The data sheet with the film box states that at one second exposures the material has an effective speed of ASA 64 instead of ASA 80 (reciprocity failure). This means opening up one-third of a stop.

Finally check that no coloured objects elsewhere in the studio are illuminated

by the lamps and reflect coloured light back at the set. Expose, shooting a second sheet at double the exposure time.

Assignment 2: An industrial landscape–foundries, railroad and canal–to be taken from high ground. A 4 × 5 in reversal colour transparency is required.

Previous reconnaissance shows that from this only possible viewpoint direct sunlight at 3 p.m. gives good frontal modelling light. Alternatively at 4.30 p.m. the sun is more to one side which is more helpful if conditions are hazy. As it is the sun is riding in a blue sky with scattered white clouds, and so you are shooting at 3 p.m.

A U-V absorbing filter is over the lens, within the lenshood. Slides contain daylight type transparency material (reciprocity failure balanced without correcting filters or speed change at shutter-settings between 1/1000 and 1/10 second). Brightness range readings are not physically practical. Instead the meter, fitted with its incident light attachment, is pointed at the unobscured sun. The needle reading transferred to the calculator dial indicates an exposure of 1/60 at *f*16. But the subject is predominantly dark tones–no important highlight down there reaches 'white card' reflectance. Adjustment of about one stop is therefore needed–making the aperture *f*11. Two sheets of film are exposed at 1/60 second–one at *f*11 and one between *f*11 and *f*16.

TABLE 13.7
COMMON CAMERAWORK FAULTS IN COLOUR

Film Appearance	Probable Cause
Colour Reversal Transparencies	
Image light with weak colours, particularly highlights	Overexposure
Image dark, highlights cloudy, shadow detail may be obscured	Underexposure
Highlight detail or shadow detail missing, or both	Excessive subject luminance range
Certain colours or areas correct, others incorrect in hue	Mixed lighting, coloured reflectors or use of non-continuous light source
Overall orange appearance of image, rebates black	Daylight type film used in tungsten lighting or with clear flashbulbs
Overall blue appearance of image, rebates black	Tungsten light film used in daylight, or with blue flashbulbs or electronic flash
Dense and yellow overall appearance of image, laterally reversed	Image exposed through back of film
Image completely black, rebate lettering normal	Unexposed
Film completely clear	Completely fogged
Film greenish overall, including rebates	Probably fogged by deep green safelight or afterglow from fluorescent tube, when loading
Colour negatives	
Image light, with missing shadow detail	Underexposure
Image dark, with excessive shadow detail	Overexposure
Dark overall, no image	Completely fogged
Image completely clear, rebate lettering normal	Unexposed

Assessing errors

Pinpointing the causes of errors in colour transparencies and negatives is rather more difficult than in black and white. The most usual camera faults are summarised in Table 13.7 (some are illustrated in Plates C19–24). Within limits a certain amount of 'pushing' or 'holding back' of transparencies in the first, black and white, stage of processing is possible, see page 256. It is therefore worthwhile to first process one sheet film, or a clip test cut from rollfilm. Provided you noted the exposure this was given relative to the remaining pictures some compensation can then be given. Negatives are almost impossible to visually assess for colour unless the errors are gross; it is not advisable to manipulate their processing because the first stage is colour development which alters colour balance as well as density. The main processing errors are listed in Table 14.2, on page 257.

Related reading

MANNHEIM, L. A. and HANWORTH, VISCOUNT. *Spencer's Colour Photography in Practice.* Focal Press 1975.

HEDGECOE, J. *The Art of Colour Photography*. Mitchell Beazley (London) 1979.

LANGFORD, M. *Professional Photography*. Focal Press 1978.

Color. Life Library of Photography series. Time-Life Books 1972.

Chapter summary—colour camerawork

(1) The main points that an experienced black-and-white photographer must watch when shooting colour are condition and type of film; colour temperature of lighting; lighting contrast and its effect on subject luminance range; exposure measurement accuracy; and the permissible duration of exposure.

(2) Stored colour emulsions must be protected from excessive humidity and heat; harmful fumes and radiation. Store sealed film in a refrigerator but allow a warm up period before use. Partly used boxes must be sealed before return to cold store. If conditions are humid dry the film with desiccating agent before re-sealing. Process exposed film as soon as possible. Practice a stock rotation system; never use outdated materials.

(3) The emulsion layers of colour film are balanced to lighting of a particular colour temperature, e.g. tungsten type (type B) and colour neg 'L' = 3,200 K; daylight type and colour neg 'S' = 5,000–6,000 K. Within limits, lighting of another colour temperature may be used, adjustment being made via filters over the camera lens and (neg/pos) in the enlarger. It is not practical to compensate for subjects lit with mixed sources having differing colour temperatures.

(4) Colour temperature can be read via a meter which compares the relative quantities of blue and red wavelengths emitted by the light source. It can give an 'apparent' colour temperature for a non-continuous source. The colour temperature of a lighting unit varies with mains voltage, age of lamp and colour of reflector.

(5) Try to avoid using fluorescent tubes as main light sources, unless pre-tests can be made to establish filtration. In emergency use tungsten type film with a CC40R filter.

(6) Blue content does not increase *in proportion* to a rise in kelvins. Colour balancing filters vary in their colour temperature effect according to the point in the scale at which they are used. By converting K into MIcro-REciprocal DegreeS a scale proportionally decreasing in blue content is formed. Filters can be given permanent *Mired-shift* values.

(7) Colour conversion filters are intended for straight conversions between a set light source and a particular emulsion balance. Colour compensating filters are used for batch corrections, fine adjustment of overall image hue, and, to a limited extent, colour printing.

(8) Any supplementary lighting used must match the colour temperature of the main light source, unless separate exposures (and therefore separate filtration) can be given. Reflectors must be neutral. Avoid subjects in 'open shade' and other shadow areas where the only lighting comes from a blue sky.

(9) Unless effects are required, subject luminance range should not exceed the maximum range for the film – about 10:1 for colour negatives; and 20:1 for transparencies. The most practical method of control is lighting range, which for 'average' subjects might be about 3:1.

(10) Overcast conditions or strongly diffuse lighting often desaturate the coloured appearance of some subjects, owing to the white light reflected from their external surfaces. Polarising filters can help in controlling this, but overdone the photograph may fail to communicate important surface qualities.

(11) Exposure reading methods should be related to the characteristics of the colour film; viz. highlight reading for transparencies, subject luminance range reading for colour negatives. Colour films have restricted latitude – remember the effect of bellows extension in close-up work and variations in equipment (shutters). If in doubt err towards slight overexposure of negatives, slight underexposure of transparencies.

(12) Reciprocity failure has a much more decisive effect on results with colour materials than black and white stock. Emulsions are RLF balanced only within a limited range of exposure times, and may vary batch to batch. Usually daylight and 'S' type materials are intended for exposure times of about 1/1000–1/10 second; type B and 'L' type films for about 1/10–1 second. Even within this range alterations in effective speed and compensating filters may be needed. The limit of compensation is reached when emulsion curves cross and colour casts differ in highlights and shadows.

(13) U-V or haze filters are used in conditions rich in U-V radiation to prevent these wavelengths recording as excessive blue. No exposure increase is necessary. Orange conversion filters usually have built in U-V absorbing properties.

(14) Polarizing filters absorb certain reflected light and can darken blue sky under favourable conditions. Neutral grey density filters allow wide apertures to be used without recourse to fast shutter speeds or slow film; also allow exposure times to be extended without making other changes. A useful camera case filter kit is made up from U-V, polarizing, and neutral density filters, along with the most common colour conversion filters and any compensation filter needed for the particular film batch in use.

Questions

(1) Explain the term colour 'temperature'. Why are colour reversal materials restricted to lighting of one set colour temperature unless filtered? What precautions should the practising photographer take to ensure the correct colour temperature of his lighting?

(2) Discuss the effects of reciprocity failure in colour films and suggest practical methods of minimising this failure or its effects.

(3) (a) A camera and lens with high flare factor are used to expose a colour transparency; the subject is a brunette in dark red dress against a bright blue sky with white clouds, and is shot from a low viewpoint with semi-back lighting. Describe the appearance of the transparency.

(b) If a flare-free unmasked colour negative of the same subject was colour printed using an enlarger with a high flare factor what would be the appearance of the final print? Explain why.

(4) Explain the term 'mired'. What is the practical purpose of the mired scale as an alternative to kelvins?

247

(5) Explain what is meant by each of the following, and indicate its significance in practical colour photography.
 (*a*) Colour temperature meter.
 (*b*) Colour conversion filter.
 (*c*) Haze filter.
 (*d*) Polarizing filter.
(6) (*a*) Discuss the factors that limit the exposure latitude of colour reversal film.
 (*b*) Explain why there may be differences between methods of measuring correct exposure for colour transparency film and for colour negatives.
(7) You are shooting colour portraits out of doors, in sunlight and clear sky conditions which give a subject luminance range well beyond the capabilities of the film. List all the methods you could use to reduce this range.
(8) Describe the appearance of two colour transparencies taken of a wide luminance range subject – one transparency having been underexposed by two stops, and the other over-exposed by two stops.
(9) Explain how you would use a hand-held exposure meter to establish correct exposure when photographing each of the following on reversal colour film:
 (*a*) A still life shot of cheeses, set up under a 'tent' of diffusing material and lit to give shadowless illumination.
 (*b*) A medium shot of racing cars travelling at speed, the lighting being summer sun in a clear blue sky.
 (*c*) A same-size shot of a small gold coin on a plain white background. One oblique spotlight and fill-in flood provide the lighting.
(10) An 8×10 in colour transparency is commissioned of a large oil painting under glass. Optimum quality is required for reproduction, especially accurate colour rendering and maximum saturation. Explain in detail how you might undertake such an assignment in an art gallery.
(11) You are producing a colour transparency of the interior of a building to record detail within a panelled room and the distant scenery seen through large windows 4.5 m (15 ft) from the camera. A 'realistic' appearance must be retained but your meter indicates a ratio between scene and interior beyond the range of the emulsion. The exposure reading of the scene above is 1/30 second at $f16$ or equivalent. You require at least $f22$ to retain depth of field. A flash head taking clusters of up to four flashbulbs is carried and you have blue bulbs (factor 45). Detail your exposure calculations.
(12) When exposing reversal colour film list the controls the photograph may use to ensure maximum fidelity of colour reproduction. Describe the effect on colour reproduction resulting from lack of control of *four* separate variables.
(13) Colour transparencies taken in the lighting from fluorescent tubes often show undesirable effects. Explain the causes of these and suggest any steps which may be taken to minimize them.

14. COLOUR PROCESSING AND PRINTING

Colour processing differs from black and white processing in several ways: (1) The chemical kit used must suit the brand and type of film or paper; there is really no choice of, say, fine grain developer type etc., as for monochrome work. (2) There are more processing stages. (3) There is much less room for error in temperature, timing, agitation and conditions of solutions (age, contamination etc). (4) Temperatures are higher (in the region of 38°C) to help reduce overall processing time. Also (5) the chemicals are much more expensive. This chapter looks at practical aspects of processing transparency and negative colour films, and making colour prints.

Film processing

Solutions. Makers of colour films supply processing chemicals in the form of kits of concentrated liquid chemicals or pre-packed powders, ready to make up into the various solutions. This is most likely to ensure that the chemical content of each solution is of suitable quality and accurately compounded. It also allows them to make slight changes in formulae from time to time to suit improvements in their colour emulsions, dye couplers, etc.

Some chemically minded photographers would prefer to know the detailed chemical action of each solution, but for the majority the pre-weighed and mixed components mean less work and greater reliability. Occasionally substitute formulae appear in the photographic press. These are interesting because they indicate the type of chemicals the manufacturers might be using. But there is little incentive to make them up, unless for some reason pre-packed supplies are unobtainable. Always you face the risk that these substitute solutions worked well with the batch of film actually used by the analytical chemist but they may not suit batches of material now on the market.

Detailed mixing instructions are packed with each kit of chemicals. They should be followed carefully, particular care being taken not to contaminate one solution with another via mixing rods, unrinsed funnels, even mis-placed stoppers. Colour kits are not cheap, and solutions made useless by contamination, mixing at the wrong temperature, or in the wrong order, prove expensive. Worse still, they may be used to ruin expensive colour film, resulting in even more costly retakes. Solution mixing is a responsible job.

Care should also be taken to protect oneself when mixing or handling colour chemicals–some of which are quite toxic to the skin and eyes. Always wear rubber gloves and preferably a rubber apron. Mix solutions in a well ventilated room. Stored ready-to-use chemicals should be protected from the air, e.g. in stoppered bottles and maintained at room temperature. (If stored in a refrigerator solution contents may crystalise out.)

Hardware. The basic materials which come into contact with colour processing solutions must be suitably inert–polyethylene or appropriate quality stainless steel are the most commonly used.

249

TABLE 14.1

TYPICAL COLOUR FILM PROCESSING SEQUENCES

Temp. Tolerance	Example Col Rev. Sequence (38°C, 100°F) E-6	Example Col Neg Sequence (38°C, 100°F) C-41	Principle Effect on Emulsion Layers
±0·3°C	1 1st dev		—B & W silver neg formed
±2°C	2 Wash		
±2°C	3 Reversal Bath		—Chemical foggant causes remaining silver halides to become developable
	Lights on		
±1°C	4 Col Dev		—Silver halides converted to black silver, oxidation products couple to form dyes
±0·2°C		1 Col Dev	—Latent image developed to B & W silver neg, oxidation products couple to form dyes
	5 Conditioner		—Stop bath
	6 Bleach	2 Bleach	—Bleaches all silver images and (some processes) finalises dye formation
		Lights on	
34°C–39°C		3 Wash	
	7 Fix	4 Fix	—Causes bleached silver to become soluble
	8 Wash	5 Wash	—Removal of soluble salts
	9 Stabilise	6 Stabilise	—Improves permanence of dyes
Time to end of last wet stage:	30 mins	20 mins	

The details listed are intended to illustrate the action of the various solutions and the degree of temperature accuracy required. Manufacturers introduce modified processing routines from time to time – the general trend being towards fewer stages, higher temperatures, and therefore shorter total processing times.

250

Small scale processing of sheet, roll and 35-mm film can be carried out in amateur-type tanks. These take single or multi-decker films in transparent spirals, or may be of the rectangular type taking three or four sheet films. As can be seen from Table 14.1, the first processing solution allows extremely little temperature latitude. It is essential to have tank and processing solutions standing on a deep dish or sink containing water of just this temperature. Use a clearly calibrated thermometer. Tank agitation must be strictly as specified in the kit instructions, and timed periods must allow the last 10 seconds for draining out one solution before pouring in the next.

This arrangement is too time-consuming and inefficient for handling a regular volume of commercial work. Most professional photographers either send films to a custom laboratory or have their own form of static installation for colour film processing. There are four main types, in increasing order of capital cost and film handling capacity: (1) A deep tank hand line. (2) Rotary discard processors. (3) Roller transport processors. (4) Rack and carriage ('dunking') machines. Each solves the problems of temperature control and consistant agitation in slightly different ways.

Deep tank hand line: Basically this requires a set of 16 litre plastic tanks. Each tank can accommodate about 30 spirals of 35-mm or 20 roll films, loaded in a rack; or about 24 sheets of 4 in × 5 in films in hangars. The photographer can construct a water jacketed installation along the lines of Fig. 14.1. Commercially made bench units also hold sufficient tanks for each stage of processing, and dials in the control

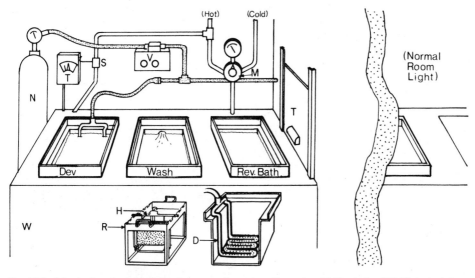

Fig. 14.1. A basic deep tank hand line for processing colour film, using 16 litre tanks (W) Water jacket enclosing all tanks and fed from thermostatic mixing valve (M). This also supplies water into the wash tank. A temperature probe located directly beneath the critical developing tank is connected to pre-set temperature control (T). Should a slight temperature drop occur this operates solenoid valve (S) which injects additional hot water. Nitrogen from cylinder N is passed through an electro valve control unit (V) on which the frequency and duration of bursts are set. Gas then supplies a distributor (D) which is moved from tank to tank along with the films. After completion of the first few processing stages the film rack is passed through light trap (T) to the other half of the unit, which is in room lighting. Here one or more other gas distributor units take over. Bottom: Film rack (R) containing sheet film on hangers (H). (Alternatively a rack carrying roll films on spirals may be used). The gas distributor is thin enough to fit between film rack and the inner wall of each tank.

251

panel allow the exact temperature of jacket and wash water to be pre-set. (Fig. 14.2(1)).

Even more important, it is practical to use gas injection into tanks of this size to agitate solutions during processing in a completely controlled manner. You cannot use air to do this as it would swiftly oxidise most solutions. A gas which is equally harmless to operator and solutions is needed – a cheap, inert gas such as nitrogen. Nitrogen from a cylinder is introduced through a distributor into the bottom of each tank of processing solution (Fig. 14.1). En route between cylinder and tanks the gas passes through an electrically operated burst valve, which switches the gas on and off in controlled intermittent bursts. Both the length of gas burst and interval can be set independently. This prevents flow marks on the films which might otherwise occur if the gas ran continuously. It also saves gas and allows agitation to be increased or decreased if necessary.

Deep-tank hand line units are relatively inexpensive and adaptable (they can be used with different chemicals for most types of colour materials). Their disadvantages include easy tank-to-tank contamination and aerial oxidation, and the need to replenish meticulously according to the quantity of film processed. Labour costs are high because whoever is processing must be in attendance throughout, manually shifting racks from tank to tank.

Manual/automatic rotary discard machine: Various manufacturers make these bench size machines – typically a light-tight box containing a large plastic motor-driven drum which rotates slowly in a shallow trough. Material to be processed is wrapped around and clipped to the outside of the drum emulsion outwards, the top closed, and solutions (including rinses) introduced in turn into the trough. Drum machines all use one-shot ('throw away') chemistry, i.e. a small quantity of solution is used once and discarded down the drain from the trough at the end of each stage. Automatic versions have a reservoir tank for each solution which is pumped up in pre-set quantities – the whole sequence being controlled by an electronic programmer.

Fig. 14.2. Processing equipment for sheet and roll colour film. 1: A commercially made deep tank hand line bench unit. 2: Automatic rotary discard machine with electronic programmer (P) for each stage. Both can process any type of substantive colour film (also colour prints, see page 281).

252

Like an automatic washing machine the unit is simply loaded and switched on. The operator can do some other job, and just return when a bell rings at the completion of final washing to hang up the films.

One-shot chemistry ensures fresh solution, removes most contamination risks and makes replenishers unnecessary. A large water jacket surrounding the trough is thermostatically controlled to maintain temperature; reservoir tanks and pipes are heated to the same temperature. The rotation of the drum gives excellent, consistent agitation. You can change from one process to another simply by coupling up different tanks and re-programming.

Note that film has to be processed in batches, and some skill is required to load the drum properly in the dark. A rotary discard machine is much more expensive than a hand line.

Automatic roller transport processor: This type of machine may be built through the darkroom wall as shown in Fig. 14.3, or take the form of a smaller, bench top unit. Using dozens of motor driven rollers individual sheet, roll and 35 mm films are guided through the tanks without having to be spliced end-to-end. The photographer simply feeds his material through a slot in the darkroom end of the unit, and waits for the processed, dry result to emerge at the far end. The machine can be left running all day and film inserted at any time – in batches, or individually as they are exposed. Deep tanks are used, with automatic 'bleed off' replenishment from reservoir tanks according to the amount of emulsion processed. Heaters in each tank control temperature, and the rotation of the rollers give ample agitation.

Roller transport processors are very consistent and efficient, and because they also handle the drying stage the absolute minimum of staff time and labour is needed.

Fig. 14.3. Fully automatic film processing machines. Centre: Roller transport machine. In each tank of solution motor driven racks of rollers (left) transport individual sheets or rolls of film. This machine is built into the wall of the darkroom, from which films are 'posted' through a slot. Right: A rack and carriage machine lifts batches of hanging films bodily from tank to tank.

253

However, the enevitable amount of surface contact made between the rollers and the film emulsion in this type of processor means that the equipment *must* be carefully maintained. Without 'good housekeeping' chemical crystals, grit, flakes of gelatin, etc., may build up on the rollers and damage films. Roller machines are costly to buy, require filling with large amounts of chemicals, and are normally designed for one process only. Fairly large, regular quantities of film are needed to justify this sort of outlay.

Automatic rack and carriage machine: In a sense this is a mechanised version of a hand line, on a much larger scale. As indicated in Fig. 14.3 batches of film are simply suspended from a rack which carries them slowly through deep tanks at a regular speed (tank length may vary to give correct timing for each processing stage). At the end of each stage films are briefly lifted, moved and lowered into the next tank – hence the term 'dunking' machine. Finally film racks pass through a drying tunnel. This type of unit is designed for one process only, and has similar replenishment and temperature control arrangements as a roller transport machine. Most units are also similar in throughput and price, but take up more space, and having large tanks are more costly to set up with chemicals. Rack and carriage machines are one of the oldest forms of mechanical processor. They are generally more suited to large scale batch processing handled in a developing and printing laboratory than a photographic unit.

Several other types of processor are made. In every case the photographer needs to make a detailed analysis of the volume and pattern of his colour film processing, and the cost of labour. Then this can be related to the most suitable type and size of machine, which again is analysed in terms of capital equipment, and chemical running costs. See *Professional Photography*, Chapter IV.

Whatever the hardware used for processing, the two most critical stages in colour processing cycles are first development (reversal materials) and colour development. The degree of first development determines, along with camera exposure, the amount of halide left to form the dye image later in processing. Colour development actually causes the dyes to form. Consequently timing, temperatures, agitation and solution condition are all more critical at these stages than at any other, and provide the real test of processing arrangements.

Process control. Quality control sounds as though it should be something to worry the manufacturer rather than the user of colour film. But when you are using costly material and possibly large tanks of expensive chemicals, some effective system of checking the solution makes economic sense.

The most useful aids for this job are the process control strips of film, a few inches long, exposed by the film manufacturer under strictly controlled conditions and supplied ready for processing in boxes of twenty or so. Each strip has been exposed to a grey wedge, some coloured patches and (usually) a head and shoulders colour portrait. See Plates C7–8. One strip in each box has been processed by the film manufacturers under 'ideal' conditions, to act as a comparative standard. Great care must be taken in storing these control strips, in case changes occur in the latent image. They should be held in a freezer at $-18°C$ ($0°F$) or lower, no more than about one month's supply being bought at a time.

254

Fig. 14.4. Quality control. Typical control plots used to check colour processing solutions. All plots here refer to one step on a control strip wedge. On the standard control strip this step gave the R, G & B density readings shown to the left of the graphs. Taking these as zero, the control strip processed along with batch 1 of actual production film is measured through an appropriately filtered densitometer (Fig. 12.1) and density departures from standard plotted as percentage plus or minus values. This is then repeated for later batches 2, 3, 4 and so on. Top graph: Reasonably consistent solution performance, well within tolerances (horizontal broken lines). Bottom graph: The effect of temperature rise or over-replenishment of first developer (reversal film) following film batch 4. Concurrent readings would probably be made from at least one other density step on each control strip, and plotted on separate graphs. (See also Plate C7).

The idea is that one control strip is processed at regular intervals, for example, along with the first batch of production film each day, and the results checked against the 'standard'. The intervals might be once a day, once a week, or with every single batch of film, according to the pattern of work. Control strips are marketed for reversal colour transparency materials and colour negative materials. They are especially useful for the latter, as colour balance faults are impossible to see in a negative with integral dye masks.

Visual comparison of the strip processed by the user and the standard provided by the manufacturer gives a spot check for gross processing errors. It may also usefully exonerate the processing lab from faults caused during exposing and film handling stages, e.g. fog, out of balance lighting, etc. With large volumes of solution it is worth plotting a simple comparative graph with the aid of a colour densitometer. The graph can show developing solution trends, indicating when their exhaustion points are approaching. Readings are made of three or more steps of the grey scale on the newly processed strip, each step being read through each of red, green and blue filters. These are compared with the readings from the same steps on the standard strip. Making a separate graph for each step, the difference between the readings of

255

standard strip and test are then plotted for each colour (Fig. 14.4). Deviations are immediately apparent this way, and the pattern of plots which exceed permissible latitude give a clue to the sort of fault which has occurred. As subsequent control strips are processed, their tri-colour readings can be marked up next to earlier ones on each stepgraph to show the general trend of the developing solutions, need for replenishment, etc. Trends are more important than individual readings.

Note that control strips are unlikely to show changes in solutions other than the developers–for example bleach and fixing baths may have deteriorated to a state whereby films processed in them show colour changes on keeping. Care must therefore be taken to log the amount of film processed, and keep these solutions properly replenished or replaced.

Processing faults. The visual appearance of processing errors varies somewhat according to the make of film. Diagnosis of a selection of the more common faults is given in Table 14.2. Note that often the black *rebate* is the most useful area to examine (like a doctor checking a patient's tongue).

Colour films which use resin based anchors for dye couplers (e.g. Ektachrome) have an opalescent 'unfixed' appearance whilst wet. The emulsion surface looks creamy orange, and the back of the film cyan. This disappears on drying. Assessment of results should always be left until the film is dry.

Special processing treatments

Uprating colour materials. By 'pushing' (extending the time in the first developer) it is possible to increase the effective speed rating of reversal colour films. This can be useful for jobs handled under difficult lighting conditions, for example photo-journalistic work. Obviously it is best to start out with the fastest colour emulsion available rather than try to force a slow film. Provided that you accept some deterioration of image quality the speed on the film box can be multiplied by up to × 4.

The limits of this uprating and the necessary increase in first development time vary with individual films. Typically these are 30% and 80% extra development time for × 2 and × 4 the speed rating respectively. Other processing stages stay unaltered. Inevitably quality has to suffer, see colour Plates C20–24. The principal side effects are empty shadows, a shift in colour balance (which may vary batch-to-batch); also changes in contrast, and reduction in maximum density. The latter is perhaps the most serious visual defect, coupled as it often is with separation of the response curves back into lighter and lighter densities. Much depends upon the type and importance of the subject matter. Weak, distorted shadows and dark mid-tones may be better than no results at all. Most commercial colour laboratories can push customers' films by one or two stops, charging extra for this service.

Compensating overexposure. To a rather lesser extent first development time can be curtailed to 'hold back' a reversal colour film known to be over-exposed. Try cutting the time by 30% to compensate for one stop overexposure. This is generally the limit, owing to the resulting poor highlight contrast and shift of colour balance. Tests will soon show how far particular films can be 'pushed' or 'held back' and still give acceptable results for your purposes.

TABLE 14.2
COLOUR FILM PROCESSING FAULTS

Typical Film Appearance	Probable Cause
Colour Reversal Film	
Too dark, with colour cast	Insufficient first dev.
Completely black	First and colour devs interchanged
Yellow, with decreased density	Fogged in first dev.
Too light, with colour cast	Excessive first dev.
Contrasty colour negative	Contamination of first dev. Given colour negative processing.
Blue spots	Bleach contaminated
Fungus or algae deposits	Dirty tanks
Scum	Contaminated stabiliser
Control plots showing:	
All densities up or down	First developer errors creating speed changes
All low, blue plot least affected	Excessive first dev.
Colour Negative Film	
Image light, and with reduced contrast	Underdevelopment
Image dense and very contrasty	Overdevelopment
Streaked and mottled image	Insufficient agitation
Heavy fogging, partial reversal	Exposure to light during dev.
Reddish-brown patches	Contamination of solutions
Completely opaque, or cloudy image	Bleach or fixer stage omitted
Colour positive, with strong cast	Given reversal processing
Opalescent yellow overall	Exhausted bleacher
Fungus, blue spots	As per reversal transparencies

Note that giving this sort of treatment to colour negatives is much more restricted – and best avoided altogether. Here the first development stage is colour developer, which controls colour balance as well as density. Although colour negatives can be filtered in printing, any non-standard processing of the film is likely to produce 'crossed curve' effects – with shadows requiring one type of colour filtration and highlights another.

Accidental processing of colour negative film in black-and-white solutions. In the rather unlikely event of a colour negative being developed and fixed as black-and-white material, it is possible to reconstitute a negative colour image. Whether the result will give a satisfactory colour print depends upon the make of colour film and type of black-and-white developer accidentally used.

The monochrome processing forms a black-and-white negative in each colour emulsion, but the colour couplers in image areas are neither coupled nor destroyed. Basically the silver image must be rehalogenized, thoroughly fogged to light and then normally processed via the complete sequence of colour negative solutions. You can see that the colour developer affects the halogenized image as if it were a latent image, forming silver and coupling the dyes. Some loss of speed, contrast and colour quality is almost inevitable. The manufacturers of the films which may be salvaged in this way publish detailed information on procedure.

Increasing graininess. Strictly speaking the dyes forming a colour image have themselves no appreciable grain structure. However, the visual graininess of such

Fig. 14.5. An attempt at correcting a blue cast colour transparency by binding it up with a sheet of yellow gelatin. The effect is to raise the defective blue curve vertically. Correction is achieved at one density level (X) but highlights are now noticably yellowish, whereas shadows remain under corrected.

an image seems to be affected by three factors – the molecular structure used to anchor the dyes; the density range of the image; and of course its magnification. A successful line up for producing a grainy colour print is to form the smallest practical image on a 35-mm colour negative material having hydrocarbon molecule anchors (Agfacolor, 3M, etc). This is exposed uprated one stop and processed accordingly. Alternatively shoot on fastest Ektachrome underexposed two stops and processed in Kodak colour negative film chemicals. In both cases keep subject lighting range low and use really first quality lenses on both camera and enlarger. A point source lamp in the enlarger will help to emphasise the globules of colour making up the image.

Aftertreatment of colour transparencies. Like black-and-white aftertreatment, the physical or chemical doctoring of colour transparencies should be regarded as exceptional, virtually emergency treatment. Only a limited range of aftertreatments are possible and these are more compromises than cures. They can be divided into:

Physical aftertreatments – Filters or stains affecting the whole transparency, or dyes applied to local areas.
Chemical aftertreatments – Reducers for each dye image layer.

Binding up a uniform filter (coloured acetate or stained sheet of gelatin) with the transparency may be helpful when the viewing light is of the wrong colour. When used to correct an unbalanced dye layer however, uniform colour can really only improve one density. For example, if a transparency is slightly too blue a pale yellow filter may greatly improve a mid-tone, but the highlights are then too yellow and the shadows remain an undercorrected blue (Fig. 14.5).

An improvement on this is to use an actual dye image, having extra density in the shadows and none in the highlights. Dye transfer matrix film can be used. In the

258

example quoted a separation negative would first be made from the transparency, through a blue filter. This would be printed on matrix film, dyed up in yellow and either bound with the faulty transparency or transferred onto its back or front surface. Colour may also be improved in local image areas by applying 'Flexichrome' or dye transfer dyes by hand. This is a very skilled job.

Certain chemicals can be used to reduce individual layers of image dye in dense transparencies. The risks are considerable – it is difficult to tell how much each layer should be reduced, and easy to go too far. Some bleachers do not have a permanent effect. Each colour film manufacturer has his own particular dyes and may therefore make his own recommendations. Expensive proprietory colour slide reducers are available with instructions listing the brand names of colour film on which they can be used. Basically the chemicals used are:

To reduce the yellow layer – acidified sodium hypochlorite.
To reduce the magenta layer – slightly alkaline sodium hydrosulphite.
To reduce the cyan layer – dilute amidol or metol solution.

Other reducers are made to give an overall reduction of density without colour change.

Several colour processing laboratories offer a colour correction service for colour transparencies, but this can prove expensive. Aftertreatments would not be used on colour negatives, as corrections to casts and density levels can be more predictably made in printing and final print retouching.

Retouching colour negatives. Tone retouching of large colour negatives – pencilling in of wrinkles, creases, blocking out of backgrounds – can be carried out in the same manner as black and white work. Where retouching is over coloured areas black pencil is still adequate unless a large area requires attention – in which case use coloured pencils to match in to the surroundings. (It is difficult to do this completely on masked negatives because the mask dye does not dissipate where retouching colour is added.)

Where coloured blemishes appear use a complementary coloured pencil or dye, e.g. for a magenta spot use a green pencil until it matches surrounding colours. If in doubt apply too much retouching density to the negative; provided that the resulting lighter area on the print is reasonably small it can be handled during print finishing. Knifing is not practical on multilayer film. It is also unsightly on the final print. Therefore always check your colour negatives for pin-holes, which are better filled in on the negative than scratched out on the print.

Printing colour negatives

Colour printing to top professional standards is a highly skilled (and well paid) job in its own right. Quite long training is necessary, mostly in practical work. The discussion here is restricted to the general principles involved. These can be amplified by reading manufacturers' working procedure – for each maker of negative-positive materials specifies slightly different routines, particularly in regard to filters.

Figure 14.6 illustrates the variety of positive images that may be produced from processed colour films. This chapter looks primarily at the making of colour prints on

multilayer paper, from colour negatives. (See page 276 for printing from transparencies).

Apart from cropping and change of image size, the colour printing stage allows alterations in density (by exposure) and colour balance (by filtration). There are two basic methods of using filters to control colour balance. Either can be used on all materials.

Fig. 14.6. Various permutations of final result possible from camera-exposed colour film. (As new products are introduced this pattern changes in detail).

(1) The *white light* or *subtractive* method. One or more colour printing filters are located usually between the enlarger light source and the negative carrier. These subtract a proportion of certain wavelengths emitted by the lamp, thus altering the colour balance of the projected colour negative image. The filters stay in position throughout the whole of the exposure period.

(2) The *additive* or *triple-exposure* method. Three separate exposures are given—through red, green and blue filters—normally located at the lens. *Varying the exposure* through each filter controls the colour balance. In a way you can think of this as exposing the three emulsions in the colour paper, one at a time.

A comparison of the two methods is discussed on page 264.

Hardware and control facilities. To undertake colour printing you need certain extra items of equipment for the printing room. These are:

(1) An enlarger with a 'colour head'. As shown in Fig. 14.8 this unit contains built-in yellow, magenta and cyan filters which can be dialled in to progressively

260

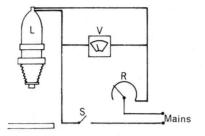

Fig. 14.7. A simple rheostat circuit to standardise voltage applied to an enlarging lamp. A lamp of slightly lower voltage rating than the mains is needed (e.g. 230v lamp on 250v mains). Exposing switch S is closed and rheostat R moved until voltmeter V reads the correct voltage for the lamp. The voltmeter must be checked regularly whilst the enlarger is being used.

tint the light source. Alternatively use an enlarger with a simple filter drawer below the lamp (Fig. 14.9). A set of yellow, magenta and cyan acetate filters of different strengths is then needed–usually about 20 in number. A third alternative, if you are prepared to print by the additive method, is a set of blue, green and red tri-colour lens gelatines.

(2) A voltage stabilizer for the enlarger light source. Stabilisers help to ensure that the colour temperature and intensity of the lamp will not vary appreciably.

Fig. 14.8. A colour head enlarger–the most convenient and flexible method of filtering for colour printing. T. Tungsten halogen lamp. H. Infra-red heat filter. F. Three independently moved, dichroic (fade resistant) yellow, magenta and cyan filters. R. Cams which raise filters gradually into the light beam, controlled by calibrated Y, M and C finger dials. D. Light diffusing box, internally finished in matt white. S. Additional drawer for U-V filter, and extra colour filters beyond the dial-in range. N. Negative carrier.

261

Nevertheless lamps should not be used beyond a certain age. New lamps need 'burning in' for a period until their output is stable. As a cheaper but less convenient alternative to a voltage stabilizer unit, a voltmeter and rheostat circuit (Fig. 14.7) can be used.

(3) A really accurate enlarger timer. The paper has to be handled in total darkness or light from a very dark safelight. You also need a safelight screen (usually dark amber) as recommended by the makers of the printing material.

(4) An electronic colour analyzer. This is not essential, but helps to save time in testing if a wide range of negatives have to be printed. The various types are described on page 271.

(5) A print processing drum, or deep tank line, or some form of print processing machine. (These are discussed on page 279). Also a temperature controlled water supply.

The printing paper. There are three main kinds of colour paper. One type is intended for printing from colour negatives (neg/pos printing). Ektacolor and Agfacolor type 4 papers are of this kind. The others are both for printing direct from colour transparencies (pos/pos printing). For this you need either dye destruction material such as Cibachrome, or a chromogenic paper intended for reversal processing, e.g. Ektachrome paper. To begin with we will be concentrating on neg/pos printing paper, the type most commonly used for professional colour prints.

Like other multilayer materials this colour paper has three differently colour-sensitized emulsions. But unlike camera materials the order of emulsions is usually reversed – the red-sensitive cyan-forming emulsion being on top. This is because a

Fig. 14.9. Basic, low cost filtering methods for colour printing. (Left) Three separate exposures can be given through primary gelatin filters – each swung in turn under the enlarger lens (see also Fig. 14.13). Alternatively (right) acetate filters can be located in a drawer between lamphouse and condensers (C), above the negative carrier (N). Filtering the light source in this way allows a single exposure to be given.

262

certain amount of diffusion of the image at the bottom layer is inevitable. It is less noticeable if this bottom layer is yellow instead of a visually heavy colour like cyan, which contributes far more to image definition.

Reversing the layers means that there is no purpose in having a yellow filter below the top emulsion layer–each emulsion must be sensitized to a separate part of the spectrum (see page 187). This is not too difficult because the paper will not have to receive light from such a wide range of subject colours as in the case of camera materials. It only has to work to the dyes formed in the colour negative. Paper emulsions can therefore be sensitized to quite narrow and well separated bands of the spectrum, see Fig. 14.10.

At the same time the characteristics of the same maker's colour negatives are taken into account ('keyed') in deciding the contrast and colour balance of the paper

Fig. 14.10. Top: Absorption curves of typical coupled image dyes. Bottom: Colour sensitivity of a set of paper emulsions 'keyed' to give maximum separation of these component images. Each paper manufacturer chooses emulsion spectral sensitivity most appropriate for his product, taking into account masking and other factors.

emulsions. This applies particularly to the kind of orange mask used in the manufacturer's colour negatives–the paper will have compensating extra blue sensitivity. Cross-printing maker A's negatives on maker B's paper may require rather heavy filtration. However, sometimes this technique, with its use of differing dye characteristics, may give a better rendition of one critically important colour. Other colours are likely to be less accurately represented.

Owing to the difficulty of manufacturing colour paper with absolutely identical characteristics, each box or packet of paper is stamped with details of its batch characteristics–exposure and filter changes needed relative to other batches. This means you may have to make adjustments between finishing one box and starting the next. See page 266. Again, unlike black and white materials, the paper is marketed in a single contrast grade, generally in glossy, semi-matt or 'silk' surfaces. The range varies according to maker. All modern colour papers are resin coated both sides to reduce chemical absorption and so allow fast machine processing, discussed on page 281.

Safelights, which are of limited value owing to their dimness, will vary according to the sensitization of the emulsion layers. Changing the make of paper often calls for a change of safelight. Many photographers processing with daylight drums or machines prefer to expose and load prints in total darkness.

Remember that in common with all colour materials, the printing paper's storage conditions are critical. The paper is supplied in a foil sealed bag within its box. Stock should be kept sealed, located in a refrigerator and as usual allowed to thaw out before use. Colour paper is 2–3 times the cost of monochrome paper of the same size.

Principles of filtering

If you could standardize the content of the light on your subject; the exposure conditions; the colour balance of negative emulsions; processing conditions; the enlarger light source; the colour balance of the paper batch and many other factors, then filtering in colour printing would not be necessary. In practice one negative in a thousand will give a satisfactory print with virtually no filtration. But this is not the point. Filtration gives us *flexibility*–enables pictures to be shot under a fairly wide range of conditions, and equally allows a wide range of interpretative colour prints to be made from one negative.

White light method

This is the most universally used method of colour printing, and consists of tinting the enlarger light source with various combinations of yellow, magenta or cyan filters. Think of this as controlling the response of the three emulsion layers in the paper–the yellower you filter the light the more blue is subtracted, so the blue sensitive emulsion is less exposed, forming less yellow dye. The colour print therefore appears more blue. Remember that the more of one colour added in filters the more complementary coloured the final print will become.

To begin with two colourless filters should always be in use. These are:
(1) An infra-red absorbing filter positioned near to the lamp in a well ventilated position. Colour enlarger light sources are stronger than black and white types, and the filter's function is to prevent overheating of colour filters and negative, as well as limiting the IR sensitivity of the red emulsion layer of the paper which may form a low contrast cyan image.
(2) An ultra-violet filter located near the printing filters to effectively limit the sensitivity of the blue emulsion at the shortwave end of the spectrum. (Some colour printing filters themselves absorb U-V, but if we relied on this method alone absorption would vary according to the filters being used).

Using a filter drawer. If the enlarger simply has a filter drawer we need a wide range of colour printing filters varying in density and hue, from which we can make up an appropriate 'filter pack'. They can be made of inexpensive acetate instead of gelatin, as their position in the lamphouse will not upset image sharpness.

The most commonly used colour printing filters are yellow, magenta and cyan, although some makers produce pale red filters too. Each of these colours is made

in a range of densities (Table 14.3). A typical set might consist of about 20 filters–but by combining colours and densities a much wider range of filter packs can be made up.

Each manufacturer has a different method of coding their filters. Kodak quote filter density (to light of its complementary colour) times one hundred. This is the same system as used with gelatin colour-compensating filters (page 234). A CP 30M filter means a magenta coloured acetate filter which, if measured on a green filtered densitometer, is found to have a density of 0·3. To make up a pack of, say, 30M+05C we could use three 10M filters and a 05C filter, or one 20M, one 10M and a 05C . . . or any other equivalent combination.

Agfa-Gevaert filters also have code figures. They are not simply density values but are directly related to the effect they have on the visual appearance of the final print (not quite the same thing). This manufacturer quotes a six figure number for each filter. The first two figures always relate to yellow filter density, the next two to magenta and the last two to cyan. Hence a 30M filter is quoted as 00-30-00, and our two filter pack as 00-30-05.

Using a dial-in colour head: This has the same function as a filter drawer but is much more convenient and time-saving. As shown in Fig. 14.8, the lamphouse has only three built-in filters, which slide into the light beam under the control of finger dials on the outer casing. (They can also be controlled electronically by solenoids linked to a colour analyser viewing the image on the enlarger easel.) The effect on the printing light varies according to the area of each filter allowed to enter the light beam. For example a 200Y filter placed one quarter of the way into the light beam has the effect of a 50Y filter. Some form of light scrambling device between filters and negative is essential to give a totally even effect. Dial-in filters therefore allow a continuous change of colour instead of 'jumps' of density given by using filter packs in a drawer. Dials are calibrated with the figure equivalents of colour printing filters e.g. from 0 to 200 in each of the three subtractive colours.

The filters themselves consist of glass thinly coated with metallic layers which reflect or transmit different bands of wavelengths by interference, rather than dye absorption. Table 14.3 shows how these dichroic filters avoid the usual unwanted absorption of dyes. They are also resistant to fading (a major problem when small areas of dyed filters are introduced into a concentrated light beam). Dichroic filters are more expensive than dyed acetates, but of course only three quite small ones are required.

Basic printing procedure. Most of the skill in professional neg/pos colour printing lies in the making of test strips which will lead quickly to a high quality final print. It is essential to get into the routine of making notes of filter packs or settings and exposure times, preferably on the back of each test print–otherwise data is easily forgotten whilst you are waiting for processing. Various electronic aids are available for assessing the filtration and exposure required for a negative, and will be described shortly.

Printing a colour negative for the first time, without the use of a densitometer, you might start by using filters suggested as typical for the particular make of colour negative–for Vericolor try 50Y+50M. Lay a test strip across a representative area of the projected image and give a series of doubling exposure times (based roughly on the exposure you would expect for a black-and-white negative at the same

265

magnification and f-number). When processed, view the test under illumination of the same colour and intensity as that which the final print will receive. If this is not known use daylight, 'colour matching' fluorescent tubes or blue tinted 'daylight' lamps. With most makes of paper the test will have to be completely processed and *dried* before accurate assessment, owing to visual differences between wet and dry prints.

The likelihood of filtration being correct with the first test is extremely remote. See Plates C25–31. Perhaps the test strip appears too magenta. This indicates that the paper's green sensitive layer has received too much light. To reduce this green light more green absorbing, i.e. magenta, filtration must be added. *The rule is to add a filter or filters of the same colour as the cast you are trying to remove, to whatever filters were used to make the test.* Add a 10 filter for a slight change, a 20 for a more noticeable change, and a 30 or 50 filter for a major change. A second test is now made using the new filtration, basing exposure on the time which gave the most satisfactory density on the first test strip and adjusted to take the extra filter density into account. (Manufacturers supply calculation charts for this purpose, or better still re-measure exposure with a colour analyser Fig. 14.14.)

Further tests bring us down to critical adjustment of the filtration. Now it is helpful to view each processed test through various printing filters until mid-tones look correct for colour. Filtration complementary in colour to the best viewing filter and about half its density is then added. Remember exposure adjustments whenever the filter pack or dials are altered.

Effect of the printing material. Colour printing material tends to vary in its characteristics, batch-to-batch. Each box of paper is therefore stamped with filter pack and exposure adjustment recommendations applicable when changing from one batch to another (Fig. 14.11.) The routine is to subtract 'old' from 'new' filter recommendations and add the result to the filtration previously used to print the negative. For example using Kodak materials you are printing a negative using $25Y+30M$ and an exposure of 15 seconds. You have just finished a box stamped $+05Y-10M$ (Exposure factor 110) and are starting a box marked $+05M$ (Exposure factor 90).

$$
\begin{array}{llll}
\text{Subtracting 'old' from 'new'} & Y & M & C \\
& 00 & +05 & 00 \text{ (New)} \\
& +05 & -10 & 00 \text{ (Old)} \\
\hline
& -05 & +15 & 00 \\
\end{array}
$$

$$
\begin{array}{llll}
\text{Adding this result to the previous filtration} & Y & M & C \\
& 25 & 30 & 00 \text{ (Old filtration)} \\
& -05 & +15 & 00 \\
\hline
\text{The new filtration required } = & +20 & +45 & 00 \\
\end{array}
$$

The new exposure time is calculated from

$$\text{New exposure time} = \frac{\text{New exposure factor}}{\text{Old exposure factor}} \times \text{Old exposure time}$$

hence, in this case

$$\text{New exposure time} = \frac{90}{110} \times 15 = 12\tfrac{1}{2} \text{ seconds}$$

266

BASIC TYPES OF COLOUR FILM

Plate C1–6 (Above) The same subjects exposed on (Top strip) reversal transparency; (Centre) integrally masked colour negative; and (Bottom) false colour record Ektachrome I-R reversal film.

Plates C7–8 (Below) Typical process control strips for (Top) reversal transparency film, and (Bottom) colour negative film.

REVERSAL TRANSPARENCY FAULTS

Plates C9—14 (Opposite page) (Top left) Correctly exposed. (Top right) $1\frac{1}{2}$ stops overexposed. (Centre left) Daylight type film exposed by 3,200 K illumination (a similar result but laterally reversed and under-exposed, results from the correct film being exposed through the base). (Centre right) Exposed in a studio with green walls. (Bottom left) Correctly exposed Ektachrome processed as if a colour negative material. (Bottom right) Type B film exposed by daylight illumination.

Plates C15—19 (This page) (Top left) Fogged to a red safelight whilst unloading. (Top right) Exposed with a green filter over the lens. (Centre right) Colour cast due to reciprocity failure (left half $\frac{1}{2}$ second exposure; right half exposed to greatly reduced illumination for $2\frac{1}{2}$ minutes, including compensation for loss of speed).

COLOUR NEGATIVE FAULTS

(Lower left) Two stops underexposure (Lower right) Colour negative film exposed through the base.

SPEED BOOSTING
Plates C20—24 'Pushing' the speed of a reversal
colour transparency material by giving longer first
development. (1) Box speed, normal development time.
(2) ×2 box speed, 30% extra dev. (3) ×6 box speed,
130% extra dev. (4) ×12 box speed, 230% extra dev.
(5) ×16 box speed, 350% extra dev. All other processing
stages as normal. (Alasdair MacGregor).

FILTERING IN COLOUR PRINTING
(WHITE LIGHT METHOD)

Plates C25–31 All the test strips (Above) show that
strong correction is required to achieve the correctly
filtered print (shown right). In each case the colour
printing filter(s) to be added to the pack would be
(Left to right) 100Y; 100M; 100C; 100M+100C; 100Y+
100C; 100Y+100M. Remember to subtract any neutral
density and adjust exposure (Peter Tillyer).

COLOUR PRINTING
Plate C32 A colour print made direct from a 35 mm colour transparency, resulting in complementary colours and negative tones. (Ian Atkinson).

COLOUR PHOTOGRAPHY IN ADVERTISING (OPPOSITE PAGE)
Plate C33 (Top) An image typifying the directness and simplicity essential in poster advertising, where a message must be communicated in a brief instant. Diffused electronic flash, $2\frac{1}{4}$ in square reversal colour film (John Hedgecoe, for Milk Marketing Board).
Plate C34 (Bottom) Strongly subjective image for a record cover. Colours and shadow detail restricted by use of deep purple acetate over the camera lens, and two stops underexposure. Overall density was then lightened in reproduction. (Dick Swayne).

FIGHT WINTA WITH A PINTA

LOCAL FILTERING (OVERLEAF, TOP)
Plates C35—36. Two prints on colour paper from the same black and white negative. By shading out local areas, then printing them back in again at different filter settings an effect similar to selective toning is possible.

BIREFRINGENCE (OVERLEAF, BOTTOM)
Plates C37—38 Two pictures of a light box almost covered by a square polarising filter, on which various items of colourless plastic are positioned. The geometric pattern at lower right is formed by overlapping strips of cellulose tape. Another polarising filter over the camera lens has been rotated 90° about its axis between shooting the two pictures. Note how plastic overlapping the boundary of the square polarising filter remains colourless throughout. See page 329.

TABLE 14.3

COLOUR FILTERS SETS FOR WHITE-LIGHT PRINTING

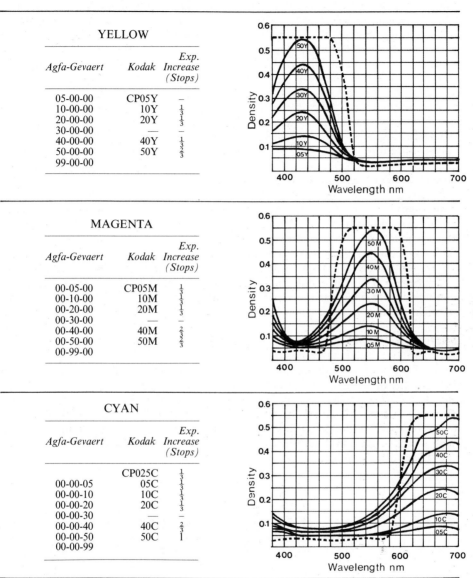

YELLOW

Agfa-Gevaert	Kodak	Exp. Increase (Stops)
05-00-00	CP05Y	—
10-00-00	10Y	$\frac{1}{3}$
20-00-00	20Y	$\frac{1}{3}$
30-00-00	—	—
40-00-00	40Y	$\frac{1}{2}$
50-00-00	50Y	$\frac{2}{3}$
99-00-00		

MAGENTA

Agfa-Gevaert	Kodak	Exp. Increase (Stops)
00-05-00	CP05M	$\frac{1}{3}$
00-10-00	10M	$\frac{1}{3}$
00-20-00	20M	$\frac{1}{3}$
00-30-00	—	—
00-40-00	40M	$\frac{2}{3}$
00-50-00	50M	$\frac{2}{3}$
00-99-00		

CYAN

Agfa-Gevaert	Kodak	Exp. Increase (Stops)
	CP025C	$\frac{1}{3}$
00-00-05	05C	$\frac{1}{3}$
00-00-10	10C	$\frac{1}{3}$
00-00-20	20C	$\frac{1}{3}$
00-00-30	—	—
00-00-40	40C	$\frac{2}{3}$
00-00-50	50C	1
00-00-99		

Colour printing filters (white light). Agfa-Gevaert and Kodak filters, are not comparable (see text). Exposure increase figures and absorption curves apply to the Kodak filter sets. Kodak make an alternative series of weak red, green and blue filters for white light printing. Broken lines show absorption curves of typical image dyes (see Fig. 10.5).

267

267

Equipment factors. Often when several enlargers are in use for colour printing the filtration required to print a given negative will vary in each enlarger. This is because of differences in light sources, and the effects of individual condensers, diffusers and enlarging lenses. In such circumstances it can be helpful to establish a relative equipment factor for each enlarger, similar to paper batch changing recommendations. To do this a colour negative is printed with each enlarger in turn, to give matching colour prints. The filter pack and exposure time required to achieve this is noted on each enlarger. Now if any colour negative printed on enlarger 'A' is later reprinted on enlarger 'B', 'A's basic filter notation is subtracted from 'B's notation and the result added to the filtration filed on the negative bag when it was last printed. Similarly exposure times are changed using the equation quoted above for paper exposure factors. Obviously changes to a piece of equipment (e.g. a new lamp) call for its recalibration.

Accumulation of neutral density. The various subtractions and additions to filter dial settings or the content of filter packs sometimes mean that they finally contain some yellow, magenta *and* cyan filtration (e.g. 10Y 05M 15C). Now this is pointless because a combination of the three colours means that neutral density is present, having no effect other than dimming the illumination.

Always look out for and remove neutral density by taking the lowest of the three figures and subtracting filters of this density from each colour. Hence 10Y 05M 15C simplifies to 05Y 10C, and 20–10–15 simplifies to 10–00–05. In each case the simplified filter pack has the same colour filtration effect as the old pack, but now needs less exposure to be given.

Shading, printing-in. Shading (to lighten local areas), and printing-in (to darken them) can be carried out in the same way as for black and white printing. Additionally selected parts of the picture can be altered in colour balance by changing filters between the main exposure and the printing-in exposure. For example, the shadow side of a building exterior may appear too blue at the filtration needed for sunlit parts. By carefully shading this area, then printing it back again with 30M+30C extra (or 30Y less) filtration this area can be made more neutral. Similarly shading with pieces of gelatine filter during the main exposure will both lighten and change the colour of chosen areas.

Fig. 14.11. Reproductions of part of (top) Kodak and (bottom) Agfa paper box labels, bearing batch filter recommendations.

Additive or triple-exposure method

This method of filtering in colour printing has the merit of requiring least extra equipment. Only three simple deep blue, green and red gelatine filters are needed. On the other hand three separate exposures must be given for each and every print, which is time-consuming and makes shading and printing-in virtually impossible.

The three filters used are narrow cut tri-colour types chosen by the paper manu-facturer to suit the peak sensitivity of their paper emulsion layers. The filters could be used in the lamphouse filter drawer, but as filter changes have to be made part-way through the exposure of every print, enlarger movement could easily occur. It is better to have them mounted on a smooth sliding or rotating turret just below the lens. Of course, since they are now in the actual path of the image, acetate sheeting will no longer do, and camera quality gelatin filters are needed instead. An infra-red absorbing filter is still desirable in the lamphouse, but as ultra-violet is absorbed by all three filters an extra filter for this purpose is unnecessary. See Fig. 14.12.

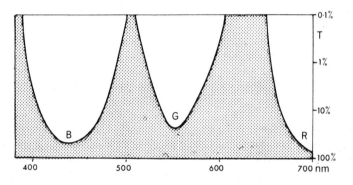

Fig. 14.12. A set of narrow cut primary filters for colour printing by the triple exposure method. Each manufacturer recommends a set to suit the colour sensitivities of his paper emulsions. Compare with Table 14.3. Note that the blue filter transmits little U-V. The red filter transmits well into I-R wavelengths—an I-R absorbing filter is therefore still needed in the lamphouse.

Basic printing procedure. The best method of testing for correct exposure times is to expose a 'patch chart', as shown in Fig. 14.13. For example, you might decide to give the whole image 12 seconds through the blue filter, then strips of 6, 12 and 24 seconds through the green filter and 6, 12 and 24 seconds (in strips at right angles to the first) through the red filter. The resulting patch chart shows the result of nine different combinations.

Earlier it was said that if a colour print appears too magenta too much green light has affected the paper's green sensitive emulsion. In tri-colour printing you can handle this by making the exposure through the green filter *shorter* than the exposure through the red and blue filters. *The rule here is to increase the exposure through the filter matching the unwanted cast, or decrease exposure through the filter(s) comple-mentary to the cast.*

As you make further prints then you alter colour by either increasing or decreasing the exposure given through certain filters. The choice here will depend upon whether you want a lighter or darker print, or wish to maintain the same density. For example

269

Fig. 14.13. Making a test 'patch chart' when printing by the triple exposure method. The colour paper is exposed overall to the image through one filter, then in strips differing in exposure time through the other two. The processed print (right) shows the result of nine combinations of exposure.

the last exposure may have been red 10 seconds, green 20 seconds and blue 15 seconds (Note: no subtraction of neutral density is needed in additive printing). Perhaps results are too blue. If you decide to compensate the blue by increasing the blue exposure to 20 seconds, the previous total exposure of $10+20+15=45$ seconds is increased to $10+20+20=50$ seconds. This will therefore also give a darker print.

But suppose the previous density was satisfactory: The new exposure times will all have to be cut proportionally to return to the original total of 45 seconds, yet maintain the new filtration. This is done by multiplying the new exposures for each filter by the original total divided by new total $\frac{45}{50}$. The result is exposure times of red 9 seconds, green 18 seconds, and blue 18 seconds. An accurate exposure timer is particularly important in tri-colour work.

Effect of the printing material. Manufacturers mark each box of paper with batch recommendations for additive printing as well as for white light printing. (Fig. 14.11.) For example Kodak give arithmetical factors for red, green and blue exposures. These are used for each colour in the same way as exposure time adjustments in white light printing.

$$\text{New exposure time} = \frac{\text{New exposure factor}}{\text{Old exposure factor}} \times \text{Old exposure time}$$

For example, if you were previously giving 20 seconds exposure through the green filter and had to change from a paper with a green factor of 80 to a new box with a green factor of 100, the new exposure required will be

$$\frac{100}{80} \times 20 = 25 \text{ seconds}$$

Other calculations would have to be made for the red and blue filter exposures, based on the factors for these colours as marked on the boxes.

270

Equipment factors. Relative equipment factors can be established for the same reasons and in a similar manner as white light printing. The exposure required through each filter is recalculated using the same formula as that used for overall exposure time in the case of white light printing.

Assessing negatives in commercial colour printing

The trial-and-error methods of colour printing described so far are slow and laborious –more suited to the amateur occasionally making prints than a professional turning out a regular volume of work at commercial speed. Most firms use short cut methods to predict the approximate filtration and exposure needed for an unknown negative, and so cut down the number of test prints. The aids used range from a simple colour analyser to complete video systems, and allow a number of alternative methods of assessment to be carried out. However, the first essential is to make a standard or master negative.

'Master' (or 'standard') negative. To set up any colour assessment system you first need a master negative–a colour negative which is known to print well, is fully documented, and which can be compared with any unknown negative in order to predict the latter's filtration and exposure. (It can also be used for printing processing control strips, establishing equipment factors, and comparing old and new paper batches.)

A master negative should be made on the film stock normally used–if you use several types of colour negative material one master negative should be made for each type. The image might as well be typical of the type of subject matter you shoot on that film. It is most helpful to include some near neutral colours of various luminosities–these are more sensitive to colour balance changes. A simple three step grey scale together with a portrait including some blue sky is often chosen as a subject for master negatives.

Once a really successful print has been made details of filtration, exposure, paper batch, f-number, enlarger, and size of enlargement are filed with the master negative. When another colour negative comes along for printing under the same conditions, density measurements can be made and compared with your master. Since you know the filtration/exposure needed for the master it is relatively simple to work out what the unknown negative will require. You can either take local, or 'spot' readings of each of the two images or make 'integrated' whole negative readings. There are advantages and disadvantages to each reading method, very similar to the use of spot or general readings of an original subject with a through-the-lens exposure meter.

Integrated readings. This method of measuring the colour and density content of a negative is based on the assumption that if all light-passing through the whole of the negative is 'scrambled' the result lacks any predominant colour and equals grey. So all you need to do is to set up the master negative, place a strong diffusion device over the enlarger lens, and take blue, green and red photo cell readings of the scrambled light. This is compared with a similar integrated light measurement of the unknown negative. The difference in readings will show what change in the filtration and exposure time is needed.

Such a system is quick and simple, but of course falls down whenever a small important subject has been photographed against a large, unimportant background differing in colour and/or luminosity. The classic example here is a small white cat photographed on a green lawn, which this assessment technique prints as a magenta cat on grey-green grass. Such a situation is known in the trade as *subject failure*. However, quite a high success rate is possible by measuring in this way, and it is used extensively for automatic printing machines in D & P laboratories. For highest quality professional work however intelligently made spot readings are much more satisfacotry.

Spot readings. This means measuring from a small portion of the negative, chosen either because it is typical of the whole, or is the most critical area for correct colour and density. The important point here is that your master negative and the unknown negative to be printed should both contain directly comparable subject matter. A mid grey area or medium flesh tone is most useful – remember that whatever area you measure will be reproduced similarly from both negatives. Avoid measuring specular highlights or dark shadows, because either extreme of the tone scale can be deceptive.

A typical photocell probe device for spot readings measures through a hole about 5 mm diameter (Fig. 14.14). Since this may be read from the magnified image projected onto the enlarger baseboard, a very small area of the negative can be assessed.

Fig. 14.14. An on-easel colour negative analyser. P. Probe carrying interchangeable heads for spot or integrated readings, and filter selector (S). A. Programming attenuators for the three filter colours, and exposure time. M. Meter readout of filtration and exposure time needed. See text.

In cases where the unknown negative has no obviously suitable area for spot evaluation (e.g. an unrecognizable technical subject) it might be better to return to an integrated reading. It can be seen that objects like this, and artwork, paintings etc, should be photographed with a grey scale propped up alongside. Provided this *receives the same lighting* it will help enormously to assess accuracy at the colour printing stage.

Making 'on easel' readings. The most generally adopted method of assessing colour negatives for printing is to use a colour analyser which measures from the actual image projected onto the enlarging easel. For this you need the sort of equipment shown in Fig. 14.14. The probe part contains a light sensitive cell behind a small spot-reading aperture. (Often the cell is housed in the main body of the instrument, fed from the probe by a fibre optic 'light pipe'.) A swing-over diffuser device converts the probe head to integrated reading, for which it is held up against the enlarger lens. The probe carries a selector knob with a choice of blue, green, red, and 'no filter', just in front of the measuring area; this also switches the cell output to different circuits inside the main instrument.

The analyser first has to be programmed for the known, standard negative. Typically this is done as follows: You set up the negative and its required filter settings in the enlarger, sharply focus the image, stop down and position the probe to receive light from the area chosen for reference. Selecting the blue measuring filter the attenuator knob marked 'Y' is turned until the needle on the instrument's illuminated meter scale moves to zero. This procedure is repeated for the green and red measurements, turning the M and C knobs. Using the no-filter selection on the probe the 'Time' attenuator is turned until the meter reads the number of seconds given when the standard negative was printed. Now the analyser is programmed and these controls should not be altered again unless the paper batch, enlarging lamp or brand of negative is changed.

The unknown negative can next be set up in the enlarger instead of the master negatives. The probe is appropriately positioned, switched to blue assessment and the value needed for yellow filtering read directly off the meter scale. A similar routine is followed to find M and C readings. You now adjust the enlarger lamphouse filters to comply with these values (remembering to eliminate neutral density). Results can be checked again if necessary – the analyser should now read all three filter settings as zero. Finally switch to no-filter and read off the number of seconds exposure required from the time scale of the meter.

The great advantage of on-easel analyser readings is that filters, lamp and lens characteristics for the particular enlarger are all taken into account along with the negative itself.

'Off-easel' readings. Whereas on-easel reading methods assume you have one analyser per enlarger, it may be cheaper and more convenient with several enlargers to have one instrument to service them all. One skilled member of staff can then pre-assess all negatives, mark them up with filter settings, and pass them on for printing. Usually this is handled with a colour densitometer (Fig. 12.1), or a special off-easel analyser. Both must of course contain their own strictly controlled light source.

One of the disadvantages of off-easel working is that differences between enlargers

(equipment factors) are not taken into account. Some instruments include memory circuits which can be pre-programmed with each enlarger's characteristics along with paper batch information.

Other instrumentation. Various other versions of colour negative assessment equipment are made for large scale users. To take a simple example, it is relatively easy to link an on-easel probe to motorised or solenoid controlled colour-head filters (or three coloured lamps which dim or brighten). Measuring then automatically alters filtering, without any further action by the user.

The video analyser is an interesting (although expensive) instrument, which is likely to become increasingly important. This is a consol unit with a closed-circuit colour TV system designed for off-easel use. When a colour negative is inserted it is shown as a *colour positive* on a TV monitor. By turning controls similar to the colour controls on a domestic set image appearance is altered until just the required colour balance and density is produced. The controls then show the exact filtration required on the enlarger.

Comparing methods of colour negative assessment

Table 14.4 opposite summarises the various methods so far discussed. The main points to remember are these:
 (1) Trial-and-error methods are usually costly in terms of wasted materials, and are also time consuming. This system is not really a commercial proposition unless your colour negatives are very similar in subject and lighting. It is more practical for the amateur working with minimum equipment, and with few worries about time.
 (2) Off easel instrument evaluation methods allow professional printing to be so organized that evaluation of negatives takes place outside the darkroom— one technician serving a number of printing staff with filtering information. It also makes maximum use of costly densitometric instruments.
 (3) On easel photometer methods allow each printing cubicle to be self-contained. The time to produce each print may be longer, but this arrangement works well when only one or two printers are employed.
 (4) Intelligently used, spot reading of colour negatives gives a higher proportion of successes than overall evaluation. However it takes slightly longer, requires some skill, and may not be possible when the negative subject is unfamiliar to the printer, or contains no suitable measurement area.
 (5) Negative evaluation based on integrated reading can be fully automated. It is therefore commonly used in automatic colour printing machines used for commercial photo-finishing. For the price charged, time does not allow individual spot grading. The results are usually quite acceptable if the subject had a more-or-less even distribution of tints and luminosities, but is otherwise prone to *subject failure*.
 (6) Finally, even the most elaborate evaluation systems cannot guarantee the best print each time. The more subjective the nature of the picture the more difficult it is for instruments to state what filtration will give the most visually effective results. This is where the man who first conceived the picture should

274

TABLE 14.4

'WHITE-LIGHT' COLOUR PRINTING

```
                    ┌──────────────────────┴──────────────────────┐
           Non-instrument evaluation                      Instrument evaluation
```

Non-instrument evaluation

Trial and Error
Slow, but requires minimum financial outlay. Suitable amateurs.

Filter Mosaic
Contact printed filter patches give more test information per exposure.

Spot
Unknown neg should have some reference area comparable with master neg.

Whole negative
(Integration to grey)
Less skill required—can be automated. No specific reference area necessary. Risk of subject failure.

Visual densitometer
Cheaper outlay, but slower then electronic.

Electronic densitometer
More accurate than visual instrument. General purpose densitometer fitted with filters quite suitable.

Instrument evaluation

Off-easel
One instrument serves several enlargers. Neg. colour balance only—equipment factors must be considered.

On-easel
Evaluation handled by enlarger operator, making each cubicle self-contained. Assesses printing exposure.

Spot
Most frequently used owing to accuracy. High sensitivity instrument required.

Whole negative
(Integration to grey)
No specific reference area necessary. Risk of 'subject failure'. Can be fully automated (e.g., in printing machines.)

Video analyzer
Highly accurate. Shows visual appearance at different filtrations. Extremely expensive.

either do the printing or at least be on hand to advise the printer what result he had in mind. If a colour negative has crossed curves (page 211) even the most accurate evaluation method can only give a compromise filtration. If a local mid-tone area measurement was made then this may receive correct filtration, but shadows and highlights may each have colour casts in opposite directions.

Colour printing from positive transparencies

An alternative to shooting and printing colour negatives is to work from colour transparencies. After all, this way should achieve the best of several worlds–a transparency is produced, which is still the preferred form of colour image for mechanical reproduction; this is also a high quality projectable slide; the film image is easy to assess visually for colour balance, subject expression etc; and finally the print on paper allows some measure of colour or density manipulation.

The disadvantages are principally poorer final quality (after all, you are working from a much more contrasty image that is also unmasked). The reversal materials needed are also more expensive and some are more complicated to expose and process than neg/pos paper. However, these problems grow less as pos/pos printing materials are improved. Provided the original transparency is not overexposed and is fairly low in contrast, (or has been contrast masked) excellent results are possible. There is a choice of two types of paper–the dye destruction type such as Cibachrome, and the chromogenic type such as Ektachrome or Agfachrome paper. Both were described on page 188.

Exposure and filtration for pos/pos printing. Because you are using reversal material all the usual filtering and exposure controls work in reverse. The greater the exposure the *lighter* the print, and to remove a colour cast you remove filters of the *same* colour from the enlarger. These and similar differences are summarised in Table 14.5. White borders are something of a problem, because the normal masking easel gives a black surround on reversal paper. Prints either need trimming flush, or edges require fogging to the filtered enlarger light while a sheet of black card covers

TABLE 14.5

COMPARISON OF CONTROLS IN COLOUR PRINTING

Required effect on final print:	When using neg/pos printing materials	When using pos/pos printing materials
Lighter image	Reduce exposure or (locally) shade	Increase exposure or (locally) print-in
Darker image	Increase exposure or (locally) print-in	Reduce exposure or (locally) shade
White borders	Cover paper edges with easel masks	Fog paper edges
Less blue	Reduce Y, or increase M + C	Reduce M + C, or increase Y
Less green	Reduce M, or increase Y + C	Reduce Y + C, or increase M
Less red	Reduce C, or increase Y + M	Reduce Y + M, or increase C
Less yellow	Reduce M + C, or increase Y	Reduce Y, or increase M + C
Less magenta	Reduce Y + C, or increase M	Reduce M, or increase Y + C
Less cyan	Reduce Y + M, or increase C	Reduce C, or increase Y + M

the image area. Be particularly careful to clean debris from the transparency before printing–this reproduces black in the final print, which is very difficult to retouch out.

Exposure is made by either white light or additive methods, using the same filters as for neg/pos printing. In general bigger changes of filtration or exposure have to be made to give perceptible alterations in the print. This extra latitude is because the material is very low contrast, to help compensate for the transparency characteristics. Colour analysers designed for colour negative assessment are not suitable for pos/pos printing unless measuring filters can be changed to complementary hues. The processing stages needed for these colour printing materials appear on page 181.

Miscellaneous colour printing techniques

The 'ring around'. In order to get used to judging colour prints it is very helpful to make a whole set of small prints off one negative at different filter settings. For example, having made the best possible print off our standard negative others might be made (a) with less and more exposure (b) with filter changes of 10, 20, 30 to each of the yellow, magenta and cyan filters (c) with similar but combined changes of $Y+M$ ($=R$), $M+C$ ($=B$) and $Y+C$ ($=G$) filters. In (b) and (c) corrected exposure should be given for each print. The resulting 21 prints can then be mounted up on a card, with the accurate print in the centre and others radiated from it in increasing order of filtration. This is known as a 'ring-around'.

Making a ring-around not only tests your ability to produce a controlled set of prints, but by labelling each one with the filter shift the chart will act as a visual comparative guide. You can refer to the chart when deciding whether another image has a cast which is, say, red or magenta and if this ought to be corrected by a 10, 15 or 20 filter shift. Ring around charts are also useful when discussing print improvements with clients.

Contact prints. Contact prints can be made from colour negatives on black and white or colour paper in the normal way. For black and white prints use normal or soft-grade paper and be prepared to give 2–3 times the exposure needed for average monochrome negatives. Strictly panchromatic paper (page 161) should be used if tone values are to be correct, but this is often too inconvenient to bother with for contact work.

For colour contact prints set up one of the negatives enlarged to 8×10 and analyse it for filtration. Then remove this negative and use the patch of light to contact print the entire film on one sheet of colour paper. A similar system can be used to contact print colour slides onto dye destruction or reversal colour paper. Generally it is possible to just lay these out on the paper, still in their (cardboard) mounts–provided that the lens is sufficiently distant and its aperture well stopped down, the point source effect should give sharp images.

Photograms, sandwich printing. All the possibilities of shadow cast images direct onto the paper are now extended to include colours. Objects can be removed part way during exposure and filtration changed to form different coloured silhouettes. Black-and-white negatives can be printed, shading back over chosen areas, then printed in again at another filter setting. See Plates C35–6

Solarisation or posterisation can be carried out using light of different colours

277

when fogging, or when printing from line separations. Colour transparencies can be sandwiched together to give strange surrealistic effects, then enlarged direct onto pos/pos paper. Photographs and lettering can be combined this way too.

Print film transparencies. Remember that colour negatives can be enlarged, contact printed, or reduction printed onto print film. This can then form a large display transparency, or a projection slide. Exposure, filtering and general handling methods are similar to neg/pos printing on paper, and processing is carried out in solutions made up from paper processing kit chemicals.

Note on reciprocity failure. Colour papers and print film suffer from reciprocity failure, becoming slower with long exposures to dim images (e.g. dense negatives or transparencies, or great image enlargement). Sometimes, if exposure time is increased to compensate this, the contrast of one or more colour layers changes and gives a colour cast. The best way to avoid trouble is to try to keep all exposure times within about 10–30 seconds by altering the enlarging lens aperture.

TABLE 14.6

TYPICAL COLOUR PAPER PROCESSING SEQUENCE

Temp. Tolerance	Neg/pos paper (31°C, 88°F)	Example sequences Dye-destruct (24°C, 75°F) ±1·5°C throughout	Rev. paper (30°C, 86°F)	Principle Effect on Emulsion Layers
±0·3°C			1 First Dev	B & W silver neg formed
		1 First Dev		B & W silver neg formed
±0·3°C			2 Stop Bath	
±1°C			3 Wash	
±0·3°C	1 Col Dev			Latent image developed to B & W silver neg, oxidation products couple to form dyes.
±0·3°C			4 Re-Exp & Col Dev	Fogs and converts remaining silver halides
			Lights on	to black silver, dyes couple as above.
±1°C		2 Dye Bleach	5 Wash	Bleaches silver and adjacent dye (p. 187)
±1°C	2 Bleach/Fix			Bleaches silver image
±0·3°C			6 Bleach/Fix	Bleaches all silver
		3 Fix		Bleached by-products made soluble.
±1°C	3 Wash		7 Wash	
		4 Wash		
±0·3°C	4 Stabilize		8 Stabilize	Improves permanance of dyes.
±1°C			9 Rinse	
Time to end of last wet stage:	8 mins	12 mins	24 mins	

Processing colour prints

Today virtually all colour printing papers are made with a plastic coated base, designed for fast, relatively high temperature processing. Table 14.6 shows the narrow temperature tolerances at the most critical stages (dye destruction materials alone allow room for error). Conventional dish processing as used for monochrome work is not practical for consistant quality professional colour printing. Chemicals easily become contaminated, the large surface area of the solutions hastens oxidation, and temperatures are difficult to maintain with sufficient accuracy. Various equipment and machinery more suitable for print processing include print drums, deep tank hand lines, various types of rotary discard machine, and bench top or larger capacity floor standing roller-transport machines.

Print drum. As shown in Fig. 14.15, this is essentially a light tight drum into which the exposed print is curved and fitted, emulsion facing inwards. Once the ends are in place all further stages can take place in white light. The drum revolves horizontally in a bath of temperature controlled water, driven by a small motor. Small measured amounts of each processing chemical are poured through a light trap into the drum interior, where it rapidly spreads over the surface of the print. At the end of each stage the drum is lifted from its cradle and the solution discarded.

Drums are efficient and trouble-free for small numbers of prints. See also the large size drum unit in Fig. 14.16. All processes can be handled this way.

Fig. 14.15. Low cost colour print processing equipment. 1. Daylight print-processing drum, in temperature-controlled water bath. (C) Stock solutions of the three chemicals. (D) Dispensers each holding enough chemical for one print. (F) Feed-in funnel. (M) Motor drive. 2. Removing processed print from drum. 3. Plastic or stainless steel 'basket' for processing prints in a hand line of 16 litre tanks.

Fig. 14.16. Some colour print processing machines. 1. Continuous feed machine. Rolls of exposed prints feed off spools (F). Dip-rods (D) carrying rollers at their bottom ends maintain each paper loop near the bottom of tanks. Processor is used in conjunction with roll-paper holder for enlarger baseboard (L). 2. Drum type hand processor. Drum revolves rapidly in trough (T) drawing up a film of solution to the emulsion-down print, held stationary on the drum by a nylon net. Water inside drum maintains temperature, and trough tilts to discard solution. 3. Manual drum discard machine for large single prints. Pre-measured solution (S) held in electrically heated water-bath is poured down light-tight funnel in drum (D). As drum is swung to horizontal the solution enters drum, and motorised rollers (M) engage. 4. Automatic roller-transport machine which fits within darkroom sink. 5. Larger capacity roller-transport machine built through darkroom wall. R. Chemical reservoirs. P. Exposed colour print. H. Heated fans fur automatic print drying.

280

Deep tank hand line. The same water-jacketed bench unit with gas burst agitation used for colour film processing, Fig. 14.2, can be used for prints too. Instead of the racks for spirals and film hangers, print baskets (Fig. 14.15) or spring-loaded print hangers are needed. These are shifted manually from tank to tank.

Hand lines allow batches of 10 to 15 prints at a time to be processed, but to make big prints a large set of tanks are needed, with corresponding investment in chemicals. Hand lines can be set up for all print processes.

Drum discard machine. Again this is the all-purpose machine shown in Fig. 14.2 but fitted with a drum designed for prints. The paper is attached to the outer surface of the drum, emulsion outwards, and rotates through a shallow trough of chemical in the same way as film.

Large drum discard machines allow about 8 prints 8×10 in to be processed at one time. All types of process can be tackled.

Roller transport machines. These machines accept exposed prints fed in through a slot at the front, and deliver a dry processed result at the rear. Small models, using transport rollers like an elaborated form of stabilisation processor (Fig. 9.2), will fit within the darkroom sink. Built-in reservoirs inject measured amounts of chemicals into the troughs, according to the length and width of the sheet of paper passing into the machine. Large roller-transport print processors work on a similar basis to film processors of this type. Unlike drum discard machines however films and prints are not interchangeable.

All roller transport machines are programmed for one particular process, although often they can be drained down and adapted for others. Typical paper speed is 25cm/min (10inch/min), and models are made for various maximum paper widths. Provided work justifies the capital and chemical costs of these machines they are well suited to a mixed output of prints from 2 or 3 enlargers. Their ability to accept exposed sheets at any time avoids the delay, inherent with drums, of waiting for one batch of work to clear the machine before starting another.

Continuous feed deep tank machine. This processor uses fewer rollers than the type described above because it relies on a continuous strand of exposed paper which can be pulled through the various tanks and accumulates on a delivery spool. Size, replenishment arrangements and cost are otherwise very similar. This type of equipment is intended for use with photo-finishing machine printers, or conventional enlargers using a roll paper holder (Fig. 14.16) on each baseboard. Obviously really accurate instrument evaluation of exposure and filtration is necessary, as test exposures are not very practical with such a system.

Most photographic studios handling their own colour printing start off with a deep tank hand line. After all, this can be largely home-constructed to save outlay. Some form of drum discard machine is likely to be more efficient and convenient. Exact type will depend upon whether prints are mostly singles or small batches, and if full automation is justified. The larger roller transport machines really need to serve several colour enlargers to be justified.

281

Processing faults—colour prints from colour negatives

The usual method of checking the quality of colour print processing is to put through a print from the master negative, and compare it with a previous print from this negative, held on file. A control print can be processed every so often, either with a batch of prints or when it is suspected that something is wrong.

A number of control prints can be pre-exposed and held in stock, like process control strips for film. Storage is critical—makers usually recommend that the exposed prints are kept at room temperature for about 48 hours to stabilize the latent image. and are then stored wrapped in foil in the freezing compartment of a refrigerator. (Allow each print time to return to room temperature before processing.)

Assuming that the actual colour negative being printed is satisfactory the most usual faults in neg/pos printing arise from solution contamination, developer

TABLE 14.7

PRINT PROCESSING FAULTS

Print Appearance	Probable Cause
Darker and rather more contrasty than normal, usually coupled with a hue shift.	Over development.
Lighter and less contrasty than normal, usually with a yellow-green shift	Under development.
Colour cast, including borders	Safelight or darkroom fog.
Clearly defined pale areas	Prints touching in developer
Brown spots or patches	Prints touching in bleach/fix
Low contrast image, with stained whites	Exhausted developer
Generally muddy appearance, particularly yellows	Exhausted bleach/fix

exhaustion, and errors in time, temperature or agitation. The appearance of faults varies considerably with the process used. Table 14.7 is therefore only an approximate check list for neg/pos printing—for detailed fault checking consult the paper manufacturer.

This is a good point at which to remember once again the vital importance of organizing really consistent conditions in colour printing. Things become completely unmanageable when exposing or processing conditions vary uncontrollably between test and print, or between print batches. Even when the basic equipment is good the following points need watching:

 The age of the enlarging lamp
 Voltage of the supply
 Bleaching or colour change in printing filters
 Lens condition
 Enlarger and darkroom light leaks
 Exposure timer consistency
 Paper batch variations and storage conditions
 Duration of exposure (R.L. failure with excessive times)
 Period between exposure and processing (Latent image regression)
 Solution condition, time, temperature and agitation

Colour print finishing and display

Finishing. Spotting colour prints is similar to the spotting of black and white work. In tackling white spots, pencil, water or alcohol based dyes are stippled in until density is built up to match the surrounding area. It is almost impossible to knife out dark spots without revealing the various dye layers or leaving an ugly hole in the print surface. This is why colour negatives should be carefully checked before printing and any clear specks spotted with opaque so that they print light rather than dark.

Mounting calls for the same techniques used with all plastic coated papers. Large prints can be mounted for display with impact adhesive (such as 'Evostick') or wide double-sided adhesive tape. Most prints are dry mounted, using shellac tissue and a thermostatically controlled mounting press. Keep the temperature within 65°C–95°C and do not exceed 99°C. Colour prints can also be given a choice of surface textures using an embossing sheet such as linen or canvas with a texturising kit, again using a dry mounting press. Another way of altering the surface sheen of the mounted print is to use a print lacquer or matting spray, available in aerosols. Lacquering also helps to protect against U-V effects on the image dyes.

Method of display. A typical colour print has a luminance range of only about 20:1. Viewed under conditions where it can be directly compared with nearby coloured objects and surfaces the print may seem desaturated and flat Isolation helps to overcome this. It is helpful too if powerful illumination can be used from an angle which minimizes diffuse scatter at the print surface. For example a flush mounted colour print might be hung in a dimmed room against a dark neutral background. It is then lit by an oblique spotlight masked to give sharp cut off at the edges of the print. Given a suitable print surface the result can appear every bit as brilliant as a colour transparency–even though the same print shows the usual deficiencies when viewed in diffuse lighting conditions. Often it is not possible to show prints completely devoid of local references in this way, unless an exhibition or display area is being planned specifically for colour pictures.

The actual size of the print influences its coloured appearance. Usually a large print will appear to have more brilliant colours than a technically identical small print, viewed from the same distance. Probably this is because the image occupies a larger area within the eye's viewing angle. As the eye scans the image lateral adaptation occurs just as it would in looking at the original subject. Consequently print colours are judged against adjacent (print) colours rather than the actual colours of objects.

Another influence is the print surround, which provides a reference level of both luminosity and colour. From black and white work you know how a large white mount may relatively darken a print; a black mount gives extra relative luminosity to print highlights. Similarly strong coloured mounts make the print appear to have a complementary cast–due primarily to lateral adaptation of the eye. Medium or dark grey mounts are frequently chosen for colour prints.

How long will they last? However well processed they may be, colour photographs have a much shorter life than the black and white kind. Chromogenically formed dyes in particular are a compromise between spectral purity, permanence, appropriate chemical structure, and several other factors. The dyes are less 'fast' than many

fabric dyes, and will fade in time. Their life will be very short indeed if exposed to direct sunlight or other strong sources rich in ultra violet. Colour prints displayed in estate agents' windows are only too often reminders of how bleaching causes deterioration into yellow deficient or even pale cyan images. Print lacquers and even framing behind glass helps to prolong image life. Despite this protection, if prints are to be on display, every effort must be made to keep them out of sunlight or strong diffuse daylight.

The longest life expectancy quoted for colour images is 25 years (in dark, refrigerated conditions), but precise life must vary considerably type to type and according to local conditions of storage. For long life, colour prints can be stored in albums consisting of transparent plastic envelopes. These should be kept under the same fume-free conditions as recommended on page 170 for monochrome images–somewhere which is dry, cool and dark. Where permanency is of maximum importance storage in the form of monochrome separation negatives offers better possibilities than an actual dye image.

Commercial aspects of colour printing

Even today the professional photographer has to think very carefully in deciding whether or not to undertake his own colour processing and colour printing. Excellent colour laboratories exist, offering a reliable service specifically to meet his needs. Is user processing worthwhile? Several points have to be considered.

(1) Is there a sufficient regular volume of work? A steady demand for colour must exist to justify the outlay on equipment and chemicals, the necessary skilled technicians and the space which will be taken up. Top quality colour printing is a full time occupation and it may be best to employ someone exclusively for the job, provided that their salary can be justified by enough work. Similarly the most expensive solutions for a tank will slowly deteriorate even when they are lying unused. Commercial laboratories charges are based on the size and number of sheets processed. What volume of work constitutes the 'break-even' point between laboratory charges and user processing costs?

(2) A smaller user-processing darkroom is less likely to have the quality control facilities of a good commercial laboratory. Having smaller volume and less automated equipment there is more risk of the user getting process-to-process variations in results.

(3) Colour printing by the photographer's own staff means that he can most easily retain complete control over the final print. This is particularly important in subjective work where the photographer was aiming for a particular mood, which may involve distortion; also in highly technical illustrations where as far as possible the print must match certain important colours in the original subject.

(4) The photographer with his own colour darkroom may more easily experiment with new visual images–co-ordinating camerawork and various possibilities such as masking and manipulated processing and printing.

(5) With processing facilities on the spot results may be seen more quickly. This is particularly valid if the nearest reliable laboratory is in another town and the material has to be posted each way.

284

Each photographer therefore has to make up his own mind which is the best way to organize his colour processing. One answer may lie in forming a 'co-operative' between several local photographers specializing in different fields, to share the costs of colour printing facilities. This is only an extension of the system by which photographic partners may share the same premises and secretarial staff.

The better colour laboratories try to give as personal a service as possible. Arrangements enable the photographer to discuss test strips directly with the technician printing his colour negatives. Thanks to the laboratory's automated processing arrangements, when the print is finally made there is unlikely to be any variation between test and print due to processing. Several laboratories offer special services such as montage work, filmstrips, giant display transparencies, retouching and duplicating to size, and improvement of customers' underexposed or unbalanced transparencies. This work requires specialist skills and is often very costly.

When planning a colour job with a client try to establish exactly what will be needed finally – prints, transparencies for reproduction, colour slides, large display transparencies etc. Only in this way can the subject be shot on the type and size of material most likely to give optimum quality results in all the required forms.

For example, imagine that the client suddenly wants a colour print, after the job has been shot on 4 in × 5 in reversal material for reproduction. He will either have to use a reversal print, or have an interneg and colour print made (both may lose quality), or pay the high cost of an imbibition print. The client may also want black-and-white prints, which could easily have been made if black-and-white negatives had been taken at the time of shooting. But working only from a colour transparency it may well be necessary to produce a mask before a negative of satisfactory quality can be made, and the prints run off.

As new colour materials and methods are introduced the relationship between quality, cost, speed and convenience may change in terms of deciding how to tackle a job. One day perhaps all work will be shot on small colour negatives. From these every form of black-and-white and colour positive will be made, with highest quality. Alternatively, everything may be shot on colour transparencies . . . But for the time being all these materials have a place, and the photographer must keep himself up-to-date on the best way to work.

Related reading

COOTE, J. H. *Colour Prints*. Focal Press 1974.
MANNHEIM, L. A. and HANWORTH, VISCOUNT. *Spencer's Colour Photography in Practice* Focal Press 1975.
LANGFORD, M. *Professional Photography*. Focal Press 1978.
Also current technical data books by Kodak, Agfa, and Ilford Ltd.

Chapter summary—processing and printing colour

(1) Colour processing demands much stricter standards than black and white work. Inattention to the factors controlling processing easily results in veering colour balances as well as density and contrast errors. Repeatable results become impossible.

(2) Solution mixing is a responsible job. Costly chemicals, colour film and even more expensive shooting time can be completely wasted because of quite small errors in mixing chemicals.

Use pre-packed chemical kits currently marketed by the makers of the film stock – and read all the mixing instructions.

(3) Processing equipment must be suitably corrosion resistant, particularly to some of the bleaches used. For film processing we might use rollfilm tanks; a deep tank hand line (with inert gas burst injection); or automatic machines working on the basis of rotary discard, roller transport, or rack and carriage deep tank systems.

(4) Large capacity solution tanks commit us to heavier outlay on chemicals – effective precautions must be taken against contamination (spaced tanks); oxidation (floating lids); and exhaustion through use (replenishment). The most critical processing stages are first development and colour development.

(5) To check processing, control strips can be purchased or made under strictly controlled conditions. These unprocessed strips of film have been exposed to a grey scale, colour patches and a recognisable colour image. One has been processed under ideal conditions to act as a standard. Strips are included with every few batches of production film undergoing processing, and results carefully compared with the 'standard'. Care must be taken to minimise latent image changes in stored control strips awaiting processing.

(6) By making densitometer readings through red, green and blue filters, three graphs can be made from the currently processed control strip. When compared with graphs from the 'standard' strip even slight variations may be seen – indicating what changes are occurring in the solutions.

(7) The effective speed rating of some reversal colour films can be uprated by increasing first development time. Results vary with make, but may allow a x4 uprating. Side effects include weak empty shadows and colour balance shift. To a more limited extent overexposed films can be 'held back' in first development. Do not use either technique with colour negatives.

(8) A colour negative processed accidentally as a black and white negative may be reconstituted as a colour negative. The silver image is first rehalogenized, then fogged and processed in the normal colour negative sequence.

(9) For grain effects use a fast, hydro-carbon anchored dye colour film, uprated and given increased first development. Keep the image small on the negative, use a good enlarging lens and a point light source.

(10) Aftertreatment of transparencies includes weak filters or dye transfer dye images which can be bound up with the image; dye locally applied by hand; also chemicals which reduce one or more image dye layers. Chemical reduction is risky, and not always permanent.

(11) Aftertreatment of colour negatives includes pencilling, blocking out etc., using complementary colours to retouch coloured blemishes. Fill in pinholes etc., as black spots cannot easily be erased from the print.

(12) A neg/pos route to a colour photograph is more flexible than direct reversal materials. Image size, density and colour balance can all be manipulated. The essential equipment comprises a light-tight enlarger with appropriate light source, also a set of filters or colour printing head, voltage stabiliser and timer. As with processing film, temperature controlled water jacket and rinses are essential, plus a system of agitation.

(13) Colour printing paper may have its three emulsion layers in an order placing the heavier cyan image on top. Colour sensitivity is 'keyed' to the same maker's colour negative material. Contrast grades and surfaces are much more limited than black and white papers. Different types are made for neg/pos printing, and pos/pos printing by dye destruction and colour development methods. Each box of paper is stamped with relative filter and speed adjustment figures.
Colour paper should be stored with the same care as colour film.

(14) The colour balance of a print from a colour negative is controlled by manipulating the exposing light using *white light* or *triple exposure* methods. When white light printing a colour cast in the print is reduced by increasing the filter colour matching the unwanted

286

cast, and reprinting. Filters are coded with figures representing colour and density. Two filters remain permanently in use – a U-V absorber in the filter drawer, and an I-R absorber near the lamp. When dialling-in or making up filter packs look out for and eliminate neutral density. Filtration has to be modified when changing batches of paper (see box) or printing negatives in another enlarger (equipment factors).

(15) In triple exposure printing part exposure is given through each of three narrow cut primary coloured gelatin filters – usually located over the lens. Colour balance is controlled by altering the exposure ratios. To reduce a cast increase exposure through the matching filter or decrease exposure through the complementary filter. An I-R absorbing filter remains located in the lamphouse. Exposure ratios again have to be modified when changing paper batches or enlargers.

(16) White light printing requires a heavier outlay on filters or a colour head than triple exposure methods, but shading and printing-in are possible, and prints can be exposed faster.

(17) In its simplest form, estimation of exposure and filtration may be on trial and error basis, viewing tests and guessing filtration largely on experience. It is more efficient to use a colour analyser and a 'master negative' (for which filtration is known). Any unknown negative for printing can be compared and its filtration and exposure measured. The master negative should be prepared on the same type of film as the production negatives, and carry an image which includes neutral areas.

(18) Colour negative assessment can be by 'spot' or overall (integrated) measurement, using an analyser 'on easel' or a densitometer 'off easel'. One off easel densitometer can feed several enlargers.

(19) On easel evaluation requires a sensitive photometer to measure the projected image in terms of red, green and blue – measuring either a local reference area or scrambled light, based on integration to grey. The instrument is first calibrated by reading the projected master negative. This method of evaluation makes each enlarger self-contained.

(20) Colour enlargers with dial-in dichroic filters give continuously variable filtration. These may be controlled directly by the evaluating instrument, using servometers or solenoids. A video analyser allows filtration to be established *visually*, without making test prints.

(21) Even the most elaborate negative evaluation equipment cannot give the best print every time. The more subjective the picture the more likely we shall have to use the instrument reading as a first test guide only.

(22) With experience, shading and printing-in can take place through different gelatin filters to adjust colour balance locally. When printing transparencies onto reversal paper the normal rules of shading, printing-in, and filtering to remove casts are all reversed.

(23) Making a *ring around* set of prints at slightly different filtrations forms your own colour reference guide, gives excellent printing practice.

(24) Print processing is not really practical in dishes. Prints suspended in baskets or hangers can be processed in deep tank hand lines, or handled in print drums, rotary discard machines, or various forms of roller transport processors. Large-scale users of roll paper operate deep tank continuous feed machines.

(25) When using prints from a master negative to check processing quality, ensure that each print has received the same post-exposure storage treatment. The usual processing faults are contamination, developer exhaustion and errors in temperature, timing and agitation.

(26) In displaying finished colour prints try to isolate the image from coloured surroundings, illuminate with fairly high intensity oblique light, and make the print large relative to the viewing distance. Avoid exposure to direct U-V rich sources. Store in dry, cool, dark conditions.

(27) When deciding whether to undertake your own colour processing and printing, balance the services offered by a reliable commercial laboratory against the volume of work anticipated. Working on the premises gives quick results, allows maximum control of results by the photographer. But is the capital outlay and employment of a skilled colour

printer justified?

(28) When planning a colour job find out from the client all the forms of final result he will need – reproduction transparency, print, filmstrip, display transparency, black and white prints, etc. The shot can then be taken on materials which will yield the highest quality in each form, instead of compromising afterwards.

Questions

(1) A general practice photographic studio has decided to undertake its own colour processing (transparencies and negatives, rollfilms and 4 in × 5 in) and colour printing (up to 10 in × 12 in). Existing darkrooms, previously used for black-and-white work to these sizes, are to be converted for colour exclusively. List the facilities and equipment which will be required, including the modification of existing black and white arrangements and the purchase of new items.

(2) It is often said that the real skill in colour printing lies in assessing correct filtration. List the various ways in which the necessary white light filtration of an unknown negative can be established.

(3) A 16 in × 20 in rear-illuminated transparency in colour is required for a window display. List the methods of producing such a transparency and compare them in terms of cost, permanence, and effectiveness.

(4) What is a 'master' or 'standard' colour negative? Suggest three ways in which a master negative could be useful when colour printing.

(5) Describe the likely appearance of neg/pos colour prints which have been submitted to:

> Slight white light fog.
> Overdevelopment.
> Underdevelopment.
> Developer contamination.
> Excessive magenta filtration.
> Long duration reciprocity failure.

(6) A client requires twenty still-life studio shots for catalogue illustrations. One colour transparency, one colour print and two black and white prints are required from each shot. Describe two alternative methods of fulfilling this order in terms of materials. Explain what factors might make you choose one method against the other.

(7) (a) What is required of a professional enlarger so that it is suitable for making colour prints from colour negatives by the 'white light' method?

(b) Complete the following (codes refer to Kodak CP filters):

Present Filter Pack	Colour Cast Produced with Present Filter Pack	Next Filter Pack
30Y 20M	05Y	
10Y	05M 10C	
15Y 55M	05G	

(8) Write a short essay on quality control in colour processing and printing.

(9) Briefly describe all the ways you know of intentionally modifying a colour image during the stages of processing and colour printing.

(10) In neg/pos colour printing explain the differences between each of the following:

(a) 'White light' and 'triple exposure' (additive) methods of filtering.

(b) 'On easel' and 'off easel' methods of negative evaluation.

288

(c) 'Spot' and 'integrated' methods of image measurement.

(11) Densitometers intended for use with colour transparencies or colour negatives are equipped with colour filters. What is the function of these filters? Make a list of ways in which a colour densitometer or analyzer can help the working photographer.

(12) Explain the following terms, applied to colour processing and printing:

> Gas burst agitation.
> Process control strips.
> Integration to grey.
> Subject failure.
> Ring around prints.

(13) Is user processing of transparencies and prints justified? Write an essay comparing processing on the premises with the use of a commercial laboratory, relative to the field of photography you hope to enter.

(14) Explain in detail how you would prepare one 35 mm film strip on colour stock from a miscellany of material composed of colour transparencies, colour negatives, black and white prints and original art work.

(15) The colour printing department of a commercial studio uses a standard negative which has, as a reference area, a neutral grey test card.

 (a) Describe how a colour densitometer may be used to determine the filtration required to print another negative which has a similar reference area.

 (b) Given the following data determine the filter densities required to print the second negative:

	Density measured by		
	B	G	R
		filters	
Densities of grey card in the standard negative ..	1·10	0·87	0·68
Filter densities used with standard negative	0·70	0·45	—
Densities of grey card in second negative	0·87	0·74	0·93

(16) Explain, with the aid of diagrams, the principle of a dye destruction process by which colour prints may be made direct from transparencies. Discuss the advantages and disadvantages of this process as compared with neg/pos processes.

Section IV

PHOTOGRAPHS INTO PRINT

15. GRAPHIC REPRODUCTION

A high percentage of professional photographs do not just end at the finished print or transparency. They provide the platemaker and printer with originals to be turned into a final inked print on the page of a newspaper, brochure, magazine or book; on a poster, on a package, and in thousands of other forms. It is these mechanically printed graphic images which are seen by the thousands–even millions –of the general public.

Were it not for graphic reproduction methods the demand for photographs would be drastically limited to markets such as family portraiture and weddings, and illustration work for media with small enough numbers off to make the use of actual prints an economic proposition. Books profusely illustrated with photographs (particularly colour) would be highly expensive, and almost as exceptional as *The Pencil of Nature* was in Talbot's day.

Thanks to modern technology, photographic originals can now be reproduced by graphic methods which give exceptionally fine quality. (Sometimes results are less acceptable, but this is often due to poor originals or lack of craftmanship rather than the potential of today's printing processes.)

Largely because of the reproduction quality now obtainable, photography is the most heavily used form of illustration. In the fields of editorial and advertising illustration alone the photographer has largely ousted the traditional artist-illustrator. Where would today's highly paid fashion and advertising photographers be without the means of publicising their work offered by graphic reproduction?

But by the same token the process of photography itself is much used to convert the photographer's finished product into a mechanically printed image. Taken still further, photography can provide the means of setting the text as well as the pictures. The subject of photography's role in graphic reproduction is enough to fill several books. This chapter looks at the basics of the principal processes used to reproduce photographs in print–both from the point of view of how photography helps to make the process function, and ways in which each process reproduces photographs. This is bound to bring up the qualities you should aim for in producing photographs intended for reproduction.

Principal photomechanical reproduction methods

Early illustrations for mechanical printing took the form of woodcuts–drawings on blocks of hardwood which were then hand-carved to form a raised printing surface. Today, metal is used instead of wood in order to stand up to wear in high speed printing presses. Photography is used to do the drawing. Instead of slow, highly skilled (therefore expensive) hand carving, acids and mechanical engraving tools are used to shape the metal surface. Hence the combination of photographic and mechanical processes is called *photo-mechanical reproduction*.

The three principal photo-mechanical methods used to reproduce photographs (black-and-white or colour) each demand different ways of preparing the metal surface, use different printing machines and apply ink to paper in entirely different

ways. Each method has certain advantages for particular work.

(1) *Letterpress* or typographic printing uses raised areas of metal to carry the ink. It can be compared to the metal characters on a typewriter.

(2) *Lithography*, which is a form of planographic printing, is printed from a flat surface. Parts of this surface are made to retain a thin skin of ink whilst other areas repel ink (e.g. printing areas are made greasy, the rest of the surface is made damp, and a greasy ink is applied which then remains in the printing areas only).

(3) *Photogravure*, which uses hollows etched into the metal and filled with a thin ink. Surplus ink is removed from the top metal surface, so that absorbent paper pressed in contact draws ink from the etched hollows. Photogravure is one of several intaglio methods of printing; hand etching is another.

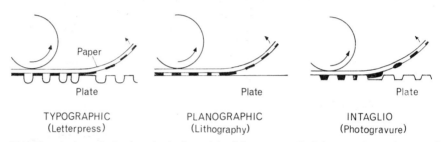

| TYPOGRAPHIC | PLANOGRAPHIC | INTAGLIO |
| (Letterpress) | (Lithography) | (Photogravure) |

Fig. 15.1. Three basic methods of mechanically applying ink to paper—all of them can be used to reproduce photographs.

Letterpress (photo-engraving)

Letterpress is a versatile, workhorse of a process, traditionally used for newspapers, books, brochures and jobbing work by local printers. Text type may be set up by hand, but is now mainly by machine. For example, operating the keyboard of a *linotype* machine aligns hollow moulds (matrices) representing each character into a whole line of type, then casts the line in hot metal to form a slug of raised metal ready for printing. Alternatively the keyboard punches paper tape feeding to a *monotype* machine, causing characters to be cast individually, and organised into lines and columns. Illustrations are produced in different ways, according to whether a *line* or *half tone* result is required.

Line blocks. The original (which may be artwork or a line copy photograph, or a photograph converted to solid black and clear white) is placed under glass in front of a process camera. This is a large copy camera equipped with process lens. To avoid vibration it is often supported, together with the copyboard, on rails. The copy is illuminated by arc, tungsten halogen or pulsed xenon light sources. The process camera views the original via a prism, giving a laterally reversed image.

First a high contrast line negative is made on a lith (described as *litho* in the graphic arts world) type emulsion, see Fig. 15.2. The image must be exactly the same size as the required final illustration. Next the printing metal is prepared. A thin zinc or zinc/ magnesium plate is coated with a light sensitive dichromated colloid. (Alternatively photo-polymer, etc.) It is then dried in the dark, or under orange safelighting.

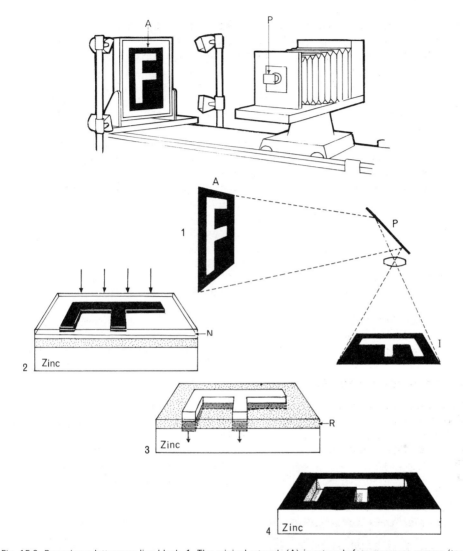

Fig. 15.2. Preparing a letterpress line block. 1. The original artwork (A) is set up before a process camera (top drawing) and imaged via a prism (P). 2. A high contrast final-size negative (N) is contact printed onto a light sensitive layer coated on zinc. 3. Processing removes the sensitive layer where shielded by the negative image. The remainder is fused into an acid resist (R) so that when placed in an acid bath unprotected zinc is etched away. 4. Finally the image-etched plate is cleaned, mounted up, and inked ready for printing. The resulting print on paper will reproduce the artwork.

The line negative is now contact printed onto the metal. The printing light source is normally a powerful arc, causing the unprotected areas of the sensitive coating to become insoluble.

Following exposure the plate is lightly inked, and the soluble areas of coating dissolved away in water (the presence of ink gives a visible positive image). After

drying again bitumen is dusted over the image and fused into an acid resistant layer over the remaining coated areas only.

Next the unprotected areas of the zinc are etched by nitric acid. The aim is to give a downward etch which does not at the same time eat sideways and so undermine thin lines. A process known as *powderless etching* does this automatically. Once the unwanted printing areas are etched to sufficient depth the plate is washed and dried. (Very large areas which are to print white may have been hand painted with resist and will now be routed by a milling machine, saving time in etching.)

Finally the zinc is nailed to a block of hardwood to take it up to the same printing height as the text typeface. Hence the terms *line block* and *blockmaking*. When inked, the unetched and therefore raised parts of the zinc transfer a line image to the paper in the same way as the typeface. Note that by using a prism when copying the original, the final block itself is wrong reading—and gives a right reading image when printed on to paper.

A recent innovation is the photopolymer wrap-around plate. This plastic plate is placed under the negative and exposed to an intense light source, which makes the unprotected surface areas harden (polymerize). The other parts of the surface which remain unpolymerized are washed away by a warm alkaline spray, leaving a relief printing image on a flexible plastic sheet, ready for fast rotary printing.

Black-and-white half-tone blocks. A letterpress block will either print ink or no ink, but cannot physically put down ink in *varying densities* to give a range of greys. This creates problems when reproducing a continuous tone range monochrome photograph—a method has first to be devised to convert the original's intermediate greys to a form calling for solid black and clean white only.

Now you know that the eye has limited resolving power. A number of small, closely positioned black dots is seen as solid grey tone. The larger the area of the dots (relative to the white) the darker the grey appears. This principle is applied in your normal print spotting. In blockmaking a *screen* is used to convert grey tones to dots of light varying in size according to the densities of the original.

Think of it in this way: the original photograph is set up in front of a process camera fitted with a prism. It is imaged at the exact size required for final reproduction.

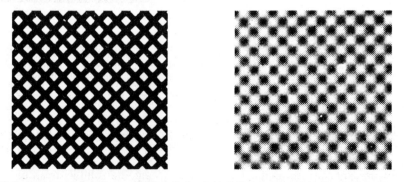

Fig. 15.3. Process screens (greatly magnified). Left: A ruled half-tone screen, used in the process camera spaced away from the emulsion. Right: The more commonly used vignetted contact screen.

296

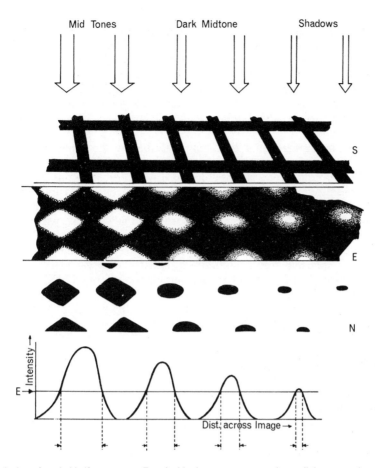

Fig. 15.4. Action of a ruled halftone screen. Top: Inside the process camera image light passes through a screen slightly separated from the emulsion (E). Owing to penumbra and diffraction effects, the screen forms vignetted 'pools' of light – the brightest pools being under highlights and the dimmest under shadow areas. When correctly exposed onto very high contrast film the resulting negative (N) shows solid black dots on a clear ground – dot *size* relating to original image *luminosity*. Bottom: The light 'pools' can be plotted as intensity against area. At exposure level E a very high contrast film will record dots at the diameters indicated.

But this time a glass screen finely ruled with sets of opaque lines running at right angles to each other, is set up very close to the emulsion surface in the camera. As the screen is just out of contact, a vignetted shadow of the grid is formed on the emulsion. Tiny 'pools' of light are formed – full illumination being achieved directly behind the *centre* of each screen aperture, tapering off to virtually nil illumination behind each line. When such an image is exposed on to high contrast lith type film the emulsion records the centre of each light pool as a solid black dot. But as the film has exceptionally high contrast the vignetted surround to the pool records as a sudden transition from black to clear film, at a particular *intensity contour*.

The exact position of the contour causing this change varies with the intensity of light reaching the screen – in shadow areas of the picture only the centre of the pool

297

records, but in highlight areas the pool of light is bright enough for it to record on the film almost out to the parts under the screen lines. Different luminosities on the original have therefore been converted to black dots of varying *size* on the screened negative (see figure 15.4).

In practice using a critically positioned conventional screen is now rather old fashioned. The process camera operator is much more likely to use a 'contact screen' – a positive film image of already vignetted dots, placed in face contact with the emulsion (Fig. 15.3, right half).

Magenta contact screens offer the facility of altering the contrast of the picture reproduction if exposure is made through an appropriate tinted filter. However a contact screen containing neutral grey dots is a must for obtaining direct half-tone negatives from coloured originals, as the magenta screen would interfere with the colour separation. In all cases the overall aim is to produce a screened negative in which the light tones of the original record as large squarish white dots joined at their corners, yet dark tones just record as very tiny dots.

The screened line negative must next be printed onto the metal (Fig. 15.7). A 1/16 in copper (less-expensive zinc is sometimes used for coarse-screen work) plate is sensitized with water soluble fish glue containing ammonium dichromate. When the metal is dry the screened negative is contact printed by arc, and the exposed layer 'developed' in water to give a positive image in soluble fish glue. The glue is next fused into an acid resistant enamel by heat, and the unprotected areas of copper etched in ferric chloride. Alternatively they may be electrolytically etched – a form of reversed electro plating. Plastic printing plates, as already described, are also used extensively. These give a relief surface without etching.

When the half-tone block is coated with black ink and printed, it deposits large black areas with small white dots (giving a visual impression of very dark grey or black) graduating through large white squares joining at the corners, to small black dots (appearing as very light grey). A continuous range of apparent grey tones have been reproduced even though the block is really only depositing black and white, see Figs. 15.5 and 15.6.

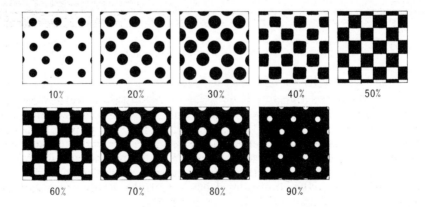

Fig. 15.5. A Continuous tone step wedge reproduced by halftone dot screen (greatly magnified). View this page from the other side of the room – each square begins to resemble a grey patch. Tones are often expressed by the percentage of black to white area . . . 10%, 20% etc.

298

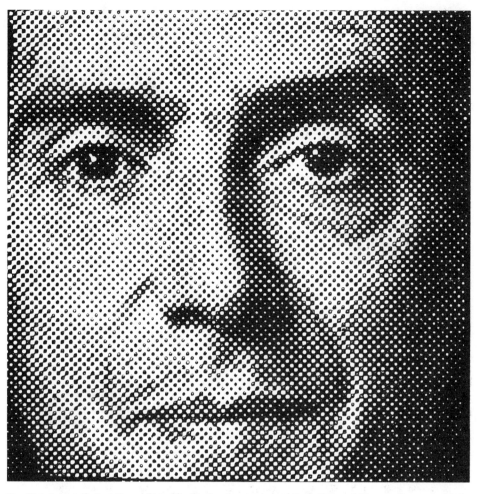

Fig. 15.6. A magnified section of Plate 13, showing the structure of the half tone dot image. Compare with the plate, which is screened at 133 lines per inch.

Examine the half-tone illustrations in this book (which are all printed on glossy surfaced art paper). Look at their dot structure under a magnifying glass. These blocks had a screen ruling of 133 lines to the inch. This gives plenty of fine detail provided that high quality art paper is used. If you were printing on cheaper paper such as this page, or on newsprint which is even more absorbent, such fine ink dots would smudge and run together, thus destroying tone separation. Coarser screen rulings (e.g. 65 lines) are therefore more satisfactory for letterpress newspapers even though some fine detail may suffer. See also Plates 29–38.

Very occasionally a screen pattern other than the usual rectangular grid is needed, for special visual effects. Contact screens are made offering parallel lines, wavy lines,

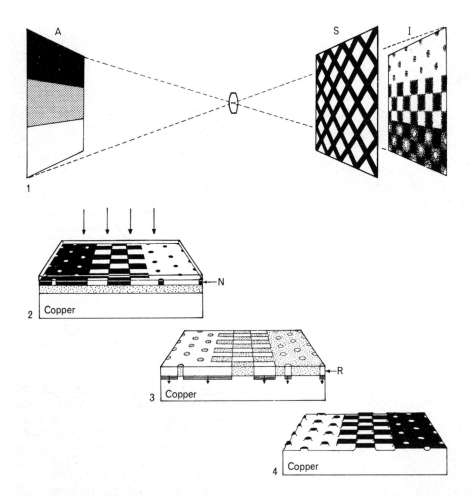

Fig. 15.7. Preparing a letterpress metal half-tone block. 1. The continuous tone photograph (A) is imaged by the process camera (prism not shown here) through a ruled glass (or contact type) screen to form a dot image (I). 2. A high contrast negative of this image is contact printed onto a light sensitive layer on metal, normally copper. 3. After processing, the exposed parts of the sensitive layer are fused to form an acid resist. Acid etches the metal in unprotected areas. 4. After cleaning and inking, the block will print as black and white only, but seen from a great distance relative to dot size, it appears to reproduce greys as well.

target circles, irregular grain and texture patterns. Most of these are rather assertive and tend to dominate the image being reproduced.

Newspapers and similar publications are printed on high speed rotary presses, therefore type matter and blocks must take the form of cylindrical printing rollers. If metal blocks have been used as intermediates a plastic or reinforced paper mould must be formed under hydraulic pressure from the flat metal. This matrix takes on all the dot detail of the half-tone blocks as well as the text characters. The matrix is then curved cylindrically, face in, and lead-tin alloy poured over it to form curved plates ready for mounting on the cylinder.

Duplicates of text and blocks made by casting in a molten material from a matrix are known as stereotypes or *stereos*. Alternatively a material such as copper can be electroplated direct onto the matrix, forming a metal shell which is then backed up to form the printing surface. This form of duplicate is known as an *electro*. Stereos and electros in flat or curved form are used for a variety of applications – for example, complete advertisements distributed free by a manufacturer to retailers for insertion in local papers or for other printed publicity purposes.

It is also possible to make flat or curved half-tone letterpress blocks direct from the original photograph by electronic engraving. A tiny light beam and photocell scan the original photograph line by line, transmitting reflection signals to a stylus synchronously moving over a metal plate. The cone shaped stylus actually cuts each individual dot hole, to a depth (and therefore size) determined by the reflectance of the part of the print being scanned. A modulated laser beam can be used in a similar way. Electronic engraving machines are extremely expensive, but work quickly and cut out many photo-engraving stages. All the monochrome half-tone blocks for this book were electronically engraved.

Colour half-tone blocks. To reproduce colour by letterpress you basically require one half-tone block from each of a set of screened red, green and blue separation negatives. Each block is inked appropriately in either cyan, magenta or yellow (in graphic art work these ink colours are termed blue, red and yellow), and printed one at a time in register onto the paper. (The screens have to be rotated between making each of the negatives, to reduce dot overlap and minimize the pattern effects produced by superimposing screen patterns, Fig. 15.8, and Fig. 10.5.)

Unfortunately printing inks, like the dyes formed in colour photography, fall short of basic spectral requirements. Colours are degraded – particularly olive-green and purples. Deep tones lack body and may show colour casts. Image masking and hand etching of the plates are common practice to help overcome these deficiencies. It is also usual to print from *four* blocks, the fourth being black, in order to give body to the shadows and cover colour casts in these areas. Techniques vary, but the black printer is often prepared from a separation made through a *yellow* filter or from part exposures made with each of a primary filter set. In any case black is required to print the accompanying text. Photo-mechanical colour reproduction is therefore often referred to as *four-colour reproduction*. (In the case of high

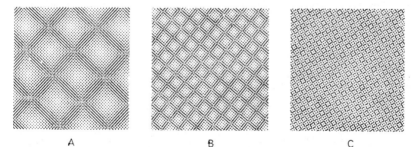

A B C

Fig. 15.8. Superimposing halftone screens. Screens superimposed at the wrong angles create a variety of strong 'moire' effects (A & B). Least effect is achieved when screens are at 30° to each other (C) giving the characteristic rosette patterns seen in four colour halftone images. (See also Colour Fig. 10.5(a) and Plate 38).

quality art reproductions many more than four colours may be used. Up to a point, the greater the number of separations and final blocks, the better fidelity of reproduction.)

Look closely at a four colour half-tone illustration–under a strong magnifying glass you can just make out the regular pattern of cyan, magenta, yellow and black dots, the largest relative dot size setting the dominant colour for the area. (It is an interesting point that the adjacent colour dots give an *additive* synthesis, whilst at the same time the random overlap of different coloured dots acts as a *subtractive* synthesis of original subject colours.) The four inks used to print colour differ appreciably from the dyes used in colour photography; for technical reasons they also differ in detail between letterpress, lithography and gravure printing.

Random dot superimpositions, the effect of the black printer, ink deficiencies, and the half-tone process itself all contribute to the need for dot etching by hand and masking (both local and overall). Masking the separations to achieve these corrections is highly skilled work. (Basic principles of masking separation negatives for colour corrections were discussed on page 218.) Electronic masking is also possible using a colour scanner.

Fig. 15.9. A cylinder type colour scanner. The colour transparency original is wrapped around a transparent section of the cylinder and scanned by a white light impulse system comprising lamp, shutter and an internal mirror (M). The illuminated spot on the transparency is measured by three filtered photocells, their signals providing the input to a computer. Here feedback circuits inter-relate the signals to give automatic masking, and generate a black printer signal. The computer reads out separate signals to lamps L_1. L_2 etc, which expose four sheets of film in unison. As exposure proceeds the cylinder slowly rotates and moves horizontally relative to the mirror–like an early phonograph machine. Scanning the whole transparency may take an hour.

Electronic scanners use a small moving beam of white light to scan the original (usually a colour transparency) converting the image into signals picked up by three appropriately filtered photocells. At the other end of the scanner each photocell signal is translated back into a fluctuating light source travelling across a sheet of continuous tone film and exposing it in tandem with the transparency (Fig. 15.9). Thus the transparency is converted into simultaneous separations ready for screening and printing down. Scanners will also work from colour prints, and colour negatives.

As the link between the pickup cells and their related exposing heads is *electronic* it is possible to cause the output of one cell to modify the signal sent to another

302

cell's exposing head. For example, a weak positive signal from the green cell is applied to the negative signal passing from the blue cell to its exposing head, thereby improving the blue record of magentas. In similar ways the black printer separation is generated out of the three colour signals, and exposed on a fourth sheet of film. All necessary colour and contrast masking is carried out with a computer automatically handling the calculations.

Use is made here of the CIE system (pages 198 and 333). Chromaticity co-ordinates of the tiny part of the original being scanned are related by the computer to the co-ordinates of the overlapping colours produced on paper by the inks, and each separation altered to finally give the appropriate dot size.

Some colour scanners work from uncorrected monochrome separations to give corrected separations. Others link up with a laser or stylus engraving machine to cut screened half-tone printing plates direct from a transparency or uncorrected separations. A scanner can produce a four-colour set of corrected negatives or positives from a transparency within minutes. The results may not be quite as good as the *best* that can be achieved by hand etching, but these machines do offer speed and a standardized level of quality in a field where tolerances are slight.

Needless to say, electronic colour scanners are very expensive and tend to be owned by magazine publishing houses and other regular users of colour blocks. Often original transparencies are first duplicated to the required size, laid out in spreads covering several pages and then scanned as one composite transparency.

Photolithography

Lithography itself originated at the end of the eighteenth century. Traditionally it called for a block of limestone (a porous rock) on which a design was made in a substance which accepted greasy ink. The absorbent block was then damped, and a greasy ink applied which only remained on the image areas–whereupon paper could be squeegeed over the surface to pull off prints.

Fig. 15.10. Lithographic printing. 1. The grease attractive image on the plate (greatly exaggerated). 2. Application of moisture from the damping roller. 3. Greasy ink application. Ink is rejected in moist non-image areas. 4. Transfer to paper. Lower right: Offset rotary lithographic printing. A: Cylinder carrying lith plate or foil, in contact with damping and inking rollers. B: Rubber offset roller. C: Impression cylinder.

303

More modern lithography uses thin grained metal sheets or foils. The grained metal has pores which retain moisture when wetted in the same way as the original limestone. The image (text, line work, and screened half-tones) is all formed photographically in a material which has an afinity for grease.

The image on a litho plate is therefore virtually flat. On the printing press the thin litho plate is wrapped around the outside of a cylinder. Here it first comes into contact with a damping roller, then a greasy ink roller and finally a large rubber roller which transfers the ink from the plate onto the paper. Almost all photolitho printing is handled *offset* by this rubber roller, so that the litho plate never comes into actual contact with the paper itself. (Strictly this should be called *offset photolithography*.) The advantages of offsetting are that a very wide range of surfaces–card, tin, wood as well as papers–can be printed upon at speed, without damage to the plate.

The basic sequence of stages in making offset photolitho plates is often as follows (variations will be discussed later).

(1) Original material is photographed on litho film to final size. (No prism is used on the process camera, as the final image is to be offset printed and must therefore be *right reading* on the image roller.) There is no question of preparing blocks for physical insertion amongst metal type face. A final size negative of text must be made along with line illustrations. Half-tone illustrations are prepared by copying continuous tone photographs to final size, using a suitably fine ruled screen (usually a contact screen) over the lith film to form the dots.

(2) The negatives, or combined negatives, of the pages are contact printed by high intensity light source onto a thin flexible aluminium foil called a *plate*. This has a sensitized surface of dichromated colloid, e.g. dichromated albumen.

(3) The colloid protected from light under the dark parts of the negative remains unhardened and can be washed away. The hardened colloid accepts greasy ink but is water repellent. As the plate is thin and flexible it can immediately be wrapped around a cylinder ready for the printing run.

This is by no means the only sequence. Many offset lithography plates today are prepared from film *positives*. Text and line diagram negatives, and continuous tone negatives are all printed onto litho film–the contact screen being used at this stage to convert the continuous tone illustrations to dot half-tones. The positives are contact printed onto sensitized thin plates or foils and 'developed' to leave a negative image in hardened colloid. In this case the unprotected metal is very lightly etched to make it water repellent and greasy ink attractive, and the hardened colloid scrubbed off. When inked up the plate delivers a positive image. Ironically this form of foil preparation is known as *deep etching*.

Deep etched litho plates stand up to longer runs than the albumenized plates (the latter give about 50,000 impressions). Other, even tougher, litho plates work on a *bi-metal* basis. A water receptive lower metal such as stainless steel is covered by a grease ink receptive top metal such as copper, which may be penetrated by very light etching.

Four-colour reproduction by lithography is usually handled on deep etch or bimetal plates. Once again contrast and colour masking of separations may take place manually or via the same type of electronic scanner described for letterpress. The scanner produces matched film negatives or positives as required. Choice of screen ruling again depends upon paper quality, and screen angles must once more

be varied for each colour. All colour illustrations and figures in this book are printed by four colour photolithography, on art paper inserts.

Unlike photo-engraving there is virtually no scope for corrections by hand-etching the litho plates themselves. Colour and tone corrections are made by locally reducing dot size on screened positives, using hypo-ferricyanide.

Great changes have taken place in photolithography during recent years. New types of plates, litho inks and printing machines (particularly *web offset*) have opened up important new fields such as newspapers and periodicals.

Litho plates are quick and efficient to produce, and can be hardwearing. But one of their disadvantages in the past has been the need to prepare photo-negatives or positives of *text* as well as illustrations. For office-type printing the text can be typewritten on an electric typewriter and photographed, or typed direct onto special paper plates. But for more important work text is prepared by the process known as filmsetting.

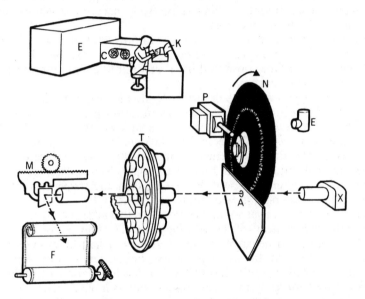

Fig. 15.11. Schemic diagram of one form of filmsetting machine. N. Negative matrix, spinning continuously E: Excitor lamp. P: Photoelectric cell activated by the excitor lamp and able to sense the exact orientation of the disc. When the wanted character is passing aperture A the cell fires microflash (X), projecting a 'frozen' image through a preselected lens in turret (T). This lens projects parallel light to moving lens and mirror unit (M) which images the character on photographic film or paper F. The unit moves horizontally like a typewriter carriage. To change *size* of character the lens turret is turned, bringing into use a lens of a different focal length. To change type style aperture A is moved vertically, until it coincides with another ring of characters. Top left: A complete system might consist of keyboard unit (K), computer and tape readout (C), and exposing unit (E).

Filmsetting. Machines have now been designed to produce photographic film negatives (or positives) of text automatically, under the command of a keyboard similar to a typewriter. They are known as filmsetting or photocomposing machines. Instead of using a keyboard to align metal matrices, then injecting molten metal to form type as in linotype letterpress work, each letter on the keyboard causes an image of the appropriate character to be exposed onto high contrast film. After keyboarding

305

the text, the exposed film is taken out of the machine and processed, whereupon it is all ready for printing down onto the plate, using normal lithographic techniques.

Filmsetting machines vary greatly in their internal arrangements. One filmsetter for example uses a 20 cm (8 in) diameter glass disc carrying photographic negative alphabets and numerals in each of sixteen letter styles. The disc, which looks something like an extended play gramophone record, rotates continuously at several revs per second. A very short duration electronic flash behind the disc illuminates only the character preselected by the keyboard, projecting a 'frozen' image through a lens and onto litho film (Fig. 15.11). By just changing lenses (twelve lenses of differing focal lengths are mounted on a turret) a wide range of type sizes can be imaged. In fact just one disc can give over 17,000 characters.

Between the keyboard and this exposing device a computer accepts text information line-by-line and *justifies* it (i.e. works out inter-letter and inter-word spacing needed to make each line the same length). The text and spacing information is then passed onto the exposing section, controlling respectively negative selection and lateral movement of the film between exposures.

Filmsetters can expose characters far more rapidly than the fastest compositor can type. This, and the cost of the equipment, makes it most practical to run the machine from punched tape – produced by several photo compositors each working separate keyboard tape punches.

Filmsetting can be speeded up still further by doing away with the master photographic negative and substituting a cathode ray tube on which the required character can be *generated electronically*. A computer memorizes the necessary signals for each character in many styles of type, feeding the signal to the tube when commanded by punched tape. The character generated momentarily on the face of the tube is then imaged optically onto the film. Filmsetters using electronic generation work off punched tape at a phenomenal speed. Rates of 750 characters per second or a complete full size newspaper page in two minutes are possible!

After exposure, the high contrast film is processed to a negative or reversal positive, according to the requirements of the printing plate. The film can be cut and joined, so that camera produced negatives of line drawings or half-tones may be inserted appropriately into the text. In newspaper work photosetters usually expose directly onto rapid developing paper, which is then roller develop/stabilized. Within seconds the columns of text are ready to be cut and laid out as a page. Black rectangles are left for the illustrations and the complete page goes in front of the process camera. Half-tone illustrations are later mounted in the rectangular 'holes' prior to printing down.

Applications of photolithography. The modern techniques and materials that have breathed new life into lithography make it an attractive proposition for books. (The text and line drawings on these pages are printed litho, all text being filmset. You can see the high quality produced by checking these words through a magnifying glass.) Once an edition is printed the plates may be cleaned off and used for some other purpose. Only the film positives (or negatives) need be retained, taking up very little space. When a reprint is required these positives are simply printed onto plates again. If it is to be a new edition minor alterations and additions are newly filmset – and may be inserted via scissors and tape into the existing positive. It is no

longer necessary to wrap up capital in bulky and heavy letterpress type stored between printings, or alternatively pay for costly recasting at each reprint.

Lithography now competes strongly with letterpress for newspapers. Papers can greatly streamline their production, and improve quality of half-tone illustrations, yet editors can still make alterations to news stories edition-to-edition with the same convenience as pulling out blocks and columns of letterpress type. This is why new newspapers in particular (uncommitted in terms of existing letterpress plant) opt for offset photolithography coupled with photosetting.

Colour television and other factors are pressurising newspapers to 'go colour' and any publishing house looking to the future knows that it is possible to produce magazines and newspapers in colour much more economically and rapidly using lithography on modern web offset presses. Such a press is built up from several offset lithography machines, lined up to print on one continuous roll (or 'web') of paper. As the paper passes from press to press it is printed on both sides simultaneously, receiving two, three or four colour images in succession and in exact register. The line-up is quite a technological feat, bearing in mind paper stretch and shrinkage, and the speed of paper travel.

Photolithography is physically better able to cope with large reproductions than the more clumsy letterpress blocks or expensive gravure cylinders. It is often used for posters and maps, also greeting cards, calendars and cheaper forms of art reproductions. At the other end of the scale, the photolithography process is simple enough to use for duplicating work where runs of only a few thousand are needed from each master. Instruction books, reports and many of the internal printing requirements of a large firm can be printed on small office type offset machines. Presensitized litho foil or paper masters can be purchased – many being based on the diazo process. Some of these materials can be exposed to an optical image under an enlarger. Another alternative is to type text direct on special litho stencils, using an electric typewriter. The paper stencil goes straight onto the machine as a master. Office document copying machines too provide an extremely valuable link in the chain of reproduction. These machines can be used to copy drawings etc. together with well typed text, and then transfer the image onto a litho master.

Self-screening ('autoscreen') film. It is possible to copy continuous tone illustrations on an ordinary plate camera and, by using autoscreen film, produce a screened half-tone image direct. The film carries a high contrast lith emulsion which is given a slight fogging exposure behind a fine (133 lines per inch) contact screen during manufacture. The exposure through this vignetted screen is strictly controlled so that it hypersensitizes the emulsion *locally*. Behind the centre of each aperture in the screen the emulsion receives most fog and therefore gains most in speed. This gain in sensitivity tapers off until we reach the area of emulsion behind each line – emulsion here has been unaffected by light and remains at its original speed (see Fig. 15.12).

In the camera this contrasty film is given a level of exposure which records the image in the hypersensitized parts of the emulsion only – the highlight parts of the image recording as the largest dots, whilst the shadows affect only the very fastest emulsion areas and just record as the smallest dots. The result is a screened half-tone ready for printing down.

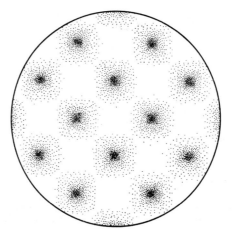

Fig. 15.12. The principle of autoscreen film. A greatly enlarged area of emulsion showing the local speed boosting effect of fogging behind a halftone screen during manufacture. Darkest tone in the diagram denotes maximum hypersensitivity, therefore maximum speed. Lighter shading denotes areas where fogging tails off, giving less sensitivity boost. Other areas which have not received any fogging remain at their original (slow) speed. Given correct exposure by the user this high contrast emulsion will record shadow luminosities only in the small, 'bullseye' fastest areas. Brighter luminosities will also affect the less sensitive areas. Thus tones record direct as dots of various sizes.

Self-screening film is more expensive than normal lith film owing to the extra manufacturing stage. Exposure level is also critical if the best dot structure is to be achieved. Against this, process camera equipment and know-how is unnecessary, and there is no need to purchase actual screens (which are expensive).

Photogravure

Photogravure, which dates from about 1895, is unique in several ways. It reproduces continuous tones by depositing ink from minute wells ('cells') of varying *depths* – unlike letterpress and lithography which rely on an optical illusion created by dots of varying *sizes*. Plate preparation is much more expensive and time consuming than the other processes described. But once prepared, a gravure cylinder can print off literally millions of impressions at high speed.

The basic process (Fig. 15.13) is as follows:

(1) Text and line drawings are prism-reversed and photographed to final size on lith-type film. From this a high contrast *positive* transparency is prepared. Continuous tone illustrations are also prism copied to size, this time on continuous tone film, and prepared as continuous tone positives (i.e. unscreened). Thus a large composite positive transparency of text, line and continuous tone illustrations covering several pages is built up. All the components of the composite must lie within a specified density range, so that the whole transparency can subsequently be printed with one exposure.

(2) Next a negative image must be prepared which is to act as an etching resist for a metal printing cylinder. Pigmented gelatin on a paper or polyester support is light-sensitized in potassium dichromate. Dried in the dark it is given two separate

308

contact exposures using an intense light source. (*a*) Behind a 'sharp' screen consisting of clear lines on a black ground. The lines are about one-third the width of the squares, about 175 lines to the inch. This therefore produces a 'sharp' fine grid of fogged lines over the sensitized gelatin. (*b*) Behind the composite positive transparency.

(3) The exposed pigmented gelatin is now carefully transferred to the surface of a copper cylinder, several metres long. Here the gelatin unhardened by exposure is washed away in hot water leaving a negative image in hardened gelatin. (Special silver halide emulsions on film may be used to make the negative instead of the dichromated gelatin. Following exposure this emulsion is processed in a tanning

Fig. 15.13. Preparing a photogravure cylinder. 1. Light sensitive material (L) on temporary support (T) is fogged behind a gravure screen. 2. It is next exposed behind a positive photographic image, carrying text and continuous tone pictures (usually many pages). 3. The light sensitive material is transferred to the surface of a copper cylinder, and unexposed (unhardened) areas washed away. 4. After the etching stages. Ferric chloride has bitten into the copper as determined by the image resist. 5. Cells are filled with thin ink, the surplus then removed by doctor blade, and the cylinder is ready to meet the printing paper. Note how fogged areas act as 'piers' for the doctor blade—particularly important in large shadow zones.

309

developer rather like dye transfer matrix, then transferred to the cylinder, stripped from its film base, and washed to remove unhardened areas.)

(4) The gelatin relief image on the cylinder is now made to form a resist to the ferric chloride used to etch the copper. The cylinder is given a set period of time in a series of etching baths of decreasing strength. The metal unprotected by resist begins etching at once; the thinnest parts of the resist delay the start of etching, whilst the heavily resisted areas are not given time to etch at all. Thus cylinder surface is etched to varying depths representing the densities of a positive image. The fine grid lines are now seen to act as 'piers' (Fig. 15.13) over the whole etched surface–they maintain the honeycomb or cell structure in shadow areas which would otherwise be etched out as a large depression in the metal.

(5) The etched gravure cylinder is mounted on the press, and flooded with a thin ink. A 'doctor blade' rather like a sqeegee passess tightly over the metal surface removing all surplus ink–the only ink remaining lies in the cells. The cylinder now comes into contact with the paper, which has sufficient absorbency to draw the ink from the cells. This paper therefore receives densities appropriate to the cell depths in each area of the image. The slight 'spread' of thin ink in absorbent paper is enough to hide the screen grid, particularly in the darker areas. Shadows have a 'solid', rich density.

Gravure cylinders take time and skill to prepare. Adjustments and corrections have to be handled by retouching and altering the density ranges of negatives and positives prior to printing down. This applies particularly to the sets of four cylinders used for four-colour reproduction. After etching, the cylinder is often hard chromed for extra durability.

Rotary photogravure is often used for very long runs in printing packaging, periodicals (such as British women's magazines and week-end newspaper supplements) and also very high quality reproductions of photographs. In the first two examples initial production costs are more than offset by the fact that over one and a half million copies can easily be printed off one four-colour set of cylinders, at 60,000 per hour. Gravure gives acceptable reproduction on quite cheap paper–and on print runs of a million or so the slightest saving per roll on paper amounts to a large sum. On the other hand, given really high quality paper (and preferably a sheet-feed press) gravure by its very nature can given an outstanding quality reproduction, with a fine deep warmth of colour in shadows and a pure limpid clarity in light tones. Its superlative reproduction of colour photographs is often claimed to be better than any other process.

Photo-silkscreens

As the name implies, this is rather different to the three principal processes so far discussed. Instead of metal the process uses a fine screen mesh (usually made of nylon) stretched tightly over a wooden frame. The screen is placed in contact with the receiving material (normally paper) and thick ink squeegeed hard through the mesh. By blocking out parts of the screen with some form of stencil a pattern or image can be printed.

To make a silk screen stencil photographically there are 3 stages:

(1) A continuous tone bromide print is copied either onto autoscreen film, or

310

through a contact screen onto line film.

(2) This half-tone negative is enlarged up to the final required size and printed onto a large sheet of line film.

(3) The processed film positive is contact printed onto light-sensitive stencil film. Unprotected areas become hardened, and after being 'developed' in hot water and transferred to the underside of the mesh the stencil film provides the means of blocking the passage of the ink. Ink therefore only penetrates through the still open dot areas, forming a half-tone reproduction on the paper.

Only screen rulings of about 60 lines or less per inch are really suitable, or the thick tacky ink fails to pass through the mesh. Consequently half-tone reproductions are rather coarse, and fine detail lost. The process is low cost in equipment and materials, and excellent for short run posters and other work using broad simple designs. It will print onto a whole range of materials with curved or flat surfaces.

Summarising the three principal processes

Letterpress: Popular for general purpose short and medium run printing, book illustration and (in rotary form) traditionally used for newspapers. Text is composed and cast separately from the line and half-tone blocks. Blocks are therefore movable and can be reused in other locations. Stereos or electros can be made of complete pages.

Sized line negatives of the illustrations are first made through a prism process camera, interposing a screen if the originals are continuous tone. When reproducing in colour four separation screened half-tones negatives (red, green, and blue filters, plus yellow or combinations of the other three for the black printer) are required. Negatives are contact printed down onto sensitised metal.

'Wash off' processing follows and the remaining light hardened material is used to form an acid resist. After etching and cleaning, the printing surface is left as raised metal areas, e.g. half-tone dots. These areas receive an even application of a thick ink which they then transfer to the paper. Four separate plates are sequence printed in register to reproduce colour photographs. Electronic engraving controlled from a scanning head speeds up blockmaking, but fine etching by hand is usually still necessary.

Excellent monochrome and colour half-tone reproduction is possible if printed on high quality paper. The process is particularly suitable for reproducing crisp 'commercial' subject matter—and least successful with diffused, soft focus high key images. Note how dots tend to deform and help retain fine image detail (Fig. 15.6).

Photolithography: Used (offset) for printing on a variety of surfaces, for printing books, journals, posters and modern newspapers; also miscellaneous office printing runs of a few thousand off. Text is formed on the same plate as the illustration—it must be filmset, or set letterpress or typed and then photographed as if a line illustration. An enlarger or process camera (no prism) is used to make line or screened half-tone film negatives to the required final size. (Some litho plates require film positives.)

The thin aluminium litho plate takes various forms . . . albumenized, presensitized, deep etch, bi-metal and plastic types. The principle remains the same in all—to cause printing areas to accept greasy ink and non-printing areas to accept water, so

311

repelling the ink. Four or more impressions from separate plates are needed for full colour reproduction.

Thanks to modern lithographic plates, inks and presses (e.g. web offset) this process can give excellent reproduction of monochrome and colour photographs, although shadows tend to lack the maximum black possible with the other two processes used on optimum quality papers. (In monochrome work a second litho plate, carrying ink in shadow areas only, can be used to strengthen blacks.) Litho allows the printing of much larger images than letterpress blocks. Plates can be prepared quickly and inexpensively, and the simpler forms of photolithography can be printed on small office machines.

Photogravure: Almost exclusively used for print runs of hundreds of thousands or more–mass circulation magazines of the less topical kind where acceptable quality must be produced on inexpensive paper.

Text is again formed on the same surface along with the illustrations and must originate by filmsetting or letterpress. A final size positive transparency containing text, and line and unscreened continuous tone illustrations is prepared to strict densitometric specifications. A light sensitive material on a temporary support is first exposed behind a fine grid of clear lines–then exposed in contact with the prepared transparency. The material is transferred to the surface of a copper gravure cylinder, unexposed areas washed away, and the remainder used to form an acid resist.

Etching produces cells of varying depth (some versions give variable area as well) according to the location and thickness of the resist. When the cylinder is brought in contact with paper, ink filling the cells discharges to form the printed text and pictures. Four separate cylinders are used for four-colour reproduction.

Preparation of the printing surface is a relatively costly and slow operation, but millions of impressions can be printed at high speed. Working at slower speed on sheet feed high quality paper, photogravure has the reputation of giving finest quality reproduction of photographic originals.

When comparing processes you cannot be dogmatic about which gives 'best' reproduction quality. Results depend on the picture subject matter; photographic print quality; the care taken in plate preparation; the type of printing paper, and the skill of the printer. The many new processes and materials produce an often changing situation. Printers and publishers can also be biased in favour of one process rather than another.

(NB. One old process still in use is Collotype printing. This is rather like a mechanical form of dye transfer–screenless, extremely expensive and used mostly for short run fine-art reproductions. It is ideal for images with fine detail patterns which otherwise clash with screen rulings.)

Recognizing the three processes

As a photographer you should be able to recognise which of the reproduction processes described has been used for a particular publication. You can then make your own assessment of relative quality–particularly if the same (e.g. advertising) shot appears simultaneously in several publications produced in different ways. Be careful not to jump to conclusions too early when assessing quality. You may easily

TABLE 15.1

COMPARING REPRODUCTION PROCESSES

Process:	Advantages:	Disadvantages:
Letterpress	Sharpness, precision and quality of printed result, if on high quality paper. Corrections and improvements by hand etching possible	Difficult to etch large picture areas (over about 20 × 16 in)
Photolithography	Prints large picture areas with ease. Offsetting allows printing on wide range of surfaces. Plates quick and cheap to prepare	Printed images tend to have less contrast than other processes (Offsetting means ink film is 'split' twice) Corrections and alterations impossible after platemaking.
Photogravure	Gives almost continuous tone reproduction of pictures, with screen pattern largely lost. Vivid, rich colours and tones even on fairly poor paper. Capable of enormous runs.	Intricate image cylinder preparation Type matter is less clear than letterpress.
Photo silkscreen	Low cost for short runs of large pictures. Excellent depth and brillience of colour	Transfer of ink through mesh restricts halftone reproductions to coarse screens (loses fine detail.)
Collotype	Outstanding retention of detail and tone/colour values. No dot structure	Very skilled, costly process. Difficult to achieve fast production rates

compare an untypically good reproduction by one process with a poorly printed example by another which is really more suitable for that type of picture.

It is helpful to use a magnifying glass to show up the tell-tale differences between processes.

Letterpress: Viewed obliquely the paper often shows slight impression marks where the metal type has pressed into the surface. Lettering has an extremely hard outline, emphasized by a very characteristic 'ink squash' effect. The ink builds up into a dark line around the very perimeter of each printed character, often accompanied by an adjacent inner contour slightly starved of ink (see Fig. 15.14). The same effect may be visible on individual half-tone dots and along the border of a half-tone illustration and white paper, particularly where the picture content is light in tone.

Offset-litho: No suggestion of impression into the paper surface and no ink squash. Each printed character has an even distribution of ink with just a slight suggestion of mealiness. Depending upon paper characteristics, the edges of letters may be very slightly 'eaten into' owing to the lack of hard edge. The whitest highlights in half-tone illustrations can run right out into clean paper at the edges without a darkening effect at borders. Sometimes the use of filmset text can be detected by the presence of a few tiny black spots caused by pinholes. These are most noticeable in large white gaps between paragraphs and on page borders.

Photogravure: The edges of each printed character show a slight spread of ink in a 'dot pattern' (remember that with gravure the grid screen extends over all text parts of the printed page to give a bearing surface to the doctor blade). Half-tone monochrome illustrations exhibit a very fine, equal sized dot pattern in highlights and mid-tones, merging into an apparently screen-free black in the shadows, see Plate

Fig. 15.14. The magnified (×10) appearance of text reproduced by (top) Letterpress, (left) Offset litho and (right) Gravure. See also plates 26–28. Some of the macro characteristics (i.e., impression marks), have been lost, owing to reproduction here by photolithography.

28. High speed rotary gravure working on cheap paper often gives a slightly mottled appearance to the darkest areas. Highest quality gravure has a richer depth of shadow tones than either of the other two processes.

Requirements of photographs for reproduction

Monochrome reproduction. Remember that basically all graphic reproduction is copying. The monochrome photograph may go through as many as four negative or positive stages including conversion to a dot structure. If it is in colour it is also analyzed four ways and then synthesized again! Altogether it is remarkable that final results can be so acceptable.

All three processes can give first class results given good photographic originals. To get the best possible reproduction and help the graphic arts craftsman you should remember the following:

(1) In deciding the amount of fine detail to be included in the picture bear in mind the final size of reproduction and fineness of screen to be used (i.e. the type of paper). Small reproductions and/or very coarse (less than 40 lines/in) screens call for a simple treatment of composition, lighting and background when shooting the picture, see Plates 29–38. A fine screen letterpress block of reasonable size and printed on art paper will allow finest reproduction of intricate detail, particularly since the letterpress technique of fine etching by hand will be possible.

(2) Whenever practical make the size of the submitted print or transparency about 50% larger than the intended final reproduction, and always marked up scaled to the final format ratios (Fig. 15.15). Process cameras have limited reproduction ratios – excessively large or small originals may have to be handled in two stages, with possible loss of quality.

314

(3) Do not submit prints made on stipple surfaced paper. Tiny highlights from the texture can interfere with the screen pattern. Submit prints on glossy paper, glazed (but not cockled or scratched glazes). For similar reasons images with a coarse grain pattern close to final dot size and copies of already screened half-tone illustrations can create difficulties. In the latter case it might be possible to make a *dot-for-dot* same size reproduction in which the screen is made to coincide with the original dots. Dots have to be clearly defined (e.g. letterpress on art paper). At other reproduction ratios the original dot screening will create strong *moire* patterns with the new screen, Plate 38. Sometimes a screened original will reproduce by line methods.

Fig. 15.15. Cropping of the image on a transparency to suit a final reproduction format having different proportions. In this case a 4 in × 5 in transparency has to be masked off to suit a final format of 5 in × 8¼ in. Always draw a diagonal to find the new height-to-width dimensions. The same principle can be applied when marking off a camera focusing screen to suit a given layout.

(4) Continuous tone monochrome prints for all forms of reproduction should be supplied with good separation of tones. This is particularly necessary in important shadow and highlight parts of the picture. Tones must not be lost by exposing on the 'toe' or 'shoulder' of the original negative emulsion; prints must be fully developed and on white based paper, preferably glazed. The maximum print density range should be about 1·3. The ultimate test is 'could you make a successful copy from it?' Good tone separation and detail are primarily created by control of subject luminance range and accurate exposure when shooting. Fiddling about with 'hard' prints or 'soft' prints for reproduction purposes will not help when the original negative is poor. If anything err towards a print which is *slightly lacking in overall contrast* – remember that in copying contrast may be increased but seldom satisfactorily reduced.

(5) All half-tone screened images have an inherent unevenness near the middle of their characteristic curves. Mid-tone reproduction tends to 'jump' at the point where the dots begin to join at all four corners. (This is minimized in some contact screens by having elliptical shaped dots, so that dots join only at two corners at a

315

time, giving two much smaller breaks in the grey scale dot pattern.) The effect on subtle mid-tone gradation is the creation of patchiness, as if bleached in ferricyanide.

(6) It is often difficult for rotary letterpress (e.g. newspapers) to lay on sufficient ink to reproduce really rich blacks. Separation of shadow detail is therefore easily lost (with the exception of one or two quality newspapers using better newsprint). When working for rotary letterpress it is advisable to avoid very low key shots where important information is carried in the dark tones. This also applies to reproduction by photolithography. Always ensure that darker areas of the picture are not underexposed on the negative.

(7) Delicate high key images often reproduce least satisfacotrily by coarse screen letterpress–easily becoming 'dirty', due to ink squash and physical contact between the paper and inked metal dots, however small. Try to arrange matters so that large light areas are at least broken up with a few tones. When working for litho reproduction our worries are less, because litho tone control methods lend themselves well to good reproduction of light tones.

(8) Although high quality gravure is capable of giving rich blacks, the slight ink spread means that shadow tones must start out well separated. Gravure can yield excellent colour reproduction, aided by freedom from the tone 'breaks', inherent in processes using half-tone screens.

Colour reproduction. Colour transparencies are still the best possible originals for photo-mechanical reproduction. Colour prints are easily made to size, retouched, montaged and assembled to form a page layout, but they generally have poorer definition and colour saturation than transparencies. This can be aggravated by the fact that the printers' separations have to be made optically from prints, instead of by contact. Reproduction from a colour print often costs more than from a colour transparency, and there are far more electronic scanners in use for transparencies than prints.

(9) Colour transparencies for reproduction should ideally have a density range of about 2·0. This is particularly helpful if electronic scanning methods are to be used, as standardization is necessary. As in monochrome reproduction, good separation of tones is important. Particular care should be taken to avoid overexposed highlights and insufficiently illuminated shadow information. Often slight (half-stop) underexposure helps the engraver by producing fuller colour saturation in light tones.

(10) Colour negatives can be used direct for photomechanical reproduction. The characteristics of the negative will probably make contrast reduction unnecessary. As the negatives are difficult to judge visually a colour print or transparency should also be submitted for guidance.

(11) Art director, photographer, blockmaker and customer should all assess colour work under the same, standardized lighting. The colour temperature agreed by the British Standards Institute for this purpose is 5,000K.

(12) Colours such as jade greens and purples, and most subtle colours, are notoriously difficult to reproduce owing to deficiencies in colour film dyes and printing inks. Just off-white subjects are reproduced by just a few dots (or cells) carried on each of the four-colour plates. Therefore even tiny errors in etching or inking

316

each plate can create relatively huge colour shifts in various directions. The margins of what a colour scanner can detect may allow satisfactory reproduction of baked beans or tomato soup, but mushroom soup can cause trouble.

(13) The tolerances in producing and printing a good four-colour set of blocks, lithoplates or gravure cylinders are far more restricted than equivalent monochrome work. Many permutations of faults are possible, particularly in screening, etching, and inking; and there are special problems such as registration and ink drying between impressions. This explains why photo-mechanical reproduction in colour is still an expensive and somewhat lengthy process.

Further developments in printing processes

In many ways mass photo-mechanical reproduction of colour is only just starting. Newspapers in the past have rarely printed colour, largely because of the considerable delay in production. Topicality in colour calls for speed. Now filmsetters, electronic scanners, automatic engraving machines and processes such as web offset bring these two previously opposing requirements together – at a price. Scanners are very costly, but scanner centres (like computer centres) have been set up in some countries for the use of several printing houses.

Even rotary gravure printing – the slowest in terms of preparation – has received a shot in the arm from new optical-electronic equipment. Working from photographically obtained monochrome separations, electronic scanners control engraving tools or laser beams cutting each individual cell directly onto the metal cylinder surface. Many stages are therefore bypassed.

Cathode ray tube character-generating filmsetters may expose directly onto the sensitized plate, instead of onto film for later printing down. At the feed-in end of the filmsetter it is possible to computerize text, page make up, and even line and half-tone illustrations in their correct positions. A spool of tape on a computer can therefore store and, when needed, set an entire book automatically.

The technological revolution which is changing printing from foundry and metalwork to optics and electronics should not blind us to the fact that basic problems still lie with the inks used. Apart from having correct spectral content there are so many things that inks have to do – such as print rapidly, lie correctly on the surface, and last without discoloration. Printing ink manufacturers are constantly researching to improve the situation.

Other processes. This chapter has looked at the three printing processes most commonly used and most closely linked with photography. There are several other processes in use. Some – like silk screen printing – are used on a large scale for purposes such as labelling containers, printing simpler posters and making printed circuits.

Other printing processes such as Collotype are used for their quality in limited fields, whilst still others serve specialised functions such as printed circuits for electronics. Nor can we rigidly differentiate between the three main processes – most systems are becoming a bit of everything these days. Hybrids exist such as offset letterpress, and in photogravure the invert half-tone processes which give variations in dot size in addition to cell depth are in common use, particularly for colour work.

Mechanical printing is only one method of mass reproducing visual information

on paper. High speed document copying machines working off already printed originals or (much more important) micro images, link up very closely with printing. For example there may be great future demands for books to be printed in micro form. Libraries, schools, even booksellers could run off any number of readable copies needed, using their own document copying machines.

Newspapers may one day be printed in the home each morning. The paper will be delivered, not by costly and clumsy physical distribution from the printers, but from a small document reproduction machine in the hall, controlled by radio or land line from the publishers.

Related reading

CROY, P. *Graphic Design and Reproduction Techniques*. Focal Press 1972.
DAVIS, A. *Graphics—Design into Production*. Faber 1973.
CHAMBERS, ERIC. *Camera and Process Work*. Ernest Benn (London) 1971.
BURDEN, J. W. *Graphic Reproduction Photography*. Focal Press 1973.
Penrose Annual. Lund Humphries

Chapter summary—graphic reproduction

(1) The photographic process is closely integrated with modern printing. Amongst other roles it is used in setting type, and preparing line, monochrome and colour half-tone illustrations.

(2) The three main methods of photomechanical printing are *letterpress*, which is a typographic system; *lithography*, which is a form of planographic printing; and the form of intaglio printing known as *photogravure*.

(3) Letterpress uses raised areas of metal to carry ink. Illustrations are printed from 'blocks'– zinc or copper plates etched or engraved out in the non-printing areas.

(4) Letterpress line blocks are traditionally prepared by making a full size line negative and printing this on the light sensitised metal to form an acid resist. Unprotected zinc is then etched or removed electrolytically to a suitable depth, and the resist removed to form the raised printing surface. Alternatively photopolymer plastic plates are used. These do not need etching. Letterpress allows considerable control of results by hand work when preparing plates.

(5) Each continuous tone illustration for letterpress printing must be converted to a half-tone image consisting of raised metal dots of varying sizes. A line copy negative is made through a vignetted contact screen (or cross ruled screen), and contact printed on copper or plastic. Further stages are similar to line block preparation. In order to print from metal blocks on rotary presses curved stereos or electros are prepared via flexible matrices.

(6) Letterpress colour reproduction calls for cyan, magenta and yellow printing half-tone blocks from each of red, green and blue screened separations. Screens are set at slightly different angles. A fourth, black printer is normally used to strengthen shadows. Masking for contrast and colour correction (bearing in mind printing ink deficiencies) is carried out at the separation making stage. Final adjustments are possible by hand etching individual letterpress plates.

(7) Electronic engraving of letterpress blocks can provide a direct linkage between original illustration (scanned) and the metal surface (stylus or laser engraved). Many colour electronic engravers scan the original through filtered heads and produce sets of corrected film separations–masking taking place by inter-relating signals from the various heads. Electronic engraving machines are very expensive but give a standardized quality of result.

318

(8) Photolithography is based on the antipathy of water and greasy ink. Plates (thin metal foils or plastic) are prepared from line or screened half-tone negatives or positives. Text must also be in film form. Complete pages are exposed onto the plate surface which is processed to give water receptive and ink receptive areas. The inked plate is usually printed offset. Modern litho printing plates (masters) are very quick and inexpensive to prepare.

(9) Filmsetting provides justified negative or positive images of text, using a keyboard input. Characters are exposed from a master negative or from the face of a cathode ray tube, in very rapid sequence. The resulting filmset material is used for lithographic or photo-gravure plate making.

(10) Photogravure utilizes tiny cells of different depths to deposit various quantities of ink. It is therefore more a continuous tone than a half-tone process. Pages of text and illustrations are prepared as full size unscreened positive transparencies. These composites are printed down onto a sensitized temporary support already exposed to a sharp screen. The processed image is transferred to the surface of a copper cyclinder, and made to act as an acid resist. After etching the resist is removed. Recessed areas are filled with ink, the top surplus removed, and the cyclinder printed on absorbent paper. Single or four-colour gravure cylinders may also be prepared on electronic engraving machines.

(11) Photo-silkscreen is a stencil method of printing. Line or coarse half-tone positive images are printed onto tough, stencil film. This is attached to a tightly stretched mesh screen, controlling the passage of thick ink onto any chosen receiving surface.

(12) Letterpress printing gives excellent 'crisp' half-tone reproduction on quality art paper, It is used for general commercial illustration, books and journals. Rotary letterpress is traditionally used for newspapers, where mobility of text and pictures, and hard wearing properties are important. Letterpress can be identified by the slight type impression mark, its hard outline and ink squash effects.

(13) Offset photolithography is often used for printing such as posters, books, magazines, greetings cards and modern newspapers; also printing on various surfaces, and office printing. Web offset presses allow rapid printing of four-colour work on a large scale. Lithographic printing is characterized by lack of hard edge or ink squash in lettering, no impression mark, and a slight 'mealiness' in solid blacks.

(14) Photogravure is costly to prepare and is used for very long printing runs—magazines which can be acceptably printed by this process on cheap paper. Alternatively, when used on high quality paper, gravure gives exceptionally fine reproduction of photographs. It is identified by a slight 'dot pattern' spread of ink around lettering (particularly cheap paper printing); also lack of screen pattern and exceptional richness in half-tone blacks, if printed on quality paper.

(15) In general, originals for photomechanical reproduction should be of a quality which would give a good photo-copy. Simplify detail if reproduction is to be very small and/or coarse; supply work of suitable size and format ratios, printed on non stipple surfaced paper.

(16) Monochrome prints should have good separation of tones, particularly in important shadows and highlight areas. Achieve this in the original lighting and negative exposure; keep prints slightly low in contrast. Maximum print density range should be about 1·3.

(17) Colour transparencies for reproduction should ideally have a density range of 2·0. If possible avoid the use of just off-white or 'difficult' colours if their distortion would prove serious. As reproduction originals transparencies have the advantages of better definition and greater colour saturation over multilayer colour prints, even though they require more masking and are less convenient to retouch etc. Colour negatives can be used direct for colour reproduction.

(18) Colour reproduction is an expensive business—arrange matters so that all concerned in assessing proofs examine work under standardized viewing conditions.

(19) Other processes such as Collotype utilize photography. There are also many variations of letterpress, lithography and gravure. Future printing developments include increased

use of scanners, filmsetting directly onto the sensitized plate, computerized book setting and improved inks. Interesting possibilities exist in the link-up of photomechanical reproduction and document copying processes.

Questions

(1) (a) Why do continuous tone photographs (unlike line originals) have to be 'screened' and converted to half-tone images when reproduced by letterpress or lithography?

 (b) How do half-tone screens work and how does screening influence the type of monochrome photograph which will reproduce well?

(2) In the form of a table headed Process; Applications; Special Advantages; compare letterpress, photolithography and photogravure methods of reproducing photographs.

(3) Discuss the requirements of a continuous tone photographic print which will give optimum results when reproduced by letterpress printing. The discussion should include consideration of the quality of the paper which may be used for the letterpress printing.

(4) Write briefly on each of the following:
> Filmsetting
> Electronic engraving
> Magenta screens
> Photopolymer plates

(5) Explain with the aid of diagrams the basic differences between letterpress and rotary gravure printing. Give reasons for the differences you would expect to find between a newspaper reproduction, printed by letterpress, and a reproduction in a large circulation magazine printed by the gravure process, made from identical photographic prints.

(6) Explain how photography is used in each of the following processes:
> Half-tone letterpress blockmaking.
> Filmsetting.
> Silk-screen printing.

(7) Photolithography has been described as currently the most rapidly expanding method of photomechanical reproduction, although it is far from being a new process. Indicate the practical attractions of modern offset photolithography and discuss some recent developments.

APPENDIX I

OPTICAL CALCULATIONS

The following formulae relating to lenses have been selected for their practical usefulness. The general symbols used follow the usual coding adopted in European literature viz:

F = Focal length
u = distance of object from the lens (front nodal point)
v = distance of image from the lens (rear nodal point)
D = total distance between object and image, ignoring nodal separation.
O = object height
I = image height
M = magnification
H = hyperfocal distance

Focal length

$$\frac{1}{F} = \frac{1}{u} + \frac{1}{v}$$

$$F = \frac{uv}{(u+v)} = \frac{v}{(M+1)} = \frac{Mu}{(M+1)} = \frac{MD}{(M+1)^2}$$

Image and object distances, magnification

Note that when using an enlarger or projector the 'object' refers to the negative or transparency; the 'image' is that which is projected on the baseboard or screen.

$$u = \left(\frac{1}{M}+1\right)F = \frac{D}{(M+1)} = \frac{vF}{(v-F)}$$

$$v = (M+1)F = \frac{DM}{(M+1)} = \frac{uF}{(u-F)}$$

$$D = u+v = (M+1)u = \left(\frac{1}{M}+1\right)v = \frac{F(M+1)^2}{M}$$

$$M = \frac{v}{u} = \frac{I}{O} = \frac{(D-u)}{u} = \frac{v}{(D-v)} = \frac{F}{(u-F)}$$

Field covered

The diameter of field coverage demanded of a lens in order to adequately cover a negative format varies with object distance, being less when the object is close.

$$D = \frac{N}{M}$$

where D = diameter of field required
N = negative diagonal
M = magnification

Supplementary lenses

Assuming that the supplementary lens is placed very close to the main lens.

S = focal length of supplementary lens

When using a converging supplementary

$$\text{Combined focal length} = \frac{S \times F}{S + F}$$

When using a diverging supplementary

$$\text{Combined focal length} = \frac{S \times F}{S - F}$$

Depth of field

When the object distance is great relative to focal length the most simple way to calculate depth of field is to work from hyperfocal distance. This gives sufficient accuracy for most practical purposes.

f = f-number
c = diameter of circle of confusion
$$H = \text{hyperfocal distance} = \frac{F^2}{f \times c}$$

$$\text{Distance from lens to nearest part of object in focus} = \frac{Hu}{H + u}$$

$$\text{Distance from lens to farthest part of object in focus} = \frac{Hu}{H - u}$$

For greater accuracy

$$\text{Distance from lens to nearest part of object in focus} = \frac{Fu(F + cf)}{(F^2 + ucf)}$$

$$\text{Distance from lens to farthest part of object in focus} = \frac{Fu(F - cf)}{(F^2 - ucf)}$$

Miscellaneous calculations

Cos⁴ law

Illumination across the field of a lens reduces as the fourth power of the cosine of the angle made between the portion of field and the axis.

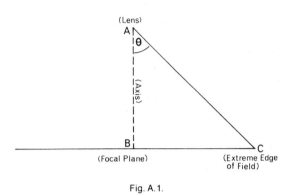

Fig. A.1.

In Fig. A.1 light fall-off at the edge of field $= \cos^4 \theta = \left(\dfrac{AB}{AC}\right)^4$

Exposure increase in close-up work

Owing to the effect of inverse square law when the lens is located much beyond one focal length from the image plane, exposure indicated by a hand meter should be multiplied by

$$\frac{v^2}{F^2} \text{ or } (M+1)^2 \text{ or } \left(\frac{u}{u-F}\right)^2$$

Alternatively f-number can be re-calibrated

Effective f-number $=$ marked f-number times $(M+1)$

(This increase becomes significant in practical colour work when subjects are less than ten focal lengths from the lens.)

POLARIZED LIGHT

The concept of light as energy using a wave-like form of travel is familiar enough. The vibrations of these waves can be considered as vibrating in all directions at right angles to the path of travel. In other words a ray travelling from this page directly towards your eye appears to vibrate in all the planes shown below (top left).

(a) (b)

Unpolarized Light

(a) (b)

Polarized Light

Fig. A.2. Linear polarization. Top: (a) Concept of an unpolarized light ray travelling from this page directly towards you. (b) An oblique view of the same ray (for simplicity only vibration in two planes is shown). Bottom: (a & b) Linearly polarized light—in this case restricted to vibrate in a vertical plane only.

Under certain conditions however light waves can be restricted to vibrate in one plane only. Such light is known as *polarised light* and the remaining plane as the *plane of polarization*. The human eye cannot normally differentiate between unpolarized and polarized light, but polarization offers the photographer some useful and spectacular visual effects.

Light may be linearly or circularly polarized. Linear polarisation offers the most scope in photography, and the information that follows applies to this form of light. (A note on circularly polarized light appears at the end of the Appendix.)

(1) Light may become polarized when reflected at certain angles from flat polished (non-metallic) surfaces such as glass, water, gloss paint, etc. The reflected rays are polarised in a plane parallel to the reflecting surface (Fig. A.3). The greatest amount of polarization occurs with light which strikes the surface at an angle of incidence whose tangent equals the refractive index of the

325

Fig. A.3. Some sources of polarized light. (A) Unpolarized light reflected from a smooth non-metallic surface is mostly polarized at certain critical angles. (B) Polarized light from a clear blue sky at 90° to the direction of sunlight. (C) Unpolarized light transmitted through a polarizing filter.

reflecting material; known as Brewster's Law. In practice this means 53° for water and about 57° for glass.

Whilst these figures represent the maximum polarization, light at other incidence angles within about 10° are also largely polarized.

(2) Light may be polarized due to scatter by very small particles such as molecules of gas, dust, etc. The most important example of this is light from a clear blue sky. Maximum polarization is found in light from blue sky at 90° to the direction of sunlight. In the Northern hemisphere this means the Western part of the sky in the morning; the Eastern sky in the afternoon; and anywhere on the horizon when the sun is directly overhead. However, even under conditions of maximum polarization a large proportion of the light remains unpolarized.

(3) Light is polarized by transmission through certain natural crystals or a man-made linear polarizing filter (or *polascreen*). The man-made filter material uses a dichroic substance (i.e. absorbs unpolarized light in all but one plane of polarisation). A typical example is quinine iodosulphate. By means of chemical and physical processes in manufacture parallel molecular chain structures are formed throughout the whole filter.

326

The action of the filter can be compared to narrow railings through which a length of rope (light) is passed. If the rope is fastened at one end, and the other end made to move up and down and side to side in all directions at right angles to the length of rope, we can simulate unpolarized light. However, of the various waveforms caused to travel along the rope by this action, only waves parallel to the railings are able to proceed beyond the railings (Fig. A.3).

Polarizing filters are marketed as acetate sheeting in various optical qualities, and also sandwiched between glass. They seem indistinguishable from grey neutral density filters. A theoretically perfect polarizing filter would halve the intensity of incident light. In practice a typical filter has a factor of x4. As the filter is colourless its factor does not vary with the colour of incident light or spectral sensitivity of the emulsion.

Methods of 'depolarizing' polarized light

Polarized light becomes depolarized when scattered. The most common way this may occur is by reflection from a matt surface or transmission through a translucent material. The degree of depolarization depends upon the thoroughness with which light is scattered. For example, the average ground glass focusing screen has a very slight depolarizing effect – whereas flashed opal glass strongly depolarizes.

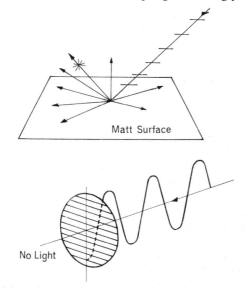

Fig. A.4. Top: Polarized light is depolarized when scattered from a matt reflective surface. Bottom: Polarized light is absorbed when it reaches a polarizing filter orientated so that its plane of polarization is at right angles to that of the light.

Example applications of linear polarizing filters

A polarizing filter will absorb light except that in one plane of polarization. Its effect on already polarized light will depend upon the relationship of the polarization planes of the filter and the light. If the two planes are parallel maximum light will

327

be transmitted; if they are at right angles vitually no light will pass (Figs. A.4 and A.6). At intermediate positions a proportion of the illumination will be transmitted. It is these features which gives polarizing filters useful photographic applications.

Use of single filters. The two main uses of a single polarizing filter are to darken blue skies, and to supress reflections.

(1) Sky darkening in colour photography. As already described, light from part of a blue sky may reach us in a polarized state. A polarizing filter can be used over the lens and rotated about its axis until it is seen to absorb the polarized portion of the light, i.e. until its plane of polarization is at right angles to that of the light. The blue of the sky is thus darkened, often to a similar extent to that given by yellow or green filter in monochrome photography. But whereas coloured filters would be impractical to use in colour photography owing to the overall cast they would give, polarizing filters are colourless.

Some cameras, such as direct vision finder types, do not allow the image to be examined through the taking lens. The filter's effect must therefore be checked, first by just looking at the subject through the filter, rotating the filter until the desired darkening occurs, and then transferring it *without any further rotation* to the camera lens.

(2) Absorbing polarized reflections from specular surfaces. Within a certain range of angles light incident on specular non-metallic surfaces is reflected as polarized light, and may be absorbed by an appropriately orientated filter. In this way some unwanted reflections from shop windows, polished floors, water etc. can be suppressed. Unfortunately in practice you are likely to find that your camera position is dictated by factors other than the angle required for maximum polarization of unwanted reflections; also that whilst some reflections are polarized others coming from other angles remain unpolarized. A polarizing filter is worth keeping in the camera case for the odd occasion when it really can help with reflections of this type.

Equally important in colour photography, a polarizing filter helps to improve the visual saturation of glossy surfaced coloured objects. The white light reflected from the top surface of, say, a car often desaturates the appearance of the colour below (page 197). If this light is at such an angle that it is polarized or partly polarized it can be absorbed by the filter. Light selectively reflected by the underlying coloured material is usually more scattered. It is thus unpolarized and unaffected by the filter.

Use of pairs of filters. Where it is possible to use two polarizing filters, the range of applications is greatly extended. For example:

(3) Light attenuation. The linear polarizing filters can be sandwiched together and rotated against each other to form a variable neutral density filter or *light valve*. Between the 90° positions of parallel and fully crossed planes of polarization a light transmission range of 200,000:1 is possible. Unfortunately the *rate* of light extinction is non-linear—most effect occurs during the last few degrees of rotation. This makes smooth 'fades' mechanically difficult to arrange.

(4) Control of all reflections. One polarizing filter over the light source and another over the camera lens allow control of reflections from both metallic and

non-metallic specular subject surfaces, at all angles of incidence. Polarized illumination specularly reflected from these surfaces is mostly unchanged in polarisation. It can therefore be fully or partly absorbed at will by an appropriately orientated filter over the lens (Fig. A.5). This will not however extinguish the entire image because diffusely reflecting areas of the subject and background depolarize the incident light and thus allow it to pass through the camera filter.

For full control a polarizing filter must be positioned in front of each lamp. In practice it may only be necessary to polarize one lamp – one which for example is

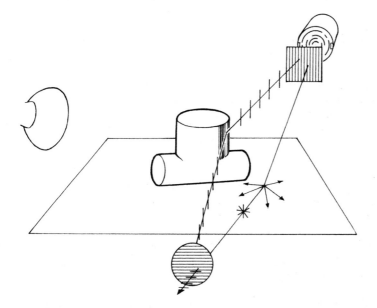

Fig. A.5. Suppression of an unwanted highlight from a metallic subject by using a polarizing filter over the offending lightsource and another (foreground) in front of the lens. Light from the spotlight reflected from the white background and matt parts of the subject is depolarized and so still passes through the camera filter.

causing an unwanted highlight but otherwise producing ideal modelling. Care must be taken to place the filter some distance from the lamp as heat can permanently damage its polarizing properties.

(5) To provide a system of viewing projected stereograms (see page 51). Each of the two projectors is fitted with a linear polarizing filter – the planes of polarization of the filters being at right angles to each other. The two images are overlapped on the screen and the audience provided with spectacles with the polarizing filters in each eyepiece at right angles to each other.

The relationship of the two pairs of filters is such that the right eye cannot see the image from the projector carrying the left hand image and vice versa. It is essential that the screen surface is metallized, and so reflects images which retain their polarization.

(6) To reveal stress patterns. Certain clear plastics exhibit the property of *birefringence* – the ability to twist the plane of polarization in polarized light.

329

Placed between two crossed polarizing filters and photographed by transmitted light such plastic appears self-illuminated against a black background.

Often the plastic shows strong bands of colour. The colour denotes areas where certain wavelengths only have been affected, and often coincides with areas where stresses have been set up. In fact it is possible to make scale models of structures such as bridges, towers, gear wheels, etc., place them under appropriately scaled loads, and photograph them in this way to locate the places where maximum strains will occur. At a less technical level interesting coloured patterns can be made with crumpled cellophane wrappings from cigarette packets, adhesive plastic tape and other birefringent oddments. See Colour Plates 37–8.

(7) To distinguish crystals in photomicrography. Different crystals, visually indistinguishable, may differ in their birefringence or ability to polarize light. By means of one filter in-between light source and specimen, and another rotated at the eyepiece, strong differences in colour and tone are apparent.

(8) To form a high speed shutter which does not use any moving parts. Certain normally non-birefringent materials have the temporary ability to rotate the plane of polarisation whilst subjected to a strong electric or magnetic field. They therefore allow light to pass through crossed polarizers *for the duration*

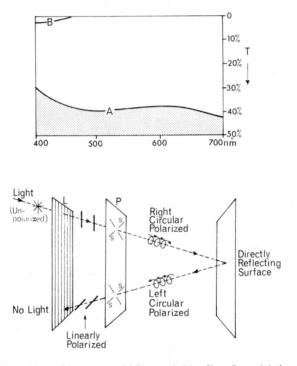

Fig. A.6. Top: Transmission curves for a commercial linear polarizing filter. Curve A is for a single filter; curve B for two of the filters with axes crossed. (Courtesy Polaroid Corp.) Bottom: Circular polarization filter. The filter is made up from a linear polarizer (L) and a $\frac{1}{4}$ wave retardation plate, (P). The latter has two axes, slow and fast. With its slow axis at 45° to the linear polarizer axis the light is given a right hand twist in one direction; a left hand twist when travelling in the other direction.

330

of the current only. For example, if a glass tank of clear nitrobenzine is positioned between two crossed polarizers no light will pass through the system. But if a powerful electric field is applied to the nitrobenzine, the polarized light passing through the tank has its plane of polarization rotated and thus passes through the second filter. The duration of light passage depends upon the time the field is applied – by discharging a pulse of electricity from a capacitor, exposure durations of 0·1 of a microsecond are easily obtainable.

The shutter described above is known as a Kerr cell. Other devices utilising non-moving devices to twist the plane of polarization between crossed polarizers include Pockels, Cotton-Mouton and Faraday shutters. Shutter speeds down to about 10^{-8} second are possible. Devices of this type are used for photographing extremely rapid events – bullets in flight, nuclear explosions etc.

Circular polarization

A circular polarizer is formed by combining a linear polarizing filter with a sheet of special birefringent material known as a *quarter wave retardation plate*. Light transmitted by the sandwich is given a 'twist' causing its plane of polarisation to form a helix (like a spiral staircase). According to the orientation of the quarterwave plate to the linear polarizer the light spirals either to the right or left. *A right handed beam cannot pass through a left handed circular polarizer and vice versa, however the filter is rotated.*

A circular polarizer forms a 'light lock' when positioned to transmit light onto a reflective surface and at the same time is used to view this surface (Fig. A.6). All light specularly reflected from the surface has its spiral laterally reversed and is therefore unable to pass again through the polarizer.

Circularly polarized filters can be used for example over the face of television tubes, internally illuminated instrument dials, etc. – where conditions of high ambient illumination (e.g. daylight) would otherwise cause light reflection which would washout the detail. Apart from some overall absorption the filter cannot affect light actually emitted from the tube or instrument face, so the displayed information appears in high contrast on a black background. Quarter wave plates are available from manufacturers of polarizing filters, such as the Polaroid Corp.

APPENDIX III

CIE INTERNATIONAL COLOUR SYSTEM

The Commission Internationale de l'Eclairage classification system for colours takes as its principle that an additive mixture of three coloured lights can be used to match all colours, including white. The three *real* primary colours usually chosen are red (0·7000 mu); green (0·5461 mu); and blue (0·4358 mu). Three coloured lights are adjusted so that equal numerical quantities of each match a particular 'white' light (equi-energy white).

Imagine that the three lights are positioned at the three corners of a triangle, shining inwards towards the centre. At each corner the light is fully saturated, becoming weaker as it spreads towards the side opposite. At the centre of the triangle all three lights, having travelled equal distances, are present in equal amounts, and so form white. At the centre of the side opposite each corner, light from this corner is at zero—these are the positions of fully saturated cyan, magenta and yellow respectively. (Note that colours along the side of the triangle between Red and Blue—mixtures of red and blue—do not in fact appear in the spectrum.)

Any point (i.e. any colour) within this equilateral triangle can be designated by co-ordinates. As shown in Fig. A.7, three co-ordinates can be quoted, but as the sum of all three always adds to 1·0 with this type of triangle, two figures only are sufficient to provide a 'fix' and therefore define a colour within the triangle.

Limitations of additive colour forming

Now unfortunately you cannot in practice match *all* spectrum hues by mixing primary coloured lights. For example the saturated blue/green found in the spectrum cannot be exactly matched anywhere in the triangle—the spectrum colour is much richer. But if you add a very little red light to our spectral colour, you can exactly match it with the best that can be obtained with the mixture of blue and green light. This is equivalent to giving the spectral colour a position *outside* the triangle—a position from which it has to be brought inwards by adding a little red light to match the best that can be formed within the triangle. As the pure spectral colour is geometrically positioned outside the triangle it is beyond the zero of the red co-ordinate and has to be quoted as a minus figure.

This situation can be compared to the problem of trying to refine a gas to match a very pure gas found in nature but not attainable by man. The match can only be made by adding impurities to the natural gas—the amount of impurity needed to do this denotes exactly how far the manufactured product falls short of its aim, and can be stated as a minus quantity for the product.

If you continue to try and match other saturated spectral colours from the mixture of coloured light we find that a large number of colours fall outside the triangle RGB. By joining all these points together we find that the colours of the spectrum fall as a curve or *locus*, coinciding of course with the corners Red, Green and Blue

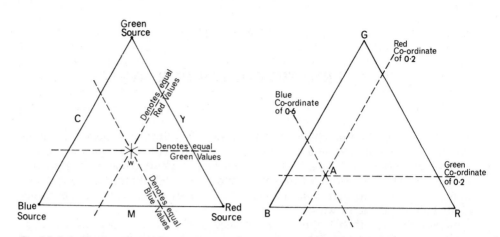

Fig. A.7. Left: Simple colour triangle formed by three primary coloured light sources. Right: Any point within the triangle (e.g. Point A) can be quoted via red, green and blue co-ordinates. As co-ordinates in this triangle always total 1.0 only two figures are really necessary.

but as several other places swinging well outside the triangle (Fig. A.8). Yellow is the only complementary colour to be closely aligned to the triangle, i.e. it is most easily simulated in practice by mixing coloured lights. You can see that cyan and greenish cyans are particularly difficult to match.

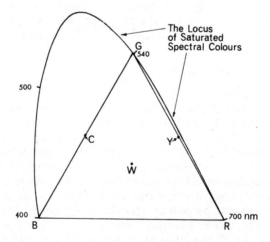

Fig. A.8. Spectral locus. Note that all positions on a straight line joining W with a point on the locus represent a colour of constant hue—its saturation increasing away from W.

Making a workable triangle

In order to avoid the inconvenience of minus co-ordinates, and to devise a triangle containing *all* spectral colours, CIE adopted three new reference primaries which have greater saturation than spectral primaries and therefore form a triangle containing the whole locus. Remember that these theoretical super-saturated primaries

334

cannot be found in nature or formed by man – they are purely geometrical positions computed from the primary colour positions, to form a usefully large triangle. To avoid confusion they are always referred to as 'stimuli' rather than primaries, and are labelled X (Red), Y (Green) and Z (Blue). Triangle XYZ contains all colours, so that it is never necessary to use negative values in quoting a colour. (Fig. A.9, left.)

Unfortunately the new triangle is not equilateral – unfortunate because, as we saw previously, any position within an equilateral triangle can be 'fixed' by quoting only two co-ordinates. However, with points X, Y and Z now clearly defined, we can draw them as the corners of a new, equilateral triangle and using them as references *redraw the R, G and B real primaries and the spectral locus inside it*. Since the outer triangle has changed its shape it is natural that the primary triangle and locus

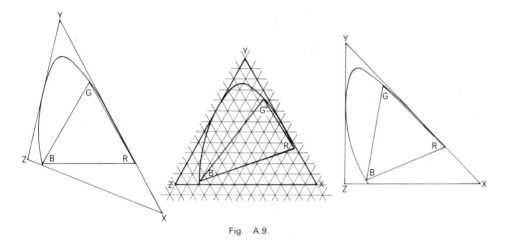

Fig. A.9.

are also changed in shape. (Fig. A.9, centre.) Thus all the relationships are maintained, but within an area where any position is easily quoted mathematically.

One small disadvantage remains. Plotting positions on an equilateral triangle entails working with triangulated graph paper. If the triangle is redrawn instead as a *right angle triangle* ordinary graph paper may be used. (Fig. A.9, right.) The side ZX forms the horizontal axis and the side ZY the vertical axis. The horizontal axis is calibrated in x co-ordinate figures and the vertical axis in y co-ordinates figures. z co-ordinates do not need to appear, as only two plots are required to locate any colour. x, y and z are known as *chromaticity co-ordinates*. These are shown in Fig. A.10.

The complete description of a colour in the CIE system comprises its position within the triangle by means of two chromaticity co-ordinates (pinning down hue and saturation), plus an expression of its luminance, e.g. in percentage luminance. The CIE committee had to specify a set colour temperature for assessing samples. Owing to different requirements for the very wide range of uses of the system it was finally decided that three alternative colour temperatures should be standardised, viz:

A tungsten lamp operated at 2854 K and shown as Standard Illuminant 'A'

335

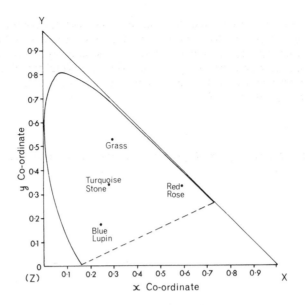

Fig. A.10. CIE Chromaticity Chart, showing the location of some sample subject colours. (See also Fig. 11.2).

Illiminant 'A' plus a (liquid) colour filter, resulting in light of 4870 K and known
 as Standard Illuminant 'B'

Illiminant 'A' but with a bluer liquid filter resulting in light of approximately
 6500 K. and known as Standard Illuminant 'C'

Hence the CIE data for a colour is always specified as relevant to measurement under one or other of the A, B or C illuminants.

The actual matching of a colour is usually carried out using a colorimeter. This instrument allows light of the colour under test to be compared alongside a patch of combined light from three projectors, each filtered to appropriate wavelengths. Each of the projectors can be varied in its relative intensity by adjustable controls. The projectors are adjusted until their combined light and the unknown sample appear visually identical in colour. Chromaticity co-ordinates can then be read from scales on the controls. Alternatively, if we happen to have the wavelength energy distribution curve of the sample (plotted when illuminated by one of the standard CIE light sources) it is possible to mathematically calculate CIE co-ordinates direct from this graph.

TABLE A.1

Subject	Chromaticity Co-ordinates		Reflection Factor
	x	*y*	
Red Rose	0·586	0·330	12·2 %
Lemon	0·473	0·467	51·3 %
Grass	0·290	0·518	29·7 %
Polished Turquoise	0·253	0·325	22·4 %
Blue Lupin	0·228	0·182	8·3 %

336

Table A.1 shows the CIE references (to 'B' illuminant) of various common coloured objects. Whilst CIE is less easy to use than the Munsell system, it is better suited to mathematical calculations, particularly those embracing dye and printing ink deficiencies for computer programming in electronic masking etc. From time to time CIE recommend small modifications to the system – for current information refer to *The Proceedings of the CIE*.

Related reading

G. J. CHAMBERLIN. *The CIE System Explained*. The Tintometer Ltd., Salisbury, England.

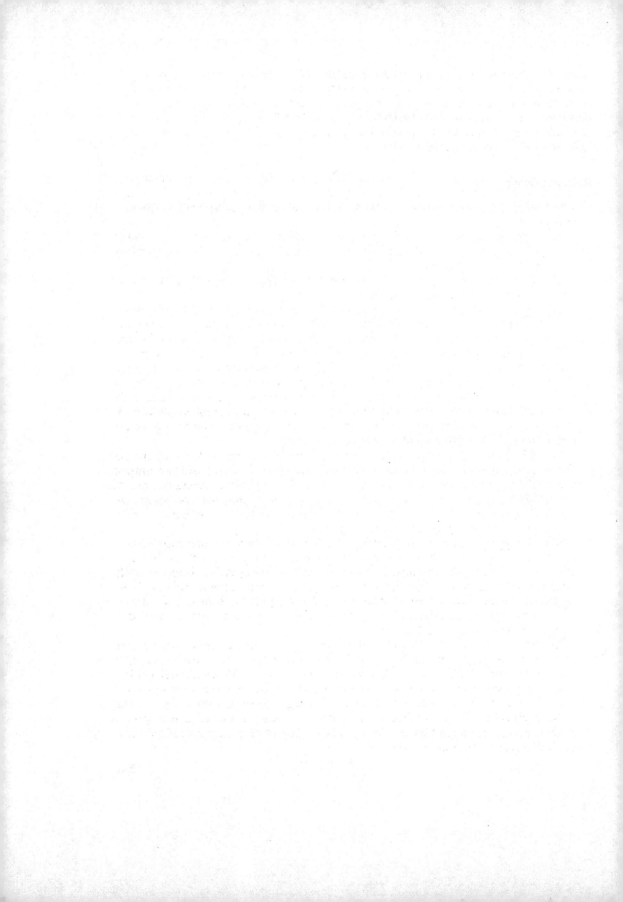

CONTRAST INDEX

Ever since the days of Hurter and Driffield, *gamma* has been the term commonly used to specify the degree of development given to an emulsion. But today gamma values do not necessarily relate to monochrome image gradation for the following reasons:

(1) Exposures now often utilize emulsion performance on part of the curve toe as well as straight line portion. The length of toe varies considerably with different emulsions.

(2) More and more emulsions are double coated – giving 'dog leg' or other mis-shaped curves for particular purposes.

(3) Special developers may also give distorted curve shapes which alter the negative's printing characteristics without necessarily much change in gamma figure.

The use of average gradient ($\overline{\text{G}}$) attempts to overcome these limitations, being the tangent of the angle made between the log E axis and a line joining the two points on the curve used to expose the extremes of subject shadow and highlight respectively. But you do not often find a manufacturer quoting development for his emulsions in terms of average gradient – because the two measurement points must necessarily vary with the luminance range of each individual subject photographed. Ilford Ltd. now quote $\overline{\text{G}}$ figures for their materials based on an image luminance range of 1·5 Log E units (32:1) from a point 0·1 above fog.

In 1965 Eastman Kodak introduced a new parameter *contrast index* to determine degree of development for monochrome continuous tone films and plates. Contrast Index is the slope (expressed in tangent values) of a straight line joining two points on the characteristic curve *that represent the approximate minimum and maximum densities used in practice*. It is therefore an adaptation of average gradient, assuming a specified 'average' image luminance range.

Kodak suggests that with continuous tone materials the two measurement densities can be taken as (*a*) 0·1 above base-plus-fog density and (*b*) the point on the curve cut by an arc 2·0 log E units long drawn from point (*a*). See Fig. A.11. More accurately (and also suitable for line materials) the densities are found at the points where two arcs cut the curve – one arc of 0·2 and one of 2·2 log E units. Both arcs are drawn from a common centre at base-plus-fog density and opposite a position on the log E axis found by using a special protractor.

As shown in Fig. A.11, two films developed to the same contrast index rather than to matching gammas both possess approximately the same density scale, and print on the same grade of paper. A contrast index of about 0·56 suits Kodak grade 2 enlarging papers printed on a cold cathode enlarger; 0·45 is needed for this same grade if printed with an opal lamp condenser enlarger. These negatives print on the paper irrespective of their toe shape or whether they have a dog-leg centre portion to their curves, although they inevitably vary slightly in *local* contrast (e.g. shadow gradation relative to other tones).

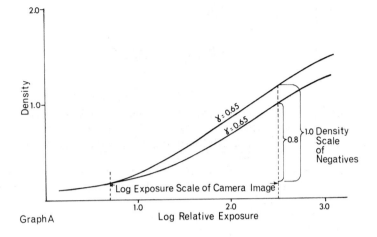

Graph A

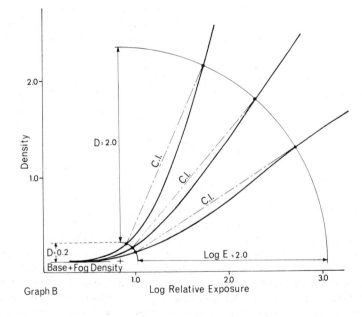

Graph B

Fig. A.11. Graph A: Two films processed to the same gamma may reproduce the same image luminance range by differeing density scales. Graph B: Basis of measuring contrast index. Graph C: Two films processed to the same CI reproduce the prescribed image luminance range as equal density scales, even though emulsion gammas differ. Graph D: Sensitometric curves (Kodak Pan X) expressed in contrast index (Curves courtesy Kodak Ltd.)

340

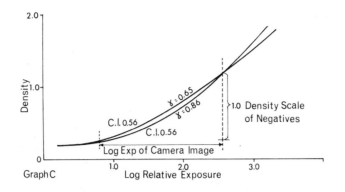

Graph C

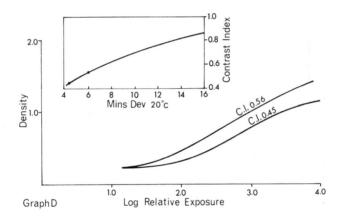

Graph D

It can be seen that this 'paper matching' system works on the basis that the higher the luminance range, the lower the CI figure to which we should develop – until a luminance range of 2·0 (100:1) is reached. This type of 'correction' inevitably calls for some adjustment in effective emulsion speed rating. If the subject is high contrast and development is therefore to be to a low CI (e.g. 0·38) the speed rating may have to be halved. Conversely a low contrast subject developed to a high CI (e.g. 0·7) allows the emulsion to be uprated in speed. Technical data sheets on specific Kodak negative materials and developers now quote recommended contrast indices.

341

CHEMICAL FORMULAE

DEVELOPERS

(All weights of solids in this table are given in grams).

	Gen. Purpose M.Q. (D61A)	P.Q. (ID67)	Low Cost F Grain (D23)	FOR NEGATIVES — F. Grain Low Alk (D76)	Max Emulsion Speed	Max Definition 'A'	Max Definition 'B'	High Contrast Type (D.8)	Lith Type	REPLENISHERS — For D76	For D61A 'A'	For D61A 'B'	FOR PRINTS — M.Q. (D163)	Warm Tone (D52)
Metol or 'Elon'	3·1		8	2	14	10				3	1		2·2	1·5
'Phenidone'		0·25												
Hydroquinone	5·9	8		5	14			45	22·5	7·5	2		17	6·3
Paraformaldehyde									7·5					
Sod. Metabisulphite	2·1								2·6		0·6			
Sod. Sulphite (Anhyd)	90	75	100	100	50	50		90	30	100	30		75	22·5
Pot./Sod Hydroxide					9			37·5						
Sod. Carbonate (Anhyd)	11·5	37·5					50					120	65	14·5
Borax				2						20				
Boric Acid (Crystals)									7·5					
Wood Alcohol					50cc									
Pot. Bromide	1·7	2			9			30	1·6		0·5		2·8	1·5
IBT Restrainer Sol.		15cc												
'Calgon'						2	2							
Make up to	1 Litre	1 Litre	1 Litre	1 Litre	1 Litre	1 L	1 L	1 Litre	1 Litre	1 Litre	1 L	1 L	1 Litre	1 Litre
Working Strength in Stock plus water (if different to above)	1+3	1+5				A+B+10		2+1		Use to top up tank	3A+1B		1+3	1+1
Approx. Mins. Dev. at 20°C. (68°F.)	14	9–15	16	17–25	4—8			2	2				1½–3	1—2

Stop bath

<div align="center">
Acetic acid (glacial) 1·5%

(Increase concentration to 3·5% for lith materials)
</div>

Immerse material for about 10 seconds.

Fixers

	Acid fixer	Acid hardening fixer	Rapid fixer
Sodium thiosulphate (crystal)	240 g	240 g	
Ammonium thiosulphate			200 g
Sodium sulphite (Anhydrous)		15 g	15 g
Potassium metabisulphite	25 g		
Acetic acid (Glacial)		13·5 ml	21 ml
Boric acid (Crystal)		7·5 g	7·5 g
Potassium alum		15 g	25 g
Make up to	1 litre	1 litre	1 litre

Hypo eliminator **Kodak formula HE-1**

To destroy traces of hypo retained in the fibres of printing paper, when prints are to be stored for long periods.

<div align="center">

3% Hydrogen peroxide	125 ml
0·880 Ammonia	10 ml
Water to make up to	1 litre

</div>

Prints should have received 30 minutes effective washing prior to treatment. Immerse for about 6 minutes and then wash for a further 10 minutes.

Stabilizer

<div align="center">

Sodium thiosulphate	500 g
Sodium sulphite (Anhydrous)	15 g
Sodium bisulphite	50 g
Water to make up to	1 litre

</div>

The material is stabilized in 30 seconds.

Monobath

<div align="center">

Water (95°C)	750 ml
Sodium sulphite (Anhydrous)	60 g
Hydroquinone	30 g
Sodium hydroxide	25 g
'Phenidone'	3 g

</div>

Sodium thiosulphate (Crystal) 150 g/l
Cooled water to make 1 litre
Add before use 10 ml of 40% formaldehyde
Process to completion (4–6 minutes at 20°C)

Reversal processing solutions

For monochrome continuous tone film.

First developer: M-Q or P-Q general purpose negative developer used at four times normal strength, *plus* 3 g sodium thiosulphate (crystal) per 1000 ml. Time varies with emulsion, typically 6–8 mins. ,

Water wash: 3 minutes.

Bleach: From a stock solution of
Potassium bichromate 5%
Sulphuric acid (conc) 5%
Dilute one part stock solution with nine parts of water. Yellow safelighting can be switched on once the film has been in this solution for about 3 minutes. Bleach until the black silver image disappears (about 5 minutes).

Water wash: 3 minutes

Clearing: Sodium sulphite 5%
Sodium hydroxide 0·1%
Soak until yellow bleach stain fully disappears (1–2 minutes).

Water wash: 2 minutes.

Fogging exposure: About 1 minute twelve inches from a 100-watt lamp.

Second development: In M-Q or P-Q negative or positive developer, or first developer solution. Blackening should be complete in about 5–6 mins.

Fixing: An acid hardening fixing bath. About 10 minutes.

Wash: 30 minutes.

For line materials use D.8 developer plus 4 g hypo per litre for first development.

Tests for image permanence

(1) Test for residual silver thiosulphate compounds.
Use a 2% sodium sulphide stock solution, diluted 1+9.
One drop of solution is allowed to remain on the (dry) rebate of the emulsion for 2–3 minutes. Any colour beyond pale cream left after blotting off denotes the presence of silver compounds.

(2) Test for residual hypo.
Acetic acid (glacial) 35 ml
Silver nitrate 7·5 g
Water up to 1 litre
Cut off a corner or other clear area of the negative or print and leave it in

345

the test solution for 2–3 minutes. The darker the discoloration of this sample the more hypo present. Photographic images intended for archival storage should show no discoloration.

Toners

Gold (protective) toner Kodak GP-1
For prolonging the life of a silver image by gold plating.
The resulting image colour is deep bluish black.

1% gold chloride solution	10 ml
Sodium thiocyanate	10 g
Water up to	1 litre

Mix just before use. First add the gold chloride solution to 750 ml of the water. Dissolve the sodium thiocyanate in a separate 125 ml of water and add this slowly to the gold chloride solution stirring rapidly. Make up to full volume.
The print should be well washed and preferably treated with hypo eliminator. Immerse for 10 minutes (20°C). Finally wash for 10 minutes.

Gold (red) toner Ilford IT-4
Prints are first sulphide toned and then treated in the following:

Gold chloride	1 g
Ammonium thiocyanate	20 g
Water up to	1 litre

Toning takes about 10 minutes, giving a chalk-red image colour.
Re-fix in 10% plain hypo solution for 10 minutes and wash thoroughly.

Iron (blue) toner Ilford IT-6

'A' Pot. ferricyanide	1 g	'B' Ferric ammonium citrate	1 g
Sulphuric acid (conc)	2 ml	Sulphuric acid (conc)	2 ml
Water to	500 ml	Water to	500 ml

Mix equal parts of 'A' and 'B' immediately before use.
Thoroughly washed prints are immersed until the required tone is produced, and then washed just enough to remove the yellow stain. Excessive washing produces bleaching. (This toner has a slight intensifying action – prints should be made *lighter* than finally required).

Intensifiers

Chromium
Bleach in:

Potassium dichromate	9%
Hydrochloric acid	6%

used 1 + 10 parts of water (preferably distilled).
The negative is allowed to bleach until yellow-buff right through, then washed to remove the yellow stain. It is re-developed in a non fine grain P.Q. or M.Q. print developer.

Mercuric chloride

This gives maximum intensification of a thin negative. However, like mercury itself, mercuric chloride is very poisonous – so handle the solution wearing rubber gloves.

Bleach in:

Potassium bromide	2%
Mercuric chloride	2%

The black silver image turns milky white (giving the image a positive appearance). The negative must next be thoroughly washed for about 20 minutes. You now have a choice of 'redevelopers' or 'blackeners'. Ammonia solution (10%) gives the strongest increase in density and contrast, but it does not give a fully permanent result. Full strength MQ developer gives a permanent result but with slightly less intensification.

Reducers

Farmer's (ferricyanide)

'A' Potassium ferricyanide 10% (crystals)	'B' Sodium thiosulphate 20% (crystals)

Make up a working solution just before use by combining one part of A with eight parts of B. First test its density-reducing action on an unwanted negative or print; dilute the reducer with water if it proves too active. Reduction is halted by transferring the film/paper to a dish of running water. The more 'A' component present relative to 'B' the more *subtractive* the action. (i.e. faintest densities are reduced more rapidly than heavy densities). Finally wash for 10–15 minutes.

OTHER FORMULAE LOCATED WITHIN THE MAIN TEXT

Toners

Sepia – Sulphide 〉 page 168
– Selenium 〉

Reducers

Iodine bleacher page 169.

347

APPENDIX VI

SUPPLEMENTARY GLOSSARY

Most new terms are defined within the text itself (*see* Index). Others relating to latent image formation are explained below:

Crystal lattice: A silver halide grain such as silver bromide appears to consist of small silver (positively charged) ions and larger bromide (negatively charged) ions, evenly spaced as a three dimensional grid or 'lattice'. When affected by light, electrons are released from some bromide ions. These are free to move through the crystal until they lodge in areas of impurities or defects–here building up an electrical charge which is the first step in the formation of a latent image.

Hypersensitivity: Increasing the speed of an emulsion before exposure to the image. This can be carried out chemically, or by means of light–for example, by pointing the unfocused camera at an evenly lit area (wall, or sky, etc.) and giving about 1/100 correct exposure. Hypersensitivity can double emulsion speed, but results are somewhat unpredictable and if overdone give noticeable fog.

Intermittency effect: Instead of exposing for a continuous period of time it might be assumed that a number of intermittent exposures, adding up to the same total, would have the same effect. For example, five exposures of 1/10 sec should give the same result as one of $\frac{1}{2}$ sec. The processed result however is likely to show less density than expected (irrespective of shutter inefficiencies which may further aggravate the situation). Exact results are difficult to predict–the intermittency effect varies with each emulsion and with differing image luminances. In the example quoted one additional 1/10 sec exposure would probably be adequate compensation.

Ions: Electrically charged atoms. Negatively and positively charged ions are mutually attractive and distribute themselves out evenly within a silver halide grain.

Reciprocity failure: The concept that changes in image *brightness* can be fully compensated by changes in exposure *time* (or Exposure = Intensity × Time) no longer holds true when either I or T are either very small or very large. For example, given a very short exposure to a very bright image, an emulsion responds as if less sensitive than normal. (Known as high intensity RLF). Similarly long exposure to a dim image (low intensity RLF) also has an emulsion speed reducing effect. There is therefore an *optimum* range of exposure times–generally between 1/1000–1 sec. Outside this range the electron release rate within each silver halide crystal becomes increasingly too fast or too slow for the emulsion to give a normal, full speed rated performance. RLF can be expressed as a graph (page 211) which at its lowest point shows the image intensity at which the emulsion performs with greatest sensitivity.

Sector wheel: An opaque disc with cut-out sections shaped like a staircase. Rotated once in front of an emulsion under test, during exposure to a light source, the disc provides a controlled range of exposure *times*, while intensity remains constant.

Step wedge: A film or glass carrying a scale of grey tones (regular increments in steps from transparent film to almost opaque density). When contact printed onto an emulsion under test the wedge provides it with a controlled range of exposure *intensities*–while time remains constant. Both sector wheels and step wedges are used in sensitometry, *see* Chapter 8.

INDEX

350

352